IMAGE ETHICS

DATE DUE

AG 1 2 10			
MAY 2 9 12			

DEMCO 38-296

COMMUNICATION AND SOCIETY
edited by George Gerbner and Marsha Siefert

IMAGE ETHICS
The Moral Rights of Subjects
in Photographs, Film, and Television
Edited by Larry Gross, John Stuart Katz,
and Jay Ruby

CENSORSHIP
The Knot That Binds Power and Knowledge
By Sue Curry Jansen

SPLIT SIGNALS
Television and Politics in the Soviet Union
By Ellen Mickiewicz

TELEVISION AND AMERICA'S CHILDREN
A Crisis of Neglect
By Edward L. Palmer

IMAGE ETHICS

The Moral Rights of Subjects in Photographs, Film, and Television

EDITED BY LARRY GROSS,
JOHN STUART KATZ, AND JAY RUBY

New York *Oxford*
OXFORD UNIVERSITY PRESS

For Barbara Myerhoff and Sol Worth

Oxford University Press

Oxford New York Toronto
Delhi Bombay Calcutta Madras Karachi
Petaling Jaya Singapore Hong Kong Tokyo
Nairobi Dar es Salaam Cape Town
Melbourne Auckland
and associated companies in
Berlin Ibadan

Published by Oxford University Press, Inc.,
200 Madison Avenue, New York, New York 10016

Oxford is a registered trademark of Oxford University Press

Library of Congress Cataloging-in-Publication Data
Image ethics : the moral rights of subjects in photographs, film,
and television / edited by Larry Gross, John Stuart Katz, Jay Ruby.
p. cm. Bibliography: p. Includes index.
ISBN 0-19-505433-4
ISBN 0-19-506780-0 (pbk)
1. Portraits—Law and legislation—United States. 2. Mass media—Law
and legislation—United States. 3. Privacy, Right of—United States.
4. Portraits—Law and legislation. I. Gross, Larry P., 1942–
II. Katz, John Stuart. III. Ruby, Jay.
KF1263.U5145 1988
174—dc 19 88-4203

2 4 6 8 10 9 7 5 3 1
Printed in the United States of America
on acid-free paper

Preface

In July of 1907 the periodical *The Independent* ran an editorial with the title "The Ethics and Etiquet of Photography," warning that

> Tourists who have loaded themselves with rolls of film for use in Europe this summer will have to be careful when they go to Germany. In that thoroughly regulated country a new law goes into effect July 1st prohibiting the photographing of any person or his property without his express permission. (7/11/07:107f)

The editorialist of *The Independent* viewed this development with a somewhat chauvinist skepticism, noting that the German government "tends to prohibit anything that can be prohibited and many things that cannot. Photography belongs in the latter class." The editorialist goes on to admit that there are "undeniably abuses in our present free and unlimited practice of photography," but these cannot be remedied without "interference with the rights of the camera"!

> As regards photography in public it may be laid as a fundamental principle that one has a right to photograph anything that he has a right to look at.

In the eighty years since that principle was stated with such clarity and simplicity, it has not been universally accepted nor has it sufficed to resolve ethical and moral issues surrounding the use of the camera. Moreover, as photography was joined by motion pictures and later by video, and as our world has become ever more inundated by visual images which inform, educate, and entertain us, these concerns grow sharper and more inescapable.

Consequently, when we began discussing these matters a few years back, it was something of a surprise to discover how little scholarly attention had been paid to the moral rights of those individuals and groups whose images are used by photographers, film-makers, and video producers. Our response to this discovery was to begin discussing these is-

sues with our colleagues and students, in an effort to stimulate more active and extensive consideration of what we began to call image ethics.

It is unlikely that any single collection of papers could do justice to the range and complexity of ethical concerns invoked by the use of visual media. Nonetheless, we believe that the present collection will make a valuable contribution, not only by calling attention to an important but neglected domain of moral accountability but by providing a set of theoretically informed analyses grounded in discussions of particular cases.

The volume begins with an introduction which provides a historical context and an overview of the territory, with particular attention to the issue of privacy—the theme most frequently encountered in the discussion of image ethics. The first essay, by Brian Winston, continues the historical groundwork by tracing the roots of the tradition that dominates most documentary work in photography, film, and video, namely, the dedication to "social amelioration through the documentation of societies' victims," and asking whether in fact the promises implied by this doctrine are realized in practice.

The next four essays examine aspects of the relationships between image makers and their subjects, approached within the framework of informed consent. These papers can be seen as representing an ever closer engagement of image makers and their subjects. Beginning with the documentary film-maker exposing an instance of social victimization (in the very tradition described by Winston), Carolyn Anderson and Thomas Benson explore an unusually challenging instance of the probelms inherent in attempts to obtain truly informed consent.

Lisa Henderson's focus is the more familiar but still sensitive terrain negotiated by photographers who take pictures of people in public places. As the editorial writer in *The Independent* remarked back in 1907, ". . . when one appears in public it is always with the expectation and often with the purpose of being seen, and nowadays he must also anticipate being photographed." Yet, we do not necessarily feel that photographers have an inalienable right to photograph us without our consent. As Henderson shows, photographers must learn the strategies necessary to obtain and sustain access and consent.

"Most documentary film-makers have relatively little commitment to the subjects of their films," Robert Aibel notes, in preparing to argue that even those film-makers who do feel a sense of commitment to their subjects will invariably encounter difficulties in balancing ethical considerations with the exigencies of film-making. Aibel illustrates the conflicts that face documentary film-makers through an example from a

film he produced and directed in collaboration with colleagues also committed to a stance of moral accountability.

Aibel and his collaborators are unusual not only in the degree of their awareness of the moral obligations entailed in documentary film-making, but also in that they were making a film in a community where they had all conducted research for several years, and in which they were no longer strangers. The people who figured in their film were known to them, and the film-makers had an investment in the community which they were interested in preserving. While Aibel *et al.* were constrained by their prior professional relationships with members of the community they filmed, Katz and Katz discuss the more dramatic case of autobiographical films about the film-maker him/herself and/or about the film-maker's family. In these instances, "the subject of the film and the film-maker often begin with a level of trust and intimacy never achieved or even strived for in other films." Using examples from many autobiographical and family films, Katz and Katz ask whether—and how—the principles of ethical practice in these cases differ from other kinds of documentary films. In addition, they pursue the intriguing question of what effect a knowledge of the 'special' relationship between film-maker and subject has on the audience's perception.

The papers by Viera and by Beauchamp and Klaidman move us away from the domain of the independent documentary to explore the practice of image makers in the more commercial branches of the visual media, and television in particular. Viera analyzes the legal and economic dimensions of subjects' images, with special attention to 'stars' and to what is known as the right of publicity; the right to profit from one's own image. Using examples such as the image of 'Elvis,' or Bela Lugosi's impersonation of Dracula, Viera explores the issues raised when image makers attempt to profit from the intangible property constituted by media fame. As he shows, a troublesome ethical and legal dilemma surrounds the question of who *owns* a star's image, and who should be permitted to cash in on the investment such an image represents.

Beauchamp and Klaidman offer a case study of a recent and widely publicized dispute concerning not the property rights but the reputation of a public figure. When General William Westmoreland sued CBS News, charging that he had been libeled by the program "The Uncounted Enemy: A Vietnam Deception," he focused public attention on the often troublesome practices common to network documentaries. Despite an official commitment to 'objectivity,' it is well known to anyone who has been involved in documentary production (or almost any

journalistic enterprise, for that matter), that the necessity of selectivity and the demand for a dramatic narrative force the producer towards an artificially simple and inevitably slanted presentation. In Beauchamp and Klaidman's judgment, "The search for 'truth' fades and becomes a search for a preconceived 'moment,' a biased hypothesis that captures the 'essence of truth' in the mind of the documentary maker."

The next four essays maintain the spotlight on mass media practices but, rather than examine the treatment of the rich and famous, these authors are concerned with the depiction of people at the margins of society. In a world dominated by centralized sources of information and imagery, in which economic imperatives and pervasive values promote the search for large, common-denominator audiences, what is the media fate of those groups who for one reason or another (racial, sexual, religious, ethnic, etc.) find themselves outside the mainstream? Briefly, and it is hardly a novel observation, such groups share a common fate of relative invisibility and demeaning stereotypes. Gross presents an analytic model of the role of mass media, television in particular, in American society and then offers a set of criteria by which to judge the ethical dimension of media practice. Stating that the "critical test of ethical guidelines applied to mass media practice will be to examine the treatment of those outside the mainstream," he illustrates the application of these principles through a discussion of how the U.S. media have dealt with sexual minorities.

"The most pervasive negative stereotype today is of the Arab people," Shaheen asserts, and few would disagree. In presenting examples of Arab roles and images on U.S. television, Shaheen shows how the Arab has become practically the last ethnic category which can be safely cast in demeaning and villainous roles. Whatever commitments to objectivity, balance, and fairness might be inscribed in production codes, writers, directors, and producers operate within a highly conventionalized dramatic code that demands easily recognizable and interpretable stereotypes. As long as Arab nations and leaders are the targets of choice for politicians, it's hardly surprising that media professionals practice their own form of disinformation.

The papers by Hostetler and Kraybill and by Volkman discuss two commercially successful films that can be seen as 'travelogues' providing mainstream audiences with dramatic revelations of the life and character of two notably exotic groups: the Amish of rural Pennsylvania and the "Bushmen" of the Kalahari desert in Southwest Africa. In each case there are serious questions to be raised concerning the film-

makers' relationship with the people who served, involuntarily, as the subjects (at least in the general sense) of their films. In these two accounts the authors find little to praise. In the first instance, the film *Witness* was made despite the objections of the Amish whose life and lifestyle form the central focus of the plot. More than merely ignoring the expressed wish of the Amish to be left alone, Hostetler and Kraybill describe tricks concocted by the film-makers to obtain footage of unwilling and unwitting subjects. Despite criticism from black groups and an official condemnation from the American Anthropological Association, the South African film *The Gods Must Be Crazy* became the highest grossing foreign film ever shown in the United States. As Volkman convincingly shows, the film "perpetuates the myth that Bushmen are blissfully simple creatures, while its popularity persuades South Africa that the rest of the world wants to continue to see them that way."

Returning one last time to the anonymous editorialist of *The Independent* writing eighty years ago, we are assured that

[the] real ground of the grudge that most of us have against the snapshooter is that he confers upon us the gift that the poet unwarrantably assumed to be a common desire of mankind, to see ourselves as others see us.

As we have noted, most of the essays in the present volume demonstrate how rare it is that image makers show us to others as we would like to be seen and, moreover, put in question the assumption that the image makers' perspective is more objective or valid than that of their (willing or unwilling) subjects. There is, however, another possible answer to whether the interests of subjects must always be sacrificed in the process of image production: why not put the means of media reproduction in the hands of the people whose image is to be presented, whose story is to be told? Waugh offers insight into this possibility in his description and analysis of minority self-imaging in the case of twenty-four documentaries made by openly lesbian and/or gay film-makers. In conjunction with Gross's analysis of the treatment of gay people by network television, it is no surprise that Waugh sees the work of lesbian/gay film-makers as inherently oppositional. Waugh brings us back to some of the themes that opened the volume—the intertwining of ethical considerations with political and social commitments.

As we began the series of discussions and investigations that led to this collection, we quickly accumulated a large number of books, articles, and clippings relating in some way to the issues of image ethics.

Lisa Henderson organized and expanded this collection of materials, and her energy and insight are clearly reflected in the annotated bibliography that closes the volume.

One of the colleagues with whom we began discussing image ethics is Howard Becker, whose dual roles as sociologist and photographer have made him unusually sensitive to the fact that ethical problems arise and must be handled within the practical realities of social relationships and institutional constraints. We benefited greatly, as always, from these conversations and are particularly pleased that our readers will similarly benefit from the Foreword that Howard Becker has contributed.

The process of moving from discussion to more formal exchanges and towards publication was encouraged by the support of Dean George Gerbner and the Trustees of The Annenberg School of Communications at the University of Pennsylvania, who funded a small working conference in January 1984 at which many of the present essays were initially discussed, and the International Conference on Visual Communication in June 1985 at which several other essays in the collection were presented. These conferences gave us an opportunity to engage in valuable and productive discussions with colleagues from around the world, and to further extend and deepen our awareness of the moral dimensions of visual media. We hope the book does justice to the contributions made by conference participants and by the many colleagues, students, and friends who have read these papers, listened to us lecture, and put up with our obsession.

Philadelphia Larry Gross
February 1988 John Stuart Katz
 Jay Ruby

Foreword:
Images, Ethics, and Organizations

HOWARD S. BECKER

Unresolvable Paradoxes

In the early 1970s, the graduate students in the department of sociology at Northwestern confronted us with this problem: how could they do research on socially worthwhile topics while ensuring that their results could *never* be used for bad purposes by reactionaries, would in fact be used for good purposes by progressive social forces, and would absolutely not hurt anyone they didn't think deserved to be hurt? Among other things, that is, they accepted what Brian Winston (in this volume) has identified as the assumption made by documentary film-makers working in the Griersonian tradition: that doing their work should and, well done, would help produce desirable social change. Their worries thus did not differ in kind from the problems of image ethics, although images probably present those problems in a much more difficult form than the typical formats of social science those students had in mind.

Most ethical problems connected with research are just as intractable and insoluble as the one our students presented us with. It seems that, in order to do their work, the workers (I'll use that generic term to cover film-makers, social scientists and others who make representations embodying knowledge about society) have to do things they shouldn't, from many ethical standpoints, do. If the work is worth doing, and if doing it is thus a good thing, this dilemma can only be settled by treating one of the values involved as the one that always takes precedence. But it is difficult to get assent to any such choice of one paramount value. Workers will not face up to the ultimate consequence of such an analysis, which might be that they should just quit doing

what they do. Andersen and Benson's discussion of Frederick Wiseman's films (in this volume) suggests, in fact, that there is an inevitable contradiction between making films in the direct cinema style and following such an ethical imperative as getting the "informed consent" of people in the film.

In fact, workers damn well will continue to work. Few film-makers and photographers will give up their skills and pleasures, their reputations and careers, no matter what they are accused of or how guilty they feel. Similarly, social scientists won't give up methods that produce worthwhile scientific results unless the codes requiring them to do so have real teeth. (Some people in both these groups, of course, will take advantage of the possibility of doing work that just doesn't address these issues: still lifes, research on innocuous topics.)

Consent, Rights, and Power

Most discussions of ethics arise, as a practical matter, in situations where workers need to defend themselves against an accusation. We use the language of ethics when people accuse us of taking advantage of someone we have used as a subject in our work. Furthermore, most ethical questions arise after the fact, after the work has been done, usually when the book is published or the film screened. Most answers to such accusations rely on some notion of consent (usually "informed") as the ethical touchstone. This criterion was first developed in connection with gross excesses in biomedical research and then transplanted to social research, where it met with great resistance and has had to be modified repeatedly. Film-makers and photographers took it over when people began objecting to their traditional practices: taking the pictures and getting a signed release, or relying on the defense of editorial freedom. If people sign up with their eyes open, or if the pictures serve some purpose that can be connected to the First Amendment, then neither they nor anyone else can complain. Those lines stopped working when subjects and others stopped accepting them meekly.

One standard ethical complaint about those standard practices and justifications relies on the notion of rights. It says that there are some rights no one can bargain away. Just as I cannot sell myself into slavery, no matter how open my eyes are, I cannot (or ought not to be able to) sign away my right to be treated, when someone collects images, in an ethical fashion, whether I want to be or not. But, as in most proposed solutions to the problem, it's not clear that you could apply the

criterion easily. For one thing, the principle conflicts with the clearly legal right (described by Viera in this volume) to sell your image. For another, the general principle doesn't make clear which rights can't be bargained away, and so only moves the problem back a step.

A second standard complaint about what might be called "consent strategies" relies on the notion of knowledge. It says that I cannot give consent unless I am truly informed, and that being truly informed requires that I know at least as much about the process of making photographs and films (or doing social research) as the people doing the work. Otherwise, I may think that I am protecting myself (or that there is nothing to protect myself against) when these people actually have tricks up their sleeves I can't even begin to imagine. Image makers can use selective editing, framing, lighting, and the rest of the familiar catalogue to produce a result in whose making I wouldn't have cooperated had I known what was coming. This principle is likewise not easy to apply. For one thing, many complaints come from or on behalf of people who in fact know quite a bit about these things. They may not know every last trick, but it is hard to imagine, for instance, that someone of General Westmoreland's experience had no idea what he was getting into when he filmed the interview for "Sixty Minutes" about which he later sued CBS (see Beauchamp and Klaidman, this volume).

What makes these problems difficult, if not totally impossible, of logically or ethically reasonable solution is that no one ever knows exactly what they have agreed to, even in situations of consent involving highly informed people. Accounts of negotiations leading to filming and social research typically describe the atmosphere of good will and cooperation in which the work begins, and its gradual degeneration into misunderstandings and recriminations. The process involves these matters:

1) Research on contracts and negotiations shows that even the most detailed contract does not cover everything, many matters being left to be settled in the light of the general principles it contains or can be read to imply; but these only settle disputes in the presence of mutual trust and goodwill.

2) Filmmakers and social researchers insist—quite reasonably, from the point of view of anyone who has ever done intellectual or artistic work—that they can't know when they begin their work what they will end up with, since that will depend on what material they finally have and how their ideas have evolved. Further, they will say, as Wiseman has, that they will not waste their time and resources making a work with no guarantee of having something to show for it.

3) Workers thus cannot say in advance what they will do so that they cannot, in principle if they are to make the kind of film or do the kind of research they intend, warn people properly. How can I warn you that I am going to expose your dishonesty if, when we are bargaining, I so take for granted that you are honest that the necessity of issuing that warning never crosses my mind?

4) This is compounded in dealings with large organizations, whose members habitually take care to cover their asses and diffuse responsibility, thus enabling themselves to deny that they agreed to anything. Something like this clearly went on in the legal maneuverings surrounding the making of Wiseman's "Titicut Follies," as Anderson and Benson have described it in this volume.

People do not usually decide these questions through a reasoned consideration of ethical principles, but rather by finding out who has the power to make their view stick. Who can do what without being successfully hassled? People who can get away with it can, in the confused ethical state of affairs that now prevails, generally produce a respectable ethical justification. Some situations are pretty nakedly matters of power and not much more. The "Migrant Mother" Dorothea Lange photographed never knew who "that lady" [Lange] was, why Lange never sent her the picture she promised she would send, and certainly not that the picture was destined to become a major stereotype of the Okie migration. And there was nothing the migrant mother could have done about that, certainly not before it happened—or afterward either, because she would have needed lawyers she couldn't afford and probably would have been suing the government anyway. On the other hand, powerful people can influence how they are portrayed. They can control access to themselves and their images more easily, can scare imagemakers off with threats of the law, and can (as has happened with Wiseman) successfully invoke the law on their side.

Organization and Ethics

This discussion suggests that we should not consider ethical problems in an organizational void. Who invokes ethical considerations, which ones they invoke, and with what success are all matters of the social organization in which the people involved meet. That organization consists of the network made up of all the people who participated in the making and distributing of the film or other work. Questions of ethics, as I suggested earlier, typically get settled in such organizations in a way that is

neither logical nor according to principles arrived at in a reasoned fashion. These questions get settled instead through accommodations and compromises, arrived at in the light of differences in power. They get settled by the various groups involved recognizing what they want and what they will have to give to get it. Remember that the heads of such institutions as hospitals, jails or schools, who need not participate in having films of themselves made, generally think there is something in it for them: perhaps a chance at reform, perhaps some public relations benefit. They may well think they are smarter than the film-maker or researcher. Is it unethical for image workers to pretend to be dumber than they are to take advantage of that arrogance? Others, less powerful, also have their own reasons for cooperating with imagemakers, so the bargain is seldom one-sided (although this argument obviously doesn't apply to people filmed without their knowledge).

A good example of the kind of organizational analysis of ethics I am proposing is Karin Becker's study (1985) of the development of the photojournalistic profession and its accompanying ethic. Where do photojournalists get their gut convictions about the ethical principles that seem so obvious to them? Keep in mind that this question, which seems very particular to journalism, can serve as a model for our understanding of the development of working ethical systems in all the lines of work that make images of social reality, visual and otherwise. Her research shows how editors, photographers and subjects reached an accommodation in the beginnings of photojournalism, as a way of regulating their mutual requirements, so that the work of putting out illustrated magazines could proceed. Subjects, knowing least and having less of a continuing stake in the work, had least to say about it. But subjects who were also photographers (in Becker's study, the workers who produced pictures for the Communist magazine and never became professionals) had more to say and, conversely, were less involved in the social and professional mobility that so affected the ethics of those who became the prototypical "professional photojournalists." In any case, once that accommodation got established as a set of morally justified working practices generation after generation of photojournalists took it up because it worked. That is, it helped them figure out what to do when confronted with accusations that they were unfair to or exploiting their subjects and the magic formula to intone when someone accused them of being unethical: "The standards of my profession."

Solutions?

Discussions of the ethics of imagemaking typically try to establish, in the philosophical style, principles from which we can deduce ethically appropriate behavior under a variety of circumstances (see Beauchamp and Klaidman, in this volume). Just as typically, they seldom discuss sanctions or any other feature of the social organization in which the behavior under consideration occurs. They emphasize, instead, finding moral people or training people to be moral. But ethical principles which have no sanctions connected to them—no rewards and punishments injured parties can invoke and no apparatus for seeing that the sanctions are applied when they ought to be—do not have the full force we hope for. While some people, once they have thought through the logic of an ethical system and accept it, will find that logic constraint enough, a system without sanctions fails to deter precisely those who most need deterring: people who are not moved by that logic or who, recognizing its validity, nevertheless find other considerations equally or more compelling. Appeals to morality simply do not solve problems of this kind, even when the principles are generally agreed to.

The sanctions I am talking about need not be official punishments: fines, days in jail or injunctions banning one's work from being shown. Sanctions like that, of course, really get image makers' attention and become one of the realities they must reckon with as they work. They may still decide to violate certain norms because the logic of their work or their political position seems to them to require it, but that will be a serious choice others will not make. More informal sanctions—the contempt of one's colleagues or the refusal of people to cooperate in the work—can be equally effective. Not being able to raise the necessary resources is also extremely effective.

Ethical systems embodied in social organization, complete with sanctions and an enforcement apparatus—what we might call working ethical systems—hardly ever have a logical coherence. Because they have to take account of conflicting interests, they inevitably have a political dimension, a logic of compromise rather than coherence. To achieve a body of doctrine that most people in an image-making (or any other) trade will accept requires that. It is the price of the consensus through which the work gets done. The result won't satisfy people who want philosophical and moral clarity. It won't satisfy people who do not have enough political power to affect the working consensus. Thus, as a number of papers in this volume argue, ultimate solutions require a redistri-

bution of power such that those presently unable to affect how work is done will be empowered. That, unfortunately, is easy to say and hard to do. The solution probably lies, at least in part, in the building of oppositional communities and organizations (see the papers in this volume by Gross and Waugh) which will support another kind of work, though that would not solve the problem of what to do about the work others do that we don't approve of.

Nor is this a matter that can ever be solved stably. Working ethics change constantly, not by the application of unchanging standards to new situations but by the continual reinterpretation of standards and working practice in the light of new technical or organizational circumstances.

In short, as a practical matter, the ethical problems of imagemaking have to be resolved politically rather than logically. That doesn't mean that ethical problems are nothing more than political problems under another name. But it does mean that insofar as ethical problems are also political, we will find their solutions in the politics of organizations. Professional codes are notoriously conservative and self-serving (students of them have remarked that most of their provisions are designed to protect the members of the profession involved from "unfair competition" from other members rather than to protect clients or the public), so this may seem small comfort. On the other hand, while professional practice will not take into account public concerns unless it has to, the public has ways of making it have to. Exposés, investigations, law suits, the close attention provoked by scandalous cases—all these serve to warn members of the professions involved that some of their hitherto unquestioned professional standards will probably have to be changed. We might even imagine that the papers in this volume constitute part of the process by which professional codes change to take into account public interests.

Contents

1

Introduction:
A Moral Pause

LARRY GROSS, JOHN STUART KATZ,
and JAY RUBY

In 1839 two French inventors, Daguerre and Niepce, achieved a goal long sought after: the technologically mediated production of images drawn directly from nature. The impact of this achievement was both immediate and widespread; within a year Daguerre's pamphlet describing his invention had been published in thirty editions and nearly as many languages (Rudisill, 1971:48), and the technology of daguerreotypy was diffused with astounding rapidity. By 1842 the U.S. Congress accepted daguerreotypes as "undeniably accurate evidence in settling the Maine-Canada boundary" (Rudisill, 1971:240). One of the first proponents of daguerreotypy in the United States was the inventor and artist Samuel Morse, who introduced the new marvel in a speech to the National Academy of Design in 1840, describing the images as having been, "painted by Nature's self . . . they cannot be called copies of nature, but portions of nature herself."

The photographic image provided a crucial impetus to the long-standing desire for an "unmediated" image of external reality, an image whose objectivity was neither limited by the skill of its maker nor sullied by the maker's tastes or biases. The photographic image was readily conceded a realism which neatly paralleled the demands of positivistic science for empirical objectivity, and the desire of literary realism for naturalistic representation. The label daguerreotype itself "soon came to be applied to any study of society which laid claim to sharp observation and total honesty" (Wilsher, 1977:84). Prominent among the enterprises which took upon themselves the mantle of 'photographic realism' was the rapidly expanding institution of journalism. The Ameri-

can press of the mid-nineteenth century "had begun to require adherence to a steadily deepening conventional ethic of 'objectivity' in news reporting" which owed much to the "widespread typification of the newspaper as a daguerreotype of the social and natural world" (Schiller, 1977:92–3). James Gordon Bennett's *New York Herald* was described in 1848 as "the daily daguerreotype of the heart and soul of the model republic . . ." (Pray, 1855:412), and Horace Greeley's *New York Tribune* was praised in 1873 as "a faithful daguerreotype of the progress of mankind" (Ingersoll, 1873:483).

The "marriage of conviction" between our faith in the truthfulness of the photographic image and our belief in the possibility of objective reporting has lasted for nearly a century and a half, and has been strengthened by the invention of motion pictures and television. Although both partners in this marriage have come under growing suspicion, undermined by our growing awareness of the inevitability of subjectivity in the selection, framing, contextualization, and presentation of images and reports, their continuing acceptance in public discourse and belief testifies to their resilience.

The cultural explosion wrought by photographic and telecommunication technologies has profoundly altered every dimension of social existence. We now accept as commonplace the steady stream of visual images pouring into our presence from all over the world and beyond, bringing us into seeming contact with events and peoples we would otherwise know, if at all, only through verbal accounts. The mission of journalists to serve the public's "right to know" is generally interpreted as also serving their "right to see" the actors and the events deemed to be newsworthy. And it isn't only news events that are caught in the visual webs of our image technologies. Ever since Eadweard Muybridge used cameras to demonstrate how horses *really* galloped, scientists of all disciplines have harnessed the camera to their needs for recording and preserving images. Even more prominently, photography and later motion pictures and television have moved into and increasingly occupied the cultural domains of story telling and entertainment. Modeling their early efforts on the conventions of stage drama, movie-makers quickly learned to utilize the powers of the motion picture camera to capture images anywhere in the world and bring them—in the form of carefully crafted narratives—to audiences of a size and heterogeneity never before reached by any artist.

The truly unique powers of visual media as well as those falsely attributed to them combine to confer upon their users the opportunity to achieve both noble and base goals: to discover and communicate

truths but also to deceive and manipulate; to unify dispersed and diverse groups but also to cultivate false impressions and stereotypes of "the other"; to cross great distances and overcome barriers that block our view of important events but also to intrude public scrutiny into individual and group privacy. Consequently, there are important ethical concerns provoked by the existence of visual media and the ways in which they are used. This volume presents a collection of original essays that explore many of the moral questions which arise from the production and use of recognizable visual images of human beings. The authors address ethical problems which occur in the pursuit of news, entertainment, art, or science, when these pursuits involve the use of pictures of real people.

Rights and Responsibilities

Members of industrialized societies have long since become inured to the omnipresence of visual media, and view with amusement the reputed response of "primitives" who worry that cameras will steal their souls. We have generally accepted the view that photographs and films are positive or, at worst, harmless (except in the case of sexual and violent content), and that pictures do not lie. Yet, there is also a growing awareness of complexities and contradictions that confound this apparent complacency.

In the United States the constitutional guarantee of freedom of expression and inquiry has been widely accepted as a charter which empowers journalists, artists, and scholars in their endeavors; whether collecting, interpreting, or disseminating information and ideas. However, many activities which are legally permissible can also be morally questionable, and even the boundaries of the constitutional charter may be contested, as when the "right to privacy" enunciated by Justice Brandeis in 1928 as implicit in the Constitution and as "the right most valued by civilized men" (*Olmstead vs. United States*) is invoked to challenge the photographer or film-maker's right to "take" and use (often for profit) the image of whatever—or whoever—they can aim a camera at. Not surprisingly, many such challenges bring the contestants together in a court of law, and a growing body of precedent is accumulating in a cluster of legal domains grouped somewhat awkwardly under the umbrella label of privacy. As we will see shortly, a survey of this juridical territory can serve to introduce us to many of the most prominent dimensions of what we are calling image ethics.

Although journalists, artists, and scholars may all use photographic technologies for different purposes and in different ways, there are moral imperatives which might appropriately be seen as common to all "professional" production and use of images:

1. The image maker's commitment to him/herself to produce images which reflect his/her intention, to the best of his/her ability;

2. the image maker's responsibility to adhere to the standards of his/her profession, and to fulfill his/her commitments to the institutions or individuals who have made the production economically possible;

3. the image maker's obligations to his/her subjects; and

4. the image maker's responsibility to the audience.

This constellation of responsibilities and standards shifts somewhat as we apply it to the practice of reporters as contrasted with scholars, and of either as compared with artists, but in some form these combine to define an ethical position for image-making and, by contrast, to identify locations of unethical practices. While all of these issues, and others, will be addressed by the essays in this volume, most of the authors are using as their point of entry the moral rights of *subjects* in *documentary* films and photographs.

If there is a common message to be heard in the voices of the individuals and groups whose experiences as the subjects of image-making are reported and discussed in the essays of this volume, it is that image makers can no longer have the comfort of their silence. Ethnic minorities, women, lesbians and gay men, third and fourth world peoples, the poor, and even four-star generals are telling the middle-class, middle-aged, white males who dominate the image industries that many of the pictures they produce are at best inadequate and at worst serve to "symbolically annihilate" (Gerbner and Gross, 1976) them. Some wish to produce their own self-representations in order to use their images for their own purposes (Waugh, this volume), some seek to monitor and even influence the ways in which they are represented by the mass media (Beauchamp and Klaidman, Gross, Shaheen, this volume), and some wish to prohibit visual images of themselves altogether (Hostetler and Kraybill, this volume). The New World Information Order has become a code name for a struggle between nations for control over the means of representation, and the demand by third world peoples that they be able to determine how they are seen not only by others but even by themselves. Similar struggles and demands confront image makers and cultural institutions within our own society, as exemplified by the

protests of blacks against the Metropolitan Museum of New York's photographic exhibit *Harlem on My Mind,* or of gays against the film *Cruising,* hispanics against the film *Fort Apache: The Bronx,* and Chinese-Americans against the film *Year of the Dragon.* The list grows daily.

The time when a photographer or film-maker can shoot and publicly use photographs of strangers (usually poor or in some other way removed from the mainstream) and justify the action as the inherent right of the artist, the reporter, or even the social reformer (Winston, Henderson, this volume).

The time when one could reconstruct an historical event or unauthorized biography of a celebrity by creating a composite and therefore fictional character for the sake of plot, so the producers were not held legally or ethically responsible, may have already ended with the popularity of the television docudrama (Viera, this volume).

Although we might wish otherwise, the complexities of real life confound our hopes for simple principles and consistent solutions to ethical conflicts. The authors of the present essays recognize that only by rooting their deliberations in the concreteness of actual events, with all their messiness and ambiguities, can they avoid the artificiality of reasoning in the absence of data and achieve an understanding of the various personal and social stakes involved. Our accumulating awareness of the issues raised by the use of visual images is thus grounded in a body of "critical incidents" and dramatic conflicts, many of which have been mulled over by public pundits, studied by scholars, debated by lawyers, and, increasingly, codified by judges as legal precedent. For the present, at least, the case study and even the anecdote offer us the richest veins of raw material in which we might trace the moral dimensions of image use. In time we may be prepared to construct an analytic and prescriptive framework for guiding professionals in the paths of ethical practice; but for now we may have to be satisfied if we can challenge the complacency engendered by an excessive faith in objectivity and the rights of image makers.

The Right to Privacy

In 1890 two Boston lawyers, Samuel Warren and Louis Brandeis, published an article in the *Harvard Law Review* which "has come to be regarded as the outstanding example of the influence of legal periodi-

cals upon the American law" (Prosser, 1960:383). The article was called "The Right to Privacy," and it was motivated by the prying of the press into the social affairs of Mrs. Warren and her friends. Warren and Brandeis argued for the existence of a specific right to privacy which was implicit in other recognized rights, "and they contended that the growing abuses of the press made a remedy upon such a distinct ground essential to the protection of private individuals against the outrageous and unjustifiable infliction of mental distress" (Prosser, 1960:384). In the years since the article was published, the right to privacy has been invoked by plaintiffs, contested by defendants, and often accepted by judges and juries, in a bewildering array of cases. The most influential analysis of the complex territory of privacy is that provided by William Prosser who proposed that

> The law of privacy comprises four distinct kinds of invasion of four different interests of the plaintiff, which are tied together by the common name, but otherwise have almost nothing in common except that each represents an interference with the right of the plaintiff, in the phrase coined by Judge Cooley, "to be left alone." (1960:389)

The four categories of invasion may serve as a map with which to survey the territory in which many issues of image ethics arise.

Intrusion

The first area that privacy law protects against is *intrusion* into one's private space, or even into one's privacy while one is in a public space if one has not consented to being filmed or photographed. In one case a New York restaurant successfully sued CBS-TV for entering and filming patrons at dinner without permission of the management (*NY Times*, July 7, 1979:10). In New Mexico the Santo Domingo Pueblo filed a $3.65 million lawsuit against a local newspaper for photographing tribal dances from a low-flying airplane and publishing them, despite the pueblo's long-standing and strict ban against picture-taking, sketching, or recording of dances (*NY Times,* March 13, 1984:A18).

Although the legal parameters of intrusion, particularly when subjects are in public places, have not been definitively established, we do generally acknowledge the relevance of ethical considerations in this domain. The fact that it may be *legal* to photograph someone in a public place, "since this amounts to nothing more than making a record, not differing essentially from a full written description, of a public sight

which any one present would be free to see" (Prosser, 1960:392), does not necessarily make it ethically neutral. Our recognition of this distinction may lie behind the strategy used to market devices such as the "Cambron Super Snooper":

> Remember the time when you wished you and your camera were invisible? Remember those "human interest" pictures you could not shoot because you were too timid to point your camera? . . . But now you can photograph *everything* and *everybody you always wanted to shoot if you disguise your camera with the Super Snooper and shoot around the corner.* . . . The possibilities are unlimited. Want to shoot the celebrity at the next table at the sidewalk cafe? Put your camera on the table, lens facing up into the sky. Rotate the camera until the Super Snooper's *real* eye points at the unsuspecting target. Click, gotcha! Nobody suspects you and you can take all the "forbidden" pictures you want.

Embarrassment

Many of the essays herein illuminate issues which concern the ways in which image makers may consciously or inadvertently intrude inappropriately upon their subjects' privacy (cf. Winston, Anderson and Benson, Katz and Katz, Henderson, Hostetler and Kraybill). Rarely is it the mere fact of intrusion that gives rise to ethical debate and legal action, it is when the images so produced are made public that objections are raised and suits filed. When this occurs we find ourselves across the border into the second province of privacy litigation: the *disclosure of true but embarrassing facts* about individuals, when these facts are not deemed to be of legitimate concern to the public. The classic case in this area is known as *The Red Kimono* case, after the title of a movie about a former prostitute who had been acquitted of a murder charge and gone on to live a quiet and respectable life under a new name. When her identity was disclosed by the movie, in 1931, she sued for invasion of privacy and won. The record in this area is not always clear, however, and legal precedents are often contradictory. The most famous exception that has been carved out of this part of the right to privacy concerns the rights of "public figures." As determined in the landmark *The New York Times vs. Sullivan* 1964 Supreme Court decision, public figures (which usually but not invariably refers to public officials) can not claim refuge behind the right to privacy when their actions or images are disseminated to the public; this vulnerability is taken to be the price of admission to the public arena. But many pri-

vate individuals find that they have been involuntarily catapulted into that arena. What rights do they have? The answers aren't clear.

> The picture showed a naked woman covering herself with a hand towel as a burly policeman hurried her away from the house where her husband had just killed himself. The question posed to the 50 newspaper editors at a workshop today was whether they would print it. . . . A majority of the editors said they would have published the picture, a dramatic portrayal of anguish and implied violence. But they would have cut off some of the bottom of the photograph to make the nudity less obvious. . . . Last year a jury awarded [the woman] $10,000 in an invasion of privacy suit. An appeals court overturned the judgment, saying the picture was newsworthy even if tasteless and embarrassing. . . . [The editor] said that if he had not used the picture his readers would have wondered how he could have missed such a dramatic story. (*NY Times,* May 12, 1983)

We suspect that few readers would have missed this photo, or even known of its existence, had the editor decided not to print it, and in any event it does not seem that such protests present a necessarily sufficient argument in favor of his decision. But there are instances in which the scales are more evenly balanced, and the ethical dilemmas more focused. In 1980 a *New York Times* reporter, Howell Raines, visited some of the Alabama families whose images had become known world-wide through Walker Evans's photographs in the book *Let Us Now Praise Famous Men* (Agee and Evans, 1941). These southern sharecropper families are still living in rural poverty, and are still, "mad as hell at Walker Evans" (Raines, 1980). "These pictures are a scandal on the family," one woman told Raines, "How they ever got Daddy's picture without a shirt on and barefooted, I'll never know." The families say they were promised that these pictures would never be seen in the South, and certainly not on the front cover of a mass-market paperback sold in local drugstores and bus stations. Should Evans have refrained from taking these pictures if he could not in fact deliver on his promise, given his contractual arrangements with *Fortune* magazine and the Farm Security Administration? That is a question whose complexities defy resolution through recourse to legal debate and juridical precedent.

False Light

True but embarrassing facts comprise one category of objection which might be made to the dissemination of one's image; far more pointed

is the claim that one has been placed in a *false light* by images which *distort* the truth and create false impressions of one's intentions, character, or actions. As with the previous examples, such claims can range from the relatively unambiguous to the morally and legally complex.

> A Federal appeals court today reversed a ruling that cleared ABC of libel in a lawsuit brought by a housewife who contended that she had been depicted as a prostitute in a documentary news broadcast. . . . At the beginning of the broadcast, the narrator said that many of the street prostitutes were black women and that their customers were white. As the comments were being made, the camera depicted three women walking down a street. . . . Mrs. Clark, a black woman, was the third woman photographed. She appeared to be in her early- to mid-20's, was attractive and stylishly dressed. As she walked down the street, the narrator said, "But for the black women whose homes were there, the cruising white customers were an especially humiliating experience.". . . Mrs. Clark said she had been propositioned, shunned by church members and refused jobs by two prospective employers after the program. The appeals court majority disagreed with ABC's contention that it was clear that Mrs. Clark was not a prostitute. The majority noted that here was a "striking" contrast in appearance between Mrs. Clark and the two women who preceded her down the street. The majority also said that ABC was not entitled to qualified privilege in the case because Mrs. Clark had only "the most tenuous connection" with the public-interest subject matter. (*NY Times,* 7/30/82)

Not all victims of actual or alleged false impressions are as tenuously connected to the images they wish to protest as was Mrs. Clark. When the Loud family of Santa Barbara appeared in the early 1970s as *An American Family* on public television, their objections to many aspects of the programs were weakened by the fact that they had agreed to be followed and filmed for many months. General Westmoreland faced other obstacles besides his status as a public figure when he sued CBS News over claims made about his role in the Vietnam War (cf. Beauchamp and Klaidman, this volume). But many of the most pointed and poignant examples are more like the case of Mrs. Clark, in which "innocent bystanders" are caught by the eye of the camera. The most significant recent landmark in this realm concerns just such an event:

> On December 3, 1978, the *New York Times Magazine* published an article entitled "The Black Middle Class: Making It." The *Magazine*'s cover . . . was a picture of a well-dressed black man, Clar-

ence Arrington. Now . . . this cover photo, and consequent legal action, are threatening the livelihood of freelance photographers, and the business of photographic agencies such as Magnum, as well as publications such as *Life, Time,* and *Newsweek,* which depend on them. . . . The cause of this mess stems from the fact that Arrington, a financial analyst who now works for the Ford Foundation, never knew his picture had been taken, let alone that it would be published so prominently. Neither his name nor his own views appeared anywhere in the *Magazine.* The fact that he profoundly disagreed with the content of the article with which he was associated further fueled his rage. According to Arrington, and as alleged in his complaint, he and readers who knew him found the article "insulting, degrading, distorting and disparaging" . . . not only of the black middle class in general, but of himself, as its supposed exemplar. He further claims friends assumed he had changed his vocation from financial analyst . . . to professional model. Arrington therefore sued the *New York Times,* the photographer, Gianfranco Gorgoni, the photographer's agency, Contact Press Images, and its president, Robert Pledge, for invasion of privacy. (Cockburn, 1982:10)

The New York Court of Appeals ruled that the *New York Times* had the right to use the picture to illustrate an article of public or common interest, and that it used the picture for editorial, not commercial purposes. But the photographer and the photo agency were not off the hook, as they had, in the words of the New York State Civil Rights Law, "used . . . for purposes of trade, the . . . portrait or picture of [a] living person, without first having obtained the written consent of such persons." Ultimately, Arrington received scarce satisfaction: the U.S. Supreme Court would not hear his appeal against the *New York Times,* and "the state legislature, heavily lobbied by the media, nullified the state court's ruling" against the photographer and photo-agency (Goldstein, 1985:120). For the present, then, the legal precedent is unclear but hardly encouraging to the rights of members of the public; even so, the case is still reverberating through the image industries.

We must note, however, that Mr. Arrington's claims were accepted as valid not when he complained of the newspaper's action in presenting him in a false light, but when he caught the photographer and photo agency in the commission of a misdemeanor for appropriating his image for their financial advantage. Thus we cross the border into the fourth and final province of privacy law: the use of a person's likeness that results in depriving that person of some commercial benefit, or making a *profit* at that person's expense.

Appropriation

> It seems sufficiently evident that appropriation is quite a different matter from intrusion, disclosure of private facts, or a false light in the public eye. The interest protected is not so much a mental as a proprietary one, in the exclusive use of the plaintiff's name and likeness as an aspect of his identity. (Prosser, 1960:406)

Once again, examples can range from the simple to the complex. Hugo Zacchini, the "Human Cannonball," successfully sued a local television station when his entire 15-second act—which audiences normally pay to witness—was shown on a news program. A Toronto mechanic agreed to a request from his barber to pose for pictures to decorate the barber shop; several years later, while on vacation in Barbados, he was approached by two strangers who thought they knew him. It turned out that the barber had sold his picture to a hair dressing company, which had used it in promotions distributed around the world. He sued the company, but when the legal costs mounted he was forced to drop the case. These cases might seem to present relatively uncomplicated issues for ethical consideration, whatever their legal disposition. But what about the following:

> In 1982, Elizabeth Taylor filed suit against ABC to stop the production of an unauthorized docudrama portraying her life: "I am my own commodity. I am my own industry. . . . This docudrama technique has gotten out of hand. It is simply a fancy new name for old fashioned invasion of privacy, defamation and violation of an actor's right."

The New York State Supreme Court determined that "the rights of Jacqueline Kennedy Onassis were 'trampled upon' when the fashion house of Christian Dior used a look-alike model in a recent advertising campaign. . . . The justice . . . ordered the model, Barbara Reynolds, to stop appearing in advertisements in which she 'masquerades' as Mrs. Onassis. . . . He said, however, Miss Reynolds could continue to work at 'parties, TV appearancees and dramatic works.' Legal specialists . . . said they did not know of a similar ruling on the question of whether the commercial use of a look-alike could violate a celebrity's right to privacy." (*NY Times,* 1/13/84).

Florence Thompson's portrait hangs in major galleries and museums around the world, has appeared in books and on television—and

she's fighting mad about it. "That's my picture hanging all over the world, and I can't get a penny out of it," the 75-year-old Modesto woman said. In 1936, when she was stranded with three of her children in a Central California labor camp, her picture was snapped by Dorothea Lange, who became one of the most famous photographers of the Depression era. Miss Lange's "Migrant Mother" pictures Mrs. Thompson holding her baby while two other children lean against her shoulders and back. It became one of the most famous of a 270,000-photo collection taken by photographers of the Farm Security Administration, hired by the Federal Government to pictorially illustrate the plight of Midwestern farm people who fled the Dust Bowl. The collection laid the foundation for the technique of documentary photography. One critic called the collection "the pictures that altered America." Mrs. Thompson claims she has been exploited for the last 42 years. "I didn't get anything out of it. I wish she hadn't of taken my picture," the full-blooded Cherokee Indian said. "She didn't ask my name," Mrs. Thompson added. "She said she wouldn't sell the pictures. She said she'd send me a copy. She never did." . . . Mrs Thompson said she is proud to be the subject of such a famous photograph, "but what good's it doing me?" Mrs. Thompson said she has tried to stop publication of the photo, but lawyers advised her it was impossible. (*L.A. Times,* 11/18/78:1)

Once again, we might agree that the problems posed by these cases do not lend themselves to easy resolution, and that legal determination of subjects' rights—or the lack of such rights—neither convicts nor acquits the image makers of moral responsibility for their actions. In the final analysis it would seem that our tour of the legal territory of privacy torts has served to exemplify many of the ethical conflicts surrounding image-making and use, but has not provided us with a recipe for determining the answers to the questions posed in such conflicts. To further clarify the nature of image makers' responsibilities to their subjects—and the ways in which these often clash with the image makers' responsibilities to their profession, their patrons, and their audiences—we must turn to several additional ethical dimensions which are explored in many of the papers in this volume.

Consenting Subjects?

Many of the examples we have noted center on the apparent lack of "informed consent" by the subjects to the taking and/or the use of their image by others. In the field of documentary image-making, in

particular, the question of consent has come to play a central role in attempts to resolve disputes over alleged violations of ethical norms. But consent, informed or otherwise, is not always a meaningful concept in practice, nor even a reliable guide through the ethical mazes confronting documentarians. What does informed consent mean when inmates in a mental institution are asked by a film crew to have their lives recorded and packaged for national television (cf. Anderson and Benson, for a discussion of Wiseman's *Titicut Follies*)? Do noble motives and the desire to correct social wrongs justify the one-way intrusion into, and exposure of the lives of the poor and helpless by filmmakers who hope to use the image of their misery to tweak the conscience of the well-off (cf. Winston, this volume)? Do film-makers have less obligation to respect the privacy of their subjects when they train their cameras on members of their own families, whose trust and consent they may take for granted (cf. Katz and Katz, this volume)? And what responsibilities apply when members of vulnerable minority groups become their own image makers, and turn their cameras upon their fellows (cf. Waugh, this volume)?

One step beyond the "simple" issue of consent (were it only simple!), there are other moral thickets. Are image makers always expected to tell "the truth, the whole truth, and nothing but the truth" to their potential subjects in order to obtain and maintain their consent? We will most likely all concur in condemning the dishonest tactics used to gather a crowd of Amish in a Pennsylvania cornfield where they could be surreptitiously filmed from a "passing train" by the makers of the Hollywood film *Witness;* a film that was being made despite strenuous objections by the Amish (cf. Hostetler and Kraybill, this volume). But, are all lies morally equal and equally to be condemned?

A question often posed by and to the politically committed filmmaker is the following: Is it justifiable to try to avoid explaining your point of view to someone in order to be able to interview them in your film? To be blunt about it, is it ethical to lie to an assumed evil person in order to perform what you regard as a positive act? For example, a film like Robert Mugee's *Amateur Night in City Hall,* an exposé of then-Mayor Rizzo of Philadelphia, could not have been made if many of the people shown in the film had known the film-maker's intention. Or, to take a possibly less ambiguous example cited by Waugh (this volume), would anyone argue with the use of false credentials by progressive Chilean and East German film crews in 1973 to gain access to reactionary interview subjects?

But lying or telling the truth is only a small portion of how film-

makers interact with their subjects, and only some of the moral re-
sponsibilities of image makers are implicated in our answers to these
questions. It is not difficult to find further dimensions and dilemmas.
Are image makers always to remain "outsiders" and observers, as dic-
tated by the norms of documentary film-making and journalism, and
when do other considerations enter the picture? Here, too, we can
range up and down the scale from relatively small to unquestionably
serious moral choices.

Costs and Benefits

Is it right for film-makers who are making a documentary on the set-
tling of a family's estate to let them throw away items which the film-
makers, but not the family, know to have monetary value? The film-
makers "found it difficult to stand by and watch this family make
financial decisions which were not in their best interests," yet were they
to "act as economic . . . 'consultants,' [they] would actively change the
normal course of events and would be perverting the process which
[they] were there to study and document" (Aibel, this volume).

 If the dilemma of these documentary film-makers does not seem
extraordinarily pointed, imagine the plight of an 18-year-old assistant
at WHMA-TV in Anniston, Alabama, in March 1983, when he found
himself accompanying a cameraman sent to cover the story of a man
who had called the station and said, "If you want to see someone set
himself on fire, be at the Square in Jacksonville in ten minutes." The
cameraman and his young assistant, serving as sound recorder, met
the caller, momentarily stalled him, then filmed as he set himself
ablaze. The assistant eventually rushed in to save him, but the caller—
an unemployed roofer protesting his joblessness—had already suffered
second- and third-degree burns over half of his body. Excerpts from
the tape were shown on WMHA, and within a week the story became
an international story, running on the front page of the *New York
Times* and on the three network evening news programs (Goldstein,
1985:29).

 Even this dramatic incident, however, does not take us all the way
into the heart of the image maker's dilemma. Few would defend the
decision of a journalist to stand by and film rather than to step in to
save a life. Although media critic Hodding Carter stated that what
the WMHA-TV crew did "was squarely in today's mainstream tradi-
tion of newsgathering," others disagree: "In almost every case that has

been documented," notes Tom Goldstein, "when other bystanders were not present to intervene, photographers chose to save lives instead of snapping a picture" (1985:30). Veteran newspaper editor Harold Evans offers an example which does confront us with a truly tangled moral thicket, one which cannot be easily negotiated by following the "rules" of professional ethics:

> At the conclusion of the Bangladesh war, photographers in Dacca were invited to a "photo opportunity" in a polo field. It turned out to be the bayoneting of Biharis who were alleged to have collaborated with the Pakistan army. . . . People were to be murdered for the camera; and some photographers and a television camera crew departed without taking a picture in the hope that in the absence of cameramen the acts might not be committed. Others felt that the mob was beyond the appeal to mercy. They stayed and won Pulitzer prizes. Were they right? (Evans, 1978)

But photographers and editors, not to mention Pulitzer juries, do need to make decisions, and moral dilemmas will not always wait patiently while we deliberate. In the process of evaluating our own decisions, or those of others, we often seem to invoke a calculus of costs and benefits, as in the classic confrontation between the public's "right to know" and the individual's "right to privacy." Not surprisingly, the application of this calculus and the interpretation of the results will depend on *whose* cost, and *whose* benefit we are considering.

Evans proposes two questions to help decide whether to publish a possibly "offensive" news photograph: "is the event it portrays of such social or historical significance that the shock is justified? Is the objectionable detail necessary for a proper understanding of the event?" But these questions concern the responsibility of the image maker to the audience; what of the subject whose life is exposed to public view or even, in the extreme case, whose life may be threatened by the presence of the image maker? Can any benefit justify such a cost? And even when the stakes are smaller, does the possibility of ameliorated conditions because of heightened public awareness justify the recording and dissemination of the image of society's most vulnerable and victimized? After all, as Winston (this volume) points out, such films rarely seem actually to help the "victims" they depict; Frederick Wiseman benefited more from *Titicut Follies* than did any inmates of the Massachusetts Correctional Institution at Bridgewater (Anderson and Benson, this volume); and Mrs. Thompson never shared in the profits from the photograph "Migrant Mother."

The Meaning of Images: Connotation and Context

These issues can be put into clearer perspective by further clarifying the nature of the photographic image itself, the ways in which images are produced and the contexts in which they are presented. We are beginning to understand the technologically produced image as a construction—as the interpretive act of someone who has a culture, an ideology, and often a conscious point-of-view—all of which cause the image to convey a certain kind of knowledge in a particular way. Image makers show us their view of the world whether they mean to or not. No matter how much we may feel the need for an objective witness of reality, we must face the fact that no such thing can ever exist and therefore our image-producing technologies will not provide it for us.

A number of scholars have argued that images are polysemic, that is, they have a variety of potential meanings (Worth and Gross, 1974; Sekula, 1975; and Ruby, 1976). The differing expectations that producers, subjects, and audiences have about the various communication events which transpire in the production and consumption of images predispose people to employ different interpretative strategies to derive signification and meaning from images (Worth and Gross, 1974). These interpretative strategies are embedded within a larger body of cultural knowledge and competencies which are supportd by a moral system. That is, systems of knowledge and epistemologies are attached to moral systems. Ethics are only comprehensible in relation to other facets of a culture.

The meaning and significance attached to a visual image are a consequence of the label attached to it, the expectations associated with the context in which the image appears, and the assumptions made by audiences about which sort of images are produced by which sort of image makers and shown in which sort of settings.

A concrete example may help clarify these abstractions. At the beginning of the century, Lewis Hine, a sociologist turned social reformer, took a series of photographs of children working in factories commissioned by the National Committee to Reform Child Labor Law. The archetypical Hine image is that of a pre-pubescent child, quite small, often frail, and always dirty, standing in front of an enormous piece of machinery. The child is staring into the lens of the camera and consequently into the eyes of the viewer. The machines are black, dirty, and the factory dark to the point where the edges of the machine often disappear into nothingness. These images were cre-

ated to appear in tracts detailing the social and psychological abuses of child labor. They were often printed on inexpensive porous newspaper with a cheap half-tone process. All the subtlety of tone and detail present in the negative disappears. The tracts were sent to legislators, the clergy, prominent citizens and handed out at meetings. The intended message of these photos in this context is clearly a pragmatic one—a call to arms. One is to feel pity for the child and anger at the exploitation by the factory owner—symbolized by the large, ominous, and dirty machine. If the photographer is thought of at all, he is assumed to be on the side of truth and justice, providing irrefutable evidence of wrong-doing.

If we were to prepare Hine's photographs for exhibition at the Museum of Modern Art in New York, enlargements of fine quality would be matted, framed, and hung with a brief but articulate and insightful explanatory text in a stark off-white room with subdued lighting. The audience in this context are people whose primary interest lies in art and photography and not in reforming labor laws. The photographs are now regarded primarily for their syntactic elements, their formal and aesthetic qualities. The waifs are no longer primarily pitiable victims of capitalistic exploitation but have become aesthetic objects with interesting if not haunting faces. The machines are now examined for their texture and lines—industrial art objects—and not as symbols of oppression. The child's stare is now a sign of his/her willingness to be photographed and not an indictment of our economic system. It is unlikely that anyone seeing the exhibit would be motivated to do anything except admire the artistic accomplishments of Lewis Hine. No one would rush to West Virginia or even lower Manhattan to see whether similar conditions might still exist. The photographs have not changed; the expectations created by the two contexts cause us to regard the photographer and his works in strikingly different ways.

From the perspective of the ethical questions we have been examining, does it make any difference to the *subjects* of Hine's photographs where the images are exhibited and how they are responded to? After all, they were taken a long time ago, and most of the subjects are probably dead. What cost is there to them, now, in being contemplated as aesthetic objects, and what benefit to them were their images to be used to awake contemporary consciences?

Perhaps many of the moral conflicts we've surveyed should be subject to a statute of limitations. But surely there is more at stake than the immediate concerns of the imaged subject, however large those

concerns loom in the legal arenas we have visited. The responsibility of the image maker to his or her subjects may not be always so different from their responsibility to the audience. In both cases, there is often an implied promise of truthfulness that is inherent in the way most of us view the media of photography, film, and video. As we have noted above, these media are generally conceded the power to record, preserve, and transmit "portions of nature herself." Photographically produced images are thus seen as if they were reflected in a mirror held up to reality, and therefore many individuals and groups have cooperated in the work of image makers because they believed that "their story" would be captured and told, and many audiences have attended to the works thus produced because they believed they were seeing slices of real life.

The Tradition of Documentary

There is a complex "contract" at the heart of the documentary tradition associated with photography and film—the promises made, or implied, to both the subjects and the audiences that the image maker will be held to standards of truthfulness, while yet aspiring to art, that is, to a personal vision and statement. This dual contract creates a tension between apparently incompatible demands placed on the image maker. On the one hand there is the role of discovery and observation, and on the other, of invention and composition. Although the photographic media present this conflict in peculiarly acute form, we can find it expressed and debated by painters, writers, and critics in the nineteenth century, as they struggled with the ambitions of naturalism in art and literature. But for these artists and critics, the crucial focus was always the skill and the sincerity of the artist, not the nature of the medium itself. The most influential solution to the dilemma of naturalism in painting and literature was that provided by Zola's conclusion that, "a work of art is a bit of nature seen through a temperament" (Shiff, 1982:7).

With the invention of film many of these conflicts were replicated with a new twist, namely, the presumed mechanical naturalism of the medium, which seemed to preclude the problematic intrusion of the artist's temperament. But, as we've noted, even the camera must be wielded by human beings, and temperament will not be so easily circumvented from influencing the images produced. These complexities have bedeviled the makers and viewers of visual documentaries from

their beginnings. John Grierson, theoretician and founder of the National Film Board of Canada, the first to use the term "documentary," in a review of Robert Flaherty's *Moana* in the *New York Sun* in 1926, later muddled the confused status of non-fiction film by defining documentary as a "creative treatment of actuality."

Since the inception of the genre, tension has existed between the "creative" role of the documentarian and "actuality." In fact, Flaherty himself, the American father of documentary, was accused of "faking" authentic Eskimo life in *Nanook of the North*. The film confused many reviewers. Some failed to see any coherent story since the narrative line was not obvious, while others accused him of using actors and staging the entire movie.

Is it important to us that Flaherty cast his films by looking for ideal types, as did Eisenstein in accordance with the theory of typage? Family members in *Nanook of the North, Man of Aran,* and *The Louisiana Story* were not in fact related to each other. They were selected because they suited Flaherty's conception of a good Eskimo, Irish, and Cajun family. Does it matter that Flaherty reinstituted tatooing, a rite that had disappeared, for the sake of the narrative structure of *Moana,* or that the Aran Islanders didn't really fish for basking sharks? Criticism of the documentary has not progressed far since the 1923 reviews of *Nanook*. Critics and theoreticians still argue about whether the documentary is art or reportage.

If documentarians choose to regard themselves as artists and are so received by the public, conventional wisdom argues that their primary moral obligation is to be true to their personal vision—that is, to make an artistically competent and sincere statement. Artists, at least in modern Western culture, generally have had no other ethical constraints. A view of the artist as set outside of, and even exempt from the mainstream of social action and practical responsibility, has been a key aspect of Western aesthetic and ethical theory since the eighteenth century, and leads to the "relative disassociation of the work of art from the praxis of life . . . [and the] idea that the work of art is totally independent of society" (Burger, 1984:46). Thus, the artist is often regarded as being somewhat outside the moral constraints which confine other people; having license to transform people into aesthetic objects without their knowledge and sometimes against their will.

However, at least in academic circles, Marxist analyses of the arts have raised the possibility that all art, even photographic art, has political and ideological content; that photographic images comprise

neither a universal language transcending cultural boundaries, nor a purely individual mode of expression. Thus, some authors argue that the ethics and politics of art should have priority over aesthetics; or, perhaps more correctly, a morally acceptable and ideologically "correct" attitude forms the proper basis for an aesthetic.

If, for example, one takes the everyday lives of people—a favorite subject of the documentary—and transforms them into an artistic statement, where does one draw the line between the actuality of their lives and the aesthetic needs of the documentary artist? How much fictionalizing or interpretation is possible before the subjects not only disagree with their portrayal, but begin to be offended by or even fail to recognize themselves in it at all? (Cf., Winston, Waugh, Katz and Katz, and Gross, this volume).

Confusion about which moral guidelines should be used to judge documentary images is compounded by the fact that some documentarians respond to aesthetic and moral criticisms of their work by suggesting that they were merely reflecting observed reality; that their role was to record faithfully and transmit what they experienced. They are not, they would argue, really the "authors" of their works nor are they responsible for any conclusions audiences might draw. If someone in a documentary appears stupid or disgusting, the implication is that the person so presented is in reality stupid or disgusting, since the camera merely recorded what was in front of it, without any modification. Such claims of aesthetic and moral "neutrality" are exemplified in Wiseman's early films (Cf. Anderson and Benson, this volume).

The typical practice of documentary film-makers, particularly in the "direct cinema" / *cinéma vérité* tradition, rests on the belief that "actors" who have become accustomed to the presence of the camera will revert to a state of relatively natural behavior and simply "be themselves." In fact, it has even been suggested that, "the presence of the camera [makes] people act in ways truer to their nature than might otherwise be the case" (Barnouw, 1983:253).

Several important components of documentary film practice are described by video documentarian Julie Gustafson:

> . . . (W)e spend as much time as possible with our subjects so that they will feel as comfortable as possible with us during the taping period. Although we recognize the influence of our presence, we never interfere in the natural flow of events by, for example, asking the subjects to do things over again for the camera. . . .

Finally, to create a powerful and attractive story, we use conven-

tional dramatic techniques of filmmakers and playwrights to finally structure our program to draw our audience in. We structure our shooting around strong individuals and clear action. We also, in editing, use the classic methods of dramatic introduction, exposition of the problem, and denouement. (1982:63f)

This approach to documentary demonstrates the mixture of presumably natural behavior on the part of the 'actors' and the obviously communicative intentions of the film-makers in choosing what to film and how to edit and structure the resulting narrative. Clearly, it will be appropriate to regard the final product as a *story* we are being told by the film-makers, based to an indeterminate degree upon the "reality" of the participants' dispositions, motivations, and circumstances. However unobtrusive and sincere the film-makers might be in their attempt to capture the way things were, we are faced with a narrative constructed within the conventions of dramatic realism.

Some documentary film-makers respond to the inevitability of participants' "reactance" and their use of narrative conventions by including "reflexive" devices in order to alert the audience to the fact that they are watching events which are to some degree "unnatural." Gustafson again:

A . . . distancing device is to include glimpses of the mechanics of the shooting process in the final work, a practice derived from the techniques of both *cinéma vérité* and American direct cinema. We may tape ourselves setting up the lights and thereby see the effects of our presence on the subject's life. We also include shots of the microphone or other equipment so that the viewer occasionally sees the complete reality of the scene. (1982:64)

However, most documentarians have not revealed the constructions within their films and some have never discussed the mechanics of their construction anywhere. To remind an audience of the constructive and interpretive nature of visual images is regarded by some as being counterproductive if not actually destructive to the film experience, the illusion of reality. Some people regard such revelations as self-indulgent, turning audiences' attention away from the film and toward the film-maker. For many, effective art requires the audience to suspend disbelief—even if the film is a documentary. Being reminded that the images have an author disrupts the fantasy.

It is commonly assumed that art should be a little mysterious to be successful. A reflexive art has never been very popular and at least in

film has become confused with a kind of autobiographical film which has recently become popular, in which young film-makers "expose" themselves, analyze their families, using the camera as therapist. Reflexivity has gotten a bad name because of its mistaken association with narcissism, self-consciousness, and other forms of self-contemplation (Meyerhoff and Ruby, 1981).

Drama and Docudrama

The film generally regarded as the first documentary, *Nanook of the North,* was also one of the first travelogues. In a curious sense, the path of naturalistic film never strayed very far away from the travelogue in the decades since *Nanook.* Although the majority of naturalistic films— whether documentary, fictional drama, or the recently labeled (but not recently invented) docudrama—have not taken viewers to distant lands, they have for the most part offered viewers glimpses into "exotic" corners of their own society. In many instances, including a large portion of fictional stories and most gossip "non-fiction," viewers are taken over the walls guarding the estates of wealth, power, and celebrity and shown the "lifestyles of the rich and famous." In the realm of documentary, in contrast, we are more often taken down the social ladder to see how 'the other half' lives. The increasingly popular genre of docudrama—a television favorite—specializes in revealing the backstage of current events, involving both the famous (e.g. several docudramas about the Watergate events and characters), the infamous (e.g. "The Atlanta Child Murders," "The Executioner's Song"), and even the ordinary, when they are caught up in extra-ordinary events (e.g. any number of stories of family heroism in the face of illness, particularly of children).

In terms of the ethical responsibilities we have been considering, naturalistic drama might seem to be a relatively free fire zone for the film-maker. After all, there are no subjects whose privacy may be invaded, who might suffer embarrassment or loss of reputation, or whose property might be wrongly appropriated. Yet, of course, this fact hardly protects film-makers from moral (and legal) criticism. No matter how prominently the producers might place their disclaimers of any intention to make reference to actual persons, living or dead, audiences—and potential plaintiffs—often believe otherwise. There is thus a generally sincere, if not legally enforceable, concern on the part of those whose

character or actions might have inspired a fictional story: they often do feel that they have been embarrassed and shown in a false light. The currently salient precedent was set in 1979 when a California psychologist won a libel suit against an author who, he claimed, had libeled him through a thinly disguised character in a novel.

The clearly labeled docudrama can present peculiarly pointed cases of putative 'fictional libel,' but many of the potential plaintiffs—as in the several Watergate docudramas—would be prevented from collecting damages because of their status as "public figures" who, *pace New York Times vs Sullivan,* cannot be libeled. Others are vulnerable, it would appear, through their status as convicted felons: Jean Harris, Jeffrey MacDonald, and Wayne Williams, to name three recent widely publicized convicted murderers, have all been depicted in mini-series docudrama. One of these, in particular, evoked interesting speculation about the responsibilities of the producers to the public, whose knowledge of the events in question might have been distorted by a biased film. The docudrama "The Atlanta Child Murders" was faulted by "an assortment of Georgia officials and community leaders . . . as being inaccurate and unfair" (*New York Times,* 2/14/85). The film was widely acknowledged to be arguing that Wayne Williams, who was convicted of two murders (and 'linked' to 23 others), "was innocent and that his conviction was sought in the interests of maintaining a positive image for the city."

> "The problem with docudramas," said Richard Salant, a former president of CBS News, "is that people don't know where docu ends and drama begins." But CBS officials continue to maintain that contemporary events are properly within the province of television entertainment. . . . Nevertheless . . . the criticism of "The Atlanta Child Murders" has "caused some introspection" at CBS about the network's responsibilities in presenting such programs. (*NY Times,* 2/14/85)

Among the features of docudramas which are being introspected about is the use of invented scenes, fictional characters, and composites—characters combining the characteristics of two or more real people. These are easily comprehensible as dramatic devices, and often helpful or even essential in story construction; but they often do serious violence to the claims of veracity made by the producers of docudramas. In the recent film *Frances,* about the unhappy life of the late actress Frances Farmer (detailing struggles with her mother, the Hollywood studio system, the law, and psychiatrists), the film-makers invented a

major character who appears as the protagonist's lifelong friend, confidant, sometime lover, and ally. While one can only wish that Frances Farmer had been as lucky as her fictional persona in having such a friend, his presence in the supposedly biographical film does distort our knowledge of her life. But so what? Frances Farmer is dead, as are her parents, Louis B. Mayer, and most likely, all other of her enemies in life. What do the film-makers owe to her, or to the audience, in terms of strict veracity and factual detail? Is it not better to deviate from fact in order to present 'truth' in dramatic form? There is not likely to be a definitive answer to this question, yet the frequency with which it is raised testifies to the strength of the feelings that are aroused when audiences suspect that they are being misled by unearned claims of verisimilitude.

Docudrama may, in fact, present an insurmountable challenge to those wishing to be both dramatic and documentary: strict adherence to 'fact' isn't likely to give us a gripping story, and a good story will almost of necessity offer us 'backstage' information which we couldn't otherwise know, and which is likely to have been invented. But, leaving aside the demands of television ratings, drama need not be cloaked in the currency of the 'docu' label. Can we finally leave these troublesome ethical—and legal—problems behind if we cross over the border into the territory of fictional drama? As we will see, many familiar difficulties will remain with us on the other side of this somewhat nebulous demarcation line.

It is only a movie, judges and lawyers are swift to point out, but somehow this movie has wended its way into the courthouse and the psyche of those whose livelihood centers on the third branch of government.

The Verdict, which was nominated for five Academy Awards but won none Monday night, has caused sharp debate among lawyers and judges who are concerned about the message it imparts to the public about courts, judges, lawyers and the law.

In *The Verdict,* [Paul] Newman [is] a [downtrodden Boston lawyer] who breaks the law and ignores the canons of ethics in his quest to prove that the doctors at a Roman Catholic hospital prescribed the wrong treatment for a pregnant but otherwise healthy woman. She suffers severe brain damage and becomes an invalid who will spend the rest of her life in a hospital, attached to life-support equipment. (*NY Times,* 4/13/83)

Among other things, Mr. Newman's character violates Federal law by stealing a letter and commits violations of professional ethics which could lead to disbarment.

> But his sins are dwarfed by those of the villains, including a judge who is in cahoots with the defense and takes steps in the courtroom to destroy the plaintiff's case. Added to that are doctors who alter medical records. And 15 defense lawyers who plant a spy in Newman's camp, pay his one expert witness to disappear on the eve of the trial and place one-sided news stories in the press. The law itself, as interpreted by the defense and the judge, is shown as unfair when it is used to keep the jury from considering evidence of the doctors' misdeeds. (Ibid)

Not surprisingly, the movie drew criticism from members of the legal profession, including an article in the *New York Law Journal*. Defense lawyers, in particular, were stung by the movie's portrayals of their profession; one was quoted by the *New York Times* as saying, "You have enough problems with doctors being an unsympathetic profession, and hospitals. This just adds one more thing" (4/13/83).

Many of us may feel that the plight of defense lawyers and their clients in the medical profession may not be among the more serious ethical issues facing film-makers and the public, but there are broader implications at stake. It may indeed be a matter for general concern to know to what extent we are all informed—or misinformed—by the realistic images we encounter in fictional forms. A good case can be made that much of what we all 'know' about our own society and the world beyond has been learned from fictional rather than 'non-fictional' sources. Stories have always been the primary vehicle of teaching and learning, and nowadays it is the mass media, and television in particular, that tell most of the stories to most of the people most of the time (see Gerbner *et al.*, 1986). We may well wish to ponder the social, political, and moral consequences of the concentration of power the mass media have assumed through their domination of our common symbolic environment.

The power of the media is nowhere more evident than in their role as mediators of information about and images of those parts of society most distant from the lives of the majority. These distant domains include the inside workings of major social institutions—such as the legal system dramatized, inaccurately it would seem, by *The Verdict,*—and the lives and characters of those who are outside the mainstream. Such

"fringe" groups might be self-contained communities who have chosen to live according to their own values and wish to be left alone (cf. Hostetler and Kraybill); they also include the minorities who may live alongside, but only partially absorbed into the mainstream: blacks, Hispanics, Arabs (cf. Shaheen, this volume), lesbian women and gay men (cf. Gross, this volume). In presenting stories set among or including characters drawn from these and similar groups, film-makers are inevitably offering audiences 'travelogue' glimpses of cultural exotica. Sometimes these take the form of showing mainstream audiences that minority group members can be, amazingly enough, just like real folks despite their funny names, shapes, or habits. While in general this is a friendly and often helpful message to impart, it can often serve to turn up the heat under the melting pot and thus promote assimilation over respect for diversity. In other, less altruistic circumstances, minority group members function as spice in the dramatic stew, convenient figures of fun or menace, whose very difference offers an easy contrast to the mainstream protagonists and whose usually unhappy fate reinforces the boundaries of the status quo. The conclusion to be drawn here, therefore, might be that members of minority groups have a kind of 'class action' interest in the ways they are depicted in mass media fiction as well as documentary accounts, because they may well be vulnerable to the damage inflicted through embarrassment and distorted impression.

A peculiarly appropriate example of the ethical problems which accompany fictional 'travelogues' can be taken right off of the front pages as well as the entertainment listings of our newspapers. In the early 1980s a movie made in South Africa and called *The Gods Must Be Crazy* broke out of the foreign-film ghetto and became the all-time biggest money-making foreign film to play in the United States. The film received rave reviews from critics, and audiences agreed; even many who felt concerns over the origin of the film in the South African apartheid system found themselves captivated and delighted. But, could they properly evaluate or appreciate the film's messages and implications—its sins of ommission and of commission—given their distance from and igorance of the true situation of the !Kung(San) people shown in the film? A South African exile, writing in the *Boston Globe*, thinks not:

> The audience I saw it with laughed and applauded, but, as an exiled South African, I cringed all the way through *The Gods Must Be Crazy*. Shot in Botswana, Jamie Uys' satirical comedy about the en-

counter between a Kalihari 'Bushman' and so-called Western civiliza-
tion has its moments, but it takes place in a blissful political vacuum,
where South Africa's black people are smiling noble savages and no
one has heard of apartheid. . . . Although admittedly quite liberal
by South African standards, the film—made by an Afrikaner—takes
many of apartheid's myths for granted.

The first half-hour or so is particularly offensive. Travel-brochure
photography, accompanied by a condescending voice-over, intro-
duces the 'Bushman' (itself a telling term: they call themselves the
!Kung). According to Uys' anthropological fantasy, the !Kung are
sweet little noble savages who spend their days gamboling about in
the desert; existence is idyllic, despite the barren earth, and you'd
never guess the Kalahari is contiguous with the apartheid state.
You'd also never guess that this ancient culture has been all but
eroded by centuries of colonialism, subsisting as a demoralized un-
derclass bereft of traditional skills and increasingly dependent on
government handouts. . . .

Despite Uys' evident intention of keeping everything unphotogenic
discreetly offscreen, ugliness sneaks in anyway, particularly in the
portrayal of blacks. A set of unconscious attitudes ranging from con-
tempt to paternalism betrays itself, along with some cherished myths
of apartheid—the "homelands" myth (blacks are happiest living in
pockets of desert with their own kind), the "noble savage" myth,
the Idi Amin myth. But American audiences will miss most of this,
seeing only the camera-safari images, the giraffes and lions and rhinos,
the lovable white hero and the happy smiling blacks. (11/18/1984)

Does it matter that audiences in the United States and elsewhere
derive misleading and mistaken impressions of South African realities
from fictional portrayals? It very well might (see Volkman, this volume,
for a detailed discussion of the film). The political context of South
African apartheid laws and their enforcement are not restricted to inter-
nal debate and struggle; they have become a world-wide political issue.
The images and assumptions held by publics in other countries may be
as relevant to their attitudes and responses to situations in far-off lands
as they are to their views of their own society; and they are even more
dependent upon the media for these images and assumptions. Fictional
characters and events may be every bit as "informative" and influential
as those reports which are classified as news. And the film *The Gods
Must Be Crazy* might well have an impact on South African decision-
making; or so critics have claimed.

A Moral Pause

> The subtlest and most pervasive of all influences are those which
> create and maintain the repertory of stereotypes. We are told about
> the world before we see it. We imagine most things before we ex-
> perience them. And those perceptions, unless education has made us
> acutely aware, govern deeply the whole process of perception.
> (Lippmann, 1922)

Walter Lippmann's pioneering book *Public Opinion* was one of the
earliest analyses of the power and role of stereotypes cultivated by the
mass media in modern society. But by 1922 these issues were neither
new nor unfamiliar to those concerned with the images disseminated by
the visual technologies of photography and film. Some of the sharper
disputes focused on the portrayals of minority groups and blacks in
particular.

From Edison's early *Watermelon Contest* of 1899 to the more
blatantly racist short films produced in the first decade of movie-mak-
ing—*Prize Fight in Coon Town, The Nigger in the Woodpile, A Night
in Blackville*, etc.—film-makers drew upon familiar routines of "heavy-
handed old style race humor" (Cripps, 1977, p. 22). However, with
the appearance of D. W. Griffith's monumental *The Birth of a Nation*
in 1915, the ethical and political issues surrounding film portrayals
became the focus of public debate.

The film was never presented or described as anything but partisan,
as the *New York Times* reviewer noted in his lead paragraph: ". . . it
is a film version of the melodramatic and inflammatory material con-
tained in *The Clansman* by Thomas Dixon" (March 4, 1915). And,
from the beginning, much discussion of the film highlighted the con-
flict between artistic treatment and racist content:

> In terms of purely pictorial value the best work is done in those
> stretches of the film that follow the night riding of the men of the
> Ku Klux Klan, who look like a company of avenging spectral cru-
> saders sweeping along the moonlit roads. (*NY Times*, 3/4/15)

But most of the debate surrounding the film moved quickly from the
aesthetic to the political and moral issues. The Boston branch of the
NAACP published a pamphlet, *Fighting a Vicious Film: Protest Against
"The Birth of a Nation"* (1915; in Mast, 1982), which sets forth the
controversy clearly:

If history bore no relation to life, this motion picture drama could well be reviewed and applauded as a spectacle. As a spectacle it is stupendous. It lasts three hours, represents a staggering investment of time and money, reproduces entire battle scenes and complex historical events; amazes even when it wearies by its attempt to encompass the Civil War. But since history does bear on social behavior, *The Birth of a Nation* cannot be reviewed simply as a spectacle. It is more than a spectacle. It is an interpretation, the Rev. Thomas Dixon's interpretation, of the relations of the North and South and their bearing on the Negro . . .

In an interview with a Boston editor, Thomas Dixon said, that one purpose of his play was to create a feeling of abhorrence in white people, especially white women, against colored men; that he wished to have all Negroes removed from the United States and that he hopes to help in the accomplishment of that purpose by *The Birth of a Nation.*

Griffith replied to his critics in a pamphlet of his own, *The Rise and Fall of Free Speech in America* (1916, in Mast, 1982), which also tackles the issues squarely, and which offers as clear an articulation of one major position as has yet been put forward by a participant in these debates:

WHY CENSOR THE MOTION PICTURE—THE LABORING MAN'S UNIVERSITY? . . . The truths of history today are restricted to the limited few attending our colleges and universities; the motion picture can carry these truths to the entire world, without cost, while at the same time bringing diversion to the masses.

As tolerance would thus be compelled to give way before knowledge and as the deadly monotony of the cheerless existence of millions would be brightened by this new art, two of the chief causes making war possible would be removed. The motion picture is war's greatest antidote.

INTOLERANCE: THE ROOT OF ALL CENSORSHIP Ours is a government of free speech and a free press. Intelligent opposition to censorship in the beginning would have nipped the evil in the bud. But the malignant pygmy has matured into a Caliban. Muzzle the "Movies" and defeat the educational purpose of this graphic art. Censorship demands of the picture makers a sugar-coated and false version of life's truths. The moving picture is simply the pictorial press. The pictorial press claims the same constitutional freedom as the printed press.

Griffith is wrapping his art in the cloak of truth, presenting his views as historical fact and, as he boasts, offering the untutored education as well as entertainment. He is also wrapping the First Amendment around the moving picture industry by presenting the movies as a pictorial branch of the constitutionally protected press. These issues are still being debated and litigated, and the questions raised by the visual media are not likely to be resolved in the courtroom.

> "Was it truly asking too much, in view of an individual's right to a fair trial, to pause—a moral pause—to respectfully withhold the disclosure for just a week?" said Federal District Court Judge Robert M. Takasugi. (*NY Times,* 10/30/83)

Judge Takasugi was lamenting CBS News's decision to broadcast videotapes of John Z. DeLorean which they obtained from an "unnamed government official" just as DeLorean's trial was about to commence. While clearly recognizing their legal right to air these tapes, which the president of CBS News characterized as "newsworthy," the judge is articulating a concern we have encountered often in this Introduction: the moral responsibilities that accompany the rights of image makers and mass-media decision makers. Photography, film, and television confer enormous power to create images that combine verisimilitude and visual impact, and the mass media can disseminate these images around the world. These powers are appropriately protected under our Constitution as an essential freedom in a democratic society, but they should also entail responsibilities. There is a *noblesse oblige* that attends power and which suggests the need for all concerned to pause and contemplate the moral implications of the images they produce and distribute.

References

Agee, James, and Walker Evans. 1941. *Let Us Now Praise Famous Men.* Boston: Houghton Mifflin.

Barnouw, Erik. 1983. *Documentary* (Revised Edition). New York: Oxford University Press.

Burger, Peter. 1984. *Theory of the Avant-Garde.* Minneapolis: University of Minnesota Press.

Cockburn, Alexander. 1982. "The Fatal Photo." *The Village Voice,* June 1, pp. 10–11.

Cripps, Thomas. 1977. *Slow Fade to Black: The Negro in American Film, 1900–1942.* New York: Oxford University Press.

Evans, Harold. 1978. *Pictures on a Page*. Belmont, CA: Wadsworth Publishing.

Gerbner, George, and Larry Gross. 1976. "Living with television: the violence profile." *Journal of Communication,* 26:2, pp. 172–99.

Gerbner, George, Larry Gross, Michael Morgan, and Nancy Signorielli. 1986. "Living with Television: The Dynamics of the Cultivation Process." Jennings Bryant and Dolf Zillman, eds., *Perspectives on Media Effects*. Hillsdale, N.J.: Lawrence Erlbaum Assoc., pp. 17–40.

Goldstein, Tom. 1985. *The News at Any Cost: How Journalists Compromise Their Ethics to Shape the News*. New York: Simon and Schuster.

Gustafson, Julie. 1982. "Toward a Cinema of Ideas." *Studies in Visual Communication,* 8:1, pp. 61–70.

Ingersoll, Lurton. 1873. *The Life of Horace Greeley*. Chicago: Union Publishing Co.

Lippmann, Walter. 1922. *Public Opinion*. New York: Macmillan.

Mast, Gerald (ed.). 1982. *The Movies in Our Midst*. Chicago: University of Chicago Press.

Meyerhoff, Barbara, and Jay Ruby, Introduction in Ruby, ed., 1982. *A Crack in the Mirror: Reflexive Perspectives in Anthropology*. Philadelphia: University of Pennsylvania Press.

Pray, Issac Clark. 1855. *Memoirs of James Gordon Bennett and His Times*. New York: Stringer and Townsend.

Prosser, William. 1960. "Privacy." *California Law Review,* 48:3, pp. 383–423.

Raines, Thomas. 1980. "Let Us Now Praise Famous Folk." *The New York Times Magazine,* May 25.

Ruby, Jay. 1976. "In a Pic's Eye: Interpretive Strategies for Deriving Meaning and Signification from Photographs." *Afterimage,* 2:9, pp. 5–7.

Rudisill, Richard. 1971. *Mirror Image*. Albuquerque: University of New Mexico Press.

Schiller, Daniel. 1977. "Realism, Photography and Journalistic Objectivity in 19th Century America." *Studies in the Anthropology of Visual Communication,* 4:2, pp. 86–98.

Sekula, Alan. 1975. "On the Invention of Photographic Meaning." *Art Forum*.

Shiff, Richard. 1982. "The Technique of Originality: 'Innocence' and Artifice in the Painting of Corot, Monet, and Cezanne." *Studies in Visual Communication,* 8:4, pp. 2–32.

Warren, Samuel, and Louis Brandeis. 1890. "The Right to Privacy." *Harvard Law Review,* 4:5, pp. 193–220.

Wilsher, Ann. 1977. "Words in Camera." *History of Photography,* 1:1, p. 84.

Worth, Sol, and Larry Gross. 1974. "Symbolic Strategies." *Journal of Communication,* 24:4, pp. 27–39.

2

The Tradition of the Victim in Griersonian Documentary

BRIAN WINSTON

> You know this film (*Children at School*) was made in 1937. The other thing is that this film shows up the appalling conditions in the schools in Britain in 1937 which are identical with the ones which came out on television the night before last: overcrowded classes, schoolrooms falling down, and so on. It's the same story. That is really terrible, isn't it?
>
> BASIL WRIGHT, 1974

One

A. J. Liebling once remarked that it was difficult for the cub reporter to remember that his (or her) great story was somebody else's disastrous fire. Much the same could be said of the impulse to social amelioration, which is a central element in Grierson's rhetoric and which, therefore, has become over this past half-century a major part of the great documentary tradition. Documentary found its subject in the first decade of sound, and by the late thirties the now familiar parade of those of the disadvantaged whose deviance was sufficiently interesting to attract and hold our attention had been established. It was not yet dominant and World War II was to distract from its importance, but it was there. Each successive generation of socially concerned film-makers since the war has found, on both sides of the Atlantic, in housing and education, labor and nutrition, health and welfare an unflagging source of material. For the most prestigious publicly funded documentarist as

well as the least effective of local news teams, the victim of society is ready and waiting to be the media's 'victim' too.

This 'victim,' however, does not figure much in the theoretical or public discussion of documentary. There an agenda has been set which concentrates on issues of transparency and narratology, on the morality of mediation and reconstruction, on the development of style, and on the effects of new equipment. The people whose co-operation is crucial to documentarists have as little place in that discussion as they do (usually) in the making of the films and tapes in which they star. Indeed documentarists by and large take an aggrieved view of this issue, should it be raised. Frederick Wiseman:

> Sometimes after films are completed people feel retrospectively that they had a right of censorship, but there are never any written documents to support that view. I couldn't make a film which gave somebody else the right to control the final print.[1]

Wiseman's attitude is, I would argue, the typical one. Interference of any kind is a clear breach of the film-makers' freedom of speech and, as such, is to be resisted. But given the 'tradition of the victim,' the film-makers' freedoms often seem like nothing so much as abridgements of the rights of their subjects, rights which, for all that they are less than well defined, are nevertheless of importance in a free society.

The persistence of the social problems that these texts are, at a fundamental level, supposed to be ameliorating is never discussed. But if it is the case that housing problems are unaffected by fifty years of documentary effort, what justification can there be for continuing to make such films and tapes? Grierson's purpose was clearly enunciated: "To command, and cumulatively command, the mind of a generation. . . . The documentary film was conceived and developed as an instrument of public use."[2] There was nothing, though, in this ambition (shared by the entire documentary movement) to be the propagandists for a better and more just society which would inevitably lead to the constant, repetitive, and ultimately pointless exposure of the same set of social problems on the televisions of the West night after night. How this came to be the case is the subject of this paper.

The Griersonian tradition cannot be contained by referencing the practice of one small group of British film-makers during two decades of activity. For good or ill, it is here assumed, that Grierson's direct and indirect influence have affected documentary film production worldwide. In particular, it is suggested that in North America the influence has been strong and obvious, both as to the institutional framework

seen to be appropriate for documentary production and in the topics documentarists choose to make films about. Thus the argument of this paper will criss-cross the Atlantic. First a crucial shift in the documentary subject will be isolated as having taken place in Britain in the mid-thirties. This, the discovery of the 'victim of society' as a suitable subject, raises a number of essentially ethical questions for Grierson and his successors, questions which confront contemporary documentary practice on both sides of the Atlantic. These will be addressed in the third section below. Since there is little debate in documentary circles about the implications of these practices in the final sections we shall turn to the courts for guidance, situating these ethical questions in the traditions of the common law and its approaches to the issue of privacy. Most of our evidence here comes from the United States, so we will conclude by concentrating, perforce, on American legal precedents. But we shall begin half a century ago in the UK, confident in the belief that Grierson's practice has directly influenced contemporary film-makers in many countries, including the U.S.; and that it is his benchmarks which have been established for all subsequent documentary work both in film and television for the entire English-speaking world and beyond.

Two

From 1929 to 1937 Grierson synthesised two distinct elements. Firstly he focused the general social concern of his time into a program of state-supported film-making. Such were conditions during the Great Depression that even on the Right in Britain the need for measures of state intervention in many fields was accepted. Indeed the generation of young Conservatives whose political philosophy was formed at this time were exactly those post-war leaders who agreed to the Welfare State and thereby established the consensus which is only now being destroyed. I mention this simply because it is easy to treat the group around Grierson as dilettantes. (Wright speaks of his "slight private income"[3]; Rotha writes of his parents as "far from well-off" who, nevertheless, managed to send him to thirteen private schools in as many years[4]; Watt states: "I came from a normal middle-class background. My father was a member of Parliament."[5]) To modern eyes the films they made, virtually all of them stilted and condescending, tend to reinforce the unfortunate impression that, as a group, they were nothing but poseurs, clutching their double firsts from Cambridge. There is no reason, though, to doubt the sincerity of their impulse to 'get the British

workmen on the screen' or indeed to help the working class in other ways.[6] "To start with we were left wing to a man. Not many of us were communists, but we were all socialists."[7] Grierson's first job, lecturing on philosophy at the Durham University outpost in Newcastle-upon-Tyne, allowed him time to work, and work seriously, in that city's slums.[8]

In its day, the social attitude of Grierson's colleagues was genuine and to be expected; and their achievement on the screen was not inconsiderable. Grierson claims that "the workers' portraits in *Industrial Britain* were cheered in the West End of London. The strange fact was that the West End had never seen workmen's portraits before—certainly not on the screen."[9]

> [The films] were revolutionary because they were putting on the screen for the first time in British films—and very nearly in world films—a workingman's face and a workingman's hands and the way the worker lived and worked. It's very hard with television nowadays and everything, to realise how revolutionary this was, that British films, as such, were photographed plays, that any working class people in British films were the comics.[10]

This emerging iconography, a contrast to the parade of Noel Coward servants that was the norm, did not, at first, concentrate on the lower classes as victims.

On the contrary, the second element influencing the movement ensured that this would not be the case. Robert Flaherty's powerful example moved the desire to document the realities of working life into the realm of the poetic. Flaherty was responsible for *Industrial Britain* although the film was finished by Gierson (and ruined by the distributor who added the 'West End' voice and overblown commentary). Grierson's group admired Flaherty's approach enormously. Their primary aesthetic allegiance was the Soviet silent cinema which meshed well with their socialist rhetoric, but they were also susceptible to Flaherty's poeticism despite the fact that it eschewed the social responsibilities they embraced. Grierson was dismissive of what he called Flaherty's emphasis of "man against the sky," preferring films "of industrial and social function, where man is more likely to be in the bowels of the earth."[11]

> There wasn't any serious attempt at characterisation of the kind you find in Flaherty because we regarded this as a bit romantic. We were all pretty serious-minded chaps then, you know, and we believed, like the Russians, that you should use individuals in your film in a not exactly dehumanized way but a sort of symbolic way.[12]

Edgar Anstey encapsulates the group's view, but nevertheless Flaherty's insistence on using the individual as the centerpiece of his narratives was to prove as seductive as the poeticism of his camera style. Flaherty's contribution to the notion of the documentary (the individual as subject and the romantic style) when mixed with Grieson's (social concern and propaganda) leads directly to privileging 'victims' as subject matter. For the working class can be heroes only in the abstract sense that Anstey describes.

> The early school of documentary was divorced from people. It showed people in a problem, but you never got to know them, and you never felt they were talking to each other. You never heard how they felt and thought and spoke to each other, relaxed. You were looking from a high point of view at them.[13]

Examining the individual worker, given the predelictions of these film-makers, meant moving from the heroic to the alienated. Hence victims, and the emergence of a sub-school of film-makers who

> wanted to lay on what the problems were for Britain so that we should see and learn and do something about it. But you don't do something unless you feel some sort of empathy and concern with the problem, and the cold commentary voice doesn't really excite you very much.[13]

The competition between Grierson's line and the splinter group was short-lived. Grierson's attempt to reconstruct the landscape of industrial Britain in terms of Flaherty's exoticism (and Eisenstein's editing methods) withered on the vine.

> We worked together [explains Grierson] and produced a kind of film that gave great promise of very high development of the poetic documentary. But for some reason or another, there has been no great development of that in recent times. I think it's partly because we ourselves got caught up in social propaganda. We ourselves got caught up in the problems of housing and health, the question of pollution (we were on to that long ago). We got on to the social problems of the world, and we ourselves deviated from the poetic line.[14]

Grierson is being a little self-serving here for the group as a whole did not get "on to the social problems of the time" and, in fact, it split apart on the issue. Arthur Calder-Marshall, ever the most perceptive of Grierson's contemporary critics, summed up the problem. Commenting

on the failure of the G.P.O. film unit to document the unrest of postal workers, he wrote:

> Mr. Grierson is not paid to tell the truth but to make more people use the parcel post. Mr. Grierson may like to talk about social education surpliced in self-importance and social benignity. Other people may like hearing him. But even if it sounds like a sermon, a sales talk is a sales talk.[15]

Grierson's autocratic grip on documentary production in Britain was loosened and the 'serious-minded chaps' established a measure of distance and independence from him. What is more significant is that they also established the way forward, a way that the 'poets' themselves came to in a few years.

Rotha, partly because of personality clashes but more on principle, had quit to set up his own unit. Now Anstey and Elton, although still disciples, also left. In the films these men made in the mid-thirties can be plotted the shift from worker-as-hero to worker-as-victim.

In *Shipyard,* a typical Griersonian project about the building of a ship, Rotha (commissioned by the shipping line and working for a subsidiary of Gaumont-British) injected an understanding of how the shipbuilders would be once more idle when the work was completed. Out of material collected on his journeys to and from the yard, he also made, for the electricity generating industry, *Face of Britain* which, inter alia, contained the first material on the slums of the industrial heartland. That same year, 1935, Elton was making *Workers and Jobs,* a film with synchronous sound about Labour Exchanges for the Ministry of Labour. With Anstey he worked on the crucial *Housing Problems* for the gas industry. This too employed synchronous sound.

In *Housing Problems,* Cockney slum dwellers address the camera directly to explicate the living conditions the film depicts. This was the first time that the working class had been interviewed on film *in situ.* Giving them a voice by obtaining location sound with the bulky studio optical recording systems of the day was an exercise in technological audacity as great as any in the history of the cinema. Sound had come slowly. In 1934 Grierson was promising, "If we are showing workmen at work, we get the workmen to do their own commentary, with idiom and accent complete. It makes for intimacy and authenticity, and nothing we could do would be half as good."[16] Rotha had used a shipworker to do the commentary on *Shipyard* but for synchronous sound it was necessary to go into the studio, building sets and duplicating all the procedures of the fiction film. It is no accident that the first of their

synchronous sound productions was *BBC: The Voice of Britain,* for the locations were studios, albeit designed for radio. In *Night Mail* technological limitations meant all the train interiors being shot on a sound stage. The desire to add the worker's voice to an authentic location image was easier to announce than to achieve.

But *Housing Problems* was much more than an early solution to a major technical problem. In making the film, Elton and Anstey had rethought much of the artistic rhetoric that Grierson had imported from Flaherty. Anstey:

> Nobody had thought of the idea which we had of letting slum dwellers simply talk for themselves, make their own film. . . . we felt that the camera must remain sort of four feet above the ground and dead on, because it wasn't our film.[17]

Because Elton and Anstey eschewed the usual proprietary artistic attitude, the people in *Housing Problems* are all named, allowed the dignity of their best clothes and the luxury of their own words (albeit somewhat stiltedly expressed for the gentlemen of the production unit). Of course, this claim of non-intervention ("it wasn't our film") cannot be taken too seriously, since the interviewees were chosen and coached by the team and the results edited without consultation. But it did represent a new theme in the group's thinking about the function of the documentary director, one which was unfortunately not to be heard again for three decades.

What was immediately influential was Anstey's view of his interviewees. Instead of heroic representatives of the proletariat, he thought of them but as "poor, suffering characters"—victims. The films were moving in topic from romanticized work through unemployment to the realities of domestic conditions.

In the years to come Anstey's view of his role, that of enabler rather than creator, and the courtesies he afforded his interviewees would disappear. The victim would stand revealed as the central subject of the documentary, anonymous and pathetic, and the director of victim documentaries would be as much of an 'artist' as any other film-maker.

Before the war, Anstey was to make *Enough to Eat* about malnutrition and for *March of Time* he was to cover a bitter strike in the Welsh coal fields—rather than the titanic miner at work who was the earlier icon of the industry. Watt was to do a number of exposés for *March of Time* on the scandal of church tithes and the riches of football pools (a soccer-based commercial lottery) promoters. Wright, the most poetic of them all, made *Children at School.*

It is with some justice that these men claim that all current documentary practice can be traced back to their activities in the thirties. The most potent of their legacies, however, is this tradition of the victim.

Factual television cements the tradition into place. It affords a way of apparently dealing with the world while, as Calder-Marshall said of Grierson's *Drifters*, "running away from its social meaning." For it substitutes empathy for analysis, it privileges effect over cause, and it, therefore, seldom results in any spin-offs in the real world—that is, actions taken in society as a result of the program to ameliorate the conditions depicted. So although the majority of television documentaries and news features deal with victims, normally as types of deviance, such treatment scarcely diminishes the number of victims left in the world as potential subjects.

Independent documentary production is in like case. The rise of direct cinema produced, by the early sixties, the currently dominant style of 'crisis structure' documentary. Robert Drew, whose position in these developments is not unlike Grierson's thirty years before, describes the goal of such work:

> What makes us different from other reporting and other documentary film-making, is that in each of these stories there is a time when a man comes against moments of tension, and pressure, and revelation, and decision. It's these moments that interest us most. Where we differ from TV and press is that we're predicated on being there when things are happening to people that count.[18]

But where the direct cinema practitioners turned out to be the same was in their choice of the people they would witness in such situations. Of course, they could and did observe presidents and movie tycoons but, as in the thirties, the more fruitful strand turned out to be not the powerful but the powerless. And, more than that, direct cinema gave the victim tradition the technology that allowed a degree of intrusion into ordinary people's lives which was not previously possible.

Direct cinema and cinéma vérité were the outcome of a concerted effort, culminating in the late fifties, to develop a particular technology—a lightweight, hand-holdable, synchronous sound film camera. The demand for this had come directly out of the Griersonian experience, where any sort of synchronous shooting required enormous intervention, if not reconstruction, on the part of the film-makers. In the years after the war it seemed to many that without such portable equipment, documentary film would never deliver on its promise to offer un-

(or minimally) mediated pictures of reality. It can be argued that this was entirely the wrong agenda because reconstruction was not the real issue, since mediation occurs in far subtler and more or less unavoidable ways whatever the techniques used. The argument was nevertheless deployed and the equipment developed.

Television had already begun to use 16mm for news gathering purposes, forcing the creation of ever more sensitive film stocks. The equipment the industry used for this work formed the basis of the direct cinema experiments. In turn, the broadcasters took up the adaptations the direct cinema practitioners made and thereby created a market for the manufacture of custom-designed self-blimped cameras and hi-fidelity battery-driven tape recorders. The possibility of events being more important than were the processes of filming them now existed for the first time. No door, especially the door behind which the disadvantaged were to be found, need or could be closed to the film-makers.

Aesthetic as well as technical trends also favored the victim as subject. It is received opinion that television demands close-ups, but it is no part of professionalisation, in my experience, to stress any such thing. The industry tends to avoid the big scene because of the expense such shots involve rather than because they are considered unreadable by the audience, which, palpably, they are not. A number of other factors lead to the close-up—against light backgrounds, receiver tubes (for at least twenty years after the war) tended to over-modulate and reduce all darker areas to silhouette. By moving into the face this could be avoided. The very small eyepieces of 16mm reflex cameras (and, latterly, lightweight video equipment) again encourage the close-up as being more easily focused than longer shots. The prevalence of the 10:1 zoom lens, which can only be properly focused at the long (i.e. close-up) end of its range, has the same effect. All these technological constraints result in the close-up emerging at the dominant shot in the documentary.

(There was an early period when the direct cinema style encouraged the use of a wide-angle lens to simplify focusing problems. This lens has been largely abandoned because the variable shot size possible with the zoom lens better serves the needs of transparent editing. It also avoids distortions, again serving the needs of transparency. And, because it is much more difficult to use than a wide-angle, the mysterium of the cameraperson's craft is more effectively maintained.)

The documentary tradition begins with the individual heroic Inuit, 'against the sky' in long shot. Currently it most often displays the private inadequacies of the urban under-class, 'in the bowels of the

earth' in close-up. The line that enabled this to happen can be traced from Flaherty's exotic individuals, through Grierson's romanticized and heroic workers to Anstey's victims caught in Drew's crisis structures. The line was an easy one to follow because technological developments, journalistic predelictions, and ideological imperatives all played a role in facilitating it.

But there is one major concomitant problem involved in the emergence of the victim tradition which has never received the attention it demands. By choosing victims, documentarists abandoned the part supposedly played by those who comment publicly on society (the watchdogs of the guardians of power). Instead, in almost any documentary situation, they are always the more powerful partner. The moral and ethical implications of this development are not only ignored; they are dismissed as infringements of film-makers' freedoms.

Three

A monstrous, giant, smouldering slagheap towering over a shabby street of slum houses, hovels fallen into ruin with one lavatory for fifty persons. But inhabited. Rent for a house was 25 shillings per week. All the property belonged to the company that owned the mine. Few men were in work. I watched the rent collectors at their disgusting job; wringing a few shillings from women some of whose men were bloodying hands and shoulders in the earth hundreds of feet below where we stood, or standing on the street corners. From some petty cash I had with me, I paid the rent for some families and bought beer in the pub for some of the miners. It gave me pleasure that the profits of Gaumont-British should be so used. How I justified it in my accounts when I got back to London is neither remembered nor important. So this was Britain in the 1930s.[19]

Rotha went to the village of East Shottom in Durham because J. B. Priestley had reported on it in a series of newspaper articles which became the book *English Journey*. This perfectly describes the normal relationship between the print and audio-visual media, but I quote the diary because it is one of the few references to a film-maker's relationship with a subject that I can find in the literature on documentary film. For instance Joris Ivens, the most overtly political of the great documentarists, in his memoir of four decades of film-making (*The Camera and I*) details only one non-unidimensional relationship.[20] Normally film-makers regard contact with their subjects as too uninter-

esting to report. In consequence the literature tends to contain only references to what are considered deviant encounters, usually where the film-maker has to resort to subterfuge to get the material needed.

> While I was waiting outside with the film crew . . . a truck pulled up in front of us and a burly guy clambered out and started yelling, "What the hell are you guys doing here. You're trespassing, and get the hell off my property." This was Chudiak, president of the farmers' co-op, but I didn't know it at the time and had to figure out, first, who is this guy; second, what do I say to prevent the whole show from disappearing then and there; third, how can I prevent him from learning what I'm really doing but still tell him a sufficient amount so that I won't feel forever guilty of having lied; and fourth, how can I keep the trust of the migrants, the crew chief, and gain the confidence of this guy, all at the same time.[21]

A film-maker's lot is clearly not a happy one—but it is, arguably, less unhappy than that of the migrant workers, the subjects of the above documentary. Film-makers do worry about lying—to exploiting farmers or the like. This sort of worry can be traced back to the thirties. Watt described conning vicars while making his *March of Time* about church tithes:

> Being film people, we'd take advantage. We used to go to sweet vicars living in a twenty room house and with a congregation of ten, mostly old women. And I'd say, "What a beautiful house and beautiful church. May I photograph?" Of course, I was showing that he was living in this enormous house and having ten parishioners. The church was very annoyed about the whole thing, but it was just what *March of Time* wanted.[22]

With all due respect to these film-makers, such worries are easy. They reveal the film-maker in a traditional journalistic role as protector of the powerless and fearless confronter of the powerful. The more vexed moral issue is raised not by the need to misrepresent oneself before the farmer but rather by the necessity of remaining silent, as to the reality of their situation, in the presence of the migrant workers. It is not the fabrication of intention for the vicar but the easy assumption that the film-maker and the film production company know better than the church established what the society best needs. And it is these issues that are not addressed. There are film-makers who bring a high-degree of sensitivity to their work. In the seventies, some like George Stoney, actively began exploring other roles for themselves. Others created what

almost amounted to a subclass of films in which the documentarist dealt with their own families, as in *Best Boy*. It is, though, our contention that these were exceptions and that the potential for documentarists they represent is still attenuated. The victim tradition dominates.

The victim tradition makes it all too easy to itemize, almost at random, a wide range of problems.

First, when dealing with the powerless what does the legally required consent mean? Since for most people the consequences of media exposure are unknown, how can one be expected to evaluate such consequences? For some people, as with the mentally ill in Wiseman's banned *Titticut Follies*, there is a question of whether or not consent can be given in any circumstances. The same would apply to the male child prostitutes appearing in the videotape *Third Avenue, Only the Strong Survive*.

In this same text is raised a second question, that of complicity. The crew reconstructed a car heist and then filmed one of the protagonists in prison subsequent to another robbery of the same kind. All films about deviant activities place the film-makers in, at best, quasi-accessory positions.

Beyond the illegal there is the dangerous. Flaherty paid the men of Aran £5 to risk their lives by taking a canoe out into a heavy sea. (There is some quite infuriatingly stupid comment about this sequence suggesting that the men were in no danger because of the peculiarities of the waters round Aran. Any who believe this have simply failed to look at the film). Or there can be more specific danger as in a student project which took a man recovering from compulsive gambling to the track to see how well he was doing and to provide the film with a climax.

A more unexpected problem arises when the subject desires media exposure, as in a BBC documentary about an exhibitionist trans-sexual shot in the most voyeuristic manner consistent with public exhibition. In another British television film, *Sixty Seconds of Hatred*, a man's murder of his wife was examined. I was invited to screen the movie, on the eve of transmission, and found, also among the critics, the murderer and the teenage son of the marriage who was a child when the crime was committed. There was no doubt that the man was eager to relive the incident; but, beyond a careful decision not to include him in the film, nobody had further considered what such a public retelling of the tale might do to the boy.

These are not, in my view, abstract concerns affecting only the subjects of documentaries. The problems also redound to the film-

makers. In a British television documentary *Goodbye, Longfellow Road*, the film crew documented a women's descent into pneumonia. The crew interviewed the doctor as he was rushing her stretcher to the ambulance and ascertained that it was indeed the result of her living in a hovel that had caused her condition. As a television producer, I would find it extremely difficult to comfort myself with the thought that I had contributed to the public's right to know when I could have, for a pittance, provided my victim with a roof, however temporary. Of course, I would have needed another subject for my film.

Other problems arise from the fact that these texts have extended and perhaps nearly indefinite lives. Paul, the failed 'salesman' in the Maysles film of that name, is constantly exposed as such wherever documentary film classes are taught or Maysles retrospectives are held. The anonymous Midwestern boy who spews his heart up as a result of a drug overdose in Wiseman's *Hospital,* spews away every time the film is screened. Should it be played in the community where he is now, one hopes, a stable and respectable citizen there is nothing he can do about it. For the film is not a lie; is not maliciously designed to bring him into either hatred, ridicule, or contempt; and, therefore, he has no action for libel. And the film was taken with his consent, presumably obtained subsequent to his recovery.

And this consent is, indeed, all that the law requires. The question must be asked, is it enough? The answer is to be culled largely from American experience.

Four

In 1909 two steamships collided in Long Island Sound. On board one of them, a radio operator, John R. Binns, successfully (and for the first time anywhere) used his machine to call for help. As a result of his C.D.Q. only six of the seventeen hundred passengers on board drowned. Binns was a hero. The Vitagraph Company, after the fashion of the day, made a 'documentary' about the incident, entirely reconstructed and using an actor to impersonate Binns. Binns, the actor, was shown as lounging about and winking at the passengers at the moment of the collision. Binns, the hero, sued—not only for libel but also for invasion of privacy. He won on both counts. But the privacy decision was to prove exceptional.[23]

The courts over the years, according to the account given by Pember in *Privacy and the Press,* were to take the basic view that any filmed event, if not reconstructed, was protected by the First Amendment.[24]

The only line of exceptions to this arose, both for films and the press, out of a series of decisions about the unauthorized use of images in advertisements, the earliest being heard in the English Court of Chancery in 1888. By 1903, New York State had a privacy statute on the books specifically limited to such unauthorized uses for advertising or "trade purposes." The courts were to be very restrictive in defining "trade purposes" and again and again privacy actions failed if the commerce involved was simply the commerce of the news business, whatever the medium. In such cases the conflict is seen as being between the public's right to know and the private citizen's right to privacy, and the former normally prevails.

The courts were happy to distinguish between advertising and news; and the above exceptions were based upon the distinction. For, despite the terminology used, the cases turn on some sense of property, upon the idea that another should not profit *directly* out of the use of one's image. Other arguments have been advanced suggesting that persons should be protected from exploitation by the news media because they are private individuals. These have been, by and large, as unsuccessful as the attempts to extend the concept of commercial exploitation. The idea of the 'public man' goes back to 1893 and was extended in the twenties.[25] The right to privacy was then defined as:

> The right to live one's life in seclusion, without being subjected to unwarranted and undesired publicity. In short it is the right to be left alone . . . There are times, however, when one, whether willing or not, becomes an actor in an occurrence of public or general interest. When this takes place he emerges from his seclusion, and it is not an invasion of his right of privacy to publish his photograph with an account of such occurrence.[26]

One can become an 'involuntary public figure' by giving birth to a child at twelve years of age, being held hostage by a gunman, having one's skirts blown above one's head in public.[27] And becoming an 'involuntary public figure' was no temporary thing. A boy prodigy could not prevent the press pursuing him and removing the cloak of obscurity he had sought.[28] Neither, since the common law has never acknowledged distress as a ground of action, could parents prevent the publication of pictures of the dead bodies of their children.[29] Nor can the victims of

rape, for the same reason, keep their names from the media, unless statute orders otherwise, which it does in some states.

Images of people in public domain, even if engaged in deviant (but not illegal) activities, are protected as newsworthy too. A couple embracing in a public place claimed that a photographer, in this case Cartier Bresson, had invaded their privacy. They lost.[30] Places of public access offer limited protection. In Wisconsin, in an admittedly obscure and extreme case, a tavern owner was permitted to photograph a woman in the toilet of his premises and show the picture at the bar.[31]

Many other examples could be given of the zealousness with which the courts have guarded press rights and the courts have not been loath to extend these protections from the press to first newsreels and latterly television. An innocent man filmed while being thrust against a wall in a hotel and questioned by police officers was held to have no action against the television station using those images, even though in no way was his innocence reported.[32] Newsworthiness encompassed all the previous excesses of the press. A newsreel company was entitled to film fat women in a private weight reduction class. The judgement states:

> While it may be difficult in some instances to find the point at which public interest ends, it seems reasonably clear that pictures of a group of corpulent women attempting to reduce with the aid of some rather novel and unique apparatus do not cross the border line, at least as long as a large portion of the female sex continues its present concern about any increase in poundage.[33]

All aspects of the law were transferred wholesale to the new media. In *Cohn v. Cox Broadcasting* the Supreme Court, in 1975, refused to acknowledge any concept of media amplification. Since the name of the rape victim in that case had appeared in the public record, the company was free to broadcast it.[34]

Consent, equally, has never been developed as a concept, except that it was deemed to be unobtainable from minors. In *Commonwealth of Massachusetts v. Wiseman* it was further held that consent was not obtained from the participants in the film *Titticut Follies*. Of the sixty-two mental patients seen in the film, most were not competent to sign releases and only twelve such forms were completed.[35] (The need for written consent had been established in a case where CBS was successfully sued by a person who was represented in a dramatic reconstruction of a real-life incident which had been made with his consent and advice but without written permission.[36]) Wiseman's account of the *Titticut Follies* case is in rather different terms:

I had permission from the superintendent. I had permission from the commissioner of correction. I had an advisory opinion from the attorney general of Massachusetts, and I had the strong support of the then lieutenant governor. However, some of these men turned against me when the film was finished, with most of the trouble starting two or three months after the superintendent and the attorney general had seen the film.[37]

Wiseman, in this interview, claims "this was the first time in American constitutional history . . . whereby publication of any sort which has not been judged to be obscene has been banned from public viewing." Rather it was the first time that an injunction was obtained on the grounds that there was a failure to obtain consent outside of advertising. The case, although therefore important, still does not acknowledge the existence of a right of privacy in any well-defined way. It joins *Binns and Vitagraph Co.* among the few precedents which go against the interests of the press and which, almost all, turn on consent issues.

The fact is, as those hostile to the idea of a tort for invasion of privacy maintain, there is no basis for such an action in the common law. It was in the *Harvard Law Review* of December 15, 1890, that two young Boston lawyers, Warren and Brandeis (who was later to become a Supreme Court Justice) that the right of privacy was first enunciated.[38] Arguing on the basis of mainly English precedent, they suggested that an action might lie specifically to prevent what they saw as the gossiping excesses of the Boston press of the day. They relied on the old doctrine of ancient lights (whereby one cannot make a window to overlook one's neighbor, unless proof of a previous window could be brought) and analogy with copyright law. They suggested that the common law acknowledged a right to an "inviolate personality" and afforded as much protection of that right as it did of inviolate property. They used a range of authorities to support this contention including a case in which the publisher of the private drawings of Queen Victoria and Prince Albert had been restrained. (The royal case, which anyway could have turned on copyright and general notions of property, is dubious since Victoria, despite Magna Carta and the English Civil War, had a way with the courts. The logical absurdity of the verdict of guilty but insane arose in another case entirely because of her objections that any who tried to kill her, however deranged, had to be guilty.)

But despite the best efforts of Warren and Brandeis, the English common law will not sustain a right of privacy or the concept of an "inviolate personality." The English textbook on torts I was assigned as a law student waxes positively amused at the thought.

A much discussed point is whether the law of torts recognises a "right of privacy." There may be circumstances where invasions of privacy will not constitute defamation or any other tort already discussed. For example, the jilted lover who makes his former sweetheart a present of a bathing costume which dissolves in chlorinated water; the farmer who offends the old spinsters across the road by encouraging his beasts to mate on Sunday mornings in a paddock in full view of the old ladies; the hotel manager who rushes into the plaintiffs' bedroom and says: "Get out of here—this is a respectable hotel" (and the plaintiffs are man and wife); the newspaper which, on the eve of an election, rakes up the forgotten past of one of the candidates . . . the newspaper reporters who, regrettably, sometimes stop at no invasion of privacy in order to 'get a story.' No English decision has yet recognized that infringement of privacy in a tort unless it comes within one of the existing heads of liability.[89]

The limited English case law relates entirely to the press. Thus the Griersonian documentary tradition, in its native land, grew up and continues to operate in a very much less litigious atmosphere than does its American step-child. In the sixties, in Britain as in the United States, privacy questions relating to modern computers were being debated, but, unlike America, in Britain, that debate excluded film and television. From 1961 on there have been a number of bills presented to the British Parliament attempting in various ways to protect the citizen against the presumed threat posed by computers. None of these bills has passed, neither have the limited proposals of a committee of inquiry, made in 1973, been enacted. The British documentary film tradition, and its television news variants, flourish far from the eyes of the British courts.[40]

It seems to me this whole area has passed beyond the 'regret' of lawyers. In Britain the right to privacy does not exist. In the United States, except against the government and in the case of unauthorized advertising, it is extremely unclear. One cannot but agree with New York Supreme Court Justice Sheintag who stated nearly half a century ago:

A free press is so intimately bound up with fundamental democratic institutions that, if the right of privacy is to be extended to cover news items and articles of general public interest, educational and informative in character, it should be the result of clear legislative policy.[41]

The legislation has never been forthcoming, and in the intervening decades the waters have been considerably muddied. Most importantly

the courts have been slow to understand the implications of new technologies. In 1927 in *Olmstead v. United States* the Supreme Court held that wire-tapping by the government did not infringe the Fourth Amendment's prohibition against, "the right of people to be secure in their persons, houses, papers and effects, against unreasonable searches and seizures." This was because no things were seized, only conversations overheard. It took exactly forty years for the Court to reverse itself.[42]

The line from *Olmstead v. United States* to the Privacy Act of 1974 (which protects citizens from the misuse of government data about them) has important repercussions on the string of press victories documented above. For now, with the emergence of the computer data bases, and the convergence of media, there is considerable and widespread concern about abuses to the right of privacy which the new technological configuration could entail. While tyranny has functioned all too well without the computer, most seem to feel it could function very much better with it, and, in many Western societies, legislation is being put in place to combat that possibility. It is likely that, in the democracies, such concern might also express itself in a more aggressive establishment of the tort of invasion of privacy than has hitherto been possible. It could also be the case that such extensions would begin to breach the protections of the First Amendment so that, in the wash of the mounting concern about information in general, important media freedoms could be jeopardized.

The situation is not unlike that of the British in Singapore in 1941. Guns facing the sea, the garrison was confident it could not be attacked from the jungle to its rear. Yet that is exactly what the Japanese did, and the British guns were captured cold, pointing the wrong way.

One understands and sympathizes with the emotions stirred by the First Amendment, but it is an eighteenth-century device addressing eighteenth-century situations. Insisting that what was conceived of as a virtual private right should attach to any legal entity in the society however large; insisting that no technological advance in communications has affected the basic essence of privacy and reputation; insisting that these freedoms are so fragile only a domino-theory approach can protect them—all of these things must be abandoned if the real dangers of the late twentieth century are to be faced. The point is that, traditionally, media have been considered as not just the representatives of the general public but the general public itself. Such a view, while understandable in eighteenth-century terms, fails to distinguish present-day realities where the media are far from being the general public but are instead a special interest dominated by an oligopolistically arranged

group of international conglomerates. The commonly held view that the freedoms of expression demanded by such entities must be protected because identical individual freedoms will be at stake if they are not is, I would submit, simply false. The individual's right of free speech is now separated from the media's right of the same name by an abyss of technology. They can and should be treated differently.

Five

Rights are normally accompanied by duties. Press rights are accompanied by minimal duties not to blaspheme, libel or utter sedition. Desuetude characterizes the first and last of these, and libel is a remedy available only to those with enough resources, emotional and financial, to take on the great corporation which is, today, the commonest libeler.

For film and video-makers caught in the Griersonian tradition of seeking social amelioration through the documentation of societies' victims, the law, given the amplification of message possible with current technologies, allows too much latitude. Documentarists, by and large, do not libel and, by and large, do not 'steal' images. Yet they are working with people who, in matters of information, are normally their inferiors—who know less than they do about the ramifications of the filmmaking process. It seems appropriate that an additional 'duty of care' be required of them.

> In order to protect the interests of others against the risks of certain harms the law prescribes certain standards of conduct to which persons in particular circumstances ought to conform, and, if, from failure to attain those standards, such harm ensues, this is actionable.[43]

The 'harm' resulting from invasion of privacy is not normally considered actionable if rising out of the exercise of press freedom. Nor does an individual have an 'inviolate personality' along the lines proposed by Warren and Brandeis. Yet, in the Universal Declaration of Human Rights adopted by the General Assembly of the United Nations in 1948, Article 12 declares:

> No one shall be subjected to arbitrary interference with his privacy, family, home or correspondence, nor to attacks on his honor or reputation. Everyone has the right to the protection of the law against such interference or attacks.[44]

The European Convention on Human Rights, signed by the member nations of the Council of Europe in 1950, states:

> Everyone has the right to respect for his private and family life, his home, and his correspondence.[45]

These widely adopted conventions offer a basis upon which the film-makers duty of care to his or her subject could be defined. In many circumstances the filming of 'victims' constitutes 'interference' which is certainly 'arbitrary' within the dictionary meaning of the word. But only in rare cases of extreme abuse would an action lie arising from the basic human rights documents; for, in most instances, consent would continue to operate protecting the film-maker. Therefore, any meaningful development of the notion of a duty of care in the circumstances here being considered must devolve upon an elaboration of the concept of consent. Instead of the crude 'consent' we now have, more refined consideration would be needed. Such refinements already exist in the area of medical and social-science research procedures developed, mainly without the pressure of law, by many professional bodies. Among the most comprehensive of these was the Nuremburg Code.

> The voluntary consent of the human subject is absolutely essential. This means that the person involved should have legal capacity to give consent; should be so situated as to be able to exercise the free power of choice, without the intervention of any element of force, fraud, deceit, duress, over-reaching, or other ulterior form of constraint or coercion; and should have sufficient knowledge and comprehension of the elements of the subject matter involved as to enable him to make an understanding and enlightened decision. This latter element requires that before acceptance of an affirmative decision by the experimental subject there should be made known to him the nature, duration and purpose of the experiment; the method and means by which it is to be conducted; all inconveniences and hazards reasonably to be expected; and the effects upon his health or person which may possibly come from his participation in the experiment.[46]

Substitute 'film' for 'experiment' and 'experimental' in the above and a fair definition of a film-maker's duty of care results. Film-makers will argue that this would massively reduce access to subjects. So be it. Since the fifty-year parade of the halt and the lame has patently done more good to the documentarists than it has to the victims, I see no cause to mourn a diminution of these texts. To facilitate the operation of a duty

of care, I would suggest that society refines its view of film and video-making activities to acknowledge the following:

1) *That different channels of communication have different effects.*
The decision in *Mass.chusetts v. Wiseman* limiting the film's distribution to professional audiences is perfectly good from this point of view. It is reasonable to suggest that social value could accrue from a film or tape in specialized circumstances whereas social damage would result in other more general situations. Questions of cui bono are not inappropriate in this setting, either. Courts should be less hesitant to examine the commerce of the media than they have been hitherto.

2) *That the law distinguishes public and private personae.*
At a common-sense level the distinction between a public figure and a private person is obvious. The law often defines social phenomena more complex than this and there is no reason why such a distinction could not be made part the consideration of privacy issues. Public and private personae should be afforded different degrees of protection. At the moment ordinary people are left naked in the glare of publicity. Conversely, public figures sometimes use the scant protection the law intends for ordinary persons to inhibit or prevent what would be, in their cases, quite proper exposés. (I am conscious this happens more in the UK than the US).

3) *That the protection afforded the private domain be extended to private personae in semi-public and public areas.*
This would allow a measure of protection to the 'by-stander.' At the moment acts of the media are like acts of God in that one can be hit by them, as it were, in almost any circumstances. It is difficult to see why this should be considered an essential prerequisite for the freedom of information.

4) *That the effect of media exposure of otherwise permissible actions be assessed.*
I have argued that social deviance is an essential element in the victim tradition. Such deviancy often crucially depends upon domain so that what is permissible in private becomes deviant, even illegal, in public. The effect of *publication* of permissible actions, where either because the actions are deviant of themselves or the fact of publication renders them deviant, ought to be considered.

Any or all of the above could be fatal to the victim tradition of documentary film making but I would see that as no loss. Indeed, for the concerns expressed here and for other reasons, I would much prefer a style of documentary along the lines of Rouch's "participatory cinema";

but the real question is not the effect such a proposal would have on documentary but rather, would it abolish essential media freedoms?

The concept of a duty of care in privacy is to be balanced against the established right of the public to know and the media to publish. These rights would be constrained, just as most other rights in other areas are. But not more so. Freedom of comment, the power to investigate the publically powerful, the right to the publication of facts would be unimpeded by the sort of development I propose. All that would go is the unfettered media right of exploitation of those in society least able to defend themselves. By defining what exploitation means, how and where it takes place, and who those defenseless people are, the constraint could be contained and the functions of the media otherwise maintained.

For many, especially in the United States, such proposals are anathema, yet the changing times demand some fresh response. It is not the case that as the thing works it should not be fixed. The thing in this case, privacy, works none too well and looks to be getting worse. The media need to establish a distance from the most vexed of the information technology areas where controversy is likely to result in serious curtailment of activity. The media need to re-establish their special position. That can only be achieved by the assumption of suitable late-twentieth-century responsibilities. Otherwise,

> [u]nlimited freedom for any instrumentality of society always threatens the stability of society, and society will react to protect its stability. Totally unfettered media could threaten and in the view of many already do threaten the stability of American life. Americans will react to re-establish and strengthen that stability. The lesson should not be lost on the press, radio and television. . . . The press is never really free unless it accepts a pattern which protects it from the perils of self-destruction.[47]

And this is not just true of America.

Notes

1. A. Rosenthal, *New Documentary in Action* (Los Angeles: Univ. of California Press, 1971), 71.

2. H. F. Hardy (ed.), *Grierson on Documentary* (London: Faber, 1979), 48, 188.

3. E. Sussex, *The Rise and Fall of British Documentary* (Los Angeles: Univ. of California Press, 1975), 21.

4. P. Rotha, *Documentary Diary* (New York: Hill & Wang, 1973), 1.

5. Sussex, *Rise and Fall*, 29.

6. Rotha, *Documentary Diary*, 49.

7. Sussex, *Rise and Fall*, 77.

8. Hardy (ed.), *Grierson on Documentary*, 29.

9. Ibid., 77.

10. Sussex, *Rise and Fall*, 76.

11. Hardy (ed.), *Grierson on Documentary*, 64.

12. Sussex, *Rise and Fall*, 18.

13. Ibid., 76.

14. Ibid., 79.

15. A. Calder-Marshall, *The Changing Scene* (London: Chapman and Hall, 1937).

16. "The G.P.O. Gets Sound" in *Cinema Quarterly*, London, 1934.

17. Sussex, *Rise and Fall*, 62.

18. In S. Mamber, *Cinéma Vérité in America* (Cambridge, Mass.: MIT Press, 1974), 118.

19. Rotha, *Documentary Diary*, 104.

20. (New York: International Publishers, 1974), 193–204.

21. Rosenthal, *New Documentary in Action*, 108.

22. Sussex, *Rise and Fall*, 89.

23. *Binns v. Vitagraph Co.*, 210 N.Y. 51 (1913).

24. (Seattle: Washington University Press, 1972).

25. *Corliss v. E. W. Waler and Co.* Fed. Rep. 280 (1894).

26. *Jones v. Herald Post Co.*, 230 Ky. 227 (1929).

27. *Meetze v. AP*, 95 S.E. 2nd 606 (1956).

28. *Sidis v. New Yorker* 133 Fed. 2nd 806 (1940).

29. *Kelly v. Post Publishing Co.*, 327 Mass. 275 (1951).

30. *Gill v. Hearst* 253 P. 2nd 441 (1953).

31. *Yoeckel v. Samonig* 272 Wis. 430 (1956).

32. *Jacova v. Southern Radio-TV Co.*, 83 So. 2nd 34 (1955).

33. *Sweenek v. Pathé News Inc.*, 16 F. Supp. 746 (1936) Judge Moscowitz at 747 et seq.

34. G. Synder, *The Right To Be Left Alone* (New York: Messner, 1976), 84.

35. Pember op. cit., 224 et seq.

36. *Durgom v CBS*, 214 NYS 2nd 1008 (1961).

37. Rosenthal, *New Documentary in Action*, 68 et seq.

38. Reprinted in A. Breckenridge, *The Right to Privacy* (Lincoln: Univ. of Nebraska Press, 1970), 132 et seq.

39. H. Street, *The Law of Torts* (London: Butterworth, 1959), 411.

40. W. Pratt, *Privacy in Britain* (Cranbury, N.J.: Assoc. Univ. Presses, 1979), 101ff.

41. Pember, *Privacy and the Press,* 112.

42. Synder, op. cit., 148 et seq.

43. Street, *The Law of Torts,* 103.

44. Ian Brownlie, *Basic Documents on Human Rights* (Oxford: Oxford Univ. Press, 1971), 109.

45. Ibid., 343.

46. In P. D. Reynolds, *Ethics and Social Science Research* (Englewood Cliffs, N.J.: Prentice-Hall, 1982), 143.

47. W. Marnall, *The Right to Know* (New York: Seabury Press), 212.

3

Direct Cinema and the Myth of Informed Consent: The Case of *Titicut Follies*

CAROLYN ANDERSON AND
THOMAS W. BENSON

As an amalgam of art, journalism, and social science, the direct cinema documentary can make strong claims to artistic license, First Amendment protection, and the autonomy of observational research, but it also shares the ethical dilemmas of these three fields.[1] Thus, recent discussions of the uses, and abuses, of human subjects in art, news, and scientific inquiry become germane when considering the ethical boundaries of documentary film. Even for the most scrupulous documentary film-maker and the most knowledgeable subject, the unstaged, relatively unobtrusive procedures of direct cinema filming and the generally inductive method of editing place unusual burdens on film-makers and subjects who subscribe to notions of informed consent. The practice of obtaining consent or release before, during, or immediately after the act of filming, however understandable in practical terms, raises questions of fairness that are compounded by the permanency of celluloid.

No contemporary American film-maker has created a body of work that better demonstrates the chameleon nature of direct cinema than Frederick Wiseman, whose remarkable series of films about American institutions[2] has influenced a generation of artists, journalists, and social scientists. Because Wiseman thoroughly rejects collaborationist cinema in favor of editorial autonomy, and because he consistently investigates communal environments, often tax-supported institutions, his

58

films are particularly forceful demonstrations of the potential and often actual conundrum of the conflicting rights of film-maker, subject, and audience. Because of its (ideally) voluntary nature, consent can re-shape the matrix of rights in documentary film.

Common criteria for informed consent—(1) conditions free of co-ercion and deception; (2) full knowledge of procedures and anticipated effects; (3) individual competence to consent—were all subject to spe-cial strain in Wiseman's first documentary, *Titicut Follies,* filmed in the hospital for the criminally insane at Massachusetts Correctional Institu-tion-Bridgewater.

Current consent regulations in government-sponsored research as-sume that subjects are asked to take risks in research that will not benefit them personally. But *Titicut Follies* does not exactly fit the assump-tions of consent for scientific research: (1) The incarcerated subjects could not provide "informed" consent in any usual sense of that word; (2) Wiseman could not, at the time of the requested consent, exactly describe the film that would emerge; (3) the effects of the film were likely to be both mixed and beyond Wiseman's and the subjects' predic-tion and control; (4) the film stood a good chance of improving condi-tions at Bridgewater, thus personally benefiting some of those who con-sented to be filmed. More than any other Wiseman film, *Titicut Follies* possesses characteristics of the exposé, which further confounds the con-sent issue.

Granted, *Titicut Follies* offers a situation of extremes in both subject vulnerability and directorial accountability; those very extremes create the parameters of common dilemmas (Anderson, 1984; Benson & An-derson, forthcoming). The current *sui generis* status of *Titicut Follies* as the only American film whose exhibition has court-approved restric-tions for reasons other than obscenity or national security reflects an atypical legal solution to the typical ethical problem of consent.[3] The legal struggle over *Titicut Follies* provides an opportunity to study not only the legalities, but the ethics of consent, since *Commonwealth v. Wiseman* made public consent practices that usually remain a matter of individual conscience.[4]

Across institutional settings, Wiseman's consent procedures have re-mained stable, with two crucial modifications, both of which provide Wiseman legal protection and were prompted by the litigation surround-ing *Titicut Follies.*[5] The two changes: After initial conversations with administrators, Wiseman summarizes his plans in a letter in which he mentions why he wants to make the film, the filming procedures, the types of events that might be filmed (indicating that these examples are

merely suggestive), and the duration of filming and editing. He explicitly states his claim of complete editorial control over the completed film. The persons (or person) in charge of this initial permission decision sign(s) Wiseman's letter, thus indicating consent to the filming agreements in this contract of sorts.

On the advice of his lawyers, Wiseman has not obtained written releases since *Titicut Follies*. Before or, more frequently, just after shooting a sequence, Wiseman audio-tapes his explanation that he is making a film for public television that will be widely seen by the general public and may be shown theatrically. He explains that he will not use all the film he shoots, and offers to answer any questions. If an individual consents, Wiseman asks for a full name, address, and phone number. Thus, he has a contemporaneous record of subject assent (Wiseman, as cited in Atkins, 1976; Halberstadt, 1974; Handelman, 1970; Graham, 1976; Levin, 1971; Westin, 1974; and telephone interview of Wiseman by Anderson, 14 November 1983).

A careful examination of the consent history of Wiseman's first film reveals the circumstances that led to the development of these procedural rules. Wiseman has often noted his recurrent thematic concern with "the gap between ideology and actual practice, between the rules and the way they are applied" (Westin, 1974:60). This essay concerns the ideals of informed consent and constitutional rights, the actual practices in the case of *Titicut Follies,* and the gaps between the ideal and the real.

Speaking before a university audience a decade after the 1967 release of *Titicut Follies,* Fred Wiseman quipped:

> Bridgewater, like any maximum security prison, is not the kind of place you parachute into and hide in the hills and make forays into the cell blocks when nobody's looking. It took a year for me to get permission to make *The Follies.*[6]

The film-maker's sarcasm anticipates and mocks any suggestion of clandestine film-making. His answer also reminds one that the *Titicut Follies* project began not with claims of journalistic rights, although such rights later become the film-maker's primary legal defense, but with what Wiseman has called the "politics of asking." Whether one sees the litigious and often acrimonious history of *Titicut Follies* as a demonstration of an unfortunate, avoidable breakdown in communication, an exercise in cross purposes and sensibilities, or an example of personal betrayal, consent—as bureaucratic procedure, ethical imperative, and oral contract—is a key concept in the film's history.

Pre-production and Consent

The Consent of Superintendent Gaughan

Wiseman began his pursuit for permission to film a documentary at MCI-Bridgewater, a permission required by state law, by the most direct and standard of procedures: he personally contacted the superintendent. Identifying himself as a member of the instructional staff in sociology at Brandeis University, Wiseman telephoned Superintendent Charles Gaughan in the spring of 1965. Their conversation concerned Wiseman's work in the area of legal medicine. That May, Wiseman met with Gaughan to discuss a potential documentary film. In his capacity as a Boston University law instructor, Wiseman had first visited Bridgewater in 1959, shortly after Gaughan's appointment. The emotional impact of three seminar tours of Bridgewater encouraged Wiseman to move from law into film-making.

After graduating from Williams College and Yale Law School, Wiseman worked in the Massachusetts attorney general's office, as a court reporter while serving in the army, and in private practice in Paris. Returning to Boston in 1958, Wiseman held various positions related to law and social policy. He purchased the film rights to Warren Miller's novel *The Cool World* and produced an adaptation, directed by Shirley Clarke. Wiseman's experience with *The Cool World* (1964) convinced him that he wanted to direct and that "there was no mystery in the process" (cited in Robb, 1983:37). Perhaps only a beginning director would have attempted such a chancy project; perhaps only a person with such a range of professional experiences would have had the acumen to pull it off. Had Wiseman's credentials been reversed (considerable professional film experience; little knowledge of the field of legal medicine), Gaughan might have been less sympathetic to his proposal. Holding an undergraduate degree from Harvard and two graduate degrees, Charles Gaughan had worked as a social worker, a community organizer, and a state administrator. During his superintendency, he had been conducting an active and largely unsupported campaign to improve the antiquated, under-staffed facilities at Bridgewater.

A large, complex facility with 139 buildings spread over 1500 acres, MCI-Bridgewater was divided into four divisions with four distinct populations: a state hospital for the criminally insane; a prison department for alcoholics sentenced by the courts and voluntarily committed for drug addiction and inebriety; a facility for defective delinquents suffering from gross retardation; and a treatment center for the sexually dan-

gerous. Although only approximately 15 percent of the total population had ever been convicted of a crime—many men were sent there for a 20- to 30-day observation period—the institution was, and continues to be, administered by the Department of Correction, rather than the Department of Mental Health. These two state units often participate in a precarious alliance at Bridgewater. Corrections officers are accustomed to taking medical instructions from doctors and security commands from supervisors.

In 1965 Bridgewater served as a threatened destination to patients or inmates in order "to allay difficulties in other mental health or correctional facilities."[7] At the time *Titicut Follies* was filmed, two psychiatrists and one "junior physician" cared for 700 men at the state hospital. Gross shortages existed in all personnel areas: security, medical, nursing, and social work. It was not uncommon during the early 1960s for a state official to visit MCI-Bridgewater, publicly express outrage at the miserable conditions, demand reform, promise support, and then go on to other projects.

Encouraged by Gaughan's expressed interest in a film project, Wiseman, accompanied by Boston journalist George Forsythe, returned to Bridgewater. There was talk of grant funding, a broadcast on National Educational Television (NET), use of the film by institutions and organizations, and the possibility of tracing an alcoholic inmate from the initial court disposition to confinement. Other sub-themes were discussed. At that time, both Wiseman and Gaughan assumed a causal relationship between heightened public awareness and improved conditions; both subscribed to the Griersonian notion that a documentary film could be a direct agent of change; both saw positive opportunities in the surface negativism of the documentary tradition of social indignation.

Seeing Wiseman's documentary proposal as an extension of his own courageous informational campaign, Gaughan became Wiseman's internal advocate. He introduced Wiseman to James Canavan, the public relations director for the Department of Correction, at a meeting where Canavan screened a documentary made at MCI-Walpole and Wiseman showed *The Cool World*. Gaughan later recalled describing the Walpole film as "didactic" and expressing the hope a Bridgewater film would "not follow that general outline" (Tr. 4:19). Wiseman's recollection of the screening sessions suggests a sensibility and an optimism rare in a prison administrator:

After viewing both films, Mr. Gaughan . . . said . . . he did not want a film like the one that had been made at Walpole because . . .

it was a phony film, that it only expressed one point of view, that it had no depth and that it didn't accurately portray, as far as he knew, the conditions at Walpole and . . . it was more a public relations job. He said the kind of film he wanted made at Bridgewater was a film that would be beautiful and poetic and true, and . . . that there was no film that I could make at Bridgewater that could hurt Bridgewater (Tr. 13:20).

The Consent of Commissioner Gavin

Wiseman had Gaughan's firm support by mid-summer, but that was not enough; the project required the approval of the department head. Therefore, Gaughan talked to his immediate supervisor, John A. Gavin, on Wiseman's behalf. Gavin's recent appointment as Commissioner of Correction by Governor John Volpe had followed the controversial dismissal of a well-respected, reform-minded penologist. After meeting with Gavin and two of his deputies, Wiseman sent a letter of request to film, accompanied by a five-page proposal. Dated August 19, 1965, and written under the letterhead "Wiseman Film Productions" (with Wiseman's home address in Cambridge), the letter announced that the proposed film "would be made for showing on NET," would also be available "for teaching and training purposes," and was under negotiation for NET or foundation funding (Exhibit 1). Wiseman wrote:

> No people will be photographed who do not have the competency to give a release. The question of competency would in all cases be determined by the Superintendent and his staff and we would completely defer to their judgment.

The letter included an offer of additional information beyond the enclosed proposal and closed with self-references of respect, gratitude, and hope. It was the letter of a courteous *petitioner*.

The attached proposal fluctuated between specificity and vagueness, between predictions of a rather routinely scripted documentary ("written by George Forsythe" and using the consulting services of Gaughan and three Brandeis sociology professors) and plans for an ambitious and determinedly innovative work. Counsel for the state would later seize upon details of the proposal as promises unkept.

Judge Harry Kalus, in his summary of facts, included "pertinent excerpts":

> This will be a film about the Massachusetts Correctional Institution at Bridgewater. Bridgewater is a prison for (1) the criminally in-

sane, (2) defective delinquents, (3) alcoholics, (4) narcotics addicts, (5) sexual deviates, (6) juvenile offenders. The prison therefore has a cross-section of the problems confronting the state in dealing with a wide range of behavior of individuals whom the state must (1) Punish, (2) Rehabilitate, (3) Treat, (4) Segregate. The purpose of this film is to give people an understanding of these problems and the alternatives available to the state and its citizens.

The story of the film would be that of *three people*—an inmate most of whose adult life had been spent at Bridgewater; a youthful offender committed from the Roxbury District Court for a 35 day observation period (Judge McKenney, Chief Judge of the Roxbury, Massachusetts, District Court, has granted us permission to photograph the sentencing); and a Correctional Officer intimately concerned with the day to day functioning of the institution. In showing the day to day activities of these *three people* it will be possible to illustrate the various services performed—custodial, punitive, rehabilitiative and medical as well as the conflicting and complementary points of view of prisoner, patient, guard, family, legislature, etc.

This will be a film about a prison and the people who are in it and those that administer it, as well as their families, friends, and the institutions, groups, agencies and forces within the community that either aid or hinder the custody, rehabilitation, punishment and return to community life of those who have been sentenced by the courts to prison.[8]

[Emphasis added by Kalus.]

The proposal also mentioned employing two staples of the traditional educational film (neither used): interviews and professional actors—"if it becomes apparent that a significant segment of the reality of prison life is impossible to obtain from a participant." Yet running throughout the outline was the promise (or threat) of a self-consciously poetic work that would tap the metaphoric potential of Bridgewater and attempt innovation in both content and form. Thus, two voices emerged: one a cautious traditionalist, the other a restless experimenter. Wiseman straightforwardly stated:

Bridgewater will be shown as an institution where conflicting and complementary forces within the larger community . . . meet. . . .

Implicit in all our experience is an awareness of how similar problems have been dealt with in other countries, therefore . . . the prison itself becomes a metaphor for some important aspects of American life. . . .

The technique of the film . . . will give an audience factual material about a state prison but will also give an imaginative and poetic quality that will set it apart from the cliché documentary about crime and mental illness. . . .

The bringing together of seemingly disparate material [audio and film footage from two different sources] will be used to provide a kind of condensation and counterpoint necessary to make the film dramatic . . .

Wiseman's summary of his intentions exhibited the complex, even contradictory, impulses that characterize the entire proposal:

Therefore, the content and structure of the film will [among other goals] dramatize the sometimes great, and often slight, differences that exist between those inside and outside of prisons and mental hospitals and to portray that we are all more simply human than otherwise . . . ; [and will] develop an awareness of . . . the dedicated and skillful work involved in the attempt to provide rehabilitation and dure [*sic*].

It was the proposal of an intelligent, imaginative, eager producer-director; it was a declaration of possibilities too numerous to find their way into a single film. Therefore, it is easy to imagine how a dedicated, optimistic administrator, weary of the didacticism of state-sponsored projects, might read his own dreams into this proposal *and* how anyone committed to the smooth running of a frequently criticized and routinely underfunded state department might see the documentary as one more risk easily avoided. Whatever their reasons, Gaughan continued to support the project, and Gavin, after first notifying Wiseman that he would "explore aspects of doing the film with his staff," wrote a letter of denial to film (Exhibit 3).

In his letter to Wiseman, Gavin stated he had made a careful judgment, after "considerable discussion with [his] staff and others regarding the total implications of such a film . . . and with full awareness of several complications which may arise." Although Gavin's reasons were vague, his answer was clearly no. Also clear was the commissioner's sense that the decision was his to make: "I am sorry to inform you that I cannot permit the filming of this story."

Although Gavin's letter emphasized his "careful review of [the Wiseman] proposal," at the subsequent legislative hearing regarding the film, he testified that there was no enclosure with the Wiseman letter of request (Tr. 3:78), which began, "I am enclosing a statement of the pro-

posed film on Bridgewater." At the trial, Gavin said that his earlier tes-
timony had been in error, he had received the proposal, but only "scanned
the memo of request" and referred the Wiseman correspondence to a
deputy commissioner (Tr. 3:82). It is possible that the initial denial de-
cision was not made by Gavin, but by a staff member. Saying no is a
routine duty for many assistants, and no documentary film had ever
been made at Bridgewater, so it was a request with no precedent of ap-
proval; however, the letter does bear Gavin's signature. Gaughan did
not receive a copy of the denial and later testified that he did not realize
that Gavin had reached a decision that summer (Tr. 4:147).

For a less determined film-maker, a denial from the commissioner's
office would have meant the end to the project, but Wiseman did not ac-
cept no as his answer. At Gaughan's suggestion, he made arrangements
to contact Lieutenant Governor Elliot Richardson.

In the 1964 campaign, John Volpe had promised Massachusetts
voters that if the Republican "team" were elected, Elliot Richardson,
as lieutenant governor, would have heavy responsibilities in the areas of
health, education, and welfare. Volpe did narrowly achieve the reelec-
tion he had been denied in 1962, and Richardson also was elected by a
slight margin. As lieutenant governor, Richardson visited Bridgewater
twice in 1965. Appalled by conditions at the prison hospital and the
lack of public interest in improving them, he pledged his support for
their reform. Widely regarded as a shrewd politician and a gentleman,
Richardson was an important bridge figure in Massachusetts politics in
the 1960s. A Brahmin by education, social background, and personal
style, Richardson nevertheless sided with the liberal Democrats on many
civil rights issues that were dividing the Commonwealth and the nation.

In the fall of 1965, Katherine Kane, a young liberal Democrat who
held a seat in the Massachusetts legislature from the influential Beacon
Hill (Boston) district and was a personal friend of both Richardson and
Wiseman, arranged for the two men to meet. Kane and her husband had
invested in *The Cool World* and strongly supported Wiseman's creative
aspirations and his expressed goals of institutional reform. Describing
Wiseman as an accomplished documentary film-maker, Representative
Kane asked Richardson to see Wiseman, which he did, in early October.
On meeting Wiseman and reading his written proposal, Richardson tele-
phoned Gavin, said he knew Wiseman personally, and asked the com-
missioner to reconsider his earlier decision. Several months later, Kane
telephoned Gavin to indicate her support of the Wiseman project. Later,
under oath, both Gavin and Richardson strongly denied that any politi-
cal pressure had been exerted on Gavin. Gavin did reconsider his deci-

sion. In late January, the commissioner met with Wiseman and Gaughan and gave his verbal go-ahead, pending advice from the state attorney general. There is no written record of this meeting; participants disagree regarding crucial facts. According to Gavin, Wiseman agreed that any release of the film would be contingent on the final approval of the Correction Department (Tr. 3:19). Wiseman has denied such contingencies, claiming that the only conditions agreed upon were that the crew would be accompanied by a Bridgewater staff member at all times during filming; that only competent inmates and patients be photographed, with said competency determined by the prison staff; and that several individuals (notably Albert De Salvo, the self-claimed Boston Strangler) not be photographed (Tr. 14:63). There was no written contract.

Within the week, Gavin wrote Attorney General Edward Brooke for a legal opinion. The letter was written under the MCI-Bridgewater/Gaughan letterhead and co-signed by Superintendent Gaughan. Earlier Gavin had given no indication that it was not in his power to say no to Wiseman, but he later doubted his right to say yes. Gavin signaled his awareness of potential legal complexities when he wrote Brooke:

> I have told [Wiseman] that I would give him permission to make the film. Provided, however, that the rights of the inmates and patients at Bridgewater are fully protected. . . .
>
> I would very much appreciate your views on the question of whether or not I can give permission to do this. (Exhibit 4)

Brooke's advisory opinion, dated March 12, 1966, quoted a Massachusetts General Law that designated the superintendent as the party responsible for prisoners. Brooke cited legal decisions that supported both the jailer's duty to exclude intruders and his large discretionary powers. The attorney general's final comment: "I conclude that the Superintendent may, if he deems it advisable, permit Mr. Wiseman to make his film at the Institution" (Exhibit 5). Brooke thus informed Gavin that it was not his decision, but Gaughan's. Again, oddly, copies were not noted. Gavin immediately sent a copy of the Brooke letter and a covering letter to Gaughan, which indicated that Gavin still perceived himself as a vital link in the Commonwealth's decision chain: "On the basis of the attached, you have my permission to proceed to make appropriate arrangements with Mr. Wiseman and get started with the usual precautions" (Exhibit 5A). Here Gavin qualified his responsibility by noting that his approval was based on Brooke's opin-

ion and contingent on Gaughan's following "the usual precautions" (Tr. 2:12). These precautions, left unspecific then, became rigorous indeed in Gavin's later testimony:

> The usual precautions are that no faces are shown in any of our institutions in filming, that no man's picture is shown under any conditions unless he signs a legal release, that he has to be competent to sign such a release and that the filming of such inside an institution would be supervised.[9]

A week later Wiseman went to Gaughan's office, where he obtained the (oral) consent that was now Gaughan's to give. It had taken a year to get, but Fred Wiseman finally had his permission to make a documentary film at MCI-Bridgewater. Gaughan later claimed he explained the conditions of Brooke's advisory opinion, gave him a copy, and the lawyer–film-maker said, in substance, "I can live with that" (Tr. 4:163–4). Gaughan has insisted that these conditions included a final right of approval by the state; Wiseman has been equally insistent in denying any censorship agreement. Such conditions are *not* stipulated in the advisory opinion. The opinion *does* quote Gavin's assumption that Wiseman would be responsible for obtaining releases from all photographed persons. Wiseman never made objection to that expectation in the meeting with Gaughan or in writing later. Charley and Fred, as they now addressed each other, seem to have assumed an equal familiarity with and acceptance of each other's intentions regarding the Bridgewater film. It was an assumption that would prove unfounded.

The same day that Brooke and Gavin had issued their approval—March 21, 1966—NET wrote Wiseman to offer advice and the possibility of broadcasting a completed film, but denied funding. Wiseman's request for foundation support was also rejected so he turned to the most common financing method known to the independent film-maker: a combination of personal investment by crew and friends and lab credit. By this time, George Forsythe had been more or less replaced by David Eames, another journalist and a Cambridge neighbor of Wiseman's. The two men had met earlier in the year, and Wiseman had interested Eames, then a free-lance journalist with some peripheral movie experience, in the Bridgewater project. Since there was neither scripted dialogue nor narration in the film, Eames's contribution as a writer per se was limited to composing letters to potential investors. Eames claimed, "We told investors that there was little likelihood of it being

a commercial success" (Tr. 7:34), yet they also indicated their hope that initial investments would be returned.

Although not officially incorporated until the following November, the Bridgewater Film Company (BFC) was formed to handle all business transactions connected with the film project. A letter to a potential—and subsequent—investor assured him that "All proceeds from the sale of stock are to be used to the sole purpose of producing, distributing, and otherwise turning to account the documentary tentatively entitled Bridgewater" (Exhibit 20). Five personal friends of the director—Carl Binger, Henry Kloss, Stephen Paine, Douglas Schwalbe, and Warren Bennis—invested a total of $10,000. Wiseman, Eames, and the third member of the crew, John Marshall, each contributed to the financing of the film and received no compensation for labor. Marshall had a 16mm camera and a Nagra recorder; Wiseman, taking sound for the first time, used borrowed and rented equipment; Eames assisted by changing magazines and tapes, keeping records, and providing a VW van.

Of the three-person crew, cinematographer and co-director Marshall was the most technically experienced film-maker and even his experience was limited. He had worked as a cameraman for NBC in Cyprus, but was best known and respected for his ethnographic film *The Hunters* (1958), part of a family research project on the San (Bushmen), begun in 1951 when Marshall was still a high school student. In 1966 Marshall was a Harvard graduate student in anthropology.

When questioned about his motives in making *Titicut Follies,* David Eames testified that he wanted

> to gain a great deal of experience in film-making, particularly in the documentary field. Another motive was by making the film, to try to let the public at large understand some of the conditions and problems and situations at Bridgewater which we had observed while filming there (Tr. 7:146).

When Wiseman and Eames were formally presented to the Bridgewater staff in early April, it was not as men looking for some documentary film training. Their stated goal was to "educate" the public about the institution. The superintendent asked the staff to cooperate fully with the film crew and, according to the testimony of Gaughan and correction officers, assured them that the state had been guaranteed final approval rights (Tr. 4:40, 180). Wiseman has contested both

the guarantee and its announcement at the meeting. After being introduced by Gaughan, Wiseman screened *The Cool World*, answered
questions, described the non-interventionist methods of film-making
that would be employed and the technical innovations that made them
possible, thanked the staff in advance for their cooperation, and told
them that he hoped the group assembled in the prison auditorium
would be among the first to see the completed Bridgewater film. No
instructions were given about the determination of competency or the
procedure for obtaining releases. It was made clear that anyone who
objected would not be filmed, yet it was also made clear that the superintendent wanted all personnel to support the film project.

Production and Consent

The Consent of the Inmates, Patients, and Staff

In April the crew began filming at a rehearsal of "The Titicut Follies," an annual inmate-patient-staff variety show. ("Titicut" is the
Indian name for the area in which the institution is located.) The
superintendent had been eager to have scenes from "The Follies" included in the film; he was especially pleased that approval had come
in time for the spring event to be filmed, since he felt it would provide
some lightness. Before any footage was shot, Wiseman and Eames told
the performers that the film crew would try not to interfere with any
activity. They explained the technical procedures of the filming and
said that anyone who did not want to be photographed should so indicate. It was an introduction that the crew would repeat frequently.

Portions of each of the four performances of "The Titicut Follies"
were filmed. During some performances, a friend of John Marshall's
and a fellow anthropologist, Timothy Asch, operated a second camera.
Edward Pacheco, a senior corrections guard who was the producer, director, and a featured performer in "The Follies," expressed an interest
in being assigned as the correction officer who would routinely accompany the film-makers. Wiseman spoke to the superintendent on Pacheco's behalf:

> I thought Mr. Pacheco would be an important person in the film be
> cause I felt that he had a great deal of charm and personality and was
> photogenic and I very much admired his manner with the inmates
> because he seemed to treat them so cordially, so affably, and so in
> dividually (Tr. 13:67).

Pacheco received the guide assignment and became so devoted to it that he sometimes accompanied the film crew on his days off. Soon on a first-name basis with the film-makers, Pacheco became another internal advocate for Wiseman.

The three film-makers were issued passes to the institution signed by the superintendent. Their presence became routine, expected. With the exception of several minor restrictions, Gaughan permitted the crew to film anyone, anywhere in the institution. This freedom was curtailed when Dr. Harry Kozol, the director of the Treatment Center for the Sexually Dangerous, made strong objections in writing to any filming there without compliance with explicit written conditions (Tr. 9:157). Neither Gaughan nor Wiseman challenged Kozol's right to make these restrictions; no footage was shot at the Center. (In the completed film, several patients from the Center appeared in a chorus number in "The Follies," which did not go unnoticed or uncriticized by Kozol.) Kozol's demands that filming privileges be subject to explicit, written conditions contrasted sharply with the implicit, oral nature of many other supposed agreements between the Bridgewater administration and the crew.

Known as "the movie men," "the boys from Channel 2" (the Boston NET channel), "the candid camera crew," "the TV guys" (Tr. 5:114, 13:121), Wiseman, Marshall, and Eames found the correction officers, inmates, and patients generaly cooperative and extremely curious about the process of movie-making. No hidden cameras or microphones were ever used, but the use of (relatively new) high-speed film (which enabled shooting in entirely natural light) and telephoto lenses made it possible for the film-makers, at times, to go unnoticed without being surreptitious. The directional microphone that Wiseman operated could, on occasion, pick up sounds the ear could not.[10] Yet most of the time it was perfectly clear what Marshall was filming and Wiseman was recording. Rarely did anyone object. The people of Bridgewater permitted the film-makers to record their lives. Soon after their arrival, the crew began to receive suggestions from guards of situations or persons that would be "interesting" to include in the Bridgewater movie. Following such leads, the crew photographed a skin search on Ward H, a high-school tour of the institution, a physician interviewing a recent arrival, the same physician force feeding an inmate, a man who sang standing on his head, a burial.

There were rare objections to filming raised by staff members on behalf of inmates or patients. Father Mulligan's request that an inmate's confession not be recorded was followed (Tr. 13:108); Officer

Moran's objection to the photographing of his interview of a boy under age was honored (Tr. 6:79). Officer Lepine later claimed he objected to the filming of nude men and was supposedly told that they would be shown only from the waist up—Wiseman denied the promise (Tr. 5:116–7) and Marshall said it was misunderstood.[11] In each of these cases, prison personnel acted in their role of *parens partiae,* making consent decisions for the confined men.

In all of the consent negotiations, staff consent was assumed. Correction officers had been told by their superiors to cooperate with the photographers. One staff member, preparing a corpse for burial, objected to being filmed. Wiseman later claimed the man's reluctance was because he was an unlicensed mortician and feared the disapproval of local undertakers (Tr. 13:108). Wiseman claimed that no inmate ever *said* he did not want to be photographed, and any inmate who expressed an unwillingness to be photographed by a gesture such as "waving away the camera, putting a hand over the face, turning around, turning a coat collar up" was not photographed (Tr. 13:132).

Marshall has described his camera work at Bridgewater, not as an activity "directed" by Wiseman, but as an emotional, personal contact the cinematographer had with the people photographed. He has claimed he was always sensitive to the desires of his potential subjects, yet also remembers that once he began shooting, it would have taken "a hand in front of the lens" to stop him.[12]

Yet the competency of these men to consent remained highly problematic. *No* objections to filming were made based on determinations of incompetence by the professional staff or by the correction officers who accompanied the film-makers, which leads one to speculate that the guards had never been given the charge of determining competency, which Wiseman said he assumed. It was, not incidentally, a charge for which prison guards were unqualified.

It is not difficult to believe Gaughan's later claim that he assumed the guards were with the film-makers for security purposes only, although Gaughan was never able to clarify exactly when or by whom competency was to have been determined in his scheme of things. Nor is it difficult to believe Wiseman's later claim that he was willing to invest considerable amounts of his time, money, and energy only because he assumed that anything the crew was allowed to shoot and record could be used in the Bridgewater film. In at least one instance— a filmed incident in which guards taunted a distraught man—Wiseman claimed he asked the accompanying correction officers if it would be all right to film and he was told that it was. (This man later became

a named plaintiff, with Gaughan as his guardian, in the Commonwealth's suit against Wiseman.)

Added to the vagueness of the consent procedures during filming were the related, and equally vague, conditions involving releases. There was never any written agreement specifically determining who would be expected to sign a release, to whom the releases would run, what form they would take, or who would expedite this process. A release is a precautionary measure; it is a protection from liability and, therefore, assumes a position potentially antagonistic to that of the releasor. Although the state's later position would be that its officers had assumed that releases running to the Commonwealth had been obtained, at no time during their period at Bridgewater did the film crew receive a release form, directions for formulating one, or inquiries about such collection. When filmed, neither Commissioner Gavin nor Superintendent Gaughan asked to sign a release or questioned why releases were not being presented for signatures. Gaughan later testified that he did not know what a release was when the matter was first discussed in January 1966.

In the spring of 1966, Wiseman, a member of the Massachusetts bar, drafted the following:

> That in consideration of the sum of $1, lawful money of these United States, to me in hand paid by the Bridgewater Film Company, with offices at 1694 Massachusetts Avenue, Cambridge, Massachusetts, and for other good and valuable considerations [*sic*], receipt of which is hereby acknowledged, I hereby grant to the aforesaid, the Bridgewater Film Company, its successors and assigns, the right to use my name and likeness and to portray, impersonate or simulate me and to make use of any episode of my life, factually or fictionally, in a motion picture tentatively entitled Bridgewater. This grant shall extend to remakes and reissues of the aforesaid picture, to television rights and to all phases of the exploitation of the aforesaid picture, including publicity, advertising, promotion and the like. (Exhibit 19)

A form similar to the one Wiseman used during the filming of *The Cool World,* this release provided wide artistic latitude for the filmmaker and legal protection for BFC investors. Eames and Wiseman obtained signed releases from 106 individuals, most of them staff members (Tr. 7:127). No one was ever paid the $1 release consideration (Tr. 7:38).

Despite a film-maker's intentions, the procedures of direct cinema filming, whereby a small crew becomes as inconspicuous as possible,

make release operations difficult. At the trial David Eames answered
a question about 'missing' releases:

> . . . at the time of filming these individuals there was either too
> much commotion or confusion or too much activity involved in the
> filming to make it appropriate or, indeed, possible at that time to
> approach them (Tr. 6:144).

The direct cinema adage of "shoot and record now—decide later"
worked against a systematic cataloging of persons photographed and
releases obtained; however, there were "scenes" that Wiseman felt fairly
sure would be in the final edit, even as filming ended in late June.
Eames volunteered to return to Bridgewater to obtain a release from
an individual who had previously refused to sign one, but had been the
focus of several provocative filmed incidents. Eames and Wiseman
agreed that Eames would get a release from anyone else that he hap-
pened to see that he "recalled not having gotten a release from during
the filming" (Tr. 5:173). During that haphazardly organized trip,
Eames obtained three or four releases from patients at the Treatment
Center for the Sexually Dangerous who had been filmed during a
performance of "The Follies."

Eames did not get a signed release from the inmate identified as
#54 in the trial proceedings, but referred to by name in the film—
Vladimir. This young inmate took advantage of the filming to state
his case, frequently saying, "I want to say this to the cameras" (Tr.
13:116). In at least three situations, two of which were included in
Titicut Follies, Vladimir was filmed complaining to the staff about
his treatment. Yet, when first asked to sign a release, he told Eames
"he would sign it on the condition that [the film-maker] arrange to get
him out of Bridgewater and not until then" (Tr. 6:179). Eames re-
called that, in August, Vladimir "said he would not sign a release
until I showed portions of the film to members of the federal govern-
ment and until I arranged to have him deported out of America and
back to another country" (Tr. 5:174). Vladimir's demands, despite,
and even because of, their outrageousness, showed a rare lucidity.
This subject realized his reproduction on celluloid was something val-
uable to a film-maker; it was a commodity to be negotiated. He did
not sign a release; yet his frustrated attempts to be transferred from
Bridgewater became a central part of *Titicut Follies.*[13] Vladimir's par-
ticular story is a capsule version of the complexity of the consent di-
lemma.

Throughout the spring and summer of 1966 Wiseman and Mar-

shall had been receiving dailies from their New York developer, Du-Art Film Lab, Inc. Neither Gaughan nor Gavin ever asked to see any of the rushes and the film-makers did not volunteer to show any footage to them. So unfamiliar was Gaughan with the process of film-making that he later claimed he assumed no film was developed until the filming was entirely completed. Whether because he trusted the film-makers' judgment and good will or believed in the state's right of final censorship, the superintendent did not interfere in any way with the filming itself. Although Gaughan testified that he reminded Wiseman of his agreements with the state, the film-makers' freedom while shooting is apparent from the footage they took with them when they left MCI-Bridgewater.

Post-production and Consent

As Selig has noted, Grierson did not define documentary in his often quoted phrase, "the creative treatment of actuality," he merely announced its paradox (1983:10). During the year Wiseman spent editing 80,000 feet of film into an 87-minute feature he might have been ethically bound by a sense of fairness, or artistically bound by his own expertise and imagination, or technically bound by footage shot with a single camera of unstaged action, but he considered himself free to treat the material "creatively." Keenly aware of his shaping function, Wiseman dismisses claims of "film truth" by documentarians as presumptuous at best and describes his films as "reality fictions" or "reality dreams," thus calling attention to their paradoxical nature. Working through what might be called an aesthetic of uncertainty, Wiseman characterizes his film-making as "a voyage of discovery" (Graham 1976:34). A combination of the dogged attention to detail central to the discovery stage in preparing a legal case and the almost mystical belief, most strongly espoused by Flaherty (Calder-Marshall, 1970), that one can approach a subject with no "preconceptions," discovery to Wiseman is a *personal* matter of developing an attitude toward his material and expressing that attitude in his structuring of the film. To Wiseman the process of editing/film-*making* is an entirely individual enterprise:

> I don't believe in this whole business of testing out a film with an audience, or asking somebody else what they think or even showing it to a small group and asking for their reactions. It's not that I'm not interested in their reactions, but after you've worked on a film for a

year and have made the selections that you have made, you are the one who knows what works and what doesn't work better than anybody else. [Halberstadt 1974:22]

Alyne Model was hired as an associate editor (the only salaried staff member), but she was essentially a cutter, making splices at Wiseman's direction. Marshall claims he played an active part early in the editing process, but Wiseman later "threw [him] out of the editing room" much to the cinematographer/co-director's disappointment.[14]

Once Wiseman left Bridgewater, he operated as an *independent* film-maker who had the right to make artistic and business decisions regarding his created product. The producer's letters to a dozen international film festival committees indicate Wiseman's perception of himself as a free agent. Writing to the Fifth Moscow International Film Festival, Wiseman said that he "had complete independence" and "no interference" while making the film at Bridgewater, which he described as "about various forms of madness" (Exhibit 44).

Abandoning the traditional narrative devices of story and character development and also the continuity of explanatory narration, Wiseman organized the Bridgewater material at a level of abstraction that was innovative in 1967 and remains rare. The method places extreme demands on the material, the editor, and the potential audience. On the levels of both form and content, Wiseman subverted traditional expectations. In trial testimony, various witnesses described footage shot at Bridgewater and not used that provided material for a completely different style of documentary. In contrast to fulfilling Wiseman's desire to put the audience in the midst of Bridgewater, this unused material might have distanced a potential viewer. The first category consisted of several types of essentially expository footage: an interview of Gaughan by Wiseman (off camera) about the institution's programs and goals; a speech by Gavin at the officers' training school; a guided tour conducted by Eddie Pacheco for students from Whitman-Hanson High School in which he explained funding problems; various scenes in which one received a general sense of context. Thus, Wiseman had the material to make his film "educational" in a more standard form had he so chosen *or* more bitterly ironic and personally damaging to Gavin and Gaughan by juxtaposing theory and practice in the most heavy-handed style of the exposé film.

The director-editor also had the footage to create a self-reflexive documentary, a type of film which by 1967 was becoming common among avant-garde film-makers. With footage of Vladimir turning to

the camera and saying that he wanted to use the film to get out of Bridgewater and of a guard repeatedly looking into the camera and saying, "We have failed, but it's not us in here who have failed, it is you out there," Wiseman could have made a camera-as-catalyst movie. There are several instances in the final film when there is an acknowledgment of the camera's presence (for example, the old man who sings "Chinatown" seems to be performing for the film crew), but the general style of *Titicut Follies* is observational and non-interventionist.

A third type of unused material could fit either of the styles mentioned. When Dr. Ross made his rounds, accompanied by the film crew, *without direction* he would address the camera to make a brief statement concerning each patient's condition. Because this footage conveys information in the authoritative manner of the expert, it could have been used in the traditional documentary format. The material would also have fit, but less easily so, in a film self-consciously examining documentary conventions and how people imitate media roles when filmed.

Some of these out-takes indicated that the Bridgewater staff did little to protect the privacy of the inmates and patients (for example, the high school excursion photographed included a tour of the wards, with students observing, among others, the man [nude in his cell which included a nameplate on the door] who later became a named plaintiff in the state's invasion of privacy suit against the film-makers). Had Wiseman chosen to construct his film in either 'direct address' style, subject consent might have appeared less problematic. Just because a person acknowledges the camera's presence does not guarantee that consent is fully informed, but there is an appearance of complicity that can assuage audience fears that social actors are unwilling or unknowing subjects. The essential characteristics of observational cinema will always make it vulnerable to charges of voyeurism and duplicity. In the first published review of *Titicut Follies* (Knight, 1967), the critic, shocked by the frankness of the film reported (erroneously) that hidden cameras had been used.

How Gaughan and Richardson reacted to the finished film is disputed. Wiseman claims they both reacted positively and he was given the impression that he need show the film to no one else; Gaughan and Richardson have testified that legal and ethical questions were raised when they first saw the film in June.

A letter of complaint based on Knight's review (published in anticipation of the New York Film Festival) was Gavin's first indication that the film had been completed and would be screened publicly. In a September 21, 1967, meeting, Richardson, now Massachusetts attor-

ney general, raised questions of privacy invasion and told Wiseman he was turning him down. Gavin saw the film that night and subsequently notified Wiseman by letter that "he did not have approval to show this film to anyone" (Tr. 3:57). The language used by Gavin and Richardson indicated they assumed they held veto rights regarding exhibition. Wiseman assumed some rights, too. The Commonwealth of Massachusetts needed more than letters of disapproval to keep Fred Wiseman from showing *Titicut Follies.* That demanded the support of the courts.

Consent as Contract

Titicut Follies' unique legal status has earned the film its national reputation as *cause célèbre* to both defenders and detractors. When treated as contract, consent (either express or implied) becomes an issue of law, in addition to being an ethical issue. In his capacity as attorney general, Richardson filed suits in Massachusetts, New York, and federal courts to block the exhibition of *Titicut Follies.* During the film's legal history at least one court has reached each of the three possible decisions regarding its showing—unrestricted exhibition, complete prohibition, and limited exhibition.

Both federal and supreme court judges in New York ruled for unrestricted showing of *Titicut Follies,* citing the First Amendment, even though the New York Civil Rights Law authorizes an action for damages and injunctive relief where a person's name, portrait, or picture is used for advertising or for purposes of trade without the person's consent. This privacy statute may not be applied in a matter of public interest, a characterization which the New York courts held for *Titicut Follies.*[15]

Suffolk Superior Court Judge Harry Kalus ruled to ban the film permanently in Massachusetts. He found that Wiseman had breached an oral contract (regarding the state's editorial control) and that the privacy of an inmate had been invaded,[16] although there was neither a statutory nor a common law right of privacy in Massachusetts at the time. Kalus was the first Commonwealth judge to base a decision on this right.[17]

On appeal, the Massachusetts Supreme Judicial Court (SJC) reversed the Superior Court decree of January 1968 and modified its provisions in 1971 so that *Titicut Follies* could be shown in Massachusetts to special audiences.[18] Although the SJC regarded the film as a "collective, indecent intrusion into the private aspects of the lives of

these unfortunate persons in the Commonwealth's custody,"[19] it acknowledged the value of the film as a social document (which Kalus had ruled was irrelevant) and allowed that "the film may indirectly have been of some benefit to some inmates by leading to improvement of Bridgewater."[20] Writing for the court, Justice Cutter explained the unanimous decision to permit showing to specialized audiences as an attempt to balance conflicting public and private interests, probable good and possible harm.

The fact—if indeed it is a fact—that state politicians raised the privacy issue as a defense to cover their embarrassment over mismanagement of a state institution and their handling of the filming does not negate the validity of the privacy argument. In an embrace of the fundamental right of free speech many strong advocates of the First Amendment have devalued or ignored the right of privacy. No group better reflects the ethical, legal, and political confusion engendered by the *Titicut Follies* case than the Civil Liberties Union of Massachusetts (CLUM), which first refused to take a position on the film, then supported a compromise similar to the SJC position, and later, in 1974, advocated action to remove exhibition restrictions.[21] According to John Roberts, executive director of CLUM, the major reason for the shift was that the privacy issue has waned with age.[22] Since almost two decades have passed since *Titicut Follies* was filmed, even Elliot Richardson now sees no reason why exhibition should be restricted.[23] Yet the passage of years also means that individuals identifiable in the film who claim they did not knowingly, freely, and voluntarily consent to be photographed have since been released from MCI-Bridgewater may object to the public showing of the film in Massachusetts (Anderson, 1981:21).

O'Brien, writing after the passage of the Federal Privacy Act of 1974, quite correctly sees privacy as "a political ideal and a practical problem" (1979:ix), yet there is little agreement as to a constitutional right of privacy. Pritchett mentions two landmarks in the legal conceptualization of privacy:

[I]n 1890 an influential *Harvard Law Review* article by Samuel Warren and Louis D. Brandeis freed the privacy concept from its propertied and criminal procedure history and defined it as a broader "right to be let alone." Not until 75 years later did the Supreme Court translate this right into constitutional terms. Then, in *Griswold v. Connecticut* (1965), Justice Douglas, in a classic exercise of judicial activism, found a right to privacy in the "penumbras" of the First, Third, Fourth, Fifth, and Ninth Amendments, while two of his

colleagues located it more simply in the due process clause of the Fourteenth Amendment.[24]

Privacy interests have often been collapsed with those against libel and slander, but as privacy legislation increases on the federal and state level and as access to the means of documentary production accelerates, it is probable that documentary film-makers will be confronted with privacy as a practical problem in the form of litigation for the invasion of privacy.

In 1974 the Commonwealth of Massachusetts added a "right of privacy" to its General Laws. The comment, written in 1973, states:

> While the common law action for invasion of privacy has received wide national judicial recognition, no recovery of damages has been had in Massachusetts based upon this tort. See however *Commonwealth v. Wiseman*, 356 Mass. 251, 249 N.E. 2d 610 (1969), enjoining the showing of the film "Titicut Follies" to general audiences in Massachusetts.[25]

Commonwealth v. Wiseman is often included in mass communication case law books as an example of the defense of consent. Gillmor and Barron speculate, "Valid releases from all who were photographed might have made a difference" (1974:306). There was no written release from the named plaintiff; the Commonwealth argued that he was incompetent to give informed consent. Although *Commonwealth of Massachusetts v. Wiseman* was supposedly not an obscenity case, part of the invasion of privacy allegation rested on the fact an inmate was shown nude in the film. In his decision, Judge Kalus called the film "a nightmare of ghoulish obscenity."[26]

Wiseman has filed two appeals for a review by the United States Supreme Court. In both petitions *Wiseman v. Massachusetts* was just one short of the needed four favorable votes, in the second case despite withdrawal from voting by a justice (William O. Douglas) who had voted for consideration previously.[27] In July of 1987 Wiseman returned to the Suffolk Superior Court, filing a motion to permit showing of *Titicut Follies* to general audiences. Wiseman's attorney, Blair Perry, argued that the motion should be allowed because (1) the applicable law had changed (regarding prior restraint) and (2) the facts had changed (few of the inmates shown in the film and identifiable are still living; attitudes of society toward public disclosure of conditions in an institution such as Bridgewater have changed; officials of the Commonwealth who sought to suppress the film are no longer in office; the original re-

lease of the film was credited with resulting in significant improvements in Bridgewater).[28]

The Commonwealth responded that it supports the showing of *Titicut Follies* to the general public "as long as a procedure is first imposed and followed to its conclusion to locate the inmates and patients depicted in the film, notify them of the pending motion and provide representation, as needed and separate from the Commonwealth to protect their privacy rights."[29] According to the state, consent by subject or their guardians should be a prerequisite of public release. As of September 1987, discussion on the motion continued before Judge Andrew Meyer.

Dilemmas of Consent

Dilemmas of negotiation immediately confront a film-maker who proposes people to consent to participate in a film, to sponsor its production, to work on its crew, to support it financially without using guile, misrepresentation, or coercion when risk is not only possible, but probable. The dilemma of consent is partly practical (how to get it), but essentially ethical (how to get it fairly and then not abuse it). Without the participation of social actors, the documentary form known as direct or observational cinema could not exist. Without the *informed* consent of the subjects, the form lacks ethical integrity; without freedom for the film-maker, it lacks artistic integrity. The dilemmas of documentary construction are both procedural and artistic. The mix of the two creates its own dilemma: Wiseman could not have made any documentary film about Bridgewater without the active participation of others; he could not have made *Titicut Follies* without independence. Thus, Wiseman relied upon cooperation while filming, autonomy while editing and thereafter. He expected the impossible.

In turn, subjects and audiences often expect the impossible from his work. A predictable consequence of Wiseman's influence on artists, journalists, and social scientists has been that they hold him accountable to the most rigorous standards of each field. Not only are some expectations among the three fields contradictory (poetic imagination, objectivity, predictive power), but expectations within fields change with the times (and the individual). Notions of consent have become increasingly sophisticated and expectations of disclosure have increased; the rights of prisoners and mental patients are now acknowledged by the courts and the general public (Lidz et al., 1984). These new ethical

demands reshape evaluations of procedures used in making *Titicut Follies*. Some activists who advocate subject-generated documentary now see the individualistic Wiseman, not as a subversive freedom fighter against the state, but as a middle-aged, middle-class authoritarian who demands artistic freedom to create bourgeois art (Waugh, 1988).

Reviewing the consent history of *Titicut Follies* is a way to see not just its dilemmas, but the dilemmas that shape the documentary enterprise. To film a Bridgewater documentary, Wiseman had to get the permission of others before he could approach the individuals who would be social actors on screen to obtain their consent. Even in this most bureaucratic of settings, the supposed state rule for institutional consent procedures (head of institution–department head–governor's office) was not followed. Governor John Volpe's office was unaware of the project's existence. This violation of protocol made the film susceptible to criticism.

Another chain of consent particular to this case, but quite possibly common in its variance from the orthodoxy of official procedures, was substituted. Lieutenant Governor Elliot Richardson's and Representative Katherine Kane's intercessions changed the permission structure, yet the alternative chain retained hierarchical features. Bridgewater was not a closed system, an important consideration when identifying the subject of the film and reactions to it. Wiseman later disclaimed any political motivations in making the documentary, yet he was willing to use the influence of friends who held elective office in order to gain permission to film. It is arguable whether a film about a publicly supported institution can ever be apolitical, whatever its maker's stated or unstated intentions. Thus, both in the narrow sense of partisan politics and in the larger sense of political philosophy, those who had assisted Wiseman were identified with and held accountable for the final product.

Exactly what final terms were being consented *to* by both the state and the film-maker were vague. It is difficult to imagine a film-maker with the fierce independence Wiseman later displayed ever consenting to state censorship as an initial and continuing condition of filming. It is also difficult to imagine a state official like Commissioner John Gavin not expecting final state control. It is equally surprising that a sophisticated politician and experienced lawyer like Attorney General Edward Brooke would not anticipate Superintendent Charles Gaughan's position as a man caught in the middle and, therefore, suggest the legal protection of a written contract. Certainly Wiseman, himself an attorney, understood the legal importance of a written contract, but its absence also had advantages for him. Nowhere in writing was there any claim

by Wiseman of the rights of the press or the public's right to know; nowhere in writing was there any claim by the state of its right of censorship. In their delay in clearly asserting what were later claimed as rights, both Wiseman and the Commonwealth positioned themselves for an inevitable confrontation.

The consent pattern had both vertical and horizontal dimensions. Every link in the consent chain was a potential breaking point, but also a point of obligation. Individuals could say no—as the film-makers claimed—but they were expected to say yes. Often the individuals filmed said *nothing;* silence was considered consent.

Staff members had been directed by their superiors to cooperate with the filming; inmates and patients were even more vulnerable to the direction of others. Although privacy and consent are usually discussed as individual matters, they have social as well as personal dimensions. Thorne reminds us: "Informed consent applies to individuals, each of whom is to be treated the same, and ignores social structure and deep-seated differences of power" (1980:293). The ethical question of whether different standards of protection should exist for different populations arises in response to a practical recognition of degrees of power. Pryluck insists that 'utter helplessness demands utter protection' (1976:28). Yet for some subjects, innocence about potential consequences seems irresponsible.

Many social activists advocate protection in inverse relationship to power; many documentary film projects work the other way around (Levin, 1971; Rosenthal, 1980). Galliher thinks that some of the controls on research to protect human subjects "limit both research and consequent criticism of officials" (1978:251). He argues against the protection of superordinate subjects when "studying up" and cites Wiseman's "muck-raking" films as successful attempts at learning about the powerful (1980). Wiseman, an accomplished practitioner of the 'politics of asking,' does not see protection, selective or otherwise, as his obligation or his privilege. Just the reverse, he puts the burden and—in Wiseman's view of the world, an equally important word—the *choice* of protection or disclosure on his subjects and their guardians.

Since some of the subjects to be photographed were wards of the state in a prison mental hospital, both freedom to consent and mental competence, on which legal competence rests, became highly problematic. The procedures for determining competence were never clearly defined or employed during the filming period. Later, Wiseman's defense took the position that the film-makers assumed all subjects were competent unless specifically informed otherwise.

The procedure of consent before, during, or immediately after the act of filming creates a situation of trust in the film-maker's judgment, rather than a situation of truly informed consent. Subjects who say yes to the film in a camera sometimes say no to the film on screen. Ideally, consent is processural, not contractual (Wax, 1980:282). But the process of making meaning of filmic images continues into the viewing situation and beyond. It is a never-ending process; neither subjects nor film-maker can ever fully anticipate audience response (Heider, 1976: 120–1), nor can subjects anticipate their own reactions to the responses of others (Cooley, 1978:169–70). Even Pryluck, an outspoken critic of many direct cinema procedures, admits that "obviously a film-maker's commitment to a subject cannot be open-ended" (1976:28). As Pryluck himself is aware, his suggestion of collaborative editing diffuses, rather than solves, the ethical dilemma of informed consent.

The case of *Titicut Follies* provides an extreme example of a pattern evident in reactions to all Wiseman films: The complaints about violation of subjects' privacy and abuse of consent were not registered by the subjects themselves, but by their actual or self-appointed protectors. Because of the nature of privacy violation, silence from a photographed subject does not necessarily mean there was no violation of consent. Wiseman's relentless "tactlessness" helps him disclose the gap between rhetoric and practice, but it also pulls his film toward the realm of voyeurism (Nichols, 1978:16). However, there is a crucial difference between tactlessness and deception. Audience members shocked by Wiseman's subversion of conventional taste sometimes assume Wiseman has deceived his subjects.

There are ways of constructing documentaries that incorporate the consent of crew members, subjects, sponsors, and financial backers into the editing process for reasons that range from democratic idealism to artistic indecision. Fred Wiseman did not work that way with *Titicut Follies,* nor has he with any later film. He thoroughly rejects collaborationist cinema when he edits/constructs his 'reality fictions.' Looking back over Wiseman's career, editorial autonomy is but part of a pattern of independence that has remained consistent and is, consequently, now predictable. In retrospect, it seems obvious that Wiseman finished making *Titicut Follies* when *he* finished editing, but in the summer of 1967, Wiseman was probably perceived as a mild-mannered academic who would cooperate with the state in order to create an earnest problem picture. Quite possibly Gaughan thought he saw a work-in-progress in June and found himself caught in the dilemma of how to modify, yet support, what was obviously going to be a controversial film.

Wiseman has claimed that Richardson clearly understood that the construction process was over in June when he congratulated the filmmaker and assured him that no further consent would be necessary. Richardson has disclaimed that pledge of support, insisting that the Commonwealth considered itself a co-producer and withheld its consent because it had serious reservations about the ethics and legality of the BFC consent procedures and needed to solve the dilemma of state responsibility to its charges and its general population. It is possible that the ambivalence of state officials regarding editorial control that summer was not an indication of support, but a sign that they were trying to discover state liability for the project and trying to figure out strategies of disengagement. Richardson possibly responded one way to the film as an individual and quite another way in his capacity as attorney general.

Commissioner Gavin and Superintendent Gaughan were appointed administrators with legal responsibilities, but with little understanding of the legalities of their charge and even less understanding of the processes and possibilities of film-making. By late September, they both saw their personal reputations and their careers endangered by the release of *Titicut Follies*. Gaughan, the interlocutor between Wiseman and Gavin from the outset, had to abandon divided loyalties and choose sides when an adversary situation developed. His allegiance went to the state. It is impossible to know if editorial collaboration would have made any difference in his alliances; one assumes it would have made a considerable difference in the film itself. *Titicut Follies* was not the documentary Gaughan had fought to make. Wiseman admired Gaughan and claimed he did not want to do anything that would harm the superintendent, but when forced to a choice, his first loyalty was to his own work.

Projects begin in a mood of cooperation that sometimes diminishes as choices are made and disappointments accumulate. The Bridgewater film project began without easy cooperation, without full disclosure of goals and consequences, among individuals and institutions that held different, even contradictory, values and sensibilities. Some of the problems *Titicut Follies* faced, and faces, were particular to the film itself, but many were related to the general social and political climate of the times and to the even more general tensions at the heart of all realist art. The litigation concerning the documentary has allowed us to overhear a debate among participants about expectations, intentions, procedures, and outcomes that probably goes on privately, but no less acrimoniously, in many documentary projects; it has forced the courts to

consider a cluster of relationships among film-makers, subjects, and audiences.

The decision of the Supreme Judicial Court of Massachusetts has made the film available to the groups most familiar with the situation presented and, in that sense, least in need of education. The elitism of the decision shows a low opinion of public interest and makes it clear that the court considers professionals citizens of special privilege and influence. Still, the controversy surrounding the film brought its existence to the attention of many and gave a special forum to a national public discussion of the rights of the mentally ill. *Titicut Follies* has provoked a national debate regarding the competing rights of free speech, privacy, and access to information.[30]

The history of *Titicut Follies* reveals a substantial gap between the ideal of informed consent and the practice of direct cinema. This is not to say that the gap cannot be narrowed from the chasm of *Titicut Follies*. Nor is it to suggest that no good ever comes from that breach. Would the general good have been better served had *Titicut Follies* not been made? We think not. *Titicut Follies* demonstrates the ethical paradox: good films are sometimes created from bad rules.

Notes

1. Many have criticized these facile distinctions. See Becker (1981), pp. 9–11, for an argument regarding the complementary qualities of art and social science.

2. Between 1967 and 1988 Wiseman has produced, directed, and edited twenty-one documentaries: *Titicut Follies, High School, Law and Order, Hospital, Basic Training, Essene, Juvenile Court, Welfare, Primate, Meat, Canal Zone, Sinai Field Mission, Manoeuvre, Model, The Store, Racetrack, Deaf, Blind, Multi-Handicapped, Work and Adjustment,* and *Missile.* The present chapter is adapted from Thomas W. Benson and Carolyn Anderson, *Reality Fictions* (Carbondale: Southern Illinois University Press, forthcoming).

3. A 1971 decree of the Massachusetts Supreme Judicial Court limits exhibition of *Titicut Follies* in the Commonwealth to audience members seeing the film in the capacity of legislator, judge, lawyer, sociologist, social worker, doctor, psychologist, a student in one of these or related fields, or a part of an organization dealing with the social problems of custodial care and mental infirmity.

4. *Commonwealth of Massachusetts v. Frederick Wiseman and Bridge-*

water Film Company, Inc., Suffolk Superior Court, Boston, 20 Nov. to 13 Dec. 1967. No. 87538 Equity. References to this trial transcript will be by volume and page number only (for example, Tr. 1:1).

5. Because of the ages and limited capacities of some of the subjects in the four-film "Deaf and Blind" series, these procedures were altered to include pre-production parental consent. (Interview by authors with series cinematographer John Davey, 14 Oct. 1986, London.)

6. "Frederick Wiseman on the Films of Frederick Wiseman," sponsored by the Student Cultural Events Organization, University of Massachusetts-Boston, 6 April 1977.

7. Charles Gaughan, History of MCI-Bridgewater, p. 3, enclosure in correspondence with Carolyn Anderson, 9 May 1977.

8. "Findings, Rulings, and Order from Decree," 4 Jan. 1968, pp. 2–3.

9. Gavin, "Hearings on the Bridgewater Film Before the Special Commission on Mental Health," Boston, 17 Oct.–9 Nov. 1967, p. 28.

10. During the *Commonwealth v. Wiseman* trial the Commonwealth tried to demonstrate that subjects were sometimes unaware of the recording of picture or sound. George Caner, questioning David Eames about the capabilities of a directional mike, asked, "And thus, to the extent that when it is directed at an object it screens out sounds coming from elsewhere, to that extent, it is able to pick up meaningful sounds that your ear might not be able to pick out?" Eames replied, "That is correct" (Tr 7:55). In a memorandum to the authors Wiseman said it was inaccurate to assume that "the mike could pick up sounds the ear could not. I think it is difficult not to notice a camera, tape recorder, mike, a bag with film and magazines and 3 strangers" (4 Aug. 1987).

11. Interview by Carolyn Anderson with John Marshall, 13 April 1984, Cambridge, Mass.

12. Marshall 1984 interview. See Henderson (1983), who, following Goffman, provides a thoughtful analysis of the strategies and justifications used by still photographers. Wiseman and Marshall have differing current memories about Marshall's independence while shooting. In various published interviews Wiseman has claimed he directs the shooting on all his films. He noted to us that "Marshall stated in [his] deposition that he did all camera work under my direction" (4 Aug. 1987 memorandum). The Marshall deposition is not included in the public file of *Commonwealth v. Wiseman*.

13. According to Wiseman, "During the trial a letter was received from Vladimir giving his consent" (4 Aug. 1987 memorandum to authors).

14. Marshall repeated this account of his role in the editing process in an interview with the authors, 27 Dec. 1986, Peterborough, N.H. According to Wiseman, "Marshall and Eames did not see the film (apart from rushes) until I screened a rough cut for them. Marshall played no part in the editing and does not have co-editor's credit. I gave Marshall co-director's credit in

appreciation for his working without pay and providing equipment free" (4 Aug. 1987 memorandum to authors).

15. In three separate decisions, New York Supreme Court Justices Murphy and Street and Federal Judge Mansfield refused to block the public showing of *Titicut Follies*. In the New York courts, Wiseman was represented by celebrated First Amendment attorney Ephraim London. See *Cullen v. Grove Press,* 385 U.S. 374, 87 S.Ct. 534, 17 L.Ed. 2nd 456 (1967), in which Bridgewater guards petitioned, unsuccessfully, for injunctive relief and damages.

16. The allegation of invasion of privacy was filed by the state in the name of one inmate who is shown nude with his genitals exposed and is provoked by guards into revealing personal information about himself. Gaughan became this man's legal guardian shortly before the trial began.

17. For a legal discussion of the case consult David L. Bennett and Philip Small, "Case Comments," *Suffolk University Law Review,* 4 (1960), 197–206; "Comment: the 'Titicut Follies' Case: Limiting the Public Interest Privilege," *Columbia Law Review,* 70 (1970), 359–71; "Recent Cases," *Harvard Law Review,* 83 (1970), 1722–31; and P. Allan Dionisopoulos and Craig R. Ducat, *The Right to Privacy: Essays and Cases* (St. Paul: West, 1976), 106–7, 224–27. Miller applauds the Massachusetts Supreme Court's balancing approach "since it enabled the court to protect privacy to a considerable degree while preserving the free flow of information thought necessary to protect the public interest" (1971:208).

18. *Commonwealth v. Wiseman,* 249 N.E. 2d 610, 356 Mass. 251.

19. 249 N.E. 2d at 615, 356 Mass. at 258.

20. 249 N.E. 2d at 619, 356 Mass. at 264.

21. Wiseman, however, has described CLUM's "compromise" as a position against the film (Westin, 1974:67). See Ellen Feingold's letter to the editor in response to Wiseman's comments about CLUM, *Civil Liberties Review* (Spring 1975:150).

22. Roberts, telephone interview with Carolyn Anderson, 3 June 1977. Attached to Wiseman's personal affidavit on behalf of his motion to remove the ban from exhibiting *Titicut Follies* to the general public was a letter of support sent to Wiseman from Harvey A. Silvergate, president of the CLUM Board of Directors. See entry 2512, 20 July 1987, No 87538 Equity, Suffolk Superior Court.

While Wiseman's July 1987 motion was under consideration, CLUM was a plaintiff in court action against the Commonwealth.

On 14 Sept. 1987 Suffolk Superior Court Judge James P. Lynch, Jr., ordered changes in procedures used for isolating violent and suicidal patients at Bridgewater State Hospital in response to the CLUM suit, one of a series of Bridgewater maltreatment suits filed by CLUM since the late sixties.

23. Richardson, in response to a series of questions asked by Carolyn

Anderson during Richardson's U.S. Senate campaign appearance at the University of Massachusetts-Amherst, 27 April 1984.

24. C. Herman Pritchett, foreword to O'Brien (1979), p. vii.

25. *Massachusetts General Laws Annotated,* 34, Cumulative Annual Pocket Part 1977, p. 67.

26. See Glasser and Jassem (1980) for a discussion of audience rights of privacy and Glasser (1982) for comments on privacy and pornography.

27. 398 U.S. 960 (1970) (*cert.* denied), 400 U.S. 954 (rehearing denied) (1970).

28. "Brief for the Respondent Wiseman in Support of Motion to Amend Final Decree After Rescript," 23 July 1987, entry 2511, No. 87538 Equity.

29. "Response of Commonwealth of Massachusetts to Motion to Amend Final Decree After Rescript," 12 Aug. 1987, entry 2522A, p. 1, No. 87538 Equity.

30. A recent example of this debate took place on the 25 Aug. 1987 *Nightline* (ABC-TV), which was devoted to a discussion of exhibition of *Titicut Follies* and the conditions at Bridgewater State Hospital.

References

Anderson, C. 1981. "The Conundrum of Competing Rights in *Titicut Follies," Journal of the University Film Association* 33(1):15–22.

——— 1984. Documentary Dilemmas: An Analytic History of Frederick Wiseman's *Titicut Follies.* Dissertation, University of Massachusetts.

Atkins, T. R. 1976. *Frederick Wiseman.* New York: Monarch Press.

Becker, H. S. 1981. *Exploding Society Photographically.* Evanston: Northwestern University Press.

Benson, T. W. (with Anderson, C.) Forthcoming. *Reality Fictions: The Films of Frederick Wiseman.* Carbondale: Southern Illinois University Press.

Calder-Marshall, A. 1970. *The Innocent Eye: The Life of Robert J. Flaherty.* Baltimore: Penguin Books.

Cooley, C. H. 1978. "Looking-Glass Self in Symbolic Interaction" in *A Reader in Social Psychology,* 3rd ed. J. G. Manis and B. N. Meltzer, eds. Boston: Allyn and Bacon.

Galliher, J. 1978. "The Life and Death of Liberal Criminology." *Contemporary Crises* 2(3):245–63.

——— 1980. "Social Scientists' Ethical Responsibilities to Superordinates: Looking Up Meekly." *Social Problems* 27(3):298–308.

Gillmar, D. M. (with Barron, J. A.) 1974. *Mass Communication Law: Cases and Comment,* 2nd ed. St. Paul: West Publishing Co.

Glasser, T. L. (with H. Jassem) 1980. "Indecent Broadcasts and the Listener's Right of Privacy." *Journal of Broadcasting* 24(3):285–99.

Glasser, T. L. 1982. Press, Privacy, and Community Mores. Speech Communication Association Annual Meetings, Louisville.

Graham, J. 1976. "There Are No Simple Solutions." In Atkins, ed. 33–45.

Halberstadt, I. 1974. "An Interview with Fred Wiseman." *Filmmakers Newsletter* 7 (Feb.):19–25.

Handelman, J. 1970. An Interview with Frederick Wiseman. *Film Library Quarterly* 3(3):5–9.

Heider, K. G. 1976. *Ethnographic Film*. Austin: University of Texas Press.

Henderson, L. 1983. Photographing in Public Places. Master's Thesis, University of Pennsylvania.

Knight, A. 1967. "Cinéma Vérité and Film Truth." *Saturday Review,* 9 Sept. 1967:44.

Levin, R. 1971. *Documentary Explorations: 15 Interviews with Film-Makers*. Garden City: Doubleday.

Lidz, C. W., et al. 1984. *Informed Consent: A Study in Decisionmaking in Psychiatry*. New York: Guilford Press.

Miller, A. P. 1971. *The Assault on Privacy: Computers, Data Banks, and Dossiers*. Ann Arbor: University of Michigan Press.

Nichols, B. 1978. "Fred Wiseman's Documentaries: Theory and Structure." *Film Quarterly* 31(2):15–28.

O'Brien, D. M. 1979. *Privacy, Law, and Public Policy*. New York: Praeger.

Pryluck, C. 1976. "Ultimately We Are All Outsiders: The Ethics of Documentary Filmmaking. *Journal of the University Film Association* 28(1):21–29.

Robb, C. 1983. "Focus on Life." *Boston Globe Magazine*. 23 Jan.: 15–34.

Rosenthal, A. 1980. *The Documentary Conscience: A Casebook in Film Making*. Berkeley: University of California Press.

Selig, M. 1983. On Fact and Fiction: Deconstructing Documentary. Society for Cinema Studies Conference, Pittsburgh.

Thorne, B. 1980. " 'You Still Takin' Notes?' Fieldwork and Problems of Informed Consent." *Social Problems*. 27(3):284–97.

Waugh, T. 1988. Lesbian and Gay Documentary: Minority Self-Imaging, Oppositional Film Practice, and the Question of Image Ethics. This volume.

Wax, M. 1980. "Paradoxes of 'Consent' to the Practice of Fieldwork." *Social Problems*. 27(3):272–83.

Westin, A. 1974. " 'You Start Off with a Bromide': Wiseman on Film and Civil Liberties." *Civil Liberties Review* 1(2):52–67.

4

Access and Consent in Public Photography

LISA HENDERSON

Framed as an aspect of photographic practice, the issue of consent in public photography occurs at the juncture of at least two sets of contingencies; the first includes features of social interaction between photographers and their subjects, and the second, organizational constraints on doing photographic work—for example, those imposed by the division of labor in newspaper production. In the discussion of consent that follows I concentrate on the first, social interaction in photographic encounters, drawing from research on the strategies both amateur and professional photographers use to take pictures of people unknown to them in public places.[1]

The study was based on a conception of photographing as patterned social interaction among photographers, subjects and off-camera participants in particular settings, and of photographs as products of this interaction whose meaning depends in part on its assessment. Moreover, while all photographic behavior is conventional to some degree, in public encounters between photographers and subjects unknown to each other, picture-taking is adapted to the broader setting, in contrast to situations or events organized around photographic imperatives, among them studio portrait sessions and press conferences. This adaptive perspective implies the need to contextualize a description of photographic strategies in public places; such a description must account for those contextual features that constrain photographers' choices among possible strategic alternatives.

By "strategy" I mean the behavioral move or set of moves a photographer makes in order to get the picture he or she wants. "Strategy"

needn't imply premeditation or even consciousness of these analytically distinct moves at the moment they and the picture are made, though some photographers' descriptions of their activities do suggest degrees of premeditation, particularly where they or their pictures are threatened. Suffice to say that premeditation is a frequent though not required criterion of "strategy" as I use the term here.

As well, "context" is not defined by the setting alone but refers to a more general set of constraints upon what photographers do, including features of the subject and of the shifting relations between photographer, subject and setting. Context also embraces a photographers' notions of both the nature of photography and of his or her professional or avocational role, to the extent these notions may foster, inhibit, or justify particular interactional approaches. Finally, it includes formal and informal conceptions of privacy photographers hold.

Consent

In photographic interactions, what do subjects consent to? To have their pictures taken or to have them used in some way? While photographic encounters imply both issues, consent strategies are framed in terms of what photographers do to sustain access (and in some cases co-operation) long enough to get the pictures they want, in other words, consent to take. In this attempt, some explanation of how the image will be used is occasionally though not necessarily offered as part of a photographer's strategic repertoire. While photographers recognize that a subject's uncertainty about the use of a picture is often the source of interactional tension, they are for the most part sufficiently confident about the harmlessness of their photographing (to subjects) or its importance (to themselves, or to "public information") and sufficiently interested in carrying on doing it that consent is not so much to be reckoned with among subjects as dispensed with. The rule of thumb is to offer up only as detailed an explanation of one's conduct as might be required to sustain access, in some cases for moments, in others for months. There is an effective distinction between consent to take and consent to use, and the second issue, consent to use, is typically not part of the strategy during the encounter.

If consent to take pictures is therefore a matter of access, how do photographers get access and how do they keep it? At the most general level, they do so by maintaining what Erving Goffman has called "normal appearances."

In *Relations in Public* (1971), Goffman outlines eight "territories of the self" to which we stake claims in our social lives. These territories include: personal space; stalls, fixed and portable, such as theatre seats and beach mats; use space, respected because of apparent instrumental need; turns, that is, the order in which goods of some kind are received; sheath of skin and clothing; possessional territory ("personal effects"); information preserve, "that set of facts about himself to which an individual expects to control access while in the presence of others"; and conversation preserve, controlling when and by whom the individual can be summoned into talk (pp. 40–41). Here I am concerned with a subset of "information preserve," in particular those facts about an individual that can be directly perceived, his body sheath and his current behavior. As Goffman points out, the cultural issue is the individual's right not to be stared at or examined, and between strangers in public places, a glance, a look, or a penetration of the eyes may constitute a violation of this territory, or, in more familiar terms, an invasion of privacy.

As practitioners (and sometimes perpetrators) of a technical form of looking, photographers are aware of the threats to privacy they sometimes pose when they work in public places. In some cases, a camera may reduce the threat of the stare by identifying its proprietor as a photographer, with a mission to look and a right to be there in the first place—for example, as a tourist or a representative of the media (cf. Becker, 1974:18). In others, enough people may be photographing to render the act unremarkable. In still other cases, the camera is the very source of suspicion. In any event, and in the interests of a particular type of photograph, photographers attempt to maintain "normal appearances."

In Goffman's terms, "normal appearances mean that it is safe and sound to continue with the activity at hand with only peripheral attention given to checking up on the stability of the environment" (1971:239). Importantly, such appearances may be real or contrived, reflecting either a stable situation or a predator's successful attempt to conceal from his prey his threatening intentions. Only rarely, however, does such an extreme model represent the circumstance between photographers and their subjects. Typically, the photographer is aware of the minor threat he may pose or the curiosity he may arouse, and will address himself in advance to the task of learning what is unexceptional for the setting, then engage in photography in whatever form or with whatever approach will fit. Maintaining normal appearances is a behavioral fact attended to by people in their everyday lives quite apart

from activities as specific as photographing; to varying degrees we monitor ourselves and others all the time with or without a camera present. But where the ante is raised by photography is in the camera's capacity not to only observe but record a person's behavior (to whatever manipulated degree, be it slight or extreme, intended or naive). Recording devices effectively undermine the everyday assumption that "there is only a hearsay link between what happens inside the frame and allegations made about this outside the frame" (Goffman, 1971: 286).

The maintenance of normal appearances needn't imply the photographer's concealment of himself or his camera, though in some cases this is an option and a preference. Rather, it means he will be present but of no concern. Thus a photographer's verbal or non-verbal declaration of his presence and his intention to photograph also fit within the normal appearances rubric to the extent that he is recognized as doing what is conventional for photographers to do. We therefore have a stylistic continuum in the maintenance of normal appearances that extends between concealment and declaration, with a popular midpoint of non-concealment, where photographers neither hide nor deliberately inform potential subjects of ther imminent subjectivity; they are simply there.

Access and Practice in Public Places:
Settings, Subjects, and Strategies

The utility of the concept of normal appearances lies in its descriptive breadth and its sensitivity to context. "Normal appearances" does not denote a specific set of moves or behaviors, but a quality of the environment sustained by a variety of behaviors depending on the type of setting and the type of interaction. What follows then is a description of those features of settings and subjects that make a difference to how photographers take pictures in public places.

Settings

Setting features relevant to photographic strategies include (1) familiarity; (2) whether the setting constitutes the "front" or "back" region of a larger area or establishment; (3) the frequency of photographic activity within the setting; and (4) the general spirit or purpose of the primary events taking place.

By "familiarity" is meant the photographer's familiarity with a specific setting, a setting category, or both (e.g. Washington Square Park in particular or parks in general). The greater a photographer's familiarity the easier it is to maintain normal appearances. He or she is better acquainted with what subjects consider ordinary and thus better able to adjust his or her conduct. However, familiarity also goes beyond the specific instance and the category to include sub-cultural knowledge about the setting and its participants that can't be known from the setting alone. Thus some photographers work amid groups in which they are or used to be members, tailoring their interactive style in light of what they know to be threatening or appealing to current participants.

The distinction between "front" and "back" regions derives from a theatrical metaphor Goffman uses to assign role, function, and stage places to social actors in day-to-day life.

> Performers appear in the front regions and back regions; the audience appears only in the front region, and the outsiders are excluded from both regions (1959:145).

For photographic strategies, the front/back distinction implies the variety of access routes photographers take into settings which, while public to a degree, demand special status from their members. Some examples are film production units on location in public and semi-public places and repair sites in subway tunnels. Both locales are back regions in settings made up of front and back, where photographers have attempted short-term status changes from audience to performer. Again, the goal is to maintain normal appearances, and in back regions this is managed in part by acquiring or pretending to appropriate status or by affiliation with a legitimate performer. For example, a photojournalist working on a feature story about the Philadelphia subway system was accompanied by a police officer, allowing her protection and entree to areas usually reserved for technicians and other officials. In another instance, a photographer's equipment choice reflects his interest in being identified as a denizen of the back stage:

> [On the sets] I used a 35mm, because it was one that I'd always used and I felt the most comfortable with it. It also was the one that the still photographer who was hired as part of the production crew used, so I seemed to be just part of the production crew in a way, or at least I felt more comfortable.

In front regions, special status is not required for access once admission to the "audience" is secure, though special claims for the photographer's role are sometimes made to mediate between other features of the situation and picture-taking.

Photographers describe an ease in photographing among other photographers whose cameras are aimed at the same principal subjects. The group's activity absorbs or neutralizes the behavior of any one member; observation and photography are expected components of the situation. Settings that include a number of photographers can therefore be thought of on a continuum of access between those in which photographing is clearly an invasion requiring maximum negotiation and those designed and conducted to accommodate photographers—for example, press conferences. However, such a neutralizing effect varies depending on the nature and function of the setting or event, be it festive or serious. In either case, the meaning of the camera in the setting changes, and with it the role identification of the photographer to other participants. At a festive event the photographer may be a reporter or specially equipped and appreciative spectator. In many instances she is an otherwise undifferentiated member of the crowd, depending on her participation in a variety of activities within the setting. At a political demonstration on the other hand, a new role for photographers is introduced, that of surveillance agent. For example:

> . . . photographing at the cruise-missile conversion project, people always ask me what I'm doing . . . One time at a demonstration there was a man who was convinced without having spoken to me that I was a detective, and that I was doing some sort of surveillance or something. He was very snarky. He said something like "did you get that one? did you get the shot that time? Do they pay you by the shot or by the hour? Who pays for your film?" and those kinds of questions . . . he was convinced that I was working for some group that was trying to infiltrate or survey that group, and I just didn't say anything.

This sense of surveillance persists where photography poses the threat of personal identification or where people are generally concerned about security if not their personal identity. Conduct ordinarily considered unremarkable is contextually redefined. Threats to security are thus among the features that define a setting for a photographer. Where the possibility of posing such a threat is known, a photographer with normal appearances at heart can try to balance the situation

through a variety of verbal or non-verbal means, generally declaring her intentions and not making any moves she feels would substantiate her subject's fear. In situations where the threat can't be anticipated, where she fails to anticipate it, or where it's ignored, a photographer may discover herself embroiled in that rare instance of non-compliance and be forced to restore the equilibrium or leave. If the picture is worth it, she may persist, depending on her sense of the likely consequences. A scolding is tolerable, being shot at isn't, though the forms of non-compliance are routinely more subtle than such consequences suggest.

Subjects

No group of people is categorically off-limits or of no interest to photographers. Still, a shifting set of characteristics among subjects invite photographers to take pictures in some instances, intimidate them in others, and modify their practice in most. The most salient among these characteristics are age, race, sex, apparent social class, situational mobility, engagement in instrumental activities, solitude or group membership, and role relation to the setting (e.g. as visitor, employee, passerby, performer, or victim).

A frequently photographed subject group (especially for amateurs) is made up of front-stage participants in a variety of formal and informal outdoor performances. Street musicians, parade marchers, craftspeople demonstrating their work, dancers, acrobats, and drill team members are familiar examples. Taking pictures of peformers, photographers are usually among other spectators, making their presence and attention unexceptional and in many cases a welcome and flattering sign of appreciation. But even without a stationary audience—for example, in the case of the street musician who plays for money from passers-by—a person's engagement in focused activity often relieves a photographer of special negotiation. Characterized both by display and engagement, such performances occupy the high end of an access continuum which diminishes as a subject's activity becomes less focused or more personal. This isn't to say that people who fall at the other end aren't photographed, but rather that different consequences are anticipated or different strategies employed, for example, using a telephoto lens. However, such an approach also depends on whether the subject is alone or with a group.

The photographers I interviewed describe photographing people in public places as a form of "singling out" that sometimes requires an explanation or justification, especially when it is clear to an individual

that he or she is being isolated by the lens and when it's not apparent that he or she has special status in the setting (for example, as performer). But this too varies depending on the nature of the location. At well-populated festivities, few restrictions are felt to exist even when singling out individuals. If the territory is uncrowded and the activity more private, care is required to avoid alarming subjects.

The situation is tempered further if the person is mobile, either walking, running, or riding a bicycle. Under these circumstances photographers anticipate that people are less likely to notice them, less likely to be sure they were the ones being photographed, and less likely to interrupt their course in any event.

Demographically, normal appearances (and thus access) are sustained most smoothly when photographers work among people whose status or characteristics they share, particularly in settings that are racially, economically, or generationally segregated. (Photographing children is an exception. Children are thought to be less self-conscious about their appearance and less likely to anticipate the "possible horrors" of photographs as they might appear in publication.) Though occupants of segregated areas can move amongst each other in integrated locations, a strong sense of tolerance or intolerance upon entry into segregated territory is apparent to the newcomer whose race or economic status is different from the established community's. This is particularly true when he or she arrives as a mechanically equipped observer, prepared to leave with recorded images that probably don't reflect the community's sense of itself and which, most likely, its members will never see. Moreover, such features of a setting not only modify how photographers approach its residents, they often prevent photographers (particularly amateurs) from even considering that setting in the first place, depending on what and how much they know or believe about the place through experience or hearsay.

Strategies

The emphasis given to long-term projects by the photographers I interviewed sets up an initial point of access I call the entry point. Where entry to a setting is controlled (for example, by invitation, membership, or price of admission), a photographer has to get in before access to individuals becomes an issue.

In some cases entry is made through a sympathetic contact who provides a photographer with both passage and a personal introduction

to individuals or subgroups. Entry is also made through official permission from an organizer or organizing body, allowing a photographer initial access and legitimate status thereafter. Finally, a photographer may be recruited to photograph particular aspects of an event and then extend his activity beyond his assignment.

Getting in is often a matter of fitting in where access to a setting is not restricted but where the population is well-defined. Appearing to belong, in terms of such immediately visible characteristics as age, sex, and dress can be enough to enter.

In situations that require entry moves, making them relieves photographers of a lot of subsequent negotiation. Once a photographer's position is established, individuals assume he's entitled to be there and he probably won't have to explain himself from subject to subject. This is not to say that having gained entry, photographers disregard the type and form of activity among their subjects—they don't, and here we shift from getting access to keeping it.

Fitting in is used to stay in a situation as well as to enter it, requiring a photographer's attention to how she looks and how she acts. This is particularly true among groups marked by conformity in appearance and conduct, be they businessmen at lunch meetings or teenagers at parties.

Particularly in small spaces a photographer's work is almost never concealed, but rather moves between non-concealment and declaration while remaining unobtrusive. His presence is known and acknowledged, though he rarely asks subjects to do anything for the camera. If and how people pose reflects their own preference, though is usually a conventional response to a photographer's declared intention to photograph (e.g. grouping for portraits or smiling).

Some photographers act like regular participants, working their way into subgroups within the setting as they might without a camera, treating it merely as an accessory. The following comment comes from an art photographer working on a project about upper-class teenagers in bars.

> I bought a Leica winder for my camera which advances the film, but it doesn't have the attachment for a flash bracket to fit onto the bottom, so if you use a flash, you have to hold it in your left hand, and hold the camera with the winder attachment in your right hand. I immediately realized the futility of a system like that for what I'm doing, because I want to be able to photograph with one hand, since I socialize with them all the time, my way of getting closer. So I have

to hold a beer. Or a cigarette. My way to get close to them is I go up and say hey, can I have a cigarette? Okay. I smoke the cigarette and take their picture.

In still other instances, photographers render their activity as un-alarming as possible by remaining within a conventional role, in turn exploiting the authority that role is typically accorded. Several non-photojournalists, professionals and amateurs among them, describe a photojournalist's deliberateness as a good way to appear to belong when you don't engage as a regular participant in the ongoing activity. Journalists are said to look almost blasé about their work. They photograph constantly, then break, never appearing undecided about what their next picture will be. When they're not working, they put their camera bags down and relax rather than glancing furtively from one person to the next. When something interesting occurs, they recognize it and take the picture, lending a purposive air to their activity rather than wandering aimlessly. To dramatize work or the idea of "serious business" by taking on a journalistic style is useful only where a journalist's presence is unremarkable in the first place. Still, photographers cultivate those features of a journalistic approach that work in their favor without necessarily hoping to be identified as photojournalists.

Finally, photographers who wish to return to a setting over a period of time are careful to stop photographing from visit to visit when it becomes apparent they are no longer welcome. They notice individuals breaking away from small groups as they approach, or waning enthusiasm among people once eager to have their picture taken. To continue despite these signs can cost photographers co-operation or even admission next time around, therefore they rarely persist.

In open settings, where no specific entry move is in order and where access need be sustained momentarily, a different set of strategies comes into play. Here photographers stress the need to be fast and ready to shoot. This means either knowing your equipment well enough to reflexively control focus and exposure, or using a preset camera. It also means swift framing, sometimes at the expense of preferred composition, and agile though not necessarily speedy movement among people. The goal is to attract as little notice as possible, and fast maneuvering through a slow-moving crowd can provoke unwanted attention. Where the stakes are high and the risks great, photographers keep moving, exposing just a frame or two in any one spot. In this way they're able to minimize the duration of each encounter and thus the

duration of their focused attention on potentially hostile subjects. However, most photographers also want to avoid appearing sneaky or suspicious. They carry cameras where they can be seen or use wide lenses that often require them to be close to their subjects. They effectively engage in what Goffman has called the "overdetermination of normalcy" (1971:256), declaring their intentions to a degree that won't be interpreted as covert or suspect.

In open situations, photographers rarely offer subjects prior explanation of their activity unless they want them to adjust what they're doing in some way, unless they anticipate difficulty, or unless they need information, such as the subject's name for a newspaper caption. In these cases, photographers simply ask people if they mind having their picture taken, or they offer a brief explanation of why someone was selected in the first place. But even here, guided by the premises of photographic naturalism, photographers usually wait until after they've exposed the negative to explain themselves or ask permission, not necessarily telling their subjects that pictures have already been taken. The technique is to "get in a few frames" before disturbing the event by asking questions. However, if things are happening quickly or an emergency is under way, photographers shoot first and ask questions later. Appearances are already not normal and expectations rearranged about what is ordinary conduct. The event is news and doesn't require delicate negotiation.

In the absence of constraints such as newspaper identification, photographers explain their activity only when subjects ask, though they may seek consent informally, in some cases a swift "take your picture?" followed by an equally swift positioning of the camera and release of the shutter. More often, photographers let subjects see the camera at some point then wait for a sign of their approval. This may be a nod or smile; or it is simply inferred from the absence of overt disapproval.

Finally, those photographers who conceal their activity are usually after a particular kind of picture though are sometimes concerned for their safety. Only in extreme circumstances do they try to hide their activity altogether, using very small cameras or very long lenses, or shooting from the hip. Rather, they simply avoid making it clear who is being photographed. Those members of a group who care to notice may realize an active photographer is present, without knowing that they are his subjects at any given moment. A common approach here is to point the lens away from the subject, pretending to photograph something or someone else until people no longer attend to the camera

directed toward them. At that moment, the photographer can shift aim and expose.

Resistance. When photographers encounter resistance (any move on the subject's part that makes a photographer think she has to do more than just take the picture) they consider whether the photograph is worth it before persevering with unwilling or threatening subjects. If it is, they can take it and leave or stay and face the consequences. On the other hand, they may attempt to neutralize resistance so that no consequences remain to be faced. In the latter two circumstances, photographers undertake "remedial work" (Goffman, 1971:108–9) in order to allay any fear, anger, or annoyance their subjects might experience. Simple requests for permission to photograph (tacit and explicit, verbal and non-verbal) are the common form of remedial work, and with the exception of the news photographer who shoots first and asks later, are usually made before the picture is taken. However, more labor-intensive forms are sometimes necessary. Again, the issue is access; photographers must judge whether co-operation is required and, if it is, what kind of account is needed to continue.

The most efficient communicative mode for remedial work is talk and the kinds of remedial talk photographers engage in include explanation, elaboration, justification, flattery, and trivialization, each or all brought to bear depending on the photographer's sense of why the subject resisted in the first place. If a subject seems wary, the photographer may trivialize his activity, claiming, for example, to be taking pictures "only" for himself, not for the newspaper or vice squad. If the subject seems to be shy, the photographer can try flattery. Indeed, many photographers report the tiresome frequency with which subjects respond to their declared intentions or to their requests by saying, "Nah, it'll break your lens." This is clearly a conventional response that may refer to a variety of types of self-consciousness quite apart from whether a subject thinks himself attractive. It is also a polite way of evading the picture, that is, without having to refuse the photographer directly. In either case, it requires the persistent assurance by the photographer that in fact the subject looks terrific and should consent to the exposure.

The flattery in this example may also constitute an elaborating move where it follows a permission request and thus becomes the second in a series of two or more remedial tasks, or an element in the process of remedial exchange. What is elaborated is the photographer's appeal for access, and in this sense every such move a photographer

makes elaborates upon those made earlier. However, more specific elaborative talk extends an initial explanation by offering further detail concerning the photographer's motivation and purpose. For example, a newspaper photographer I interviewed approached riders on the Philadelphia subway by introducing herself as a *Daily Planet* staffer working on a subway story and explaining what it was about the subject that had caught her eye. At that point, she followed any resistance with an embellished description of the attractive feature, be it how the children's red plastic trains looked great against their navy coats, or how the gentleman holding his baby looked pleasantly calm amid the chaos of rush-hour. In turn, she followed these elaborations with another permission request and the photograph was rarely denied.

What is being elaborated upon in these examples is the initial explanation. Photographers explain themselves in order to assure subjects that their motives are honest, benign, or exciting (witness the prospect of having one's picture published in a high-circulation daily). In the subway examples, the elaborated explanations serve in part to tone down the minor threat of singling out. They account for why a subject was chosen in the first place and help him overcome any mild suspicion he might experience about his selection. This can also be accomplished by describing the subject as a member of a class of subjects ("I'm photographing shoppers") or by displacing accountability for the choice ("My boss told me to," "It's a school project"). Such institutional affiliations (work, school) are also called upon to justify a photographer's actions under scrutiny.

An important issue relevant to all types of remedial talk is the potential for photographers to fabricate their explanations. Some photographers make up stories as a way of getting around lengthy truths they feel would be meaningless to subjects, in exchange for terse and effective deceptions. They believe that as long as no harm will come to their subjects as a result of the photograph, it's okay to tell them whatever they seem to want to hear based on who they appear to be and how their apprehensions are expressed. From these photographers I got the sense that *they* considered their work and their photographs to be innocent and their subjects' suspicions unreasonable. Again the emphasis is on getting the picture. However, even the most concerted efforts at remedial work are sometimes unsuccessful, and here photographers usually don't persist. Though photographers on the run often shoot despite a mild frown or left-to-right nod of the head, those who fail to get permission after an elaborated attempt rarely take the picture.

Conclusion: Photography and Privacy

What emerges from an account of photographic practice in public places is a contradiction between taking pictures and "informed consent," if by this phrase we mean consent without coercion given the consequences of taking and publishing a picture to the extent these consequences can be anticipated. In other words, there emerges a contradiction between consent to take and consent to use. In maintaining normal appearances, photographers downplay the intrusion or threat a camera represents, a practice clearly at odds with the discussion that would ensue were any subset of the potential outcomes of publication to be understood by photographer and subject. While photographers recognize this incompatibility, their practice is guided by the notion that "you can decide not to publish, but you can never publish what you didn't take." The practical emphasis is on getting the picture, and the ethical emphasis, where there is one, is on whether or not to publish it.

Not one of the photographers I interviewed, amateur or professional, reported ever using model releases for public photography. As a legal issue, the invasion of privacy by photographic means is based on the nonconsensual publication of a photograph for purposes of advertising or trade.[2] Generally, in the U.S. news photography and artistic exhibition are protected by the First Amendment. Among amateur public photographers, the legal right to privacy isn't an issue because their photographs aren't sold. Among professionals, it is rarely an issue because their photographs are used for technically "editorial" purposes (in the case of news, documentary, and artistic publication).[3] Moreover, those photographers who have thought about consent consider model releases strictly in terms of their own protection and vulnerability to legal action. They are a way of "covering yourself," not a means of ensuring that the rights and concerns of subjects are respected.

Cast as a more broadly defined social issue, however, personal privacy is of concern to photographers, related to a subject's activity and his capacity to resist being photographed if he so chooses, or in other words, to his power. These two dimensions intersect whenever someone's activity renders him powerless to resist—for example, the victim laying prone at the scene of a car accident. For subjects in intimate, embarrassing, or grievous circumstances, some photographers consider it improper or cruel to intrude upon the situation at the moment or to

create a record of private behavior that subjects would probably find undesirable or that might violate cultural norms. Even if there is nothing apparently grievous or embarrassing about the situation, it may deny participants the chance to present themselves to the camera in their "best light," according to prevailing standards of representation.

However, it is part of a professional photographer's socialization to overcome a reluctance to photograph in the face of grief or threat (conditions routinely encountered by photojournalists). Among fellow professionals, it is a sign of competence and reliability to be able to get pictures regardless of the circumstances, an ability seasoned photographers are assumed to possess and novices are rewarded for acquiring.

What the practical contingencies of public photography therefore suggest is the essentially exploitative relationship that prevails between photographers and subjects. Moreover, as long as professional photography continues as it is currently organized in the news, documentary, and artistic mainstreams, the likelihood of changing that relationship is small.[4] This is not to say that photographers are an unusually predatory group, for anyone whose work requires the participation of others who stand to gain little or nothing in exchange are similarly implicated, be they photographers, film-makers, or social-science fieldworkers. Despite some recent challenges (see n.3), existing privacy law is not designed to protect the public except against invasive abuses as they are commercially defined. Importantly, however, it is not only the "abusive" photographers, the *paparazzi,* who exploit their subjects. It is instead a quality of the relationship that persists as long as photographers and their employers, not subjects, control the production of photographs. Some people, with more money and more power, are better able to intervene in this relationship, better able to inhibit access, maintain privacy, and take to task those photographers and publishers whom, for whatever reasons, they feel have trespassed. But this doesn't help the less-monied, less powerful person whose objections to being photographed are dismissed by the photographer working on assignment, or the person who might not object until some unanticipated consequence occurs after the picture is published.

Notes

1. This exploratory research combined field observation and in-depth, semi-structured interviews with fifteen photographers, representing the traditions of photojournalism and art photography (see Henderson, 1983).

2. *Galella vs. Onassis* is an important exception, where a photographer was held liable not for publication but for his aggressive conduct while photographing. For a good discussion of *paparazzi* photography in general and Galella in particular, see Sekula (1984).

3. However, in 1982 news photography was threatened by the New York State Court of Appeals ruling in partial favor of the plaintiff in *Arrington vs. New York Times Company et al.* Three years earlier, Clarence Arrington, a financial analyst in New York City, had sued the New York Times, Contact Press Images photo agency, CPI director Robert Pledge, and CPI freelancer Gianfranco Gorgoni for the nonconsensual publication of a photograph of him in the *New York Times Magazine*. Unbeknownst to Arrington before hearing from a friend one Sunday morning, he'd been photographed by Gorgoni for the cover illustration of an article "Making It in the Black Middle Class," an article he felt offensively misrepresented the attitudes of many middle-class blacks. Arrington's suit was dismissed in the State Supreme Court, though his complaint against CPI and its employees and directors was upheld on appeal. According to the appeals court ruling, the *New York Times* involvement with the photograph was for purposes of news and therefore not actionable, while the agency's involvement was for purposes of trade and therefore liable under state privacy law. Though the suit was finally settled out of court some two years later, the interim threat to freelance agencies and their photographers was widely felt. Either photographers would have to get signed model releases from all identifiable individuals in any photograph that would eventually be sold, or indemnify clients against claims of privacy invasion, both measures that would have radically altered, or destroyed, the freelance industry and publications dependent upon it.

4. Some photographers, notably members of oppositional groups, have tried to find ways of doing things more collaboratively. See, for example, JEB (1983).

References

Becker, Howard. 1974. "Photography and Sociology," *Studies in the Anthropology of Visual Communication* 1(1), 3–26.

Goffman, Erving. 1971. *Relations in Public*. New York: Harper Colophon.

———. 1959. *The Presentation of Self in Everyday Life*. New York: Anchor Doubleday.

Henderson, Lisa. 1983. Photographing in Public Places: Photography as Social Interaction. Unpublished Master's Thesis, Annenberg School of Communications, University of Pennsylvania.

JEB (Joan E. Biren). 1983. "Lesbian Photography—Seeing Through Our Own Eyes," *Studies in Visual Communication* 9(2), Spring, 81–96.

Sekula, Allan. 1984. "Paparazzo Notes," in *Photography Against the Grain: Essays and Photo Works 1973–1983*. Halifax: The Press of the Nova Scotia College of Art and Design.

5

Ethics and Professionalism in Documentary Film-making

ROBERT AIBEL

Social scientists, journalists, photographers, film-makers, and others who study and report on human behavior constantly face numerous moral issues. However, outside of the social scientific community, few set time aside for serious exploration of the ethical dilemmas which confront them, and there is little formal or informal pressure for moral accountability. As professional humanists we are accountable, and we must make time for moral reflection. This essay explores an incident which occurred during the production of a film, *A Country Auction*,[1] I co-produced and directed with Ben Levin, Chris Musello, and Jay Ruby. This particular incident was chosen because I believe it raises ethical issues that commonly face documentary film-makers.

As a film-maker, I appreciate how difficult it can be to think about these issues. It's almost impossible to make time to consider an ethical question during production. Split-second decisions cannot be delayed for moral reflection. Between productions it is easier to avoid general questions about the morality of one's profession. The potential results don't seem worth the effort, and there's always the risk that honest introspection might lead to unresolvable conflicts. The film-making process is difficult enough without the added weight of moral confusion.

Beyond these practical and personal difficulties, the normative practices of the documentary film-maker make such reflection unlikely. Most documentary film-makers have relatively little commitment to the subjects of their films. This is not to say that film-makers don't care about their subjects, but that time is usually short and involvement is precluded by the exigencies of film-making. In fact, many film-makers

argue that making a documentary demands distance. Some believe they are providing a service to society with a journalistic commitment to "objectivity" and "surveillance of the environment."[2] Others argue that the only true documentary captures a reality unmodified by the film-making process. In either case, as professional documentary film-makers, they believe they must avoid genuine involvement with the subjects of the film.

Under these conditions, the possible effects of the film-making process on the subjects are rarely an issue and will only be noted if they interfere with the normal course of production. To make matters worse, many documentary film-makers firmly believe good film-makers have little real effect on the people and activities they film. With such a wrong-headed conceptual framework it isn't surprising that moral issues are not raised. If we mistakenly believe that we have little effect on the people in our films, then there is no ethical problem to face. It is those who are unaware of their impact—who accept the possibility of an unmodified documentary reality—who often do the most damage.

The team that produced *A Country Auction* was very much aware of the potential effects of the film-making process and the moral obligations incumbent upon us. Three of us were ethnographers as well as film-makers, and we were trained to be attentive to our moral responsibilities. In addition, on a practical and self-serving level, we already had a seven-year investment in our research in this community. We wanted to behave in a way which would allow our research to continue after the film was finished.

Ethical issues were further heightened by the commitment we had made to a true and "absolute" collaboration. Documentaries are usually shaped by a team of people working together. But, in order to make films in a timely and economical manner, the team is organized by a more or less formalized authority structure. There is a chain of command in which final decisions rest with a producer or director. When necessary and expeditious, all disagreements can be resolved unilaterally. However, *A Country Auction* was produced by the collaboration of four producer/directors. Every major decision had to be agreed upon by all four of us. Each member of the team had to be a part of the decision-making process; a process that forced us carefully and consciously to evaluate what we were doing and to consider the ethical implications of our activities.

Still, informal behavior was not subject to the team's control, and each of us had a personal style and beliefs which affected the way we worked. Despite all of the circumstances cited above and extensive pre-

planning focused on strategies for working through conflict, differing attitudes and behaviors finally forced us to confront an ethical dilemma that almost destroyed our working relationship.

Before turning to a description and analysis of the incident under scrutiny, it is necessary to further contextualize it by describing the background, method, and subject matter of the film.

Background of the Film

Based on preliminary fieldwork in 1978, Ruby and I wrote a comprehensive research proposal for the study of visual communication in Juniata County, Pennsylvania. While we never secured funds for the entire project, Ruby, Musello, and I each conducted our own ethnographic research in the county. Ruby (1981) studied still photography; Musello (1986) studied the role of home decor in social communication; and I studied amateur art (Aibel, 1984) as social communication.[3] While each of us was involved in the study of a particular visual domain, one of our shared goals was to understand the relationship between the socio-cultural system of the community and the various forms of visual communication. Therefore, in-depth ethnographic study of the social and cultural structure of the community was a central part of our research.

In 1981 the three of us decided to produce a film which would reflect our co-operative understanding of the culture of the community. We chose to make a film about estate auctions, because we saw them as visually exciting events which would allow us to communicate some of what we had learned about values, beliefs, and behavior in Juniata County. At the same time, we felt that such a film would enable us to deal with what we had learned about estate auctions in the county. We had come to understand auctions as social rituals through which a family and community dealt with the symbolic and economic aspects of death, dissolution, and the redistribution of material goods. As we said in the Study Guide to the film:

> From the family's perspective, estate sales occur at the end of a life, at the end of a family's life-cycle, and within the succession of generations. In the cross-generational view of family life, estate sales are a means for dealing with death. They are rituals through which the family recalls the deceased and attempts to reconcile their loss while simultaneously working to adapt and affirm relationships among the

living. They also offer a last chance to collect material symbols of the deceased and thereby sustain symbolic continuity among the generations.

At the level of community process, estate sales are ritual institutions. Auctions move the family crisis into the public sphere by prescribing traditional methods for dealing with death and the redistribution of the estate. Members of the community anticipate a sale as an important occasion in which the property and life of the deceased and surviving family may be evaluated. Everyone has a chance to examine and contemplate the possessions of a home at its end; to reminisce and buy remembrances. In this way, estate sales carry the family and community from mourning to a collective recollection of the deceased. The structure of relationships in the community is redefined and reaffirmed in the process. The deceased becomes symbolically reintegrated into the community as an ancestor. Viewed in this way, estate sales are part of a regular cycle of events—rites of passage—and serve as the last phase of a set of funerary rituals.

Finally, *A Country Auction* explores the sale as an economic event— integral to the local economy and a source for the antique market. Sales attract dealers and collectors from outside the local community and are thereby subject to consumer trends on a national level. These outside interests have functioned increasingly in the past decade to reshape the social and symbolic aspects of auctions. The film considers the impact of these national influences on the sale. (Aibel, Musello, and Ruby, 1985:2)[4]

We envisioned the film as a report on our research, a film which would consider the scholarly standards of ethnographic research as well as the conventions of documentary film-making. Our backgrounds were such that each of us had some experience in both film production and ethnographic research. We all had a strong scholarly interest in ethnographic and documentary film-making. Musello and I were trained in ethnographic research and social scientific film-making at the University of Pennsylvania's Annenberg School of Communications. Both of us had made films, and I had spent three years teaching social scientific film-making at the Annenberg School. Ruby was an anthropologist who had been a consultant on a number of films and had been writing about ethnographic and documentary film for over ten years. We invited Ben Levin, a documentary film-maker who team-taught a course in ethnographic film with Ruby, to join us in the production in order to have the viewpoint of one who understood ethnographic and documentary

film, but who knew little about Juniata County or auctions. Funding for the film was secured in early 1982 from the National Endowment for the Humanities and the Pennsylvania Humanities Council.

Immediately thereafter we began to meet regularly in order more fully to conceptualize and plan the production. First, we had to develop a strategy for working as a team of four equal co-producer/directors. This required common agreement on a method for decision-making as well as the assignment of areas of primary responsibility. We agreed that we should make all substantive decisions on the basis of unanimity. While this was likely to be a difficult result to achieve, we believed that we could talk through most disagreements as we already knew each other. Also, we were all committed to making the best film possible. We were aware that this could lead to lengthy discussions and arguments, but we felt that the explicit articulation of our ideas and methods of working was essential to the kind of film we wanted to make. In fact, because the film was grounded in our research, such a method for decision-making forced us to attend very carefully to the concepts and findings which informed the film. While it was impossible to pre-plan every detail, our discussions led to elaborate plans for filming the auction, including shot lists and explicit directions to two crews about angles, camera placement, style, and content.

As it turned out, we had to wait until the summer of 1983 for an auction that met our conceptual and practical needs. We secured the agreement of the family of the deceased just two weeks before the auction was to take place, giving us considerably less lead time than we had hoped. We immediately moved to Juniata County, where we remained for approximately five weeks and shot the major portion of the film. Follow-up shooting continued through 1983 and into 1984, and the film was completed in October 1984.

The completed film is an ethnographic documentary about an estate auction that examines the personal, social, symbolic, and economic processes involved when a family dissolves their homestead through auction. The auction process is portrayed as integral to the social life of the community and as a method for a family and community to deal with the death of one of their members.

The estate sold in the film consisted of the last general store in town, the adjoining home, and the contents of both. Everything from real estate to pots and pans was placed on view and auctioned off. The proceeds were divided among the heirs.

The film follows the Leitzel family as they clean, sort, and prepare for the auction, and as they hold a "preview" the evening before the

sale. All of this culminates in the auction itself, where members of the community come to get bargains, buy remembrances, share memories, and take a last look around the home. At the same time, antique dealers move through the event as merchants, transforming household objects into commodities. The aftermath of the auction is depicted by following some of the objects to their new homes in the local area and others to distant parts of America. For example, a glass candy dish in the home of a local relative is seen as a commemoration of the deceased and as a material reference to a shared social network. On the other hand, the store benches move through the hands of three antique dealers and a decorator to their final home in a fraternity house at Kansas University, where they are recontextualized as antiques.

Prior to and during the making of the film we attempted to become sensitive to the effects of our activities on the community and family. As researchers we had already grappled with the moral considerations of studying this community. When we began to shoot the film we had already made a commitment to considering the ethical implications of our activities. Three of us had spent extended periods of time living and working in the community. We had made significant investments in our research and wanted to be able to continue our work following the production of the film.

Despite this, we found ourselves faced with a moral dilemma which was never truly resolved. Due to differential attitudes about our roles in the process, we had to face a divisive conflict over the nature of our involvement with the family.

The Incident

One of the main difficulties that faced us from the beginning was that we had more knowledge than the family did about the market value of the objects in the estate. Musello, Ruby, and I were already collecting antiques, and I was a part-time antique dealer with a developing interest in ephemera. Given our knowledge of the marketplace, we easily could have completely altered the event and helped the Leitzels to earn more money by calling dealers from New York, Philadelphia, and Baltimore. However, since that was unlikely to have a positive effect on the community, the family, or the film, we never considered it.

Our particular problem arose while we were filming the family as they prepared for the auction of their father's estate. They were sorting through mounds of materials in the house and in the adjacent general

store, deciding what to keep, what to throw away, and what to sell. They were filling boxes with things to burn or haul away to a trash dump. In the backyard they accumulated piles of "burnables" and burned them whenever the pile warranted the effort. As we filmed this process I found it particularly hard to watch them destroy or discard materials which I felt were of historical value to the community or of economic value to the family (if sold at the auction). Finally, I found myself intervening in the process during a period when we were not filming. I wandered out to the burn pile and removed a number of paper objects which I believed had monetary value as collectibles—e.g. old store bills, letterheads, advertising items, and political flyers. I had seen similar things sold at paper shows and auctions, and I thought they might sell at a Juniata County auction. I took them inside to a family member and suggested that they might be of some value at the auction. They thanked me for my advice and put the objects on a shelf until they could ask the auctioneer if he thought they should be sold.

Unbeknownst to me, questions about historical and monetary value were being posed simultaneously to Ruby. Because he had been identified as having a strong interest in the history of the area, he was asked about objects that might have been of historical and antique value. He had not solicited the role of a preservation and antique expert, though he did have some knowledge of the market. The family felt the need for some guidance in this area and requested his assistance. At this point Musello noticed what was happening and expressed serious concern about offering advice about economic and historical values, even in response to questions. He felt that if we began to act as economic and historical 'consultants,' we would actively change the normal course of events and would be perverting the process we were there to study and document. That is, we would be modifying their values through our interference, leading them to act in ways which would be aberrant in the community.

I argued that we were already modifying their behavior by our presence—we were sensitizing them to the value of things simply by the questions we were asking and the events we chose to film. Further, I felt that it was proper to offer advice rather than stand by and watch them destroy objects of value. It seemed to me that if there was any moral question about our involvement, it was whether we had a right to be there at all. We were modifying the process every step of the way in order to make *our* film. Once the decision to film had been made, I still found it difficult to stand by and watch the family make decisions

I regarded as not in their best financial interests or in the best historical interests of their community. Further, while financial gain was not the only reason that the family was having this auction, I said that it was certainly a major reason. While I didn't want to use my knowledge in a damaging way, I had some limited expertise which could help them to make more money and to preserve items of historical value.

Musello disagreed and argued that the financial and historical values were not their own, but were being imposed by us. He said decisions as to what to sell, keep, and discard were going to be made according to symbolic standards which involved things like respect for parents and their possessions and a sense of the auction as an homage and memorialization. That is, certain things would be kept or discarded out of respect for their parents—the auction would be an opportunity for the children to offer public homage to their parents by showing their home and possessions in the best light possible.

At this point we were at something of a standoff. Ruby and Levin had taken somewhat neutral positions, feeling they could see both sides. In fact, as our research had led us to believe that the auction would be seen as both an economic and symbolic event, we all expected to see both factors actively, maybe competitively, involved in family decisions. We knew that both factors would be present, and there was no way to know which, if either, would predominate.

While my actions were motivated by a sense of responsibility to the family and community, Musello felt that I was potentially encouraging the economic and historical aspects to dominate the symbolic aspects of the family process. Financial and preservational considerations were at the forefront of my position; symbolic considerations were at the forefront of his position. He felt that I was overemphasizing the economic, and I felt that he was attempting to deny its centrality to the whole process.

After some thought, I came to realize that my trip to the burn pile was too disruptive and would inevitably lead to an undesirable level of distortion, but I argued that we should be willing to give advice in response to a request—a form of passive involvement. That is, *they* were seeking certain types of advice in response to our presence and presumed knowledge, despite the fact they might not have sought or received answers in our absence. I felt we should not actively efface our presence—numerous events were already altered in response to the filmic situation and this was another such event. Rather, the most defensible position was to acknowledge and document ways in which our

presence may have skewed the events depicted in the film, and present this within the film itself. We had already decided to do this in our interviews—one of the most disruptive of all filmic activities—by recording the questions and filming the interviews as interactions between a film-maker and an interviewee. Further, I had a gut feeling that it would be unethical to pretend ignorance unless we felt that our answers would do *them* more damage than good.

Ultimately, we chose not to resolve the ethical dilemmas posed by the circumstances. The situation had become emotionally explosive, and the entire project was in danger of falling apart, despite the extensive effort we had made to circumvent such problems. The issue was much too divisive and complex to try to grapple with in the midst of shooting a film. No one had easy answers, and we simply didn't have the time or energy to struggle with hard ones. Given enough time and philosophical expertise, we might have teased out and resolved the ethical questions involved. Yet, the pressures of the moment didn't allow us that opportunity.

In the final analysis, the decision as to how to proceed was made on the basis of what was best for the film. We decided that we would all steer clear of any advisory capacity. We did not want to distort the precarious interaction of the symbolic and economic that we had observed during our research. As the film had emerged from our research, our primary goal was to document that research, not to document the immediate circumstances in which we found ourselves with this family. What was best for the film we had decided to produce was to make certain that nothing we did would endanger it.

In an interview with Susan Raymond, Alan Raymond, and John Terry about their work on *An American Family,* they discussed a morally repugnant shooting situation which faced them. Explaining their response, Susan Raymond said: "Some part of you just shuts off, and you keep filming. It's automatic." Alan Raymond responded: "It's a matter of being a professional" (Ward, 1973:30). While I was initially revolted by their implicit opposition of the "moral" and "professional," I now think that I understand what they experienced. We also made the "professional" decision. It's not that we intentionally made an immoral decision, rather we simply chose to make the "professional" decision and go no further. Even with our commitment to moral reflection from the very beginning, circumstances made it impossible for us to examine fully the ethical implications of this decision. I still don't feel comfortable with our inability to explore our options, but looking at the final product, I think I would make the "professional" decision again.[5]

Conclusions

Despite what we felt were "heroic" efforts to bring ethical considerations to the foreground of our activities, we were unable to fulfill this goal at a critical juncture. Considering the practicalities of film-making, I wouldn't be surprised to discover that many other documentary film-makers find themselves caught in moral dilemmas left unresolved due to economic, personal, practical, or temporal considerations. The fear of criticism or the pressures of getting on to the next film leads too few of us to think and talk about our experiences.

Some documentary film-makers may not have moral conflicts. Professionalism acts as a shield. Some part of them shuts down; they function on "automatic" and get the job done. Yet, the public has become sensitive to the ethical immaturity of the documentary film community. Many are wary of participating in any documentary. People fear that they will be maligned by a film-maker-in-search-of-success. All too often this fear is well founded. Film-makers often find the first and hardest step is to overcome fear and mistrust.

The ethical sophistication of the documentary film community remains at a very low level. Unless changes are made in the attitudes and actions, it will only become harder to make films, and to live with ourselves. We must begin by acknowledging that our actions are subject to an ethical code and by recognizing that we have a moral responsibility to the people who participate in our films. We do have an effect on our subjects and can't neglect our ethical obligations to them. We aren't exempt from moral accountability. Sharing our conflicts and confusions can be a first step.

Notes

1. *A Country Auction* is available from The Pennsylvania State University, Audio-Visual Services, Special Services Building, University Park, PA 16802.

2. See Wright, 1959, for a more extensive discussion the functions of mass communication.

3. See Birdwhistell, 1970, for a more comprehensive discussion of the social or integrational approach to communication.

4. A more complete discussion of the context, theory and methods of *A Country Auction* is available in the Study Guide which can be obtained by

writing to: The Center for Visual Communication, PO Box 128, Mifflin-town, PA 17059.

5. I would like to relate one incident which is somewhat beyond the scope of this paper. It demonstrates the kind of unpredictable occurrences which our intervention could bring about. As luck had it, this one had a happy ending for all: The executor of the estate, Celo, was cleaning his father's office while we were filming. During a break from shooting he was showing Ruby some of the things in the office. Celo was sharing his finds and seeking advice about what to save, sell, and destroy. He took out an old dilapidated ledger to get another opinion on what to do with it. The family had planned to burn it. Ruby suggested to him that this locally produced 19th-century Justice of the Peace ledger might be of some historical and/or economic value to someone in the area. At least partially as a result of our "interference," the ledger was sold at the auction and did not suffer the fate of many other historical records which were classified as "burnables." The man who bought it was one of a small group of people who were collecting local historical documents. He wanted to be sure that this "invaluable" historical record remained in the community, and he planned eventually to donate it to the local historical society. He paid $410 for the privilege. Ironically, the interview with the buyer turned out to be an indispensable part of *A Country Auction*. In this case our involvement coincidentally helped the family financially, the community historically, and improved the film. We could not have anticipated this outcome, and further involvement on our part might have led to many other unpredictable events.

References

Aibel, Robert. 1984. Art as Social Communication. Unpublished Dissertation, University of Pennsylvania, Annenberg School of Communications.

Birdwhistell, Ray L. 1970. *Kinesics and Context: Essays on Body Motion Communication* (Philadelphia: University of Pennsylvania Press).

Musello, Christopher. 1986. Family Houses and Social Identity. Unpublished Dissertation, University of Pennsylvania, Annenberg School of Communications.

Ruby, Jay. 1981. "Seeing Through Pictures: The Anthropology of Photography." *Camera Lucida*, No. 3:20:33.

Ward, Melinda. 1973. "The Making of an American Family." *Film Comment*, Vol. 9, No. 6 (November-December).

Wright, Charles R. 1959. *Mass Communication: A Sociological Perspective* (New York: Random House).

6

Ethics and the Perception of Ethics in Autobiographical Film

JOHN STUART KATZ AND
JUDITH MILSTEIN KATZ

Since the early days of documentary, the 'objectivity' of the camera as a recording instrument has come into question with the widening recognition that the camera records differentially. This parallels a growing awareness in the social sciences that perception and interaction are themselves constructive (Berger and Luckman, 1967; Blumer, 1969; Bruner, 1957; Kelly, 1955). As these theorists tell us, we do not perceive an objective reality. Rather, we focus selectively on the virtually infinite aspects of our environment, interpret and evaluate what it is we see, and respond to our theories about what is happening, not events per se. In turn, others respond to our behavior, interpret what we mean by what we do and say, and respond not to us directly but to their own interpretations of our actions.

Just as we do, the camera records selectively. It selects (if we may be forgiven for anthropomorphizing) from the myriad objects within its range to focus on some objects and not others. It suggests to us as viewers, what is important and where we should attend. In fact the camera, because it precludes our scanning outside its field of vision, limits our possibilities in ways we are not limited generally. The camera, not the viewer, determines what we see. Film-makers are in this sense responsible for what they show us within the range of options. They determine not only what we will focus upon, but the angle, depth, and sharpness of focus, camera movement, and/or zooms. (Sound is manipulated in a similar fashion.) Further, they edit specific shots so

as to embed them in various contexts, all of which influence the particular interpretations we make about the preselected events they shoot. Far from being objective, the camera shows us a narrowly selected, highly personal and—of necessity—edited version of objects and events.

The problem of ethics arises exactly from this fact: if the camera is not objective, if it operates 'selectively' and thereby influences what we see and how we interpret what we see, what obligations if any do documentary film-makers have to the subjects of their films, the audience of their films, or themselves?[1]

Most discussions concerning the ethics of documentary film-making (Pryluck, 1976; Linton, 1976; Rosenthal, 1980) deal with ethics while assuming that the subjects of the film and the film-makers are strangers, or at most acquaintances, prior to filming. Typical cases are the subjects of Fred Wiseman's films, all of whom were unknown to him prior to filming; Billy and Antoinette Edwards of *A Married Couple,* who were acquaintances of Alan King and his crew; and the Beales, whom the Maysles had just met prior to their initial shooting of *Grey Gardens.* The 'rules' of ethics for such 'traditional' documentary films concern how far the film-maker can go with the subject, how intimate he or she can become, how much protection the subject needs, and the balance between the public's right to know and the privacy of the individual.

These 'rules' involve some latitude and vary if the subjects of the films are media stars or public figures (*The Most, Jane, Showman*); persons well versed in and comfortable with the media (the Edwardses, *Conversations with Willard Van Dyke*), those on tenuous or shaky ground (the Beales, the Louds, Paul Brennan of *Salesman*); those who are incompetent or incapacitated (the subjects of Wiseman's *Titicut Follies* and Richard Cohen's *Hurry Tomorrow*); or those in need of special attention (the Weatherpeople in Emile de Antonio's *Underground* or the Ethiopian Jews of *Falasha*).

But there is a separate and considerable body of documentary works for which the rules of ethics seem to differ because there exists *prima facie,* an actual relationship between the filmer and the filmed. In the case of autobiographical works (films about oneself or one's family) the subject of the film and the film-maker often begin with a level of trust and intimacy never achieved or even strived for in other films (Katz, 1978b:14–15). In these cases the question is how, or *whether* the rules of ethics (or exploitation) differ from other kinds of documentary films. Lastly, if it is argued that it makes an ethical difference if the subject and the film-maker have a special relationship, then one

must also ask how a knowledge of this relationship makes a difference to the audience. Specifically, how does the prior relationship affect the audience's perception of ethics and exploitation in the film they are viewing?[2]

This essay will concentrate on ethical questions asked about documentary film-making, examining them in the light of several autobiographical works. When 'instant intimacy' does exist, how do the issues of trust, informed consent, and disclosure change? Secondly, if we as information processors must make inferences and evaluations of events we perceive—if our perception is not objective, how is our judgment about what is ethical/exploitative influenced by our knowledge of prior intimacy?

Articles dealing with ethics in non-autobiographical documentary film suggest four variables which act as criteria in our effort to judge whether a film-maker has or has not acted ethically: consent, disclosure, motive, and construction. A discussion of these variables, particularly the first three, suggests a variety of ways autobiographical film-making differs ethically from other documentaries.

Consent

The obligation of film-makers to obtain consent (usually a legal release) is both generally accepted and legally enshrined as the minimum moral obligation of film-maker to subject, though there is still some question of whether an individual in a public place is, imageably speaking, public property. On the whole, however, *voluntary* and *informed* consent is required if the film-maker is to be considered as having acted ethically. Voluntary here includes a lack of coercion, a lack of intimidation, and a lack of deceit. Were the subjects (prison inmates, employees fearful for their jobs, victims of crime fearful of reprisal, or hospital patients fearful of authority) genuinely free to refuse (or accept) participation? Has the film-maker taken advantage of consent that was not genuinely voluntary? Informed means that the person knows to what he or she is in fact consenting. Does the subject understand the risks?

What makes the issue so interesting—a question for discussion rather than legislation—is the complexity of these simple words: informed voluntary consent. Consider informed consent. The subject knows he is to be interviewed. Does he know he may be filmed from

an unflattering angle because the film-maker is biased against his view? Does he know his remarks may be edited to omit the footage he expects will be in the film? Does he know the film may be edited so the context of his remarks is altered, their meaning changed? Does he anticipate how his life may change when the film is shown; how neighbors, friends, or business associates might respond to his (possibly distorted) views? Last, but not least, does he know how he might be affected by reviewers' opinions even when the film-maker and he like and agree upon the fairness of the presentation? (When Fred Wiseman made *High School* in 1968 the faculty members and school staff were shown the film before release. Everyone concerned was pleased with the film until the school was severely faulted by critics. Response was so controversial that a threatened injunction prevented showing of the film in the Philadelphia area for over ten years.)[3]

Note here that we judge ethics on whether informed voluntary consent has been given. But in most cases, we watch a film without knowing how consent was obtained and whether it was informed. What did the film-maker say to the subject? What in fact did the subject understand from what was said? The distinction is important. In her book, *Pat Loud: A Woman's Story* (1974), Pat Loud 'confesses'[4] to not understanding what producer Craig Gilbert said when he approached the Louds about using them in the series *An American Family:*

> Then on Sunday night Craig came back again and sat for about two hours talking about educational TV, living anthropology, how candor leads to truth, public TV—its considerable problems. Craig is very knowledgeable, but he does ramble a bit. And somehow after it was all over, none of us really understood what he was talking about. That conversation set the tone for many future talks we had with Craig: *What did that nice man* really *say?* (85, italics in original)."

The gap between what a film-maker says and what his listener hears is probably greater than we generally acknowledge. Ethical questions arise when the usual gaps in understanding are deliberately left unclarified by film-makers trying to gain consent they think might otherwise be at risk.

Secondly, we should remember that, even if we *could* see and/or hear consent being obtained, we might differ as to whether it was voluntary and whether it was informed. We might even agree about the words spoken. We might not agree about what they mean and at what they hint. What we think people mean, even when we hear their words, is

determined by our own templates, our knowledge, and our past experience (Katz, 1981).

In fact, judgments about whether people were properly informed are largely influenced by our assumptions about their sophistication, experience, and expertise (our assumptions about their templates). That is why we have different ethical standards for film-makers' shooting politicians, actors, or other media-wise people compared with people-on-the-street or poorly educated, easily exploited populations. We expect the film-maker to be more fair, more open when he is likely to be his subject's only source of information. In cases in which "they should have known anyway," let the subject beware.

How then, is the standard of informed and voluntary consent affected when the film-maker is filming his own friends or family in a film he represents as autobiographical? Assuming for purpose of discussion that the family or friends in question are not themselves public figures, they probably do not differ from most people regarding knowledge of film-making. We would therefore expect at least the same degree of information be given prior to informed consent as with less sophisticated members of the general public. Why *at least?* Ironically, the fact that these are family or friends suggests a *greater* degree of responsibility on the part of film-makers. The issue gets clearer when we acknowledge that it is often a daughter or son who is filming her or his parents. In our culture people are *supposed* to treat their families and friends with greater consideration than strangers. The assumption we make that families are groups which nurture and protect us from the harsh cruel world 'outside' implies greater care should and will be taken of family members. Whether we are right in assuming that family members are more protective of each other than of strangers is an empirical question. Nonetheless, that assumption influences our perception of appropriate behavior. In our culture we would be more offended by discovering a film-maker deceived his family than that he deceived a stranger. How could he do such a thing? The standards we apply are higher.

The issue is confounded by assumptions we make about why a family agrees to be filmed; assumptions which relate to whether or not we think consent was voluntary. It boils down to this: would the families in autobiographical films have, in similar circumstances, agreed to be filmed by strangers? Had Bill Reid (*Coming Home*) approached Amalie Rothschild's family (*Nana, Mom and Me*) or vice versa, would either family have consented to the film? If we think the answer is

"no," it's worth our while to consider what variables might operate in cases of 'intimate consent' that do not operate generally.

Such variables would of course vary from individual to individual and family to family. We might, however, hypothesize that in families, love, guilt, the fear of loss of love, a sense of favors owed, a desire to help, and a desire to be helpful add to the usual confusion of motives which contributes to consent among strangers. These of course are the conscious variables. For purposes of this discussion it is suggested that non-conscious motives are probably more complex and more weighty between intimates.

In fact there is a hint in many autobiographical films that the subjects of the films consider, at least in part, that they are doing the filmmaker a favor. This is made clear by Bill Reid's parents in *Coming Home,* by Nana in *Nana, Mom and Me,* by Joe in Maxi Cohen and Joel Gold's *Joe and Maxi,* and by Richard Rowberry's parents in *The Three of Us.*

Consider Mrs. Scorsese's response when Martin Scorsese included scenes to which his parents objected in his autobiographical documentary *Italianamerican*: "I kept saying, don't put that in, and he'd say 'oh, no, I wouldn't put that in,' but then he did anyway. I told him he was a son-of-a-gun. But he said if he had taken everything out that I had asked him to there wouldn't have been anything left" (Weis, 1975:57). If child, or lover, husband, or friend who is a film-maker asks if you will cooperate in a film he wants to make, pressure exists in our culture to do so, certainly more pressure than one would feel with a stranger. How can one refuse, without incurring consequence?

Disclosure

Even after consent is granted, ethics in documentary film hinge on disclosure. As Pryluck (1976) notes, persons

> may have agreed to serve as subjects for the films, but a waiver of privacy is not absolute. The right to privacy is the right to decide how much, to whom, and when disclosure about one's self are to be made. There are some topics that one discusses with confidants; other thoughts are not disclosed to anyone; finally, there are those private things that one is unwilling to consider even in the most private moments (1976:24).

Film-makers are accused of being unethical when they use their film for obtaining disclosure that the subject, audience, or critic considers "too personal." In such instances the camera seems invasive, more a weapon than an instrument of inquiry.

Within this context, discussion of image ethics, disclosure, and autobiography rests on several questions. How much disclosure is generally too much? What variables affect the degree of disclosure considered acceptable? Are criteria for disclosure different for autobiographical film than for more traditional documentary?

Generally speaking, 'appropriate disclosure' is bounded by the subjects' willingness to disclose. They tell viewers (through verbal and non-verbal cues) what is acceptable. And, as in ordinary social interaction, we are not comfortable "seeing" more than others wish to show. Both they, and we, are embarrassed by those instances in which "too much" is thought to be revealed.

There are of course various specific contexts in which 'overdisclosure' is acceptable. Investigative reporting is one example. The journalist film-maker is supposed to "get beneath the surface" to "expose" the object of inquiry—the crooked politician, the hypocritical corporate executive. Here, as with informed consent, people in power, or people who are themselves deceivers, seem fair game for deception and manipulation.

A second context in which we are 'allowed' to see or hear more than subjects mean to show or tell involves academic study and/or therapeutic situations. In such cases the *object* of the exercise is to see beneath the surface; the expertise of scholars and/or therapists is their ability to do just that. They get paid for seeing more than others.

In general, viewers of documentaries raise the issue of ethical violation when it seems that subjects have lost control or have been pushed to disclosure they would not allow, if they had control (either self-control or editorial control). In fact, disclosure—and the control of disclosure—occurs at both these levels. Subjects refuse to answer questions, or choose to answer them. They try to control their emotions and/or the show of emotion, or choose to express their feelings openly. When physically able they approach, or avoid, the camera. At the editorial level the film-maker chooses to incorporate or obliterate such footage.

As viewers, we begin to feel uneasy, to wonder if something is ethically wrong when confronted with disclosure we infer the subject finds excessive. As viewers, it seems we make inferences about the people we

are watching. We try to determine, using cues they offer, whether *they* are comfortable. If they seem uncomfortable we try to determine if the film-maker is the cause of their discomfort, and whether he or she is sensitive or insensitive to it.

Some examples: The Edwardses offer themselves to the camera in their underwear, the Lords in bathrobes, Philly's mother (*Best Boy*) in a house dress, the Rothschilds in street clothes. Each seems fairly comfortable in his or her chosen attire. We may be surprised that Antoinette and Billy eat in underwear, but we are not embarrassed watching them. We would, we assume, be embarrassed had the camera peered around a corner catching the Rothschilds in a similar state of dress. We think we would be embarrassed and/or angry (at the film-maker) because we infer that the Rothschilds would be. They do not want disclosure at that level, and as well-socialized viewers, most of us are sympathetic.

Regarding the disclosure of "information," many viewers find portions of Amalie Rothschild's film about her grandmother (*Nana, Mom and Me*) too probing. Midway through the filming Nana got sick, lost interest in the project, and stopped co-operating with Amalie. At one point Nana is in the hospital, so Amalie cannot film her, but she brings a tape recorder to the hospital. She has recorded a conversation with Nana (the audience does not know if Nana realized she was being taped), and we hear the tape played later. Nana says that Amalie has become too outspoken and brazen, alluding to the fact that Amalie made her (Amalie's) abortion public through an earlier film, *It Happened to Us*. Amalie then asks if Nana had not once had an abortion. The suggestion to the audience is that she had. Nana replies that she doesn't want to remember what happened long ago. Many viewers think Nana is entitled to the privacy she wants around that issue; privacy which the question itself seems to violate. The problem here is complex, because the issues underlying Amalie's film are family myths and communication.

Similarly, Bill Reid's father finds the conversation in the family room "too pressing." His pain is obvious both from what he says, "I don't need you to come home and psychoanalyze me," and from his posture (for over 15 minutes he seems about to leave the room, and eventually he does walk out). The scene is, for many viewers, difficult to watch. They feel and identify with Mr. Reid's discomfort. Some think he is bullied into staying by the presence of the camera. Others, that he is free to leave. Judgments they make about Bill Reid's ethics

are based on two considerations: was Mr. Reid uncomfortable with the level of disclosure (most agree he is); and, was he free to leave?

These points should be stressed. Disclosure is relevant to ethics primarily when combined with the issue of constraint. When disclosure seems voluntary (no matter how extreme), the subject's judgment, not the film-makers' ethics, is in question. We may not like watching a film which is too intimate for us. But that is a question of proclivity, not ethics.

Secondly, autobiographical film is more contaminated by issues of intimacy because, as a general rule, these films are more intimate. The people know each other well and relate as intimates, ask questions which imply intimate knowledge, and discuss material that is generally not disclosed to strangers. Because we, as viewers, often find such material "too intimate" we are more likely to err in perceiving discomfort among the filmic subjects. We may perceive (or project) discomfort when none exists.

If we also imagine that participation is less than voluntary, and it is suggested here that may be the case regarding voluntary consent, then we are more likely in autobiographical films to suspect or accuse the film-maker of acting unethically (or pushing the boundary of the ethical) than we would in less personal cinema. Our standards regarding disclosure do not change for autobiographical film; rather our perception of 'overdisclosure' is likely to be contaminated as our perceptions of intimacy and/or constraint increase.

Motive

In addition to issues of consent and disclosure, the motives of film-makers are often an issue in discussions of ethics. Even when consent and disclosure seem appropriate, the film-maker who "pries" for no socially redeeming purpose other than his own personal or financial aggrandizement seems suspect. In our culture it is not acceptable to "use" people without good cause.

Good cause in film is generally defined as the public's right to know. In politics that right is obvious. We seldom question the motives of political or journalistic inquiry. Similarly, films about esoteric professions, anthropological films about different cultures, or educational films are generally justified by the information they convey.

To many viewers the justification for autobiographical films is not

self-evident. In many cases both audiences and critics question the value of such films, the propriety of "washing one's dirty linen in public" or "using film as therapy." But failure to see the "educational" value of such films suggests a lack of justifiable motive in the film-makers themselves. Lacking appropriate motive, they seem suspect. To many they seem self-indulgent and manipulative: unethical.

Families often share the audience's doubts regarding justification; they do not know why they are going through the pain and/or bother. What's the value in it? The topic arises repeatedly in the films themselves (*Coming Home*; *Nana, Mom and Me*; *Sherman's March*; *Joe and Maxi*). In one example (*Joe and Maxi*), Joe tells his daughter Maxi that he doesn't understand why she is making movies, "going around with bobbing cameras taking pictures of me and of people in corners" when she could have gotten a good job as a secretary, worked her way up, and "become somebody." At one point near the end of the film Joe has had enough: "You came to make a documentary . . . well this isn't a documentary. I'm not a document. I'm a person."

In fact, autobiographical films are legitimate, both as artistic self-expression (though they sometimes fail—as do films of various genres) and in terms of the public's right to know. Family life in the twentieth century is surrounded by a high degree of secrecy. Though most of us grow up in families we know very little about how other families in general work, how people interact, or how they spend their time. Except for people in the helping professions (social workers, psychologists, psychiatrists), we are, on the whole, excluded from the family life of others.[5] The exclusion has its consequences. We compare ourselves with myths, not reality. So the privilege of entering the homes of others, on an intimate basis, should not be undervalued as an educative and humanizing experience. What we have a "right" to know about particular families is debatable. But the value of knowing, in more realistic fashion, about other people's interior lives is unquestionable.

Nonetheless, autobiographical film-makers have to date, been harshly judged on motives. To many, "therapy" does not justify the sort of exposure they request or demand of family members. Further, viewers question their "underlying" motives in ways they do not question mainstream film-makers.

In *Elephants,* one of the more abrasive autobiographical works, Richard Rogers attempts to reconstruct what it was like for him to grow up as part of a wealthy New York family. His film is clearly interpretive and makes little claim for objectivity. His parents co-operated only minimally. Rogers substitutes pictures of his parents with impression-

istic visions, mostly of elephants. But we hear on the sound track the litany of their words that haunt him . . . security, responsibility, love. Rogers says the following: "For a long time I tried not to have this film shown. Seeing it, both my parents were hurt—they felt exploited and misrepresented" (Katz, 1978a:74). Viewers would not be surprised. Many wonder why he did release the film at all, or why he made a film that seems, to some, destined to hurt.

As a second example, consider motivation in Ira Wohl's very positive film *Best Boy*. Ira's own position is stated in the voice-over introduction:

> This is my cousin Philly who is 52 years old and has been mentally retarded since birth. In 1938, when he was 12, he started to become self-destructive. His parents, not knowing how else to deal with it, sent him to live in an institution. They hoped he would learn discipline there and he did, but it was an unhappy experience for all of them. So after two years, they brought him home and that's where he's been ever since.
>
> I suppose I'm as guilty as everyone else in the family for always having taken Philly for granted. I remember them saying his mind stopped growing when he was five and I guess I always accepted that. But three years ago, at a family gathering, I began to wonder what would happen to Philly after his parents were gone, so I spoke with them and his sister. I told them that I thought he needed to become more independent. Although this idea was very difficult for them to deal with, they realized that for Philly's sake, as well as their own peace of mind, something needed to be done. This film is a record of what they did and how it changed Philly's life.

A good deal of Ira's motivation comes from his awareness that Philly's parents are aging. In the course of the filming Philly's father does die and shortly after, under Ira's urging, Philly is placed in a home for the retarded. (As the film progresses, he is also educated to be for more self-reliant than when he stayed home.) The closing credits tell us that soon after the film was completed, Philly's mother also died.

Most viewers respond with great appreciation that Ira's efforts have assured Philly continuity, security, and independence, despite his parents' deaths. A second, more complex, more critical (and also less frequent) reaction occurs to some viewers. They wonder whether concern for his cousin motivated Ira as much as guilt and/or the opportunity to use Philly's situation to produce the film.

Though motive is always 'overdetermined,' viewers bring different

assumptions about motive to autobiographical films than to others. Specifically we suspect that self-interest and/or prejudice (whether conscious or not) are likely to operate when film-makers are working autobiographically. We look at their motives when we would not look at others'.

Construction

Most autobiographical filmmakers are in fact 'exposed' to scrutiny by being either on camera or an integral part of the sound track—a contrast to the tradition in which film-makers observe and record events which seem external. They are therefore available to inspection at a level avoided by the traditional observer stance. Furthermore, we viewers are likely to study them carefully not only because they are often the subject of the films but also because we imagine they are motivationally complex.

Ironically, our own greater scrutiny, and the film-maker's added visibility make autobiographical film-makers and their films more transparent than most. Consider Ruby's argument that truly honest documentary film should be *visibly* interpretive:

> We are beginning to understand the technologically produced images as a construction—as the interpretive act of someone who has a culture, an ideology, and often a conscious point-of-view all of which cause the image to convey a certain kind of knowledge in a particular way. Image makers show us their view of the world whether they mean to or not. No matter how much we may feel the need for an objective witness of reality our image-producing technologies will not provide it for us.

> It is my belief that the maker of images has the moral obligation to reveal the cover—to never appear to produce an objective mirror for the world to see its *true* image. . . . So long as our images of the world continue to be sold to others as the image of the world, we are being unethical. (Ruby, 1981:3–4)

In fact documentary film is both constructive and collaborative (though the collaboration often ends when the shooting stops).[6] What is interesting about autobiographical film is that the nature of the construction, the film-maker's role in influencing and directing the flow of action, is far more obvious than in other documentary. Naive viewers might assume, for example, that the Louds' behavior would be essen-

tially the same if the film crew were absent. Even the most naive viewers probably realize the discussions held by the Reids, the Rothschilds, or Joe and Maxi, would not be occurring were Bill, Amalie, and Maxi, elsewhere. The film-makers are "up front" active participants, shaping action and conversation.

For those concerned with manipulation at this level, autobiographical film-makers have been, to date, more open, transparent, and reflexive than their non-autobiographical colleagues. We may question the motives behind their actions (they themselves encourage us to do that); the actions themselves are, to an unusual degree, open to scrutiny. The film-makers in autobiographical film are on stage. Traditional film-makers are backstage (Goffman, 1959). Most autobiographical film-makers are, of necessity, reflexive. They participate in and shape the action of their films; then they edit them. What is interesting is that we as viewers know that they play both roles. In this way they sharpen our appreciation of processes we usually fail to acknowledge.

Conclusions

The recognition that film is not an objective recording of external reality has important implications regarding film-makers' ethics. This paper considered four variables relevant to the ethics of documentary film-making: consent, disclosure, motive, and construction.

Particularly the authors investigated whether the rules of ethics in autobiographical film-making differ from other kinds of documentary. Secondly, the authors ask how knowledge of a prior relationship between film-maker and subject affect the audience's perception of ethics and exploitation in the film they are viewing.

Regarding consent, the authors conclude that cultural standards require a somewhat higher degree of protection for family members than for strangers. Cultural assumptions that family members should, and will, protect one another (whether that assumption is factual or not) lead to more stringent criteria in judging the ethics of film-makers informing intimates. On the other hand it is recognized that family members are not free, in the same way as strangers, to refuse requests from film-makers. Assumptions about family obligations that affect the film-makers similarly influence their families' decisions to support and help when requests (to act as subjects) are made. Lastly, strangers who refuse to act as filmic subjects probably never see the film-maker again. Family members who refuse to help must live with the conse-

quences of their refusal. The ambiguity around those consequences act as further restraint against strictly voluntary acquiescence. At the very start, because we suspect that co-operation is not strictly voluntary, autobiographical film-makers seem ethically vulnerable.

With regard to disclosure, the standards we apply to autobiographical film-makers do not change (as they do regarding informed voluntary consent). As in any documentary, we judge disclosure according to our own perception of the subject's comfort with and control of his/her disclosure. Film-makers who overstep those bounds appear unethical. The problem with autobiographical film arises not in the standards we apply, but in the application of those standards. We, as viewers, are more likely to err in *perceiving* discomfort among subjects when we are uncomfortable with the level of intimacy presented. The chance of our doing so increases as the level of intimacy increases, and autobiographical film is, in general, more intimate than other documentary.

Because we think that consent is not purely voluntary when family members are filmed, our assumptions about consent contaminate our judgment regarding disclosure. To the extent that disclosure seems involuntary; the film-makers look unethical.

A similar dilemma faces autobiographical film-makers regarding their motives. We assume that self-interest governs both their choice of subject, and the way in which that subject is treated. We are less likely to make similar attributions regarding non-autobiographical documentary (though we are probably often wrong). As a result we scrutinize the ethics of autobiographical film-makers more closely than in general. As in any effort, extra close scrutiny leads to the perception (often false) of what it is we search for.

The problem is exacerbated by a cultural resistance to disclosure of all but the most superficial aspects of family life. When confronted by less sanitized visions of other families presented in autobiographical film, we feel embarrassed, as if confronted by 'overdisclosure.' Though such disclosure is often justified in other contexts, cultural assumptions about the privacy of family life denies autobiographical film-makers the justification for exposure which non-autobiographical filmmakers rely on—the public's right to know.

In this way the taboo against disclosure, a cultural sense that the disclosure is not justified, casts further doubt on the motives of the film-makers and leads many viewers to evaluate autobiographical film-makers more harshly than others. In contrast the authors argue that the justification of autobiographical film (above and beyond its artistic or

self-expressive merits) lies exactly in its value as an educative and humanizing behind-the-scenes view of others.

Lastly, regarding construction, autobiographical film-makers seem especially forthright in their acknowledgment that the films they offer us are personal constructed visions of reality. Though no film is objective, autobiographical filmmakers are, on the whole, more up-front than others in the recognition and presentation of their own impact on the subjects and events they film. In offering themselves as part of the interaction, they demonstrate the constructive nature of film-making. The impact of this lesson should not be underestimated. It is crucial both for film-makers who often pretend (to themselves or others) that film is objective, and for viewers who believe that what they see is "reality." Autobiographical film can demonstrate how social interaction is constructive, how we influence and shape events around us. This has important implications for daily life, implications regarding social responsibility and ethics, whether or not a camera is present.

Notes

1. This essay will not concern itself with the subject's ethical obligations to the film-maker.

2. Most of the remarks concerning autobiographical films will confine themselves to those which are direct cinema or cinéma vérité films (Katz, 1978). Not included in this discussion are experimental, avant-garde, or non-linear films which arise from the diary, notebook, or journal tradition (e.g. works by Bruce Baillie, Stan Brakhage, Andrew Noren, the Mekas Brothers, Jerome Hill, and Howard Guttenplan). Many of these and similar works have been discussed under the rubric of "home movies" (Chalfen, 1975).

3. Similarly, Hugh Hefner is reported to have responded favorably to *The Most* (Gordon Sheppard and Richard Ballentine's filmic biography of him). Critics and audiences saw the film and found him a crass egomaniac. It was only when others saw him as he did not see himself that he objected to the filmic portrait.

4. Her "confession," though probably honest, is self-serving.

5. There have been a few major documentary films on television that deal with families: *An American Family, Six American Families,* and three of the "Middletown" series (*Community of Praise, Family Business,* and *Second Time Around. Seventeen,* the most interesting of the "Middletown" series was never aired). Unfortunately these are closer in both form and approach to fictional films (or even sitcoms) than to autobiographical works—

they are systematically endistanced, episodic, and, with the exception of *An American Family,* lacking in intimacy.

6. Some theorists and film-makers argue that for documentary to be truly ethical, collaboration must extend to editing, distribution, and promotion. This relates to disclosure and control discussed above.

References

Berger, P. L., and Luckman, T. 1967. *The Social Construction of Reality.* New York: Doubleday Anchor.

Blumer, Herbert. 1969. *Symbolic Interactionism.* Englewood Cliffs, N.J.: Prentice-Hall.

Bruner, J. S. 1957. "On Going Beyond the Information Given." *Psychological Review.* 64: 123–52.

Chalfen, Richard. 1975. "Cinéma Naiveté: A Study of Home Moviemaking as Visual Communication. *Studies in the Anthropology of Visual Communication.* 2(2): 87–103.

Goffman, Erving. 1959. *The Presentation of Self in Everyday Life.* New York: Doubleday Anchor.

Katz, John Stuart, ed. 1978a. *Autobiography: Film, Video, Photography.* Toronto: Art Gallery of Ontario.

Katz, John Stuart. 1978b. "Autobiographical Film." In *Autobiography: Film, Video, Photography,* Ed. J. S. Katz, pp. 10–15. Toronto: Art Galley of Ontario.

Katz, Judith Milstein. 1981. *Why Don't You Listen to What I'm Not Saying?* New York: Doubleday Anchor.

Kelly, George A. 1955. *The Psychology of Personal Construct.* New York: W. W. Norton and Co.

Linton, James M. 1976. "The Moral Dimension in Documentary." *Journal of the University Film Association* XXVIII, 2: 17–22.

Loud, Pat, with Nora Johnson. 1974. *Pat Loud: A Woman's Story.* New York: Bantam Books.

Pryluck, Calvin. 1976. "Ultimately We Are All Outsiders: The Ethics of Documentary Filming." *Journal of the University Film Association* XXVIII, 1: 21–29.

Rosenthal, Alan. 1980. *The Documentary Conscience: A Casebook in Film Making.* Berkeley: University of California Press.

Ruby, Jay. 1981. Image Ethics-or-"They're going to put me in the movies. They're going to make a big star out of me . . ." Edward R. Murrow Symposium on Ethical and Social Issues for an Information Society. Pullman, Washington.

Weis, Elisabeth. 1975. "Family Portraits." *American Film* I, 12: 54–59.

7

Images as Property

JOHN DAVID VIERA

The invention of the photographic apparatus and subsequent film and television image-fixation systems separated the visual image from its real-life subject and allowed for the mass production and consumption of images far beyond the range of painting and lithography. The mechanical reproduction of our visual world made possible the commoditization of the image. Actors' performances, individual visages, dances, rituals, nature, vacation trips, the family, in short the entire visual phenomenological world, were capable of being fixed in material forms and exploited over time.

The impact of all this on the individual has been startling. The average citizen, whose visual aspects had always been essentially public domain—a transient phenomena in the minds of others, free for the looking—not only became "Kodaktized," but he encountered a variety of problems in his relationship to society in the form of how to protect his/her privacy from the omniscient media, and how to prevent the exploitation of his image by others for their own commercial uses, as with photographs used in advertising.

Famous persons also had their relations to fans and society altered. For one thing, the new media/art forms created new types of entertainment stars (cf. the rise of motion picture stars in the teens and twenties or the rise to stardom of broadcast journalists today). For another, the important historical figure, the notorious, the hero, and the celebrity alike, became the central content of the new image society, to the extent that the almost total loss of privacy became the price for media stardom. Fixation of images also enhanced the possibilities for society-wide, commercial exploitations of "personalities" in whom the public, for however short a term, was interested.

This expansion of the image domain generated a number of legal and ethical problems. In the legal area, two doctrines protecting personhood developed in this century: the right of privacy and the more recent property right in personality called the right of publicity. Both developments center on the concept of the 'individual' and what that 'individual' may assert as private, a feature of personhood, and what s/he must concede to society and the higher good of the group.

A range of ethical concerns has surfaced as well, often in conflict with the established legal norms governing the 'individual.' One central ethical dilemma involves the question of image *ownership:* who does own one's image and who should own it? Another area is the ethics of image *use* and the relation between the subject portrayed and the user of his/her image. Tied in with this is the problem of delineating the scope of the subject's authorization and whether consent, once given, is revocable. Another area of concern centers on *how* images are gathered, since many film and photographic techniques involve means that violate our sense of individual privacy—for example, hidden cameras and microphones or spying via telephoto lenses.

This essay investigates the questions of who owns a person's image and who should own it. I shall point out where the law (which grants minimal individual protections in this area) and ethics diverge as our society attempts to deal with these new media-society problems. Following the traditional legal distinction, Part I will concentrate on privacy and the individual and Part II on publicity and the celebrity. Part III will deal with the relation between the First Amendment and a celebrity's right to control his/her "life story" in the context of docudramas.

Privacy and the Individual

Privacy and publicity represent complementary relationships between the individual and society. Privacy is passive, something guaranteed to the individual by society's legal and political concepts. The individual says: "You can't do that. I have a certain privacy domain you can't make public." Nothing proprietary is assumed, just a socially granted and legally protected right.

Publicity, on the other hand, is something demanded by the individual. Unlike privacy, which is passive, publicity is assertive. In the case of publicity, the individual says: "I own that. It's my property and society should protect it." This is obviously a more, aggressive position.

It also implies that the image being protected has economic value, usually the case only with celebrities.

Prior to the right of privacy, which was explicitly formulated in 1890, protections for the individual were centered on physical well-being (assault and battery) and reputation (libel and slander). Individual property rights had also been recognized in artistic creation, photographic likeness, and personal history, though these recognitions were in the minority.

With the concept of privacy came the idea of "inviolate personality," the notion that the individual had the right to be an individual, with his/her own unique and secret, private side. Interestingly, this "need" for an expansion of the individual's domain was a reaction to life in the nascent media society of the late nineteenth century.[1]

The right of privacy is essentially the right to be left alone, free from unwanted publicity. The press privilege represents a limit on the boundaries of an individual's privacy. Generally, broadcasters can photograph and report on any matter of legitimate public or general interest, particularly where a public person is involved. Obviously news photos are privileged. Other educational and informational portrayals, such as in documentaries and "soft news," are also generally privileged. Fictional uses, such as in feature films, are less clear since the producer may lose the privilege if it appears he is exploiting an individual for his own commercial gain.

Private persons in private places are relatively well protected. But if they enter a public place (a street, a store) they are usually said to have lost their privacy rights. The mass media (and individual) privilege to photograph persons in public places and to use such photos in factual-type reportage is protected, even if the person is unaware of being photographed.[2] This even includes unauthorized man-in-the-street photos used to illustrate feature articles that put the subject in a context inconsistent with his values and opinions.[3]

In contrast, the privilege to cover "public figures"—public officials, celebrities, notorious persons thrown into the limelight—is almost unlimited. A public figure has few privacy rights.[4] With stars, politicians, athletes, and historical figures, this seems fair; but what about those individuals who are *involuntarily* thrown into the public limelight, for example, victims of crime? It is in this area that ethical concerns arise, but not legal ones. The media is generally free to report such matters, even for years after the event.[5] Besides the press, artists, documentarians, film and video makers also assert claims to an individual's visual image.

An overpowering, omniscient, minority-controlled media is always a danger to both the individual and society; therefore, limits on the press privilege have been delineated. They are particularly important in light of recent developments in the electronic media such as voice editing techniques and computer-controlled photographic enhancement and manipulation systems. For example, consider the motion picture, *Zelig,* and its ability to intermix the present and past while hiding the manipulation.

The conflict between the individual's right to privacy and the use of his/her historical image-continuum by others in documentaries, docudramas, and feature films arises because our lives have public and private aspects. Courts have been forced to draw the boundary between what is private (protected) and public. Courts have had to balance intrusions on individual privacy, the rights of media producers to create from reality-based data, and the needs of the mass audience to know. Judges can only draw these boundaries by reference to internal moral standards and external ethical canons, often buried under historical traditions of law. In attempting to adjudicate rights in this area, the law has essentially taken ethical positions, forbidding commercial exploitations on the one hand, but permitting extensive unauthorized uses in news, documentary, and docudrama.

Ownership of Image

The standard contractual relationship between subject and photographer/film-maker works to the disadvantage of the subject in a number of ways. Typically, a person who consents to being photographed or filmed signs a release granting the image-fixer the rights to any and all uses of the image in perpetuity, in any medium now known or ever developed. Usually a person signs these waivers for a nominal sum, say one dollar. The release works as a waiver of privacy rights. The photographer is the owner of the negative and, hence, the particular concrete image.

Current practices are unfair. This is because the ordinary person does not share in subsequent increases in the economic value of the photo as professional models do via residuals. For example, suppose a person consents to being filmed for a documentary on miners. The photographer may freely use the photo in a magazine article, sell it to a picture agency, sell it to another film producer for use in a documentary on miners, or sell the print to a collector. It is possible that, over time, the photo could generate revenues of several thousand dol-

lars, none of which would go to the subject unless s/he had insisted upon those conditions in his/her waiver. Most likely, the subject just signed the standard waiver and sold his/her image for one dollar. Not only does the subject not share in the economic benefits flowing from the photo, s/he loses any control as to the political and social contexts in which the image may be placed.

Some of the most famous photographs in this century have been of the above, documentary, man-in-the-street type. Consider the work of the Farm Security Administration and their documentation of the Depression. Several of those images have been widely disseminated throughout our society and currently function as symbols of the Depression. A few photographers, for example, Dorothea Lange, made careers out of those photos. Yet the subjects gained no economic benefits from their loss of privacy and subjection to eternal, symbolic, image existences. The famous photo by Lange, "Migrant Mother," is one such example. On the other hand, society could claim that such uses of images—to document our national heritage—are of such value that it becomes a civic duty to be photographed.

There is also the issue of consent buried in these sorts of situations. When you consent to having your photo taken, you are probably not considering the full implications of the release. As mentioned, the photographer may sell the photo to a picture agency where it may have a media half-life of many years. He might also place it in a context alien to you as subject. Your most basic values may be contradicted by how the photo is used. A media-naive person all too often releases his privacy for a nominal amount, unaware of the potential, perpetual media-life the image might have.

On the other side of the coin, society presumably wants to encourage photographic art and such uses as photographic exhibitions and documentation of historical events. The almost automatic waiver system functions to promote that goal. We would be a poorer world absent the work of Cartier-Bresson who built his art from mostly unauthorized, often secretly snapped, documentary photographs.

There are good arguments for both subject and media producer on this question. Perhaps the only solution, as society becomes more 'mediatized,' is the institution of a compulsory license scheme for images, whereby consenting and non-consenting subjects alike would share in subsequent economic benefits via royalties. On the other hand, a photographer might well argue that the value in a photograph derives not from the subject, but from the artist.

It must be remembered that photographers themselves (and more

often so, painters) are generally excluded from sharing in the subsequent rise in value of their work also. Most of the money made in the resale of paintings and photographs goes to investors/owners and galleries. Of course, this situation also presents serious ethical difficulties. Current commercial practices, which are quite legal, are innately unfair. Attempts to correct this situation through Fine Art Residuals legislation (*droit de suite*) are only beginning to bring the U.S. into line with European countries.

Early Notions About Use of Image

As said previously, privacy is a right guaranteed by society which allows the individual to have a core "personality domain" in the midst of the social context in which s/he exists. The 1902 case of *Roberson v. The Rochester Folding Box, Co.*[6] exemplifies early twentieth-century judicial notions about privacy and individual control of image. The Box Company had used Roberson's baby picture, without her consent, on a calendar advertising the company's flour mill. She sued for "injury to feelings."

The court refused to recognize a right of privacy and could find no other basis for relief. Roberson did not claim she had been libeled. The likeness, in fact, was flattering to her. Today, of course, the claim would not be for "injured feelings," but rather for commercial appropriation of name/likeness.

The *Roberson* decision became historically important because as a result, the New York legislature passed the New York Privacy Statute.[7] A dissenting judge in *Roberson* expressed the view more prevalent today. He used property and proprietary concepts in discussing a person's rights to his image. It was assumed that Roberson's image belonged to her initially.

> I think that this plaintiff has the same property in the right to be protected against the use of her face for defendant's commercial purposes, as she would have, if they were publishing her literary compositions. The right would be conceded, if she had sat for her photograph; but if her face or her portraiture has a value, the value is hers exclusively; until the use be granted away to the public.[8]

In 1905, the state of Georgia in a case involving a similar unauthorized use of a person's image in advertising, first recognized the right of privacy as an independent personal right.[9] Subsequently, in

1907, a New Jersey court laid out what today is the ordinary right the individual has to his name and likeness in commercial-use situations.

> If a man's name be his own property, and no less an authority than the United States Supreme Court says it is . . . difficult to understand why the peculiar cast of one's features is not also one's property, and why its pecuniary value, if it has one, does not belong to its owner rather than to the person seeking to make an unauthorized use of it.[10]

Even at this early date, there was a tendency to protect against unauthorized commercial exploitations while intermixing notions of privacy as personal and proprietary. One large loophole became a legal truism and that was that famous, public persons had lost their right to privacy, even where there was an unauthorized advertising use.

In the 1942 Texas case, *O'Brien v. Pabst Sales Co.,*[11] plaintiff David O'Brien, a famous football player of the time who had been picked as an All-American in 1938, sued the Pabst Blue Ribbon Beer Company. Pabst Blue Ribbon had been distributing yearly football calendars with photos of the All-Americans prominenly featured amidst the ads for Pabst beer. Today we would require that Pabst secure O'Brien's permission, but the court in 1942 found that even if:

> the mere use of one's picture in truthful, repectful advertising, would be an actionable invasion of privacy in the case of a private person, the use here was not, as to plaintiff, such an invasion, for as a result of his activities and prowess in football, his chosen field, and their nationwide and deliberate publicizing with his consent and in his interest, he was no longer, as to them, a private but a public person, and as to their additional publication he had no right of privacy.[12]

The decision exemplifies how public figures were treated by judges, the theory being simply that anyone who promoted himself as a star or famous person or athletic hero had waived his right to privacy. In the case of O'Brien, this was held in spite of the fact that O'Brien established that he worked with an organization whose goal was the elimination of alcoholic consumption amongst young people and that he, O'Brien, had refused to endorse beer ads in the past and was ashamed of the implications that might arise from his photo being on the calendar. The court emphasized that O'Brien could prove no pecuniary damages.

Ethically, to allow this use of O'Brien's photograph seems wrong,

but legally, Pabst was on solid ground. It had purchased O'Brien's photo from the publicity department of Texas Christian University, where O'Brien had attended when All-American. Besides, the lower court had held, in a somewhat naive view of the power of personal endorsements:

> [T]here was no representation or suggestion of any kind that O'Brien or any of the other football celebrities whose picture it showed were beer drinkers or were recommending its drinking to others; the business of making and selling beer is a legitimate and eminently respectable business and people of all walks and views in life, without injury to or reflection upon themselves, drink it, and that any association of O'Brien's picture with a glass of beer could not possibly disgrace or reflect upon or cause him damage.[13]

It would take plaintiffs another eleven years to establish the concept of the right of publicity which would give image control and ownership back to the famous person on a basis equivalent to the private individual's control.

Current Privacy Parameters

The right of privacy is a state-granted right, thus, the scope of the right varies from state to state. However, most follow a standard similar to the Restatement of Law Sec. 652(d) which is:

> That a person is liable for invasion of privacy if the matter publicized is:
>
> (A) Highly offensive to a reasonable person,
> *and*
> (B) Not of legitimate concern to the public.

In cases where falsity is an issue and the person doing the publishing is a media organization, as is almost always the case, the plaintiff must also show that the organization intentionally, or with reckless disregard for the truth, made the publication. This is the same standard applied to allegations of media libel and one that makes it very difficult to win against a media defendant for invasion of privacy, a problem particularly vexing for stars who are continually laid out in front of the public by *National Enquirer*–type magazines.[14]

The famous writer on torts, Prosser, identified four categories of privacy invasions: (1) intrusions, such as wire taps or trespasses; (2)

the public disclosure of private facts, where the issue is always whether the facts were truly "private" or whether the plaintiff had lost his privacy cloak; (3) false light, the publication tends to place the plaintiff in a position, as with O'Brien, of appearing to endorse or hold a view he does not in fact hold; and (4) the appropriation of name or likeness, which we have discussed above.

The above legal standards give little value to individual privacy rights outside of commercial appropriations of name or image. Throughout the century, privacy protection has only been begrudgingly granted by judges and then only under outrageous circumstances. A look at the famous *Farmers' Market Lovers* case is illustrative of judicial attitudes.

This 1953 California Supreme Court case involved a husband and wife whose photo had been taken without their knowledge, little alone their consent, while they were relaxing at work in Los Angeles' Farmers' Market. The photographer was Cartier-Bresson. The photo revealed the couple seated in an affectionate pose at their place of business, an ice cream concession.

The photograph was originally used in a full page blowup in *Harper's Bazaar* in a 1947 article entitled "And So the World Goes 'Round," a short commentary centering on the idea that love makes the world go around. Plaintiffs were presented as the quintessential "couple in love."

The publishers of *Harper's Bazaar* subsequently sold the photo to the *Ladies' Home Journal* which, in 1949, used it to illustrate an article on "Love" which claimed that of the several kinds of love, love at first sight was 100 percent sexual attraction and sure to end in divorce. The photo was used to symbolize this love-at-first sight syndrome and was accompanied by the following caption: "Publicized as glamorous, desirable, 'love at first sight' is a bad risk."[15]

Plaintiffs objected to this use by the *Ladies' Home Journal* and contended that they were depicted in an uncomplimentary pose, that their right of privacy had been invaded, and that they had been subjected to humiliation and annoyance to the sum of $25,000. The case was decided upon a procedural ground, but the California Supreme Court took the opportunity to state its position on the right of privacy:

> The recognition of the plaintiffs' right to proceed involves the further observation that mere publication of the photograph standing alone does not constitute an actionable invasion of plaintiffs' right of privacy. . . . The right of privacy may not be extended to prohibit *any* publication of matter which may be of public or general interest.[16]

The Supreme Court noted that the photo had not been surreptitiously snapped on private property, but had captured a pose voluntarily assumed in a public marketplace.

> By their own voluntary action plaintifls waived their right of privacy so far as their particular public pose was assumed for "there can be no privacy in that which is already public."[17]

The court said that the effect of the photograph was merely to extend and increase the number of members of the public who could view plaintiffs in their romantic pose. Their affection had in effect become part of the public domain. Once part of the public domain, they could no longer later "rescind their waiver and attempt to assert a right of privacy."[18] As well, the court noted there was nothing particularly offensive about the photograph. If anything the plaintiffs were shown in a complimentary light. The event disclosed a romantic couple, something so ordinary as to have no need for protection.

The court made no mention of the fact that perhaps plaintiffs "owned" their image. The court said that to find that plaintiffs had the right to prevent publication of a voluntary pose taken in a public place with nothing offensive about it, would mean that they had the absolute legal right to prevent the publication of their photograph. This might not be such a bad idea on an ethical scale, since the publisher could easily have utilized models and posed them for the image, particularly where, as here, the image was used for its entertainment value not its news authenticity.

The one dissenting justice noted that the fact that they revealed their intimacy to a small group of people in the Farmers' Market, perhaps people who knew them or worked with them, did not mean that they intended their photo be conveyed to millions of readers in the publishers' magazines.[19]

> In effect the majority holding means that anything anyone does outside of his own home is with consent to the publication thereof, because, under those circumstances he waives his right of privacy even though there is no news value in the event.[20]

With few exceptions, the majority holding in the *Farmers' Market* case is still the law today. This "public place" doctrine coupled with the press privilege has virtually eliminated effective recovery for media intrusions on individual privacy.

Personality as Property

The rise of the mass media and the efficacy of advertising created the possibility for exploitation of public personalities in the form of merchandising rights. Individuals, particularly entertainment and sports stars, commoditized their images, separated their personalities (which privacy would protect) from their public personae and deliberately exploited the latter in a variety of concrete forms (from merchandising and personal endorsements to posters and fan clubs).

Such media images represent a new form of intangible intellectual property. They exist in the minds of others and their value derives from the public's willingness to buy concrete copies (posters, magazines, music videos) or pay to see the celebrity-image in films or on television. Media images exist society-wide in a shared cultural plane. For example, we all have a mental image of certain famous people or stars such as Elvis Presley.

Ownership claims to non-concrete, transcendent aspects of personality (such as a star image or unique character) have been the source of much legal confusion. Protection of intangibles runs counter to our society's concretistic, empiricist bias. On the other hand, our sense of fairness tells us the person should own his image, at least in the commercial context.

Courts today, following their sense of morality, have striven to protect these images with neighboring legal doctrines (privacy, copyright, unfair competition), while slowly hammering out a new doctrine specifically geared for the protection of an individual's intangible value—his/her right of publicity. Other courts have resisted the new expansion and have refused to recognize the property aspects of a person's image.

Since the value of one's image is related to the degree of one's fame, only celebrities have valuable media images. Celebrities have attempted to expand control over their images in a variety of contexts: from claims to personality-type, name, and character-portrayals ("Dracula"), to attempts to control the commercial exploitation of the live star-image ("Elvis"). Stars even assert ownership over their life stories in a docudrama area by threatening to sue the media. In this section I shall discuss representative examples of character claims ("Dracula") and live image claims ("Elvis"). The docudrama assertions will be examined below.

Who Owns "Dracula"?

From the days of radio and movie serials to current television series and film sequels, the industry has long recognized and fought over the rights to use a certain "character" in a production. Characters are a valuable form of media image. The law pertaining to "characters" is likely to be the law applied to "media images."

It is undeniable that characters have value. The law, however, provides little protection for characters. Copyright does not protect characters independent of the underlying work unless they are concrete expressions (animated figures like Mickey Mouse). What then happens if an individual so endows a character-type with his/her specific, unique, and particular concrete features that this expression in effect becomes the character-type? And what if that specific character-expression is part of a film, but of such value outside the film, that the image per se is merchandisable? Can the actor claim his character-expression back from the film's copyright holder? These are the complicated questions that faced the courts in the Bela Lugosi/"Count Dracula" series of cases.[21]

An examination of the "Dracula" saga reveals many of the law's tacit premises. There may have been an historical "Count Dracula" from the sixteenth century or so and, of course, the archetypal "Vampire" has been around at least since the early Christian era. Who owns this character? Our law posits: no one.

In 1897 Bram Stoker wrote a novel, *Dracula*. We allow him to copyright the novel and under that legal umbrella the expressions of the characters therein. Stoker does not own the "Dracula" character-type but the concrete expression of Dracula that he has created (in the case of a novel, Stoker owns his verbal descriptions of Dracula— nothing else—and even that only for a limited time span). Others are quite free to write about "Draculas" and certainly about Counts who are vampires and wear capes, since the essence/idea of vampire and Dracula belongs to all.

Stoker's novel is a concrete expression, a "writing" under the copyright laws, and incorporates plot, sequence, and a host of other additions to Dracula so that we grant him the more general right to prevent others from copying his novel, that is, from creating derivative works based on his plot, characters, and structure. Unless a novel is in the public domain, film producers/distributors will purchase the right to make and exhibit a film (film rights) and possibly subsequent films (sequels). The film is a derivative work and is itself independently

copyrightable, although its copyright only extends to those portions that are new, unique, original, and different from the underlying work (the novel).

In 1931, Universal made its film and copyrighted that. It then owned all the new "expressions" it had added to the novel. The character "Dracula" still belongs to all, but you cannot copy the particular expressions as embodied in the novel or the film. This means you can make a new film about "Dracula" the vampire and he can have strange teeth, wear a black cape and speak in an East European accent (because that's all just vampireness), but he can't look or talk exactly like Bela Lugosi in Universal's film.

To make its film, Universal had to contract with Lugosi for certain of his rights/claims to his image (acts, poses, plays, and appearances). In turn, Universal paid Lugosi for his performance. The actual contract reads as follows:

> The producer shall have the right to photograph and/or otherwise produce, reproduce, transmit, exhibit, distribute, and exploit in connection with the said photoplay *any and all of the artist's acts, poses, plays and appearances of any* and all kinds hereunder. . . . The producer shall likewise have the right to use and give publicity to the artist's *name and likeness, photographic* or otherwise . . . in connection with the advertising and exploitation of said photoplay.[22] [emphasis added]

What actually happened with the film is history. Lugosi was so good that his interpretation of "Count Dracula" (his character-expression) became synonymous with "Dracula" the character-type. Lugosi's expression became a transcendent media-image which completely escaped the copyrighted film. Once Lugosi's image and manner of speaking reached this cultural status, Universal attempted to exploit that value.

In 1960, Universal began to license its stable of horror film "characters" and their likenesses. Universal controlled "The Wolfman," "The Mummy," "The Hunchback," and others beside "Count Dracula." Authorized manufacturers tied these character-images to a variety of products: shirts, games, kites, and Halloween masks and costumes. In the case of "Dracula," Universal licensed Lugosi's likeness as it appeared in their film.

All of this seemed quite natural. Universal owned the copyright to the films and hence, presumably, the right to exploit the characters from the films. No actor complained of being exploited, not even Lugosi; probably because that was how it had always been. An actor tra-

ditionally lost all rights to his performance and character-expression once it was in a film.

In the case of certain types of character-expressions this is probably the way it should be. For example, to merchandise the "Wolfman" is to merchandise the creature's costume and makeup as developed by studio personnel, not the actor's likeness and performance. But "Count Dracula" is different. With that character you are merchandising Lugosi's image and likeness along with the cape and costume. This, according to Lugosi's widow and son (the plaintiffs in the case), constituted both a violation of the original contract and an invasion of their rights (as heirs) to Lugosi's "property." The widow and son went to court in 1972 to recover Universal's past profits from its "Dracula" merchandising program and to enjoin future unauthorized licensing of Lugosi's image.

The first issue raised was exactly what did Lugosi grant to Universal in the original contract? The contracts themselves (both 1930 and 1936) are silent as to merchandising rights for Lugosi's name, likeness, and appearance as "Count Dracula." Does this mean that Lugosi did not grant them to Universal, or does this mean that he failed to reserve them for himself and thus they belong to Universal?

> . . . Universal Pictures was given the right to reproduce and exploit in connection with the photoplay "Dracula" any and all of the actor's "acts, poses, plays and appearances of any and all kinds," and to use the actor's "name and likeness, photographic or otherwise" *in connection with the advertising and exploitation of said photoplay.* . . . [t]he Bela Lugosi contract, by express language, limits the producer's right to use the actor's acts, poses, appearances, and likeness in connection with the photoplay "Dracula" or in connection with the advertising and exploitation of this photoplay.[23]

Thus, the trial ruled Lugosi had retained all merchandising rights to his "acts, poses, appearances and likeness" as "Count Dracula." Universal only got what it had bought: the rights to Lugosi's image in the film and advertising therefore. Lugosi himself had owned the rights to other uses of his particular character expression, but did those rights survive his death?

The basic theory of privacy is that a person's feelings and peace of mind, the "inviolate personality," should be protected. Privacy does not concern itself with property, business, or economic interests. Privacy rights die with the individual. Property rights, however, transcend his death. After discussing the case precedents, the trial court followed

the property view and held that Lugosi's right to control the publicity value of his name, likeness, appearance, and personality should be considered separate and apart from his right of privacy.

The court concluded its discussion of the "Dracula" character by pointing out that Universal's copyright gave them precious little to merchandise apart from Lugosi's specific likeness. The specific Lugosi expression was the thing of value. That was why manufacturers were willing to pay license fees to use a character already in the public domain.

> . . . [T]he very essence of the Count Dracula character in the photoplay, *Dracula* produced by defendant, consists of the *characteristics, makeup, appearance and mannerisms* of Bela Lugosi in the role. Only the dress is not created by the actor. In licensing the use of the Count Dracula character's *characteristics, makeup, appearance and mannerisms,* of necessity Bela Lugosi's appearance and likeness in the role are the things being licensed. The horror character, Count Dracula, as taken from the films, *Dracula* and *Dracula's Daughter,* cannot be divorced from Bela Lugosi's appearance in the role.[24]

Needless to say, Universal appealed the decision. While tacitly agreeing that the right of publicity *could* be a property right, the appellate court held, however, that what Lugosi had actually had was the *personal right to convert* his image-value into a property right.[25] Because Lugosi had not exploited his image via merchandising while alive, he had not actually converted the right from personal to property. The right to convert had expired with him in 1956 and couldn't pass to his heirs. Universal was thus the owner of Lugosi's specific character-expression, of the "Dracula" media-image, by default. Universal was not only free to use Lugosi's image, but it could prevent use by others by virtue of its film copyright.

The appellate court wanted more business and property-like activity on Lugosi's part before it would recognize his right to control the value of his media-image. This is fine as long as we realize the arbitrariness of this position; for example Lugosi did exploit his image in a variety of ways (via film and a wax bust), at what point did his property right crystallize? The court is actually saying that the copyright holder gets the rights to character expressions not specifically allocated in a contract. No mention was made of any possible public claim to the media-image it had helped create. The effect of the reversal is to give exclusive rights in the Lugosi media-image to Universal at the expense of both his heirs and society.[26]

Elvis Presley and The Right of Publicity

> Elvis was an American original who . . . was
> merchandised as "a commodity, a can of tomato
> soup right off the conveyor belt."
>
> *People Magazine*[27]

Perhaps the most exploited imago to be found in the case law is Elvis-the-King, whose contractual, economic, and merchandising empire fell apart only with his untimely death when various licensees suddenly found themselves with nothing as unlicensed rivals churned out the Elvis memorabilia by the boxcar load.

With Elvis, there is no question that he exploited his image while alive and thus the issues of descent and transferability have to be faced. As might be expected, the courts arrived at contradictory decisions with the result that the 'law' and scope of protection for the Elvis image varies from state to state.

Federal courts applying New York law have been at the forefront in developing the right of publicity. Confronted with a set of facts that show the deliberate development of a valuable media image subsequently pirated by outsiders, these courts hammered out the right of publicity, a right which protects a star's right to exploit his/her name and image by converting his personality into property.

In the case of Elvis, a typical New York result is found in the *Creative Card* case, in which, on October 12, 1977, slightly less than two months after Elvis Presley died, a Federal court granted a preliminary injunction enjoining Creative Card from "manufacturing, distributing, selling or by any other means profiting from souvenir merchandise bearing the name or likeness of the late Elvis Presley. . . ."[28] Defendants challenged the validity of the August 18, 1977, license agreement on the grounds that it had occurred two days after Elvis's death and that, therefore, there had been nothing to assign. The court concluded that "the 'right of publicity' inhered in and was exercised by Elvis Presley in his lifetime, that it was assignable by him and was so assigned, that it survived his death and was capable of further assignment."[29]

The *Creative Card* court, aware that the "Lugosi" case in California had denied descent of the right of publicity, relied on a case involving Laurel and Hardy under New York law and said, "There is no reason why the valuable right of publicity—*clearly exercised by and financially benefiting Elvis Presley in life*—should not descend at death

like any other tangible property right."[30] The court clearly differentiated between Elvis-the-person and Elvis-the-image. "The instant action does not present the Presley name or his face *enhancing* a product—Presley *is* the product."[31]

But "Elvis" ran into problems back home in Memphis, Tennessee. There, the Sixth Circuit Court of Appeals, interpreting Tennessee law, ruled straight out that the right of publicity was not devisable and that "after death the opportunity for gain shifts to the public domain, where it is equally open to all."[32] In this case, the Memphis Development Foundation, a nonprofit corporation, brought suit to enjoin an "Elvis" licensee's interference with its attempts to advertise and sell small statuettes of Elvis to raise money for a large statue of Elvis to be given to the city of Memphis. At the time of the case, the city had no relationship with the Development Foundation.

The *Memphis Development* court phrased the central question in the case as "Who is the heir of fame?" and then went on to state that a person's fame belongs to the public at large (read commercial competitors). "Fame often is fortuitious and fleeting. It always depends on the participation of the public in the creation of an image."[33] The court pointed out that media reportage plays a large role in the spreading of fame and that fame may arise out of bad and good conduct alike. The court said that all these reasons "combine to create serious reservations about making fame the permanent right of a few individuals to the exclusion of the general public."[34]

The *Memphis Development* court viewed the right of publicity as a new kind of *personal* right and stated that "the memory, name and pictures of famous individuals should be regarded as a common asset to be shared, an economic opportunity available in the free market system."[35] The court seems to confuse "fame" with "commercialized image" and nowhere does it discuss or refute the theories and rationales put forward by the proponents of the property side of the argument in New York.

After *Memphis Development*, we were left with two Federal Circuits in direct opposition on the same set of issues. The situation got worse, however, when a Second Circuit court ruled that the Sixth Circuit's holding should be applied to a New York case which had been in the courts since 1977.[36] To complicate matters, a Tennessee lower state court ruled that the right of publicity *did* descend in Tennessee.[37] This not only added to the Elvis confusion, but opened up formal issues of court procedure and jurisdiction whose importance (to the courts) may overwhelm the substantive issues themselves.

In *Zacchini v. Scripps-Howard Broadcasting*,[38] the Supreme Court identified the right of publicity as a state right. It has refused to hear the leading "Elvis" cases. Apparently, the Court is prepared to leave the various Federal Circuits at odds over the descendibility issue raised in the right of publicity area. In view of the national character of our media society, this may not be such a good idea since it can lead to the loss of a great deal of time and expense, particularly where one Circuit defers to another Circuit itself merely guessing the true situation under state law. By analogy to copyright, a uniform Federal right of publicity would best serve society's needs.

Ultimately, the New York versus Tennessee conflict represents two differing views as to what constitutes an "individual" and the extent of society's claim to that individual. The decision to give "Elvis" to the public domain, in itself morally noteworthy, is actually an allocation of economic value away from exclusive control by the Presley estate (what Elvis wanted) to license free exploitation rights for other commercial entities.

The Sixth Circuit was certain society's best interests were being served by public domain status, but to argue that the right is personal, and thus terminates with death, is to create a contradiction and to ignore the "purely commercial nature" of the right of publicity. One cannot assign one's defamation rights or one's right to privacy. If the right of publicity is personal, then it should not be assignable (of course, if it is not assignable its value is slight). If we allow assignment, we have allowed the creation of a property right. To deny that right the tradtional scope of other intangible property rights is confusing and vitiates contract tradition.

To allow assignability, but to declare its automatic evaporation at the moment of death, creates more problems than it solves. For one thing, we have altered the stability of long established contract principles. For another, we have created an unnecessary market uncertainty. Elvis might have died at anytime. The price one would be willing to pay for the assignment and the capital one would be willing to invest on speculation would be greatly affected by this termination risk. Also, other assignable, intangible property rights transcend the death of their creator, why should it be any different for the right of publicity?

Hate-enacted Legislative Solution

Legal battles for control over the Elvis media image continued well after that media image had lost much of its immediate value. The slowness of the court system in dealing with the phenomenon (eight years) and the irreconcilability of the two positions indicate a legislative policy is necessary. Several states have taken first steps toward the right of publicity problems with legislation, though there is little uniformity of approach. Of particular interest are the Tennessee and California personhood statutes.[39]

In 1984, Tennessee enacted its "Personal Rights Protection Act" which explicitly provides that an individual has a property right in name, photograph, personality, and likeness that survives death. Though not expanding the image concept to characters and performance style, the Tennessee legislation does provide that "every individual has a property right in the use of his name, photograph or likeness in any medium in any manner." This is a very important clause in that it places initial ownership with the image bearer, thus overruling the current presumption of public domain status for most images. Also the phrase is not limited to celebrity images and arguably could be used to prevent non-commercial, but exploitative, uses of personal images. This statutory property right is assignable and licensable and survives death even if not exploited during life. Unless assigned, it passes to the estate for ten years. A fair-use exemption is provided for news, sports, and public affairs.

California's "Celebrities Rights Act," which became effective January 1, 1985, differs significantly from the Tennessee version. For example, the California statute provides for an after-death duration of fifty years, forty years longer than the Tennessee counterpart. In addition, the explicit list of fair-use exemptions is expanded to include political campaigns, plays, books, films, and works of fine art. The statute also requires a deceased personality's heirs or assignees to register with the state in order for the right to become effective.

Unlike the Tennessee statute which applies to all individuals living and dead, the California version applies only to deceased "personalities." This leaves open the question of who is a "personality." The statute defines a "deceased personality" as "any natural person whose name, voice, signature, photograph or likeness has commercial value at the time of his or her death. . . ." The statute overrules the *Lugosi* majority's conclusion that the right of publicity did not descend in California.

The use of different terms, definitions, and provisions in these two statutes results in separate and independent protection systems with differing degrees of coverage for the same image. If all fifty states enact similar statutes, a national media image, like "Elvis," will still be treated differently in differing jurisdictions even though those jurisdictions are a part of our national media network. Media images are national phenomena. Most are delivered via films, television, and magazines. Though individual state statutes are welcomed, they will tend to Balkanize personhood rights, as happened with the right of publicity case law. Only federal legislation can construct a consistent, all-encompassing statute which would give positive definitions to an individual's privacy rights and proprietary rights to his/her public aspects.

Docudrama: Where First Amendment and Right of Publicity Collide

In theory, the right of publicity applies strictly to commercial exploitations, the type of exploitation of no interest to the First Amendment. Concern has been expressed that stars will attempt to extend the bounds of "commercial" to the point that assertions of their right of publicity will conflict directly with the freedom of the media to report events of public interest. Stars could use the right to shield themselves from public scrutiny and frustrate society's right to know about its cultural icons.

In the leading case, the U.S. Supreme Court ruled that the First Amendment did not shield a television station from liability for showing its viewers Hugo Zacchini's human cannonball act in its entirety (fifteen seconds).[40] Zacchini had performed in public at the local county fair. The Ohio Supreme Court had found a privilege.

> A TV station has a privilege to report in its newscasts matters of legitimate public interest which would otherwise be protected by an individual's right of publicity, unless the actual intent of the TV station was to appropriate the benefit of the publicity for some non-privileged private use, or unless the actual intent was to injure the individual.[41]

The Ohio court interpreted earlier U.S. Supreme Court decisions to mean that the press is privileged to report matters of public interest even "when an individual seeks to publicly exploit his talents while

keeping the benefits private."[42] Zacchini's principal contention was that the station had not merely reported the occurrence of his performance but had "filmed his entire act and displayed that film on television for the public to see and enjoy."[43] The station was, in effect, using the news as a pretext for "entertainment."

The U.S. Supreme Court stated that the right of publicity and the copyright laws have similar goals: to encourage the creation of entertainment. Both also focus on the "right of the individual to reap the reward of his endeavors."[44] In a case like this, the issue was *not* whether the event gets reported at all (which would present First Amendment problems) but only a conflict as to *who* gets to do the publishing, of little direct concern to the public interest. In short, the station could easily and fairly pay for a license to show Zacchini's act. The First Amendment does not "immunize the media when they broadcast a performer's entire act without his consent."[45]

Entertainment as well as news enjoys First Amendment protection, but not to the extent that a television station can appropriate Zacchini's entire performance. Can it then appropriate a star's life story? This is the central issue in docudrama as stars argue that television's uncompensated dramatizations of their "public lives" impact on the economic value of their images.

Most of the cases applicable to docudrama derive from unauthorized biographies in book form. Such cases show that the factual reporting of public persons and events is protected and in the public interest. A star has no "right of biography." Thus, there is no prevention of unauthorized docudramas for public figures. However, this "right" is limited to "factual" public occurrences. Fictionalizations of the private events in such figures' lives are not allowed.

Fact v. Fiction

In a leading case under New York law, a baseball pitcher, Warren Spahn, successfully restrained the publication of an unauthorized biography which contained a mixture of factual and fictionalized material.[46] The book was restrained on the grounds that an unauthorized, fictionalized exploitation of personality for purposes of trade was prohibited by the privacy statutes of New York. A biography with fictional elements held out as true amounted to a reckless disregard for the truth and thus the publisher could be held liable for exploiting Spahn's name. The true, factual portions, based on his public life, were of course publishable.

The court distinguished Spahn's public, professional life from his private life. The public life was available to any biographer. The private life would be protected by the privacy statutes. The fictional elements defendant invented to cover gaps in Spahn's public life were not protected as news.

Defendants claimed they had invented the dialogue and various scenes in good faith to flesh out the known facts and create a good biography.[47] The court found the accuracy of their facts to be so false as to defeat this claim. But this leaves open the question of how then do you portray inner events, emotions, and states of mind as well as the mundane details necessary to take the book past the "report" stage to that of biography? This issue is still unanswered.

The *Leopold v. Levin*[48] case concerned the movie *Compulsion*. Leopold claimed that the producers had knowingly fictionalized part of his crime and that those episodes were offensive and outrageous to the community's sense of decency. The court distinguished *Spahn* on the grounds that there the biography had fictionalized Spahn's private life; but here, Leopold's public life had been fictionalized and this was allowable. Again left open is how does a writer determine what is public and what is private? Aren't all inner moments "private"? By categorizing Leopold as public, the court predetermined the outcome of the case. But this categorization is more likely based on the ethical position that a criminal should not object to subsequent public treatment of his character.

Docudrama

Elizabeth Taylor yesterday filed suit in federal court here against ABC. . . . Taylor said in her request for injunction relief against the broadcast that the fictional made-for-TV film would cause irreparable damage to her by exploiting her name, likeness and public and professional reputation and image. "I am my own commodity and industry. . . . This is my industry and if someone else portrays me and fictionalizes my life, it is taking away from my industry."[49]

The Hollywood Reporter

It is difficult to determine the extent to which a producer can utilize "public" events and the extent, if any, s/he may fictionalize "gaps" in the story and "inner" events of a public person's life. Fiction and docudrama present the same uncertainty. Elizabeth Taylor has aggressively

challenged ABC's right to docudramatize her life by asserting a proprietary interest in her own life-story, a right of biography as it were.

Taylor's central claim is that docudramas about her life compete against the films she chooses to appear in for an audience's attention, that is, that unauthorized docudramas impact unfairly on her means of making a living since she, in effect, is forced to compete against herself (with someone else perhaps garnering the profits).

Taylor's position foregrounds arising contradictions inherent in the relationship between the public's First Amendment "right to know" and this century's expansion of the concept of "personhood," which grants to the individual certain privacy rights (and corresponding power to prevent media attention) and publicity rights.

Competing against Elizabeth Taylor's asserted right to control her life story are the rights of the journalist to document its public aspects, the docudramatist to re-create it, and the feature producer to fictionalize it. Does society have the right to docudramatize its own heroes, its own famous people? Can/should the star be allowed to prevent this?

Obviously, these questions are only answerable by policy positions. The courts' responses have been very consistent here, however.

> Whether the publication involved was factual and biographical or fictional, the right of publicity has not been held to outweigh the value of free expression. Any other conclusion would allow reports and commentaries on the thoughts and conduct of public and prominent persons to be subject to censorship under the guise of preventing the dissipation of the publicity value of a person's identity. Moreover the creation of historical novels and other works inspired by actual events and people would be off limits to the fictional author.[50]

Fiction Films

In 1976 Agatha Christie died. In 1977 film producers made a movie fictionalizing a true incident from her life, a mysterious disappearance in 1926. In the film, the eleven-day hiatus is used to plot the murder of her husband's mistress. In 1978, Agatha Christie's heirs arrived in court on a right of publicity theory.

The court found under New York law that the right of publicity had descended to her heirs and assignees, but then had to face the question of the relation between the right of publicity and expressions in books or movies. The court said:

The question is novel in view of the fact that more so than posters, bubble gum cards, or some other such "merchandise," books and movies are vehicles through which ideas and opinions are disseminated and, as such, have enjoyed certain constitutional protections, not generally accorded "merchandise."[51]

The court stated it was necessary to balance the individual's interests and society's needs. Its holding does not bear too well for Elizabeth Taylor's docudrama claim:

[T]he right of publicity does not attach . . . where a fictionalized account of an event in the life of a public figure is depicted in a novel or a movie, and in such novel or movie it is evident to the public that the events so depicted are fictitious.[52]

Conclusion: The Need for a Federal Personhood Statute

In purely commercial contexts, there is no reason for treating person-as-product images differently from product images. "Who should own these images?"—the creator.

The law carefully distinguishes the private individual from three types of public individuals: the famous, the involuntarily notorious (e.g. victims of crime), and stars (manufactured). The last are big business. Who should own these star media-images—the public who 'creates' them, the producers who exploit them, or the image bearer himself?

Does the public have the right to know about its stars? Of course, but only if the star-image is part of an "expression" (book, film, news) rather than another commercialization (bubble gum cards). Complicated value problems arise at this point. Should the businessman/producer be allowed to exploit our psychological desires/needs projections with his media-image dream-placebos? Does the viewer/consumer have a moral duty not to project his inner existence onto outside media images? These questions are only answerable by reference to the basic values of our society and our preference for free and unfettered expression.

One thing is clear. A star is not an involuntary phenomenon. Star status results from a combination of luck and hard work. The price a star pays for this stardom is the diminution of his/her right to privacy. By capitalizing on society's interest, the star's life becomes a matter of

public concern and public record. Elizabeth Taylor, in her attempts to prevent unauthorized docudramas about her life, is trying to have both stardom and privacy, to have it both ways. This seems intrinsically unfair.

Judicial interpretations of current law, with their reliance on legal case precedent, fail to clearly resolve the media image controversy. Images have both personal and property aspects. What is needed in the legal discourse is a theoretical framework which can provide guidance for the allocation of economic value while ensuring the integrity of the person, a scale capable of differentiating between the use of personal images (implicating privacy concerns and fame issues) and fungible images (triggering ownership claims).

Such a statute would commence by defining and distinguishing personal images from media images, since the interests to be protected are quite distinct, the former being essential to an individual freedom assumed by the First Amendment and the latter, in essence, a commercial property interest.

A personhood statute would allocate initial ownership of both rights to the image bearer and simultaneously define the rights of the media to access those images so the First Amendment's goals would be well served. This would mean that absent a valid consent, waiver, or privilege in the case of a personal image, or a contract in the case of a publicity claim, a copy of a person's image, including name, life story, and other characteristics besides likeness, would be subject to the control of the image bearer in the name of individual integrity and legal personhood.

If the statute presumes that ownership of a media image rests with the image bearer, the legal discourse would have a definite starting point for allocating ownership in disputed cases. This conceptual starting point is what is currently lacking. The statute would have to deal with the question of ownership since an image is often constructed by a variety of "authors." One solution would be to require a claimant (e.g. a film studio) to explicitly contract with the image bearer. This is the common industry practice as between actors and agents/personal managers. Rights in the media image could be severed and divisible and proportioned as rights to a movie are today, as when the director gets ten points, the star ten points of the gross, and so forth.

A registration system could be required in order to establish an ownership claim. One advantage of a statutory allocation would be that in the area of characters like "Dracula," the image bearer's rights

would be given a fairer analysis since the presumption would be that the image bearer, and not the copyright holder, should reap the value from the intangible media image embedded in that character.

Once the media image is declared an intellectual property by statute, devisability is a moot issue. Control and ownership of media images would pass through one's estate like other property interests. In the *Lugosi* case, California's Chief Justice Bird analogized to copyright and argued that the right of publicity should exist, that is, be managed and controllable, for the life of the author plus 50 years. This seems reasonable though many arguments have been made that this limits its entry into the public domain; but public domain arguments usually result from the confusion of celebrity fame with celebrity image exploitation.

The proposed legislation would have to distinguish access to "fame" from commoditization and exploitation uses of that fame. It is difficult to differentiate the two since the celebrity tends to claim that all uses exploit the commercial value of the media image. By differentiating three categories of "famous" images (the newsworthy, the cultural hero, and the celebrity), society can grant public domain status to the first two types and uses, thus preserving traditional media rights to images of the famous, and restrict property status to the fabricated celebrity image.

If, as a society, we are genuinely concerned, as was the *Memphis Development* court, with the rights of the public, then a personhood statute could also provide a compulsory license/royalty scheme for the use of the celebrity media image.[53] Thus, no one would be excluded from use of the "Elvis" image, and its creators/fabricators, though losing the absolute controls available to "owners," would receive fair compensation for their efforts.

Notes

1. Warren and Brandeis, "The Right to Privacy," 4 *Harvard Law Review* 193 (1890).

2. See discussion and annotations in 86 ALR 3d 374, 57 ALR 3d 16.

3. *Arrington v. New York Times,* 8 Media L. Rptr. 1351 (1982).

4. See discussion in W. Prosser, *Law of Torts* (4th ed., 1971), 822–30.

5. See *Leopold v. Levin,* 259 N.E. 2d 250 (1970); and *Sidis v. F-R Pub. Corp.,* 113 F.2d 806 (2d Cir. 1940).

6. 171 N.Y. 538, 64 N.E. 442 (1902).

7. N.Y. Civil Rights Laws, Secs. 50 and 51.

8. 171 N.Y. at 564.

9. *Pavesich v. New England Life Ins. Co.,* 122 Ga. 190, 50 S.E. 68 (1905).

10. *Edison v. Edison Polyform Mfg. Co.,* 73 N.J. Eq. 136, 141 (1907).

11. 124 F.2d 167 (1941).

12. *Id.* at 168.

13. *Id.* at 169.

14. See "Court Reduces Carol Burnett's Award for Libel," *Los Angeles Times,* July 19, 1983. Much of Burnett's saga against the *National Enquirer* is chronicled in the *Los Angeles Times,* 1981–83.

15. *Gill v. Curtis Pub. Co.,* 239 P.2d 630, 632 (1952).

16. *Gill v. Hearst Pub. Co.,* 253 P.2d 441, 443 (1953).

17. *Id.* at 444.

18. *Id.*

19. *Id.* at 446.

20. *Id.*

21. *Lugosi v. Universal Pictures,* 172 USPQ 541 (1972) (the trial case); 139 Cal. Rptr. 35 (1977) (The appellate decision reversing the trial court's ruling in favor of Lugosi's heirs); 25 Cal. 3d 813, 160 Cal. Rptr. 323 (1979) (The California Supreme Court decision upholding the appellate decision in favor of Universal by a 4–3 majority.).

22. 172 USPQ at 542.

23. *Id.* at 543.

24. *Id.* at 553.

25. 139 Cal. Rptr. at 38.

26. See discussion by Chief Justice Bird in dissent commencing at 160 Cal. Rptr. at 332.

27. *People Magazine,* Aug. 31, 1981, p. 19.

28. *Factors Etc., Inc. v. Creative Card Co.,* 444 F. Supp 279, 288 (1977).

29. *Id.* at 282.

30. *Id.* at 284.

31. *Id.* at 283, note 3.

32. *Memphis Development Foundation v. Factors Etc., Inc.,* 616 F.2d 956, 957 (6th Cir. 1980).

33. *Id.* at 959.

34. *Id.*

35. *Id.* at 960.

36. *Factors, Etc., Inc. v. Pro Arts, Inc.,* 652 F.2d 278 (2d Cir. 1981).

37. *Commerce Union Bank v. Coors,* 7 Media L. Rptr. 2204 (1981).

38. 433 U.S. 562, 97 S.Ct. 2849 (1977).

39. California Civil Code, Section 990+3344 (1984); Tennessee Trade Practices Code, 47-25 1101 (1984); Oklahoma, title 21, sec. 839.2 (1983);

Utah, sec. 45-3-1 (1981); Virginia, sec. 8.01-40 (1977) and Florida, sec. 540.08 (1972).

40. 433 U.S. 562, 97 S. Ct. 2849 (1977).

41. 351 N.E. 2d 454, 455 (1976).

42. *Id.* at 461.

43. 433 U.S. at 569.

44. *Id.* at 573.

45. *Id.* at 575.

46. 233 N.E. 2d 840 (1967).

47. *Id.* at 842.

48. 259 N.E. 2d 250 (1970).

49. "The Week in Review," *The Hollywood Reporter,* Oct. 26, 1982, p. 8.

50. *Guglielmi v. Spelling-Goldberg Productions,* 25 Cal. 3d 860, 872, 160 Cal. Rptr. 352, 359 (1979).

51. *Hicks v. Casablanca,* 464 F. Supp 426, 430 (1978).

52. *Id.* at 433.

53. A compulsory license means the user has the right to use the image as long as a royalty is paid to the image owner.

8

A Study in Multiple Forms of Bias

THOMAS BEAUCHAMP AND
STEPHEN KLAIDMAN

"The Uncounted Enemy: A Vietnam Deception," a CBS documentary alleging that General William C. Westmoreland falsified reports of enemy strength, is a textbook case of various forms of bias and distortion that are common to television. What follows is a brief history of the genesis of the program and an analysis of the motives and techniques that shaped its production. We have also included an appendix excerpted from an interview conducted for "The Uncounted Enemy" to illustrate how such material can be manipulated to suit the producer's purposes.

The months leading up to the major North Vietnamese and Vietcong assault known as the Tet offensive at the end of January 1968 were intensely political in the United States. It was a presidential election year, and the predominant campaign issue was the Vitenam War. A consensus was building in the press that the war was unwinnable. President Lyndon B. Johnson was increasingly identified as the chief hawk, and Democrats with presidential aspirations were beginning to attack him. Official reports from the war zone were more encouraging from the president's perspective. In November 1967, the Johnson administration launched a high-powered campaign to spread the word that the tide was turning. Ambassador Ellsworth Bunker, the U.S. envoy in Saigon, Ambassador Robert Komer, the president's special representative for Vietnam, and Gen. William Westmoreland, commander of U.S.

forces in Vietnam, all declared publicly that progress was being made.

Meanwhile, a seemingly less cosmic but closely related contest was being fought. It concerned the size of the enemy in Vietnam, and it centered on a judgment about the political and military weight that should be given to irregular enemy forces facing U.S. and South Vietnamese troops. A key question was whether partially trained and poorly armed irregular units should be lumped together with fully trained and well-armed local and main-force units and included in the running total of enemy strength. This total was the central figure in the overall evaluation of enemy forces and was known as the order of battle. It was treated by the press as an important indicator of the Vietcong and the North Vietnamese army's capacities to continue fighting. The order of battle had considerable political importance. If President Johnson were to be reelected, the American people had to be convinced that the war was going well, which meant that some attrition in enemy force levels had to be shown.

Westmoreland argued then, as he still does today, that new, significantly higher numbers of self-defense militia, secret self-defense militia, and other irregulars being reported by some U.S. civilian and military intelligence analysts should never have been included in the order of battle. He maintained that the units to which those forces belonged lacked offensive capabilities and that their counterparts on the South Vietnamese side had never been counted in the order of battle. He said there was a danger that the press and some officials would misinterpret the higher numbers and mistakenly assume that the United States was losing the war. Such an assumption by the press could affect the upcoming elections.

Sam Adams of the CIA was one of the order-of-battle analysts who had concluded, mainly from captured documents, that more enemy forces existed than had been previously estimated. These forces were usually farmers by day and soldiers by night. Adams discovered that some military intelligence analysts had made estimates lower than his but significantly higher than those carried on the official books. He concluded on the basis of conversations—principally with Col. Gains Hawkins, who was in charge of providing order-of-battle estimates in Saigon—that these estimates were being suppressed for political reasons. After a series of negotiations between intelligence officers of the Military Assistance Command–Vietnam (MACV), headed by Westmoreland, the CIA, and other intelligence units, a compromise on how to calculate the numbers was reached, but it did not satisfy Adams. The key number to be used, the central order-of-battle total, was Westmore-

land's figure of less than 300,000, not Adams's figure of 600,000 or more. The estimated increase in irregular forces was included as a textual note.

A magazine journalist, George Crile, became aware of the controversy in the mid-1970s while working as Washington editor of *Harper's*. He met Adams and encouraged him to write an article expressing his viewpoint. Crile later edited the article, which was published in May 1975.[1] It was based on research Adams had done after failing to get his 600,000-man estimate accepted as the official enemy strength figure. The article was instrumental in the establishment of the House Select Committee on Intelligence (the Pike Committee), which examined the issues raised by Adams.

Four years later Adams contacted Crile, then a CBS producer, to share the results of his continuing research. Crile found Adams's new evidence compelling and agreed to propose a documentary to his CBS superiors that would demonstrate that Westmoreland had "cooked the books." On November 24, 1980, Crile submitted a blue sheet, the document CBS producers use to sell a program to network decision makers. The blue sheet is usually one page long, but in this case it ran sixteen single-spaced pages. "It was all overwhelmingly clear to Adams," the blue sheet said. "He had come across the most significant intelligence discovery since World War II. The captured enemy documents [he was analyzing] *proved* that we were fighting a far larger war than anyone in authority had imagined. Now the President, the congress, the American people would have to make a choice: Either escalate dramatically or get out."[2]

After winning executive approval to make the documentary, Crile spent months interviewing about eighty sources. His primary list had been supplied by Adams. It consisted mainly of persons who could be expected to contribute to proving the thesis that Westmoreland had conspired to falsify the order-of-battle. Not everyone interviewed was of the same mind, but none of those who challenged the Adams thesis, with one twenty-one-second exception, got on the air. Of those who supported it, nine—including Adams himself, as the documentary's paid consultant—were used on the program. Mike Wallace, who had the title of chief correspondent, was there not only because of his skill as an interviewer but to give the show star quality. Wallace handled the toughest interviews, including the one with Westmoreland. Finally, on January 23, 1982, fourteen months after Crile delivered his blue sheet (a week short of the fourteenth anniversary of the Tet offensive), "The Uncounted Enemy: A Vietnam Deception" was aired. Almost

eight months later, on September 13, 1982, Westmoreland sued CBS for libel. After many emotionally draining weeks in court, Westmoreland dropped his suit, convinced that he was unlikely to prevail under the existing legal standards for libeling a public figure.[3]

The trial's outcome, however, has no bearing on whether "The Uncounted Enemy" was a biased documentary. It was. The bias in "The Uncounted Enemy" was manifested mainly in Crile's skillful selection and marshaling of information to make his case as convincingly as possible, even though a fair and distanced reading of all the available evidence would not necessarily have yielded the same conclusion. Our assessment is not intended to suggest that Crile was dishonest. On the contrary, he apparently believed that what he put on the air was as close as he could get to what he called "the essence of truth." The problem is that he chose a method of inquiry that, together with his personal convictions, was predestined to yield biased or otherwise distorted results. He formed a hypothesis—or, rather, adopted Adams's hypothesis—and carefully gathered evidence to support it, rejecting almost every conflicting piece of evidence. Even the interview segments with Westmoreland and Lieut. Gen. (then Col.) Daniel O. Graham that were used on the air looked as if they had been chosen because they made the two officers appear either foolish or guilty.

Crile was following fairly common procedures in documentary production, and he had arguments for breaking a few more rules than usual. For example, he was forced to condense an extremely complicated story into a relatively tight time frame, an instance of a structural constraint. The program, exclusive of commercials and station breaks, ran about an hour. The printed transcript runs just over twenty-six single-spaced pages. Of the eighteen military officers, diplomats, and intelligence analysts who were central to the dispute, most were interviewed, and many appeared on the program. Some did not appear, and at least six potentially important sources were not interviewed at all. If all eighteen had been interviewed and all of the interviews had been aired—and the entire show had been devoted to them—each interview would have had to be reduced in the cutting room to barely three minutes in length. If a minute and a half had been allowed for questions and a minute and a half for answers, the interview subjects would have been allocated about 250 words each. There were simply too many sources to pack into a single documentary.

To portray such a complex story effectively on television, a medium that for the most part is not used in a nuanced fashion, required an uncomplicated story line that most viewers could follow with a minimum

of mental exertion. Television requires movement, a parade of pictures across the screen that holds the viewer's attention. It demands clarity, simplicity, and repetition to reach the largest possible audience with maximum impact. It must capture complex ideas in simple images to drive home its message effectively. Therefore, if Crile believed he had the goods on Westmoreland and that his basic obligation as a journalist was to make the most compelling case possible, he had little choice but to produce the program in the language and images of certainty, not ambiguity. These are the terms of television. Thus, Crile was, at least in part, a captive of structural distortion.

This kind of technically distorted presentation is not without justification, however. Assuming that the preponderance of evidence supported Crile's case, both justice and the public interest arguably might be served by marshaling the considerable power of an incisive television documentary. Just as a segment on "60 Minutes" had contributed to overturning the robbery conviction of Lenell Geter, an engineer sent to prison in an apparently blatant example of racism,[4] so "The Uncounted Enmy" might have corrected the historical record and contributed to a proper apportioning of credit and blame in one of the most politically and socially wrenching of America's wars.

Crile and his colleagues did seem convinced that they were investigating "one of the major national security scandals of our recent past,"[5] and the evidence gathered by Adams in highly detailed chronologies warranted a vigorous examination of the thesis that high-ranking military officers were coerced by Westmoreland into suppressing evidence of a larger enemy. Moreover, one military officer and CIA officer after another gave persuasive testimony supporting the Adams–CBS thesis. After the program was aired, several key CBS witnesses were asked by Westmoreland to make statements that their words were taken out of context. They refused.[6] None of these "friendly" witnesses complained to CBS about bias, misrepresentation, or out-of-context editing. Furthermore, Westmoreland was briefed in advance about the subject matter of his interview, and the nature of the program was discussed with him before he was interviewed.[7] His denials that his command was "cooking the books" were aired on the broadcast.

TV Guide charged, in an article titled "Anatomy of a Smear," that the supervisory work at CBS was sloppy and that the standards for safeguards against bias, unfairness, and inaccuracy were loose.[8] However, the magazine provided no hard evidence to support those charges, and at least some evidence supports the contrary view. For example, a CBS News vice-president, Roger Colloff, appears to have been more

extensively involved than is usually the case. According to CBS's internal review of the broadcast, usually referred to as the Benjamin report because it was prepared by senior producer Burton Benjamin, "Roger Colloff went far beyond what a vice president with extensive managerial functions normally does on a broadcast—reading some transcripts and meeting with the producer." Benjamin also wrote that Mike Wallace, who was not as fully engaged as he is in the average "60 Minutes" segment, "was hardly uninvolved in the Vietnam broadcast. He attended some screenings, adjudicated some creative disputes and conducted four interviews."[9] CBS also had a veteran staff working on the program. The show did not suffer from a lack of testimony supporting its central thesis. Moreover, to persuade the high-ranking military officers and former CIA officials to make the confessions on camera that they did, and to marshal so much statistical and historical evidence, was a considerable achievement. It is therefore far from obvious that CBS produced a biased documentary or that a charge of personal bias against Crile can be sustained.

Yet a biased program is exactly what CBS did produce, although there was no way in which the average viewer could discern it. Even someone reasonably knowledgeable about the history of the war would almost certainly find the documentary persuasive—unless, of course, that person had at some point focused on the highly specialized question of pre-Tet enemy force levels and knew more than a little about the art of intelligence gathering and interpretation—or unless he or she had been permitted to see the outtakes or read the transcripts of the interviews conducted for the program, which provide potent circumstantial evidence of bias.

Crile stated his central thesis as follows:

> That in 1967, American military and civilian intelligence discovered evidence indicating the existence of a dramatically larger enemy than previously reported [and] that instead of alerting the country, U.S. military intelligence under General Westmoreland commenced to suppress and alter its intelligence reports, in order to conceal the discovery from the American public, the Congress, and perhaps even the President.[10]

Later, in response to the controversy ignited by the *TV Guide* article, Crile said that only a minor modification of this statement was required. He wrote, "Now that I look at it I would put a period after the words 'intelligence reports,' "[11] thereby eliminating the phrase "in order to conceal the discovery from the American public, the Congress, and

perhaps even the President." But Crile's comment is unsatisfactory. Even if there were no objection to his contention that military intelligence was suppressed, it would be journalistically unacceptable to produce a documentary without at least offering defensible hypothesis regarding why it was suppressed.

The Benjamin study was ordered by the president of CBS News, Van Gordon Sauter. Benjamin found that "The premise [of the program] was obviously and historically controversial. There was an imbalance in presenting the two sides of the issue. . . . Even today military historians cannot tell you whether or not MACV 'cooked the books' as the broadcast states. The flow of definitive information is painfully slow and may never be conclusive."[12] Benjamin's judgment is correct, but was the imbalance he cited sufficient evidence of bias to be termed immoral? Did "The Uncounted Enemy" significantly overstate its case? Or, worse still, did it present a case that was not sustainable through an unbiased use of the available evidence?

The answer to all these questions is affirmative. Deletion of views opposed to the Adams–Crile thesis was at times egregious. Crile seemed resistant to virtually all evidence at odds with his fundamental premise, although material exists in the deleted portions of "The Uncounted Enemy" to produce an equally sound documentary that would support precisely the opposite thesis from the one Crile was promoting. It would demonstrate, mainly through the use of quotations cut from interviews used on the program, that Westmoreland acted to present the most militarily valid view of enemy force levels in Vietnam just before the Tet offensive.

Had it been produced, the excerpts from such a program—drawn from CBS's own interview transcripts—would have appeared as follows:

> WALLACE: The people we're talking about here, the self-defense militia, these very people that sharpen the pungy stakes . . . ?
>
> WESTMORELAND: In order to include a lot of teenagers and old men, village defenders who could prepare pungy stakes, in the enemy order of battle, we had to also include the counterpart in the order of battle of the South Vietnamese. The fact is that these village defenders had a minimum to do with the outcome of the war.[13]

Westmoreland made substantially the same point nine times in his interview with Wallace. Why include irregulars of this sort in the enemy order of battle, he asked, if we do not include them in our own? The question is never raised or discussed in "The Uncounted Enemy," yet

it is Westmoreland's firm position, and it directly challenges Crile's thesis.

Two other excerpts from the outtakes read as follows:

> CRILE: What did you think of Mr. Adams' argument, of his figures?
>
> COL. GAINS HAWKINS: I disagreed with Sam on the magnitude of the strength. And we just . . . I just disagreed with him on the methodology. My figures were . . . I believe, at all times generally lower than Sam's figures.
>
> CRILE: You had some concerns about the—the reliability of the overall estimate, didn't you?
>
> COMDR. JAMES MEACHAM: Oh, we always have concerns about—sure.
>
> CRILE: Did you think they should have been considerably higher?
>
> MEACHAM: No, I don't recall having thought they should be considerably higher; I thought they should've been more accurate, but I think we just couldn't make them any more accurate.[14]

These were Crile's witnesses—the people who made his case on the air unequivocally. They were able to do so because all the equivocation—all of the contradictions, qualifications, and ambivalence—was edited out before the airing.

The same interviews that Crile and Wallace conducted could have been mined to produce a program that would discredit the Crile–Adams thesis no less convincingly than Crile discredited Westmoreland's. However, it too would be biased in much the same ways that "The Uncounted Enemy" was biased. No strong thesis either way can, without bias, be sustained, because the record, including thousands of pages of unused interview transcripts, is replete with ambiguity and conflicting testimony. The editing of the interviews demonstrates that Crile and Wallace were not interested in getting the answers to hard questions that might weaken their thesis, such as: Is the task of collecting order-of-battle intelligence as General Westmoreland has suggested more like estimating roaches than counting beans? Are disputes of the kind described unusual between intelligence agencies? Is it uncommon to negotiate an order of battle total in the way it was done by CIA, DIA (Defense Intelligence Agency), and MACV? Was General Westmoreland wrong in wanting to keep irregular forces out of the order of battle? Did the analysts who were making order-of-battle estimates—Hawkins, Meacham, and McArthur—have sufficient information to make accurate estimates? Did Westmoreland believe he was reporting the best possible estimates of enemy capabilities?

These are tough questions, especially considering the structural constraints of television documentary and the situational constraint of reporting on an event that had occurred years before. It would have been extremely difficult for Crile to have simultaneously used the medium effectively and to have accurately characterized the uncertainty of the situation. Those interviewed repeatedly qualified their statements and offered exceptions to facile generalizations. Many interview sequences would have left audiences confused about what conclusion to draw. For example, what would viewers have made of the following exchange between Crile and Gen. Joseph McChristian, Westmoreland's chief of intelligence, had it been aired:

CRILE: How should I put this—so that I can best express it? Maybe just this question: Did—did you ever, while in command of MACV Intelligence, have pressures put on you to keep enemy estimates down?

MCCHRISTIAN: I had pressures put on me from time to time, George; not exactly that bluntly to keep any estimates down. Never. But I did have pressures put upon me to review my criteria: maybe my criteria wasn't (sic.) just right. . . .

CRILE: Were there any other [instances or] incidents?

MCCHRISTIAN: There were other instance[s] when my intelligence was questioned. At one time, the chairman of the Joint Chiefs of Staff considered that what information he had been furnished in Washington that he used to brief the President, was not agreeable to the intelligence that was coming from my office, so he sent a team of officers from his—from the Joint Chiefs of Staff to Saigon to investigate. And they found out that what they had been using back in Washington was not my intelligence to brief the President, but it was operational reports, which is raw information and not intelligence. I was completely vindicated in that case; and in every case where my reporting was questioned, every single case I was vindicated, and in no case was there the slightest change made in any of my reporting or any of my criteria.[15]

McChristian here acknowledges that whereas he was pressured to review his criteria, neither his reporting nor his criteria were ever changed. This contention does not definitely falsify the Adams–Crile conspiracy thesis, but it dilutes the thesis and directly calls it into question.

The structural constraints of a television documentary may have left Crile with little choice but to scrap the program, at substantial cost to CBS and possibly his career, or to proceed as he did despite the testi-

mony that conflicted with his findings. But, if so, he made the wrong choice. By purging the documentary of ambiguity, by avoiding the hard questions, by using loaded language, and by compromising the integrity of the evidence to a kind of dramatic intensity, Crile produced a biased program that deceived viewers into thinking that the case against Westmoreland was solidly grounded. He also damaged the general's reputation in a way that, if not legally libelous, certainly carries moral liability.

Even if Crile is given the benefit of the doubt by assuming that he was entirely persuaded by Adams's thesis, he failed to fulfill his obligation to the public to avoid presenting an unfair and one-sided version of a delicate and complicated subject. Consider how Westmoreland is presented and how a viewer who is unfamiliar with the background of the controversy almost inevitably must react. First, the general's defense is confined to five minutes and thirty-eight seconds of personal testimony. CBS argued that General Graham also testified on Westmoreland's behalf, but this claim is misleading. Graham was on the air for twenty-one seconds and testified in defense of himself, not Westmoreland. By contrast, eight interview subjects pilloried Westmoreland at length—nine if Adams is included. Yet, as the Benjamin report correctly noted, "For every McChristian there was a Davidson; for every Hawkins, a Morris; for every Allen, a Carver."[16]

General Philip Davidson, who succeeded McChristian as chief of military intelligence in Vietnam, supported Westmoreland. CBS said they believed he was dying of cancer and therefore did not make a serious effort to interview him for the program. Although Davidson did have cancer of the prostate in 1974, his personal physician reported that the retired officer was in good health at the time the broadcast was being prepared. Crile assigned his secretary to contact Davidson. She tried only during working hours at his home number. Two other equally qualified observers, who held views that were dramatically different from the views of those who appeared on the program, were not heard on the air. One was George Carver, George Allen's boss at the CIA. He personally negotiated the final order-of-battle compromise with Westmoreland. His view of the events depicted on "The Uncounted Enemy" was closer to Westmoreland's than to Allen's. Col. Charles Morris was Davidson's deputy. He, too, disputed the Adams thesis. Moreover, Walt W. Rostow, President Johnson's national security advisor, was interviewed and disputed the conspiracy thesis, but did not appear on the program. Ambassador Bunker, the U.S. envoy in Viet-

nam at the time, and Robert Komer, Johnson's special representative for Vietnam, were not even interviewed.

There were equally compelling examples of biased interviewing and editing, such as a critical omission in the following cable sent by Gen. Creighton Abrams to the Joint Chiefs of Staff on August 20, 1967, and misattributed by CBS to Westmoreland (who "signed off" on it, but was not its author). Wallace read it on the air, in modified form, and it appeared in large type on the screen, as follows (with the phrase in brackets deleted by CBS): "We have been projecting an image of success over the recent months, [and properly so]." Wallace then added, "The self-defense militia must be removed," words that do not appear in the cable at all, and concluded, "[or] the newsmen will immediately seize on the point that the enemy force has increased. No explanation could then prevent the press from drawing an erroneous and gloomy conclusion."[17] The deletion of "and rightly so" has the effect of making the preceding language, "We have been projecting an image of success over recent months," sound like a fabrication because of the ill-chosen words "projecting" and "image."

When Westmoreland was quizzed on "Meet the Press" in November 1967 about the number of North Vietnamese infiltrating into South Vietnam in the months leading up to the Tet offensive, he gave this answer: "I would estimate between 5,500 and 6,000 a month, [but they do have the capability of stepping this up.]"[18] Asked the same question fourteen years later when interviewed for "The Uncounted Enemy," he answered with a figure of 20,000. The Tet offensive began more than two months after the "Meet the Press" interview, and therefore the phrase in brackets, which was deleted from Westmoreland's answers by CBS, was highly relevant. Furthermore, on June 9, 1981, seven months before the broadcast, Westmoreland sent Crile and Wallace an official MACV document that put the infiltration total for January 1968 at 21,100 and the highest monthly total for September through December at 6,300 (in September). This document was accompanied by a letter acknowledging that he had misspoken about the infiltration rate (during the fall of 1967) when he was interviewed by CBS in 1981. Neither the letter nor the document was mentioned on the air. The program contains numerous similar examples of selective and misleading editing and use of materials, and in virtually every case the presentation serves, without adequate justification, to undermine Westmoreland's credibility.

To understand what Crile says he was trying to accomplish, it helps

to know his conception of the art of interviewing for a television documentary. He expressed his views on this subject in a conversation with Benjamin on June 22, 1982:

> The documentary interview is so different from live news, hard news or print interview. It is not supposed to be timeless, but you are supposed to get certain truths. It is a producer's nightmare. You are out on a limb. In print it doesn't matter if you get it over 12 hours. In a documentary the producer can only deal with what is on film. I need to find a way to get in the clear that person's perceptions of what we are dealing with. If a person is only saying lies or speaking uncharacteristically, you have a different truth than what you know him to be. You're in a pickle. . . . To get to that right moment you go another route to get it out. . . . It's like a dance, an art form. You're moving toward a moment. You're trying to get the essence of truth on film.[19]

Crile's description of the interview process goes directly to the heart of the problem with "The Uncounted Enemy." The war footage, the menacing helicopters, and the driving, table-thumping speeches of Lyndon Johnson are dazzling and add drama to the program, but in the end the premise of the show can only be sustained by the spoken words of the interview subjects and the documentation of events of which few, if any, pictures are available. Furthermore, if this kind of documentary is to be lively enough to meet the dramatic requirements of the medium, the interviews must generate drama independent of the file footage that supports them. Carefully hedged answers are undesirable because they lack clarity, sound pedantic, and will quickly drive viewers to another channel. To hold an audience, the remarks of those interviewed must be hard-hitting and unambiguous. But editing for that effect produces a warped result. The distortion of television technique replaces the objectivity of sound reporting. The search for "truth" fades and becomes a search for a preconceived "moment," a biased hypothesis that captures the "essence of truth" in the mind of the documentary maker.

When Crile described the technique as "a dance, an art form," his metaphor was apt. Questions were asked, rephrased, and asked again, approaching the subject from various angles, until the desired response was elicited. If the interview subject seemed about to say too much, Crile or Wallace often cut him off by asking the next question. If that maneuver failed, the quotation could easily be—and often was—edited or used out of context to fit the interviewer's apparently preconceived

requirement. For example, Crile's interview with Meacham shows the process at work. Almost nothing of what Meacham said was aired, and what was used failed to reflect the essence of what he was saying—that is, his general viewpoint. No matter how hard Crile tried, he could not induce Meacham to support the documentary's central thesis that intelligence had been falsified. Nor could Crile get Meacham to agree that Graham was seeking to change the computer database without proper justification. Instead, Meacham says that no intelligence was falsified, "all of the numbers were soft," and "at the end of each month, we didn't have much faith in that [enemy strength] figure anyway."

Graham had access to data to which Meacham did not have access, and Meacham did not question that Graham believed he was justified in changing the computer database. Meacham said he thought "we could have lost an argument before an objective jury" about this matter of changing the database. None of this appeared on the air. Here is what Crile chose to use from the Meacham interview:

WALLACE: According to Colonel Cooley, there was a general agreement at this time that something had to be done. Cooley and another senior intelligence officer, Commander James Meacham, have told CBS REPORTS that several weeks after Tet, Col. Daniel Graham, General Westmoreland's chief of estimates, asked them to alter MACV's historical record. In effect, they then accused Graham of personally engineering a cover-up. First, Commander Meacham:

CRILE: There comes a time when Colonel Graham asked you and Colonel Weiler to tamper with the computer's memory, to change the data base in some way.

COMDR. JAMES MEACHAM (RETIRED): Yes, that's it.

CRILE: You said no.

COMMANDER MEACHAM: Well we—we didn't say no. I mean, this thing wasn't our private property. It belonged to the intelligence directorate. We were the custodians of it. We didn't like what Danny Graham proposed to do. We didn't want him to do it. At the end of the day, we lost the fight, and he did it.

CRILE: What was so wrong about going back into the memory? What got Meacham so distressed about it?

COLONEL COOLEY: I would—a little bit of the 1984 syndrome here, you know, where you—you can obliterate something or you, you know, can—can alter it to the point where it never existed type of logic.

COMMANDER MEACHAM: Up to that time, even though some of the current estimates and the current figures had been juggled around with, we had not really tinkered with our data base, if I can use that

jargonistic word. And—and Danny Graham was asking us to do it, and we didn't like it. . . .

GENERAL GRAHAM: Oh, for crying out loud. I never asked anybody (to) wipe out the computer—computer's memory. I don't know what he—I honestly haven't got any idea what he's talking about.

WALLACE: We stress that Colonel Graham denies the allegation and insists that he never falsified nor suppressed any intelligence reports on the enemy. But Commander Meacham and Colonel Cooley insist that Graham did alter the record. And they suggest that because of this, we may never be able to go back and understand exactly what happened.[20]

The material aired leaves the clear impression that Meacham thought Graham was acting dishonestly by changing the computer database. It also implies that he charged Graham with altering the "record," a word Meacham specifically rejected as too strong. As a result, viewers were led to think that Meacham supported the documentary's minor premise that Graham intended to falsify the enemy order of battle. Yet Meacham repeatedly observed that even though he disagreed with Graham about whether there was justification for altering the database, Graham had access to more intelligence and might have been right.

Crile denies that he intentionally deceived viewers in his use of the Meacham material. He insists Meacham told him things off camera that justified the way in which the interview was edited. But Crile failed to reconcile the contradictions between what Meacham said off camera and on. Instead he chose to use selected on-camera material to support the program's premise. If Meacham contradicted himself, Crile could have dropped him from the show or perhaps tried to prove conclusively that he was lying. Instead, he used comments taken out of context in a biased fashion, and he elected not to use an evaluation by a source with solid credentials (Meacham) that cast grave doubt on the documentary's major premise.

We could provide numerous additional examples of such editing, and we could devote pages to describing biased visual techniques that were used to make Westmoreland look bad, such as excessive tight shots of him emphasizing his facial tics and his growing anger, discomfort, and impatience under Wallace's sustained grilling. These television techniques are often used to heighten drama, but when their intent is to slant the story being presented, they are a visual expression of bias.

An astonishing political conclusion is also almost inevitably inferred by the viewer. Without explicitly saying so, the show leaves the impression that Lyndon Johnson decided not to run for reelection because he

was deceived about the enemy order-of-battle for the months leading up to Tet. (Evidence uncovered during the trial discovery process indicates that this was not the case.) Crile has disavowed that it was his intention to demonstrate that Westmoreland's alleged conspiracy was meant to "conceal this discovery [of an allegedly larger enemy force] from the American public, the Congress and perhaps even the President." But the program was orchestrated to make this conclusion almost unavoidable. Its climax went like this:

> WALLACE: What had happened is that after Tet the CIA had regained the courage of its convictions, and among other things, they told the wise men [a small group selected by the President to advise him on the conduct of the war] of the CIA's belief that we were fighting a dramatically larger enemy. That was at least one of the reasons why Lyndon Johnson's advisors concluded that despite the military's insistence that we were winning, the enemy could not in fact be defeated at any acceptable cost. The wise men then stunned the President by urging him to begin pulling out of the war. Five days later, a sobered Lyndon Johnson addressed the nation.
>
> PRESIDENT JOHNSON (3/31/68): I shall not seek, and I will not accept, the nomination of my party for another term as your President.
>
> WALLACE: Two months after the President's speech, General William Westmoreland was transferred back to Washington and promoted to become chief of the army. To this day, General Westmoreland insists that the enemy was virtually destroyed at Tet. Be that as it may, the fighting went on for seven more years after the Tet offensive. Twenty-seven thousand more American soldiers were killed; over a hundred thousand more were wounded. And on April 30, 1975, that same enemy entered Saigon once again, only this time it was called Ho Chi Minh City.[21]

What are we to infer from Wallace's reciting those two speeches and sandwiching between them the brief but emotional Johnson statement? There is certainly an implication that the alleged Westmoreland conspiracy to "cook the books" was the decisive triggering cause and Johnson's decision not to run was the effect. The documentary also hints that Westmoreland was responsible for seven more years of war, 27,000 additional American deaths, and 100,000 more U.S. wounded. Many viewers almost certainly rose from their chairs at the end of the show with this message embedded in their minds, although no such inference is ever explicitly drawn by CBS. These inferences may not be inevitable in that they do not flow logically from the evidence, but they

are implicit in the selection and juxtaposition of the information, and in Wallace's portentous delivery.

It would be difficult, we think, to prove conclusively that Crile intentionally pilloried Westmoreland. We are not convinced of this intention after interviewing Crile and reading through thousands of pages of documents pertaining to his work. But we are confident that a charge of bias can be sustained. By stacking the interviews 9–2 against Westmoreland, which made the Adams thesis seem impregnable—even though there were plenty of knowledgeable participants prepared to support Westmoreland's viewpoint—Crile failed to present a substantial amount of available counterevidence. No prudent journalist, no matter what his or her personal views, would handle the evidence so unfairly. Crile displayed bias by deleting highly relevant material from the interviews that were conducted, by not asking a whole range of important questions, by failing to put the order-of-battle question in proper context, and by creating the impression that Johnson decided not to run again because he was misinformed about enemy troop levels as the result of a conspiracy led by Westmoreland.

Crile's first obligation was neither to history nor to CBS. His principal responsibility as a journalist was to accurately represent to the public a complex controversy. He should not have become an advocate for a cause, no matter how noble he believed it to be. If a cause is just, in the end it will be best served by reporters through unbiased presentation. By taking up Adams's cause—some would say his obsession—Crile lost too much of the fair-mindedness, truthfulness, and objectivity that is vital to maintaining journalistic integrity. He also publicly crucified a man who, based on the available evidence, almost certainly deserved a fairer hearing.

Notes

1. Samuel Adams, "Vietnam Cover-Up: Playing War with Numbers," *Harper's,* May 1975, p. 41.

2. George Crile, Blue Sheet, November 24, 1980, p. 1.

3. According to the 1964 *New York Times* v. *Sullivan* case, to libel a public official a journalist would have to willfully lie or act in "reckless disregard of the truth." That standard was later extended to public figures.

4. CBS, "Lenell Geter's In Jail," "60 Minutes," December 4, 1983, produced by Suzanne St. Pierre.

5. George Crile, Letter to CBS President Van Gordon Sauter, July 7, 1982.

6. George Crile, White Paper, "Response to *TV Guide*," June 3, 1982, p. 1.

7. Ibid., pp. 10–11.

8. Don Kowet and Sally Bedell, "Anatomy of a Smear," *TV Guide,* May 29, 1982, pp. 3–15.

9. Burton Benjamin, *CBS Reports: "The Uncounted Enemy: A Vietnam Deception": An Examination,* July 8, 1982, pp. 52–53, (CBS internal report).

10. Ibid., p. 6.

11. Ibid.

12. Ibid., p. 57.

13. Transcript, Westmoreland interview with Mike Wallace, May 27, 1981, pp. 35–36.

14. Transcript, Hawkins interview with George Crile, March 12, 1981, p. 32; transcript, Meacham interview with George Crile, March 6, 1981, p. 21.

15. Transcript, McChristian interview with George Crile, March 24, 1981, pp. 4–6.

16. Aside from Adams, Hawkins, Meacham, and McChristian, there were Lieut. Col. Russell Cooley, a military intelligence officer, Joseph Hovey, a CIA analyst, George Allen, the CIA's number two man on Vietnam, Lieut. Richard McArthur, an order-of-battle analyst, and Col. George Hamscher, a military intelligence officer; Benjamin report, pp. 1, 57.

17. Photocopy of Department of Defense cable.

18. Benjamin report, p. 29.

19. Benjamin report, pp. 23–24.

20. CBS, Transcript, "The Uncounted Enemy: A Vietnam Deception," p. 24.

21. Ibid., p. 26.

Appendix

The following excerpt from George Crile's interview with Navy Commander James Meacham is reproduced verbatim (with corrected spelling) from a transcript of the full interview that was produced by CBS News and made public in connection with Gen. William C. Westmoreland's libel suit against CBS. The full transcript, dated March 6, 1981, totals fifty-seven pages. We have reproduced only pages 28 through 44. This excerpt is sufficient to provide the context for the part of the Meacham interview that was aired on the

documentary "The Uncounted Enemy: A Vietnam Deception." We reproduce it to show Crile's technique in an on-camera interview and to provide a sense of the complexity of the interview, very little of which was eventually broadcast. Material that was aired appears in boldface type. Here is the excerpt:

(*Meacham overlapping indistinct*) On April first . . .

MEACHAM: You're gonna have to speed things up here . . .

CRILE: O.K. Give me a little more time 'cause otherwise we'll be in a pickle. On April first, you probably remember very well, the end of March, the president resigned. And afterward, you were called to a meeting in General Davidson's conference room; it was a meeting attended by all of the key people in the intelligence section. And at that meeting, Colonel Graham called on—on you and Colonel Wyler to help him erase the computer's memory.

MEACHAM: Yeah.

CRILE: What was he asking you to do?

MEACHAM: Well, again, the specifics of this are fairly complex. We had a—

CRILE: In its simplest form.

MEACHAM: —a running account of enemy in the country that we kept on a computer, for which we had a couple of fairly good anchors way back in antiquity, and some checks since then that indicated we were basically on the track, or we thought we were basically on the track. One of the problems of doing this on a computer is it's fairly simple to go back at any one specific time way back in—several months or even years ahead of time, change the base line then, and automatically, without any—any effort, changing all the figures since then. **Up to that time, even though some of the current estimates and the current figures had been juggled around with, we had not really tinkered with our data base, if I can use that jargonistic word. And—and Danny Graham was asking us to do it. We didn't like (?) it.**

CRILE: Was the [sic] the equivalent of burning government records?

MEACHAM: No, no. Not at all. It's—wasn't equivalent of burning anything. All . . .

CRILE (*overlapping*): (*Indistinct*) destroying . . .

MEACHAM: No. I wouldn't say it was equivalent destroying anything at all. It was—we had a long series of accounts, a running . . .

(*cut*)

CRILE: Maybe you could just explain it a little bit, which is that—that **there comes a time when Colonel Graham asked you and Colonel Wyler to tamper with the computer's memory, to change the data base in some way.**

MEACHAM: **That's it.**

CRILE: **You said no.**

MEACHAM: **Well, no—we didn't say no. I mean, this thing wasn't our private property; it belonged to the intelligence directorate. We were the**

custodians of it; we didn't like what Danny Graham proposed to do. We didn't want him to do it. At the end of the day, we lost the fight and he did it.

CRILE: He did it.

MEACHAM: He did it.

CRILE: With your help?

MEACHAM: Never (?) got my help. I mean—he took the—insofar as we were the custodians of the records; well, we gave them to him; we were ordered to give them to him, we did. And some of my computer people went up to instruct him in the—in the techniques of—of doing this.

CRILE: This was Bernie Gattozzi.

MEACHAM: This was Bernie Gattozzi.

CRILE: What exactly did they do?

MEACHAM: Well, they changed the data base way back. We have this running record that started years before, where there were additions and subtractions each month, retrospective corrections, and ideally we came up with a—with an accurate figure at the end of the month, certainly we came up with a figure at the end of each month. (*Indistinct*) even though we had, on occasion, tinkered around with the monthly figures, all of which were pretty soft and which were estimates—it got harder as time went on, but on any given day, our figure for that day was a pretty soft figure. We tinkered with those, but we never really compromised the overall system because we could always go back and start from ground zero and work forward again. And indeed, if we tinkered with this figure today, as long as we didn't change it permanently, why at the end of the day, it would work out. And we would still get a—six months from now, we'd get a better figure for today, regardless of what we changed, how we changed this estimate; there was nothing permanent here. Now what Danny Graham was proposing to do was to go back and—several years before, and change this data base, which would've changed the figure for every single month from then on.

CRILE: And why did he want to do this? What was he worried about?

MEACHAM: I don't know that I can recall the specific issue. I suppose it was that—that the figures were getting too far out of balance at that time, between what we thought was true and what he thought should be true. I think I—it's only fair for me to say at this point, of course, that Colonel Graham had access to lots of different kinds of intelligence that we didn't—my section didn't.

CRILE: I understand. But there was a—this was in—this was for you a moral dilemma. You had done a number of things that you didn't like doing before.

MEACHAM: Yeah, we didn't want—we didn't want to tinker with the data base at all.

CRILE: That was tantamount to what? In your mind? It was something you—you couldn't get yourself to do, but why? How could you have been criticized had you participated in it?

MEACHAM: Well, I don't know. I don't know if I could'a been—could'a been criticized for it. I mean, to a certain extent, all of these figures were estimates; they were—they were—it's not like going out and counting a whole—whole bunch of people in a football game.

CRILE: Would it, for instance, have been against military regulations to do that?

MEACHAM (*overlapping*): No, no. It was certainly not a falsification of official records, if that's what you're asking.

CRILE: Was it—but you drew the line and said no.

MEACHAM: Didn't want to do that; didn't want to do that. But we didn't have any choice. At the end of the day, why, my people had to go up and—and assist him to do this.

CRILE: And was it a hard thing to do? Was it easy just to go in and (*indistinct crosstalk*) . . .

MEACHAM (*overlapping*): . . . well, there wasn't—there wasn't anything—no, I mean, physically no; there wasn't anything to it. It was, you know, a couple hours work for a computer programmer.

CRILE: You know, you—you wrote to—to Adams saying, "I'm glad you got hold of Bernie Gattozzi; he was the key man in the great computer hassle. As I think I told you, about the end of my tour, he was a more or less seconded (?) to Danny Graham to tinker around with the whole historical basis of the thing."

MEACHAM: That's right. That's correct.

CRILE: Now, if that had gotten out at the time, if Secretary McNamara had been told that somebody had gone and done this to (*word*) these computers, what would the response have been?

MEACHAM: Well, I don't know. I mean, you're trying—you're trying to make something harder than it is here. We didn't like this because we thought our data base was right, we thought we had some fixes back there on some—with some very reliable documents; we'd spent months of our lives working that system; we thought it was okay. We didn't want it fiddled with. However, we wouldn't'a had—I think we could've lost an argument before an objective jury about this; officers senior to—to me and to anybody in my section would've said, "We have seen other evidence that justifies—" Indeed, this is the argument Danny Graham made, "We've seen other estimates that now justifies our correcting our data base; this is why we have it on a computer; we realize now that we were wrong three years ago; therefore we—we choose to reset the system, based on our estimates." At the end of the day, of course, their estimates were the estimates. I mean, the—every estimate starts out at the bottom and filters up to the top, and various people can put in their judgment of the—on these things. It wasn't our judgment, and we didn't like it. But I don't think that it was hard and fast enough that any one of us could've gone to Secretary McNamara and say—and said,

"Danny Graham is tampering with official records." And—and made a case that he would've believed.

CRILE: Can I express a certain amount of wonderment? You're now a reporter. You were then an intelligence analyst. You were writing home to your wife . . .

MEACHAM: Yeah.

CRILE: . . . very clear-cut language. "I'm not talking about the confusion and inefficiency, which to a certain extent are products of all wars." You said that you were "talking about cover-your-ass orders, lies, from the very highest levels." Your letters are filled with talk of lying. Isn't it clear that something stronger, more questionable was happening than you are now allowing yourself to (*word*)?

MEACHAM (*overlapping*): Well, it's not all clear that—that—that these particular sentiments were applying specifically to these sets of numbers that we're talking about. It's not clear in my mind even that—that that's what I was talking about. We were all disillusioned with the way we had to operate in that war out there. And—and we didn't like it.

CRILE: You know, let me read you another section: "We shall see if I can make the computer sort out the losses since the Tet offensive began in such a manner as to prove we are winning the war. If I can't, we shall, of course, jack the figures around until we do show pro-progress." You wrote that.

MEACHAM: Well, so what?

CRILE: So, aren't you saying that you were manipulating figures to come up with preconceived notions as to what the estimates should be? Faking intelligence.

MEACHAM: No, no. I'm not saying that at all.

CRILE: You say, anyhow, "We are winning the war, and now I can prove it, having received sufficient, adequate guidance from my leaders."

MEACHAM: (*Indistinct*) well, we certainly weren't faking any intelligence. Nobody that I have any connection with ever faked any intelligence.

CRILE: What—what were you doing? How do you describe this?

MEACHAM: How do I describe what?

CRILE: Your own characterization of the process that you were pursuing.

MEACHAM (*overlapping*): Look (?), the—the problems that we had are as follows: we had a set of numbers that we tried to keep in balance. When we had large numbers of losses, these had to come from somewhere. Now, I started to—to outline this system before, and I didn't quite get finished with it, but the fact of the matter is whenever we would have a large loss, it's almost invariable in that system—it may have been a bad system; it was just the best we could think of—that we wouldn't know where to take these losses from.

CRILE: Gee, I hate to do this. This is you again, to your wife: "Dear

Dorothy: You should've seen the antics my people and I had to go through with our computer calculations to make the February strength calculations come out the way the general wanted them to. We started with the answer and plugged in all sorts of figures until we found a combination which the machine could digest. And then we wrote all sorts of estimates showing why the figures were right. And we continue to win the war." What could be clearer than that? You're not producing honest intelligence reports.

MEACHAM: Well, there isn't such a thing as an honest intelligence report; there's my view and somebody else's. We quite clearly didn't agree with the figures that we were having to use, but it's not a question of honesty or dishonestly, and I think it's wrong of you to try to use those words.

CRILE: I was only asking you to try to tell us what happened.

MEACHAM: Well I've been trying—I've tried two or three times, and I have yet to get to the end of the story. It's a long, complicated story, and I'm not trying to force it on you if you don't want to hear it, but the fact of the matter is when you have a large number of losses, you have trouble finding where these guys have come, because invariably you haven't got all the additions (?) that should go with that number of losses into the system at that time.

CRILE: Pardon me, but let's take El Salvador, or the Soviet Union today. If—if the DIA (?), military intelligence is told to prove that there are 3,000 missiles aimed at us, and they start with the answer, what's the point of having an intelligence service? Shouldn't we be . . .

MEACHAM: I don't have any idea of what you're talking about, or what the connection has to . . .

CRILE: Let me make an analogy: if you're trying to figure out how many guerrillas there are in El Salvador today, you should begin, I presume, in a classic sense by adding up the reports of the different units and coming to a total.

MEACHAM: Not necessarily. I mean, there's two or three ways to go about this. We're getting in an area that's very, very complicated here.

CRILE: Well, please—please help me, because it's not a mystery what— (*indistinct crosstalk*) . . .

MEACHAM (*overlapping*): I mean, you're trying to—(*indistinct*) get me to say that we all falsified intelligence, I'm not gonna say it 'cause we—I don't have any sense of having done that.

CRILE: What do you have a sense of having done?

MEACHAM: I don't know how to answer . . .

CRILE: Are you proud of the—of your performance, of Mac-V's performance—?

MEACHAM: Well, of course not. But I mean, I don't see the connection.

CRILE: What we're really trying to do is just to determine in your own mind what actually happened. Is this something which- which should cause

people to be concerned about the reliability of our intelligence reporting? Or not?

MEACHAM: I think—you mean at that time? You mean the reliability of our intelligence reporting at that time?

CRILE: Yeah.

MEACHAM: I think certainly we ought to be—you know—be concerned about it. It's certainly open to doubt that—that we (?) were getting the—the correct answers out of it.

(*cut*)

CRILE: Do you understand that the—I mean, what Sam and I are both trying to say right now.

MEACHAM: I understand perfectly well what you're trying to say.

CRILE: And . . . ?

MEACHAM: I don't agree with it.

CRILE: Well not—not that—agree with it; it's a question of—of whether there isn't some way to—to reach a—well, I would love to have you present this history with some perspective which would be . . .

MEACHAM: Well I've done the best I can do. I'm sorry that it's not satisfactory to you.

CRILE: Well no, it's not—it's not that; it's just that I—you know, I'm—I'm sorry just to have had to have been a hectoring (?) force here. I would've liked something different.

MEACHAM: Well, I mean, you—quite clearly know what you want me to say, but that's not the perception that I have.

CRILE: No, that's not. I really was only trying to—well, we'll wait a second. . . . Let me try to give you a little bit of a sense of what seems to have emerged. Do I—in this whole exercise, you know, we've talked to a number of different people, and what—what has happened to many of them—Colonel Morgan, I grant you, you're not altogether sure about how formidable a man he is . . .

MEACHAM: Well, he wasn't there through much of this.

CRILE: Well, but different people at different levels all felt very badly about what happened; they don't think it was right. And—

MEACHAM: Well, I didn't think it was right, but—there's no reason to say that—the thing is, you know, any different from the way I actually saw it, or remember now that I saw it.

CRILE: Yeah.

MEACHAM: You see, you've missed this one point that I keep coming back, and I've been over this with Sam, and he—you know, we don't agree on this. But the fact of the matter is: each—at the end of each month, we didn't have much faith in that figure anyway. And if some guy says, "Look, we want to change this," why (?) there's—there's hardly any way to argue about it, really.

CRILE: Except when it comes to something as—as really basic . . .

MEACHAM (*overlapping*): As long as we didn't—as long as we didn't tinker with the data base, you see, this would all wash out, sooner or later. This is a temporary figure. As long as you don't tinker with the—with the antecedent dates. This is all—this is all temporary, and it all washes out. These—a figure for this month changes each month for six or eight months.

CRILE: But the data base is something different.

MEACHAM: That's it.

CRILE: Because then—then you're doing something permanent.

MEACHAM: That's it.

CRILE: And you can't get back.

MEACHAM: Well I suppose you could keep a duplicate record, but basically what you say's true. That's right.

CRILE: So it's really—it's like going back through the files and creating a separate set of records, and then burning the originals.

MEACHAM: Yeah, except I think records is probably too strong a word for this.

CRILE: The memory of the computer.

MEACHAM: Yeah. Yeah. Yeah. Well, I mean, these weren't records in the sense that you said—I wrote a check for 17 dollars and 52 cents on this day. They were all a little softer than that. Although we thought—the—you know, the early records were pretty good; we thought the data base was not too bad.

CRILE: But you took what was a principle stand at that point, which was no . . .

MEACHAM: No, we didn't like that.

CRILE: No dice.

MEACHAM: And—and we didn't do it. And then he had to do it on his own. He had to get Gattozzi up there and do it on his own. We didn't do it.

CRILE: Did that compromise Gattozzi?

MEACHAM: Well, I don't know compromise. I mean, you know, he—he's—here's a lieutenant in the army that's ordered to do a specific job on a computer, and he did it. That's all. Whether (?) he's compromised by it or not I don't know. But—

CRILE: Would—would Danny Graham feel embarrassed by this if he were asked about it?

MEACHAM: I doubt it. I imagine he would—he'd say he had good reasons to do that.

CRILE: But would you feel . . . ?

MEACHAM: He said—he said at the time he had good reasons to do it.

CRILE: And you challenged that.

MEACHAM: We didn't challenge that he thought he had good reasons; we just thought we had better ones for him not to.

CRILE: (*Word*) remember, he went off to—well, when he went off to Washington earlier, to defend the figures, with you as a part of the team, didn't (*word*) actually tell the DIA (?), "Look, this is an issue of a battle between the civilians and the military, and you've got to line up on our side."

MEACHAM: (*Word*) I think he probably did, yeah. I think he probably did.

9

The Ethics of (Mis)representation

LARRY GROSS

Cannon to Right of Them, Cannon to Left of Them

In the spring of 1980 I was present at the East Coast session of the White House Conference on Families held in Baltimore. My role was that of "resource person" to provide factual information (certainly *not* opinions) to the Task Force on Media as they prepared resolutions for presentation to the Plenary of the Conference. Among many interesting things I observed, one in particular stood out. There were two clearly opposed poles of opinion and belief represented in the Task Force, yet they were in agreement on the fundamental point: they didn't like the way television (other media were barely considered) represented social issues like The Family and sexual behavior. What each side didn't like about these representations, I should make clear, was almost completely the opposite of what the other side was upset by. The point is that the conclusions were the same: they felt unable to control the medium that is instructing their children about family life and sexual behavior, and they knew that the media in general were not held accountable for their actions. The liberal members f the task force saw TV as overly traditional, even sexist in its treatment of women, families, and social issues in general. Conversely, the right wing of the group, led by self-identified members of Christian fundamentalist churches, saw network TV as dangerously subversive of traditional values and as a threat to the very existence of the sanctified Nuclear Family.

In a sense the conflict came down to the liberals being worried about *how* certain social phenomena were shown on TV, and the conservatives upset that they were being shown at all. Neither side felt that the media institutions were responsive to their concerns.

Well, faced with such apparently conflicting pressures, what's a network to do? The obvious answer seems to be that the best path lies in between these extremes, safely in the mainstream of American culture; the comfortable middle ground that holds the largest possible audience. The ethical issue is presumably thus resolved by the simple algebraic procedure of canceling out opposing values and solving for the common denominator. My colleagues and I have recently termed this process—and its possible effects on audience beliefs—mainstreaming (Gerbner et al., 1980, 1982).

The mainstream solution offers decision-makers an attractive ethical refuge because it appears to fulfill the basic ethical tenets of journalistic practice in the U.S.: objectivity and balance, particularly the latter. The logic seems to be that if you balance opposing views, from "responsible"—that is, institutionally legitimated—sources, then the truth can safely be assumed to "lie somewhere in between" and thus objectivity is achieved. The fatal flaw in this credo is that how one defines the "responsible" extremes will determine where the center will appear to be. Speaking subjectively, it is clear to me that in our system the mass media legitimate positions a lot further to the right than to the left, which puts the "objectively balanced" mainstream somewhere to the right of center.

Objectivity is a myth, but it is a myth with consequences. All mediated events incorporate values and are therefore in large part subjective. This is hardly a novel statement; the point has been articulated from a variety of theoretical and research perspectives. I am concerned here with a somewhat different question: if we reject "objectivity" and "balance" because they are insufficient as solutions to the ethical dilemma facing the media, can we find a better basis for making normative judgments in media practice? If truth and fairness can't be found by looking for the middle, where can they be sought?

Justice Holmes defined the principle of free thought as requiring, "not free thought for those who agree with us, but freedom for the thought we hate." Similarly, I believe that the critical test of ethical guidelines applied to mass media practice will be to examine the treatment of those outside the mainstream: minorities and deviants of all kinds.

In the main body of this essay I will describe some ethical criteria I advocate in making normative judgments about mass media practice, and illustrate their application through a discussion of how the media have dealt with sexual minorities, focusing on some illuminating examples of unethical treatment. Before presenting these ethical criteria,

however, I will introduce a few (terse) propositions about the role of the mass media, particularly television, in our society.

The System is the Message

First, the economic, political and social integration of modern industrial society allows few communities or individuals to maintain an independent integrity. We are parts of a Leviathan, like it or not, and its nervous system is telecommunications. Our knowledge of the "wide world" is what this nervous system transmits to us. Television is the chief common ground among the different groups that make up a heterogeneous national community. Never before have all classes and groups (as well as ages) shared so much of the same culture and the same perspectives while having so little to do with their creation.

Second, representation in the mediated 'reality' of our mass culture is in itself power; certainly it is the case that non-representation maintains the powerless status of groups that do not possess significant material or political power bases. That is, while the holders of real power— the ruling class—do not require (or seek) mediated visibility, those who are at the bottom of the various power hierarchies will be kept in their places in part through their relative invisibility. This is a form of what Gerbner and I have termed symbolic annihilation (1976:182). Not all interests or points of view are equal; judgments are made constantly about exclusions and inclusions and these judgments broaden or narrow (mostly narrow) the spectrum of views presented.

Third, when groups or perspectives do attain visibility, the manner of that representation will itself reflect the biases and interests of those elites who define the public agenda. And these elites are (mostly) white, (mostly) middle-aged, (mostly) male, (mostly) middle and upper-middle class, and entirely heterosexual (at least in public).

Fourth, the contributions of the mass media are likely to be most powerful in cultivating images of groups and phenomena about which there is little first-hand opportunity for learning; particularly when such images are not contradicted by other established beliefs and ideologies. By definition, portrayals of minority groups and "deviants" will be relatively distant from the real lives of a large majority of viewers.

Fifth, the dominant conventions of our mass media are those of realism and psychologically grounded naturalism. Film and television are nearly always taken to be transparent mediators of reality which can and do show us how people and places look, how institutions op-

erate; in short, the way it is. These depictions of the way things are, and why, are personified through dramatic plots and characterizations which take us behind the scenes to the otherwise inaccessible backstages of individual motivation, organizational performance, and subcultural life.

Finally, we should not take too seriously the presumed differences between the various categories of media messages—particularly in the case of television. News, drama, quiz shows, sports, and commercials share underlying similarities of theme, emphasis, and value. Even the most widely accepted distinctions (i.e. news vs. fiction programs vs. commercials) are easily blurred. Decisions about which events are newsworthy and about how to present them are heavily influenced by considerations of dramatic form and content (e.g. conflict and resolution) that are drawn from fictional archetypes; and the polished minidramas of many commercials reveal a sophisticated mastery of fictional conventions, just as dramatic programs promote a style of consumption and living that is quite in tune with their neighboring commercial messages. More important, the blending of stylistic conventions allows for greater efficacy and mutual support in packaging and diffusing common values.

Ethics of Representation

Having said all this, can we formulate ethical criteria by which to judge the uses of the inherent and inescapable power of the mass media? I think we can, and should.

The first principle I would propose is that groups should be allowed to speak for themselves. Since the mass media have become the inescapable forum for public discussion it seems only fair to permit a diversity of voices and perspectives to be represented. In the U.S. the media contend that they are a disinterested party, giving us objective facts and balancing opposing points of view. In fact, as I have argued, the selection and presentation of these facts are neither objective nor balanced.

Given the limits of "prime" channel space as well as audience interest and attention, not to mention time itself, it is hard to see how every group could speak for itself in the national, even world-wide mass media system we have at the moment. It is simply not likely that mainstream audiences will receive—or desire—many messages shaped by minority perspectives. When these groups do achieve access to the media, they usually end up speaking to themselves; their images and their

interests are seen by the majority only when filtered through mainstream lenses.

Consequently, we need to consider the ethical obligations that apply when groups are *not* speaking for themselves. As Brian Winston has shown (this volume), there is in media documentary a long tradition of focusing on the plight of the "victim." What happens when image makers present mainstream society with the stories they don't usually hear, the images they don't usually see? Well, for one thing, again as Winston notes, the situation of the "victims" rarely improves much as a result; the film-makers' careers usually benefit more dramatically. But this does not in itself subject the film-makers to ethical condemnation: one can always hope to do good *and* also do well. While I don't deny the pertinence of inquiring, *qui bono,* there is a related question I would pose. Placed in the middle ground between the insiders and the outsiders, which way do you face? There is a crucial difference between a film-maker who acts as the agent of the majority, spying out the lay of the outlands, and one who truly attempts to represent the perspectives and views of those living outside the mainstream. I doubt that one can play both roles successfully.

Within the spirit of my first principle—the right to speak for oneself—a second principle would apply when speaking for others. I have already noted that the media invariably empower—and impoverish—through selection and characterization. The power of the media should be used to equalize and not to skew further the radically unequal distribution of material and symbolic resources in our society.

If we accept the moral superiority of media practices that promote greater equality, it follows that because small-scale communications systems have the potential to permit and possibly ensure communal interaction and even accountability in a way that is inconceivable in a large-scale system, they are preferable (on these grounds among others). Underlying this point is the belief that a social system can not grow very large without becoming oppressive and exploitative in important ways. Most crucially, accountability is lost as those who make decisions that fundamentally affect the lives of a community are not themselves subject to these effects, nor accountable to the communities that are affected.

The mass media in a society organized on a continental or even global scale are thus likely to be morally insensitive simply due to size. It is not hard to see how media systems on this scale militate against the opportunities of people and groups to speak for themselves. If the audience is nation- or world-wide, will they want anything but the "ob-

jective" neutrality of the professional news reporter who appears to speak for no one but thereby speaks in fact for the status quo?

On the face of it, many of the new communications technologies appear to have the potential to counter the centralizing tendencies of the "traditional" mass media. The introduction of low-cost video equipment and the richness of cable space create possibilities for individual and local input and selectivity and may represent an opportunity to counter the centralization and massification of communications media. But will this opportunity be realized? Unfortunately, the history of previous similar opportunities, and the progress of current developments give little reason for optimism.

We can already see minorities using film and video as vehicles for intra-group communication (Waugh, this volume), but the size and diversity of their audiences remain limited. They are increasingly able to speak, but most of their fellow citizens aren't listening. As before, most of what we know comes to us through mainstream channels. And, we must now ask, how do minorities fare in the mainstream? We will explore this question through an analysis of the position in society—and in the media—of what may be the most "unusual" minority group: homosexuals.

Homosexuals and Television: Fear and Loathing

Close to the heart of our cultural system is the pattern of roles associated with sexual identity: our conceptions of masculinity and femininity, of the "normal" and "natural" attributes and responsibilities of men and women. And, as with other pillars of our moral order, these definitions of what is normal and natural serve to support the existing social power hierarchy.

Racism is the belief that important differences between racial groups are ultimately traceable to the gene pools they represent, and, moreover, that these differences reflect value dimensions in terms of which one group will always be better than the other. *Heterosexism* represents the belief that a particular complex of culturally defined sex and gender roles and responses is natural, that other configurations are unnatural—deficient, diseased, or delinquent—and, again, that these differences represent a value dimension in which the "natural" is the better alternative. Lesbians and gay men suffer in a way from a condition opposite to that of blacks: invisibility. Blacks are largely kept out of sight of the majority through residential, social, and occupational segrega-

tion; lesbians and gay men are out of sight because they are for the most part not known as such to the "straight" world they move in. If the virulence of racist hatred against blacks can be traced to a shared guilt over centuries of oppression which the majority culture still benefits from, the hatred revealed by heterosexist attacks on the rights (and lives) of gay people may spring from the uneasy sense that "there but for the grace of God, go I, or my brother or sister, or my child. . . ." Gay people, like the science fiction fantasy body-snatchers, are invisible "aliens" hidden among normal, God-fearing Americans; apparently like everyone else but, in reality, unnatural, criminal, sinful, or, at best, sick. Homosexuality can crop up in anyone's family—even yours—and that seems to be a peculiarly unsettling thought to most Americans.

The maintenance of the "normal" gender role system requires that children be socialized—and adults retained—within a set of images and expectations which limit and channel their conceptions of what is possible and proper for men and for women. This gender system is supported by the mass media treatment of sexual minorities. Mostly, they are ignored or denied—symbolically annihilated—when they do appear they do so in order to play a supportive role for the natural order and are thus narrowly and negatively stereotyped. Sexual minorities are not, of course, unique in this regard: relative invisibility and demeaning stereotypes are the common mass media fate of most minorities.

However, lesbians and gay men are uniquely vulnerable to mass media power; even more so than blacks, national minorities, and women. Of all groups in society, we are probably the least permitted to speak openly for ourselves. We are also probably the only minority group whose enemies are generally uninhibited by the consensus of "good taste" which protects most minorities from the more public displays of bigotry.

The reason for this vulnerability lies, quite simply, in our invisibility. A baby is born and immediately classified as male or female, white or black, and is treated as such from that moment, for better or worse. That baby is also defined as heterosexual and treated as such. It is made clear throughout the process of socialization—a process in which the mass media play a major role—that one will grow up, marry, have children, and live in nuclear familial bliss, sanctified by religion and licensed by the state. Women are surrounded by other women, blacks by blacks, etc., and can observe the variety of choices and fates that befall those who are like them. Mass media stereotypes selectively feature and reinforce some of the available roles and images for women, national

minorities, blacks, etc.; but they operate under constraints imposed by the audiences' immediate environment.

Lesbians and gay men, conversely, are the only self-identifying minority. We are assumed (with few exceptions, and these—the "obviously" effeminate man or masculine woman—may not even be homosexual) to be straight and are treated as such, until we begin to recognize that we are not what we have been told we are, that we are different. But how to understand, define, and deal with that difference? Here we generally have little to go on other than very limited direct experience with those individuals who are sufficiently close to the accepted stereotypes that they are labeled publicly as queers, faggots, dykes, etc.

The mass media play a major role in this process of social definition, and rarely a positive one. In the absence of adequate information in their non-mediated environment, most people, gay or straight, may have little choice other than to accept the narrow and negative stereotypes they encounter as being representative of gay people. The mass media have rarely presented portrayals which counter or extend the prevalent images. On the contrary, they take advantage of them. Typically, media characterizations use popular stereotypes as a code which they know will be readily understood by the audience, thus further reinforcing the presumption of verisimilitude while remaining "officially" innocent of dealing with a sensitive subject.

But there is more to it than stereotyping. For the most part gay people have been simply invisible in the media. The only exceptions were either present as victims—of violence or ridicule—or as villains. (For an account of the way gays have been depicted—and denied—in American films, see Russo, 1981). Until recently, the "love that dare not speak its name" was the minority whose existence was rarely acknowledged by the mass media. With the AIDS crisis of the past few years, gay men have become a much more frequent item on media menus; but again, largely cast in their familiar roles of victim and/or villain.

The gay liberation movement emerged in the late 1960s in the United States, spurred by the examples of the black and feminist movements. Consequently, media attention to gay people and gay issues increased in the early 1970s, much of it positive (at least in comparison with previous and continuing heterosexist depictions and discussions), culminating (in the sense of greater media attention) in 1973, with the decision by the American Psychiatric Association to delete homosexuality from its official list of mental diseases (cf. Marotta, 1981; Bayer, 1981). By the middle 1970s, however, a backlash against the successes

of the gay movement began to be felt around the country, most visibly in Anita Bryant's successful campaign to repeal a gay rights ordinance in Dade County, Florida, in 1977. In the years since 1977 the gay movement and its enemies, mostly among the New Right, have been constant antagonists (right-wing fund-raisers claim that anti-homosexual material is their best bet to get money from supporters), and television has often figured in the struggle. But, although the right wing has attacked the networks for what they consider to be overly favorable attention to gay people, in fact gay people are portrayed and used in news and dramatic media in ways which serve to reinforce rather than to challenge the prevailing negative images.

The rules of the mass media game have a double impact on gay people: not only do they pick and use weak and silly, or evil and corrupt, cliché'd characterizations, but they exclude and deny the existence of normal, unexceptional as well as exceptional lesbians and gay men. Almost never shown in the media are just plain gay folks, used in roles which do not center on their deviance as a threat to the moral order which must be countered through ridicule or physical violence. Television drama in particular reflects the deliberate use of cliché'd casting strategies which preclude such daring innovations. As a casting director put it, speaking of their general practice, "You have to figure what the audience can buy instantaneously" (Turow, 1978:20).

The stereotypic depiction of lesbians and gay men as abnormal, and the suppression of positive or even simply "unexceptional" portrayals, serve to maintain and police the boundaries of the moral order. It encourages the majority to stay on their gender-defined reservation, the minority to stay quietly hidden out of sight. For the visible presence of healthy, non-stereotypic lesbians and gay men does pose a serious threat: it undermines the unquestioned normalcy of the status quo, and it opens up the possibility of making choices to people who might never otherwise have considered or understood that such choices could be made.

There are several ways in which mass media practices cultivate negative conceptions and beliefs: First, through the infrequent but consistently stereotyped depictions of homosexuals, and the implicit references to them in the form of demeaning innuendo; second, the denial of this aspect of the lives of people who are otherwise presented as exemplary; third, the definition of any discussion of homosexuality as inherently controversial and therefore requiring a "balanced" presentation which gives opponents equal time with gay people or their supporters (an approach which has been, by now, largely overcome in the case of

other minorities: discussions of black civil rights do not typically include a balancing spokesman from the Ku Klux Klan). Finally, the general invisibility of homosexuals (particularly, of course, non-stereotypic ones) only serves to further the impact of media imagery.

And That's the Way It Is?

So far I have tried to indicate some of the ways in which media power has been used unethically according to my second principle: the power of the media to deny through invisibility and to distort through selective stereotyping has been used overwhelmingly against rather than for the interests and welfare of a sizable portion of the population. In order to justify the wielding of this power to the detriment of a minority, it is reasonable to expect, it should be necessary to define the minority as a threat to the moral order and thus deserving of such treatment. This leads us to the first of my ethical criteria—the right of groups to speak for themselves. For, more than any other group in the population, lesbian and gay people have suffered from the denial of the right to speak for themselves. And, when we began to demand and to take that right, the media have used their power for massive retaliation.

Until recently the standard format for new media treatments of gay people was one of which presented the views of "experts" who were permitted to define and evaluate the morality, mental health, and social being of a large segment of the population—from the outside. A typical example was the *CBS Reports* program "The Homosexual" broadcast on March 7, 1967, co-written and narrated by Mike Wallace. The only gay men identified by name are white, middle class, and visibly respectable; others are shown strategically placed behind potted palms as their tormented psyches are bared by Wallace's probing objectivity. (The program explicitly excludes lesbians from its discussion of homosexuals.) As befits an objective reporter facing an anomaly in the natural order, Wallace is anxious to know what causes homosexuality (thus, presumably helping society learn to prevent it).

For authoritative answers to his questions, Wallace next turns to psychiatrists; in this case Irving Bieber and Charles Socarides, two men who have profited for years from a socially inflicted misery they themselves have done much to promulgate. Their pronouncements are made with a confidence that is as assured as it is baseless, for they consistently fail to acknowledge the most elementary handicap facing a responsible scientist who wishes to study gay people: the impossibility of

obtaining a non-biased sample from an "invisible" population. Two things are clear: the samples studied by psychiatrists are invariably biased as they are drawn from people who are voluntarily or involuntarily in treatment; and whenever a researcher attempts to construct matched samples of non-patient gays and straights, the differences between them are trivial and as likely to show the homosexual group in a better light (cf. Hooker, 1957, for an early example, and Peplau, 1981, for a more recent one).

The point, really, is that gay people are not allowed to define themselves except in individual, autobiographical terms. Individual gays are allowed to testify to their own personal experience; especially if it is miserable. General statements which characterize gays as a group—and implicitly suggest that any contrary testimony must come from exceptional cases—these are made by Mike Wallace, with no stated source of evidence, or by "legitimate" experts. Charles Socarides informs us that, "the fact that somebody's homosexual . . . automatically rules out the possibility that he will remain happy for long."

The rest of the program follows much the same pattern of defining and framing gay men from the outside, and Wallace concludes:

> The dilemma of the homosexual: told by the medical profession he is sick, by the law that he's a criminal. Shunned by employers. Rejected by heterosexual society. Incapable of a fulfilling relationship with a woman or, for that matter, with a man. At the center of his life, he remains anonymous . . . a displaced person . . . an outsider.

And that's the way it was, Tuesday, March 7, 1967.

But it didn't stay that way.

By the late 1970s lesbians and gay men had become a more visible segment of society through organizing efforts and actions. We were demanding equal treatment and basic rights much as had other minorities and women; including the basic right to speak for ourselves. We began receiving more media attention: cover stories in national magazines, lesbian and gay characters in media fiction—although almost always cast in the old stereotypic molds—and once again we became the focus of television documentaries.

On April 26, 1980, *CBS Reports* once again presented a program about gay men called "Gay Power, Gay Politics." Although it has been years since the program aired, I am still enraged at its manifest dishonesty—incompetence is not a credible explanation of the producers' behavior. The program, in fact, stands as an outstanding example of the

unethical use of media power. Ironically and interestingly, George Crile, the reporter responsible for the program, survived criticism by the lesbian and gay community, only to become embroiled in a much wider public controversy when he used what appear to be the same unethical and unprofessional methods to "get" General Westmoreland in the *CBS Reports* program, "The Uncounted Enemy: A Vietnam Deception" (see Beauchamp and Klaidman, this volume).

"Gay Power, Gay Politics" is selective and biased and willfully ignorant and manipulative. Gay men are interviewed but the framing and editing turn their words and their meanings to the producers' purposes. The reporter, George Crile, constantly puts words in people's mouths and asks blatantly leading questions. People appear to speak for themselves, but in fact, they are being used in the service of Crile's "angle"— that gay men have become a powerful force in San Francisco and they are using that power to destroy traditional values in their demand for "absolute sexual freedom."

It seems likely that at some point in the making of the documentary the producers hit upon the dramatic theme they would use as the news frame for their story and that frame became a Procrustean bed to whose dishonest contours the true shape of events and motivations was made to fit. The program opens and closes with footage of the National March on Washington for Lesbian and Gay Rights in October, 1979. Harry Reasoner plays bookend anchor, lending his gray-haired, plain-speaking credibility to back up the unknown young reporter, George Crile. Reasoner introduces the program by telling us that the homosexuals gathered in Washington "publicly proclaimed themselves to be the newest legitimate minority . . . In this program we'll see how the gays of San Francisco are using the political process to further their own special interest, just like every other minority group before them. . . . What we'll see is the birth of a political movement and the troubling questions it raises for the eighties, not only for San Francisco, but for other cities throughout the country." In fact, what CBS is presenting is the dread spectre of the Lavender Menace.

But Crile and Co. were not exactly showing us "how the gays of San Francisco are using the political process . . ." because they chose to focus entirely on one political issue—the 1979 mayoral election— and even this issue is presented in a distorted and misleading fashion. In order to support their false claims that gay power was a recent phenomenon, that it was used almost exclusively for the procurement of what CBS calls "absolute sexual freedom," it was necessary for them to ignore or deny many facts.

The imperatives of their highly slanted story line were stringent. In order to make it credible it was necessary to narrow their view of the gay community to men (lesbians are invisible in the program, although several had been interviewed by the producers, among them women who play prominent roles in San Francisco's political life); mostly white men who are shown in either of two versions: the smoothly dangerous upper-middle-class elite who are becoming backstage power brokers, and the menacing, leather-clad, sex-obsessed street gays who frighten the children with their unbridled animal lust.

CBS's "Gay Power, Gay Politics" was one of the most virulent attacks on a minority group ever broadcast in the U.S., and its message was not lost on the enemies of gay people. The program has been shown and explicit references to it prominently featured in the successful campaign to repeal a gay-rights ordinance in San Jose, California, and in right-wing campaign material in elections in Toronto and Houston among others.

In these cases, and others, the parallels were clear: don't let it spread. Ironically, the Moral Majority has included this program in its list of complaints against the networks. It seems that even hostile attention to gay people is too much attention.

This is where we came in. Messages addressed to scores of millions sacrifice or offend the interests and concerns of those who are outside the mainstream. Many of the important social and political needs of sub-cultural groups can best be met through smaller scale, self-generated communal networks.

There are numerous examples of such networks that have sprung up, as it were, along the right bank of the mainstream. Most organized—and visible—among these are the Christian fundamentalist-centered syndicated television programs and the cable-carried Christian Broadcasting Network. These programs provide their viewers with an array of programs, from news to talk shows to soap operas to church services and sermons, all reflecting perspectives and values that they quite correctly feel are not much represented in mainstream prime time.

The sponsoring and producing organizations are not merely engaged in meeting their audiences' unmet need for a symbolic environment in which they feel at home; they are also attempting to translate the (usually exaggerated) numbers of their viewers, and their (constantly solicited) financial contributions into a power base from which they can exert pressure to alter the channel of the mainstream and bring it even closer to where they now reside, up on the right bank.

At the moment, and for the foreseeable future, there is no compa-

rable settlement on the left bank of the mainstream. There are many reasons why the left has been unable to match the right's success in harnessing the available resources of media technology, nonetheless, the potential to do so is there and may yet be realized.

As a geographically dispersed and intermingled minority, gay people have already begun to take advantage of alternative media channels to cultivate the consciousness of community and the strength of communal action. But gay people do not have the security of being able to wrap themselves in the flag or shelter behind a pulpit; we are not merely outside the mainstream, but hated and feared by those of it. Consequently, there are dangers as well as opportunities here: we need to link people across distances; we need to make it easy for people to locate and join networks without risk if they are unable to be openly gay; and we need to ensure the security and confidentiality of identities and messages not meant for public dissemination. Quite simply, we cannot ignore the potential for external infiltration and electronically based search and destroy missions. But that isn't exactly a novelty for gay people, or for any minority group which might wish to take advantage of these innovations. Gay people were not the first minority group to learn the complex realities of specialized communities and institutions. Ghettos are liberated zones for those whose reality is despised and rejected by those of the mainstream, but they can also be concentration camps.

I cannot end this discussion with a feeling of optimism. History offers too many precedents of new technologies which did not live up to their advance billing; which ended up being part of the problem rather than part of the solution. There surely are opportunities in the new communications order for more equitable and morally justifiable structures and practices, but I am not sure we can get there from here. As Kafka once wrote in his notebooks, "In the fight between you and the world, bet on the world."

References

Bayer, Ronald. 1981. *Homosexuality and American Psychiatry*. New York: Basic Books.
Gerbner, George, and Larry Gross. 1976. "Living with Television: The Violence Profile," *Journal of Communication,* 26:2, pp. 173–99.
Gerbner, George, Larry Gross, Michael Morgan, and Nancy Signorielli.

1980. "The 'Mainstreaming' of America," *Journal of Communication,* 30:3, pp. 10–29.

————. 1982. "Charting the Mainstream: Television and Political Orientations," *Journal of Communication,* 32, pp. 100–127.

Gross, Larry. 1983. "The Cultivation of Intolerance: Television, Blacks and Gays," in G. Melischek, K. E. Rosengren, and J. Stappers, eds. *Cultural Indicators: An International Symposium.* Vienna: Austrian Academy of Science.

Hooker, Evelyn. 1957. "The Adjustment of the Male Homosexual," *Journal of Projective Techniques,* 21, pp. 18–31.

Marotta, Toby. 1981. *The Politics of Homosexuality.* Boston: Houghton Mifflin.

Peplau, Letitia. 1981. "What Homosexuals Want in Relationships," *Psychology Today,* March, pp. 28–38.

Russo, Vito. 1981. *The Celluloid Closet: Homosexuality in the Movies.* New York: Harper and Row.

Turow, Joseph. 1978. "Casting for TV parts: The Anatomy of Social Typing," *Journal of Communication,* 28, pp. 19–24.

10

Perspectives on the Television Arab

JACK G. SHAHEEN

Many of our perceptions of the world—of people, issues and events—come not from direct experience, but from second-hand information. Such information, Walter Lippmann observed, forms a large portion of our ideas—ideas that create long-lasting "pictures in our heads."[1] This information causes us to view people in particularly limiting ways, as mere stereotypes.

Stereotypes are especially confining images. They are "standardized mental picture[s] . . . representing oversimplified opinion[s] . . . that [are] staggeringly tenacious in [their] hold over rational thinking," elaborated Joseph Boskin, a professor of history at Boston University. Boskin further stated: "Once implanted in popular lore, image(s) attached to a group, an issue or event tend to pervade the deepest senses and profoundly affect behavioral action."[2] Stereotypes endure in defiance of all evidence.

Preconceived images are especially tenacious if a group is foreign and distant. Few people question repetitious one-dimensional portrayals of a foreign people and culture. Thus, fair and balanced portrayals are not presented. Often a few negative characteristics are attached to a diverse group. Eventually, the characteristics may become accepted. The group becomes fair game for more serious slurs, bigotry, and prejudice.[3] False perceptions not only lead to the universal evils of bigotry and prejudice, but they also limit our ability to interact responsibly in the world community.

The negative, stereotypical images of Orientals helped fuel the racism that led to the internment of Japanese-Americans during World

War II. For years the motion picture industry typecast the Oriental as villain, as did the press, especially the Hearst newspapers.[4] Fortunately, the yellow peril hysteria, the stereotyping, and the myth are gone.

The most pervasive negative stereotype today is of the Arab people. The stereotype exists on television, motion pictures, comic books, novels, news reports, and editorial cartoons. Other groups have been stereotyped. However, an awareness of the negative images of blacks, Orientals, native Americans, Italians, Hispanics, and others has led to more balanced depictions. The civil rights movement of the 1960s did much to curb the Stepin-Fetchit-type portrayals of blacks. Orientals are no longer slanty-eyed villains. Native Americans are not screaming savages. Italians are not Mafia types. Hispanics are no longer Mexican banditos. We are beginning to see multidimensional portrayals of these groups.

Today's Arab stereotype parallels the image of Jews in pre-Nazi Germany, where Jews were painted as dark, shifty-eyed, venal, and threateningly different people. After the Holocaust, the characterization of Jews as murderous anarchists or greedy financiers was no longer tolerable. Many cartoonists, however, reincarnated this caricature and transferred it to another group of Semites, the Arabs. Only now it wears a robe and headdress instead of a yarmulke and a Star of David.

The television Arab is a dehumanizing caricature. Ignorance, fear, and prejudice contribute to the development and perpetuation of this stereotype. The intent may not be calculated or malicious, but the result is nonetheless damaging, for some viewers perceive the Arab caricature on TV to be the true Arab.

When the Arab people and their culture are stereotyped in a medium designed to "entertain," the outcome is especially detrimental. Communications scholar Erik Barnouw pointed out that programming which "we call entertainment—which suggests relaxation (and) . . . a kind of passive, neutral experience—is really a tremendously complicated experience. . . ." We absorb what we see, but with our critical guards down. "I think that politics on television has not been primarily in speeches, but in dramatic material. . . . Drama is inevitably propaganda, it's politics," contended Barnouw.[5]

The influence of televised popular culture was noted by the poet and playwright Archibald MacLeish in 1959. He stated, "The programs lumped together as entertainment have as great an influence on the minds of the human beings who watch them as programs which have a more serious purpose. Indeed, they have a greater influence."[6]

According to Dr. George Gerbner, Dean of the Annenberg School of Communications of the University of Pennsylvania, "television more than any single institution molds American behavioral norms and values. And the more TV we watch," Gerbner maintains, "the more we tend to believe in the world according to TV, even though much of what we see is misleading."[7]

An episode of a popular entertainment program may be seen by 40 million people the first time it is telecast. With reruns, the program may attract 150 million viewers.[8]

This essay focuses on Arab images in television entertainment programs. The images will be limited to those found in programs beginning with the 1975–76 season through 1984–85. Stereotypical Arabs were found in more than 100 different children's programs, dramas, and comedies. To avoid exposing the reader to one long bleat, only selected examples are offered.

I spoke with seventeen television writers and producers and nine network executives. In the interviews, I attempted to determine whether television professionals were aware of the negative image of Arabs, to ascertain why the image exists, and to exchange ideas for more balanced and fair depictions. Their selected comments will be included.[9]

Our most impressionable viewers, children, watch TV more than 30 hours a week. David Pearl, chief of the National Institute of Mental Health's Behavioral Sciences Research Bureau, said that young adults spend at least a fifth of their waking hours in front of a TV set. By the time a youngster completes high school, he has spent twice as much time watching TV as he has spent in classrooms: 22,000 hours before the TV set and 11,000 hours in classrooms.[10]

Before many children reach school age, most have formed well-developed prejudices and stereotypes, Carlos Cortes, a professor of history and chairman of Chicano Studies at the University of California at Riverside, pointed out. Few children have had personal experiences to contradict media images.[11]

Apparently, the images children receive from media carry through to adulthood. The results of a national poll revealed a rerun of long-standing media perceptions of Arabs. According to the poll, Arabs are "barbaric and cruel," "treacherous," "warlike," "rich," and "mistreaters of women."[12]

While teaching in Amman, Jordan, in 1982, an American associate told me about her original perception of Arabs. As a child she had watched a Mr. Magoo cartoon, *1001 Arabian Nights*. The ugly "Ara-

bian" with "the beard" was a depiction that persisted in her psyche. She recalled no positive TV portrayals of Arabs.

Television's portrayals of Arabs encompass the following myths:

—*Arabs are extremely wealthy.* The average Arab has a per capita income of approximately $1000 per year.[13]

—*The dominant religion of the Middle East, Islam, is radical.* Like Christianity and Judaism, the pillars of Islam are allegiance to God, compassion, and respect for the elderly. The radicalism emanates from those who pervert the religion.[14]

—*Arabs are sex maniacs and white slavers.* Most Arab husbands are monogamous, and the family is the basis for society, along with religion. Slavery is outlawed.[15]

—*They are Bedouins.* Fewer than 5 percent of the Arab people are Bedouins (desert dwellers). We often see them depicted as unfriendly nomads. Despite their harsh existence, Bedouins are known for their hospitality, courage, honesty, and endurance.

—*They are terrorists.* A small minority of Arabs, Israelis, Europeans, Americans, and others resort to terror. As journalist David Lamb pointed out, this does not represent the whole, "any more than the more than the 19,000 murders committed in 1982 in the United States make America a nation of killers."[16]

—*Arab society is violent.* Arab cities probably have less violence and less crime than other cities. Crimes against persons are all but unheard of in Cairo, a city of 14 million. In Saudi Arabia a visitor could leave a $100 bill on the street with his name attached and reasonably expect to have it returned.[17]

—*They are buying up America.* The U.S. Treasury reports that Arab investments in America, compared with those of other groups, are minimal. The leading investors are the Dutch, British, Canadians, Germans, Swiss, French, and Japanese. Investments made by Arabs are tagged "Arab money" in a way German marks and French francs are not.[18]

When an Arab buys property in America, it is sometimes a minor scandal; when a non-Arab buys the same property, it is usually considered a sound investment. When a European or Canadian acquires an expensive painting, he is considered cultured and refined; when an Arab does the same, he is decadent.[19]

—*Iranians are Arabs.* Iranians are Persians. They do not speak Arabic; they speak Farsi, an Indo-European tongue that shares several common characteristics with Western European languages. At the

height of the Iranian hostage crisis, 70 percent of the Americans surveyed identified Iran as an Arab country, and 8 percent admitted they did not know.[20]

—*The Oil Producing and Exporting Countries (OPEC) are synonymous with "Arab."* In fact, only seven of the thirteen member nations are Arab. As of July 21, 1985, two non-OPEC members, Mexico and Britain, pump more oil than Saudi Arabia.[21]

The preceding myths are incorporated with the 'Instant Arab Kit,' which includes belly dancers' outfits, headdresses, veils, dark sunglasses, flowing gowns and robes, oil wells, evil mysticism, limousines, and camels. We see Arabs as billionaires, bombers, or belly-dancers—villains of choice.

Why does television not show us the significant contributions made by Arabs in the fields of medicine, mathematics, astronomy, chemistry, and the arts?

Children and Teens

In children's programming, Arab villains abound. Children often see their heroes defeat lame-brained Arabs on magic carpets in cartoons with an *Arabian Nights* setting. Their heroic actions subdue monstrous genies, crush corrupt rulers, and liberate enslaved maidens. Some syndicated animated shows that reveal distortions are *Richie Rich, Mork and Mindy, Scooby-Doo, Laurel and Hardy, Laverne and Shirley, Fonz and the Happy Days Gang, Bugs Bunny, Porky Pig, Popeye, Plastic Man, Heckle and Jeckle, Woody Woodpecker,* and *The Superfriends.*

Wonder Woman rescues the Superfriends from "the inner world of a genie's lamp."

Woody Woodpecker stuffs a ruthless genie back into his bottle.

Popeye's muscles humble "a sheik in wolf's clothing."

Heckle and Jeckle pull the rug from under "the desert rat."

Plastic Man flattens an Arab sultan with "egg in the face."

Porky Pig, in *Ali Baba Bound,* dumps a blackhearted Arab into a barrel of syrup.

Bugs Bunny, in *Ali Baba Bunny,* escapes from being "boiled in oil" by satisfying the whims of a sheik's story-hungry nephew—"the son of an unnamed goat."

Fonz saves Princess Charisma from the clutches of her Uncle Abdul—"Abdul-O, the Un-Cool-O," says Fonz.

Laverne and Shirley stop oil-sheik Ha-Mean-Ie from conquering "the U.S. and the world."

Laurel and Hardy rescue a heroine held hostage in Aba Ben Daba's harem.

Mork and Mindy are held hostage by Egyptians in a "pyramid snake chamber."

Richie Rich topples an outlandish sheik.

Scooby and his pals outwit Uncle Abdullah and his slippery genie.

In another *Scooby-Doo* show, an Arab magician, on seeing Scooby, boasts: "Just what I've been waiting for. Someone to work my black magic on." He tries to turn Scooby into a monkey.

But his magic backfires. The Arab, himself, becomes a monkey. Chuckles Scooby: "That mixed-up magician was sure sorry he monkeyed around with us."[22]

As children grow into their teens, their television viewing shifts to more family-oriented programs, adventures, and comedies.

In a *Fantasy Island* show, "The Sheik," a meek school teacher befriends some Arabs and becomes a macho man. However, there is a trap—the old sheik has set him up for assassins. He fends off the attack by using the sheik's bedpan as a shield. Scimitars are no match for a bedpan. The blades fall to the floor, and the teacher easily escapes.

The bionic champions of freedom, Steve Austin in *The Six Million Dollar Man* and Jaime Sommers in *The Bionic Woman,* frequently face foolish Arabs bent on creating world chaos. In "Return of Death-probe," Steve must deliver two nuclear bombs to a Middle Eastern diplomat named Mahmoud or suffer the wrath of Deathprobe, an invincible machine capable of destroying thousands of innocent people in Colorado. Mahmoud intends to use the nuclear device to overthrow his cousin, King Faud. This tired Arab-versus-Arab theme focuses on Steve trying to stop the Middle East from "going up in smoke." Thanks to Steve, Mahmoud is captured and Deathprobe does not trigger a holocaust.

Harve Bennett, producer of *The Bionic Woman* and *The Six Million Dollar Man,* told me that television people resort to stereotyping because, "It's easy." He added, "Let me put it to you this way. Do you know how to play the game of Charades? Television is one great charade. You don't go for the meat of the material. You do a pantomime of a guy in a *burnoose* (headdress). It's sign language. It saves the writer the ultimate discomfort of having to think."[23]

TV wrestling features "The Iron Sheik," "Akbar the Great" and "Abdullah the Butcher." The Iron Sheik shouts: "Russia No. 1. The

U.S.A., blaaah. Uck!" He then spits on the floor.[24] Abdullah, a "despicable" wrestler, eats live chickens in front of horrified audiences. Akbar and the other so-called "Arabs" wrestle "for the sheer pleasure of inflicting pain on others," states the ring announcer.

Can youngsters continue to watch TV programs and not form prejudices? Ask a child to define Arab. The response will encompass the previously described depictions. To a child the world is simple, not complex. Good versus evil. Superman versus the Arab.

Cartoons perpetuating stereotypes of any group should be relegated to video purgatory. For example, "during the 1930s and early 1940s, Walter Nantz produced several all-Black cartoon musicals, including *Scrub Me Momma with a Boogie Beat* and *The Boogie Woogie Man*," notes Professor Walter Brasch of Bloomsburg University of Pennsylvania. "The cartoons were well-directed and animated . . . but because of negative racial overtones are no longer in television syndication," notes Brasch.[25]

In the late 1960s, black entertainers expressed concern about TV's effect on black children in big-city ghettos. Bill Cosby, the first positive black male in a TV series, *I Spy,* said that these youths had too few black heroes they could emulate.

In Los Angeles, ABC's vice president of broadcast standards and practices, Tom Kersey, spoke with me about meeting several years ago with cartoonists Hanna and Barbera "to find an identifiably black hero to bring to television." Said Kersey, "We searched New York for a proper cartoon." They eventually came with a Black Vulcan character. "One of the most sincere promises this department can make is the inclusion of minorities in positive portrayals in all of our programming," said Kersey.[26]

Arab-American youngsters do not have an Arab role model on television. There is, however, an exception. NBC-TV took a positive step with an Arab father and child in a 1984 "Smurfs" episode. The child, a whiz at algebra, and his father were lovable characters. Furthermore, no Arab heavies were lurking in the shadows—a first.

Drama

Police and detective shows attract adult and child audiences. Today's TV detectives are usually extraordinary individuals who have penetrating intelligence and sharp intuition. Quite often these private eyes are more efficient at solving crimes than the local police. We com-

monly find them in the shadows of mosques and pyramids or in mysterious sheikdoms confronting bestial types who would willingly kill family members for "the cause," honor, or the throne.

Kidnappers abduct the son of an Arab king in *Matt Houston*. The youth may be killed because the king lacks sufficient money to pay the ransom. Unlike most detective programs, the kidnappers here are not Arabs. The writer offers realistic portrayals. He does not employ the standard Arab-against-Arab ploy. Instead, he focuses on traditional beliefs—friendship, religious devotion, and the love of a father for his son.

Only one character mars the taut teleplay—Fahad, the king's brother. Fahad "wears bedsheets on his head," has a TV harem and wants to pay $10 million for a modest restaurant. "Price does not matter," he sighs.

In *Scarecrow and Mrs. King,* Arab bodyguards are mute and bewildered. Their princess goes off to see a children's play with Mrs. King, and the guards panic. They burst into a crowded auditorium. The audience screams. On seeing the Arabs, the performing kids freeze, then slowly raise their hands over their heads—they fear it is a stick-up.

The princess explains that "Arab mothers don't do anything, especially talk or give opinions." She also shares anxieties with Mrs. King. "Do you know what it's like to have men with machine guns outside your door when you're in bed with your husband?"

A *Rockford Files* show presents an Arab family as heartless and hateful. Jim Rockford learns that his friend Sean is having an affair with a married Arab woman—Khedra. Jim warns him: "Picture yourself hanging upside down while some Arab is picking your teeth." Sean says that Khedra is "an old-style Moslem wife—no matter what he (her husband) does, you sit and wait for your man."

When Khedra's father learns of the affair, he conducts a mock trial. With a copy of the Koran in view, a relative states: "She must be dealt with at home where she was born, not here in this country."

Rockford is aghast: "Families are supposed to stick together." The Arabs, however, ignore his pleas and whisk everyone off to their private plane. Khedra will be executed in the Middle East. But Rockford creates confusion by setting off an explosion so he and Khedra can escape. Khedra's father has a heart attack and dies. No one grieves.

Television would have us believe that Arabs treat women harshly, and that they are twice as satanic with pretty, young American girls. Thus, white slavery is a favorite theme. In an episode of *Vega$*, actor Cesar Romero plays a ruthless man who lures women to yacht parties, drugs them, and then flies them off to—where else?—Arabia. Romero

tells one showgirl who is bound and gagged, "You as a person mean nothing to me, but your body and your looks are worth $25,000 to anybody who likes blond hair and straight teeth."

In a *McCloud* episode, "Our Man in the Harem," Sam McCloud confronts Arabs who abduct American beauty-contestant finalists to the Kingdom of Aramy. The Arab heavy, Ramal, likes his women to be "blond, beautiful, young and innocent." He tells one captive: "When I return, you will be willing, docile and loving." Eventually, McCloud frees her and the other enslaved women in Aramy by knocking out several saber-yielding TV Bedouin-types with six solid cowboy-type punches.

In one *CHiPs* episode, "The Sheik," we "learn" about Arab customs. A reckless playboy tries to bribe the police officers with two envelopes full of $100 bills. When the officers resist, the Arab states, "You see, in my country this is custom." Like the backward TV sheik of the desert, this irresponsible hot-rodding sheik of the freeway must be "educated." "Ponch" teaches him that laws must be obeyed and that friendship cannot be bought.

CHiPs producer Cy Chermack told me, "The program may be offensive in some ways we're not aware of. If so, we'll try to mend our ways."[27] Like most producers and writers, Chermack dies not know many Arabs or Arab-Americans, personally or professionally.

In a *Cagney and Lacey* episode we see the policewomen dupe the arrogant oil-rich Hassan Bin Moqtadi. Moqtadi drives a new Rolls-Royce with a license plate, "OILBUX," and runs over an American Jew, Saul Klein. Moqtadi won't pay Klein's hospital bills, and since he has diplomatic immunity, he can't be arrested or forced to pay.

Cagney angrily says: "You know what ticks me off, Inspector? In this guy's country you steal a piece of fruit off a cart and they cut your hand off. He comes over here (New York City) and . . . nearly kills a man. And we can't even touch him."

The policewomen call Moqtadi a "clown" and a "spoiled brat" with "crooked teeth." On visiting his embassy, Cagney says, "I feel like I'm in the middle of the *Arabian Nights*." The women are served Arabic coffee and Lacey complains: "Ohhhh, how do they drink this stuff?" Caustically, Cagney says, "It's a ritual of politeness." The women laugh. Lacey then dumps her coffee into the nearest flower pot.

Eventually Cagney and Lacey outsmart the Arab. He agrees to pay Klein's hospital bill. And he gives the officers a $500 donation to a "worthy charity—the United Jewish Appeal."

What if the writer had reversed the role of the show's protagonists,

Klein and Moqtadi? Would CBS telecast a *Cagney and Lacey* program that shows a rich Jew running down a poor Arab?

Not all programming personnel are willing to admit the existence of a problem. Others, like CBS-TV Director of Program Practices, James Baerg, admitted: "I think the Arab stereotype is attractive to a number of people. It is an easy thing to do. It is the thing to do that is going to be most readily accepted by a large number of the audience. It is the same thing as throwing in violence when an episode is slow."[28]

Through organized pressure, the stereotypes of most ethnic groups have been replaced: The popular comedy *Benson* features a black as the savvy, sophisticated aide to a governor. *Chico and the Man* features a Hispanic in a leading role as a tough, lovable Los Angeles Chicano. And Captain Frank Furillo of *Hill Street Blues* is the Italian-American Eliot Ness—just the right blend of law-and-order cop and compassionate civil servant. On Barney Miller's staff in the popular *Barney Miller* series was the easy-going Sergeant Yemana, an Asian-American. Why shouldn't Arabs win the same kind of acceptance as other ethnics?

Comedy

Ethnic groups have always been fair game for satire. Yet some programs have been misleading. The situation-comedy *One Day at a Time* portrays Arabs as fabulously wealthy and oblivious to social concerns. One episode features an oil sheik accused of "buying up all the businesses in town." The sheik has "a palace in his homeland and a little place here—Rhode Island." When the Arab arrives in the U.S., protestors shout, "Arabs go home." Angry demonstrators carry signs that read: "America is not for sale," and "Arabs cannot have this country."

The series star, Ann Romano, must entertain the Arab because her boss wants the sheik to sign on with his public relations firm. Complains Ann, "What else do you want me to do, a belly dance?"

The sheik, a male chauvinist, will do business with a man but not with Ann. Throughout the program, the writers stress that Arabs will not do business with women.

On learning Ann Romano will host the sheik, the feisty janitor Schneider says, "To make the guy feel more at home, I'll spread a little sand in the lobby." Schneider continually jokes about Arabs—he "doesn't want to be replaced by a desert nomad." Arab men call their women "ships of the desert—that's why they wear veils," says Sch-

neider. He adds, "And Arab men make their wives walk five steps be-hind them. Except for World War II. Then they walked five steps in front of them." At one point the sheik is asked, "Have you heard of ERA (Equal Rights Amendment)?" He replies, "the ERA? Is it for sale?"

The creator of *One Day at a Time,* Norman Lear, did not grant me an interview, but I did meet with two of his associates, Alan Raf-kin, executive producer of *One Day at a Time,* and Virginia Carter, Lear's vice president of creative affairs. Carter explained why the *One Day* program enhanced the myth that Arabs are buying up America. "Most of the people who create television programs live in Los Angeles. When they see Arabs buying real estate in Bel Air or Beverly Hills, it is obviously bound to influence the way they write," she said.[29]

Rafkin believes that "most of the things people learn to love or hate or mistrust or adore, they get from television." He doesn't recall ever seeing a decent TV Arab. "The Arab's from a fake country and he's the sheik of so-and-so. He's a terrific guy. But his father is evil," he said.[30] "Or," added Carter, "He's the sheik of Araby folding his tent and slinking off into the night."

One episode of *Alice,* "Florence of Arabia," has Flo meeting Ben, an oil baron, at a checkout lane at the Quick Mart. Flo was buying a can of Spaghetti-Os, and Ben was buying the Quick Mart. Alice says, "He's one of those Arabs who's coming over here to buy up the whole country."

Ben wants to make Flo his fourth wife. All his brothers have four wives; he will be merely catching up with them. Alice warns Flo: "They don't divorce in the shadow of the pyramids, they just put another bed in the tent. . . ."

Flo asks Ben if he has a harem. "My goodness, no," says Ben. "It would be immodest of me to call three wives a harem." Flo abruptly departs, but not before she throws Ben's $100,000 ring into a bowl of soup. "Ben, kiss my couscous," she shouts.

The producers of *Alice,* Bob Carroll, Jr., and Madelyn Davis, dis-cussed the "Florence" episode with me and television stereotyping in general. Carroll said, "Stereotypes take a long time to wither away." Both producers admitted that they had never seen a humane or heroic Arab character on television. This situation exists, they said, despite the fact that TV stereotyping "is not the 'in' thing to do. . . ."[31]

Viewers often see their favorite TV stars ridicule anything Arab—from fillies to fashion to food. Bing Crosby's daughter, Mary Frances, told Merv Griffin in a 1983 program that she was fond of her Arabian

fillies. "We lie down together and sleep at night," she said. Griffin then equated Arabian horses with Arab people. "If you lie down with *Arabs,* (you) get up with fleas."

Joan Rivers is often a guest host on the *Tonight Show.* Concerning Arab fashions, she told viewers, "I can never tell if it's the wife or the husband because they're all in bedsheets."

In *TV's Bloopers & Practical Jokes,* Phyllis Diller is wooed by a wealthy Arab who wants her for his harem. After checking Phyllis's teeth for cavities, the potentate overwhelms her with gifts, including a baby goat. "Good meat," says the Arab. The pet is to be the entrée for supper.

In *What's Happenin',* Amid, the Arab, is a hit-and-run driver who sups on "goat's milk and pigeon's brains." His Rolls-Royce demolishes the protagonist's car. Amid won't pay up—his father has business relations with the U.S. government.

In a *Hart to Hart* episode, the Harts grimace when they see their evening meal—"dried camel eggs."

When Mork prepares a Moroccan meal for Mindy in a *Mork and Mindy* episode, he insists they eat with their fingers. First, they wash their hands in dishwashing liquid. "Feet next," chuckles Mork. Silverware is a no-no because "all the silverware in Morocco is used to break out of prisons." When Mindy gags on the food, Mork sighs, "It's so hard to get fresh camel lips in Boulder."

Television's coterie of talented writers and producers might consider providing more comedy shows in which Arabs are depicted not as objects to be mocked, but as people to be respected—with feelings, weaknesses, strengths, and a sense of humor.

The 1984–85 Television Season

TV Arabs still prowl the tube. In more than thirty programs—from the *A-Team* to *Hail to the Chief*—Arabs are seen as a group separate from Americans—an indigestible lump, a foreign body. Slurs are thrown into shows otherwise unrelated to Arabs.

In the *A-Team,* a Middle East princess will marry some Arab rebel "with a towel around his head." The *A-Team* beats the socks off the rebel and his henchmen.

Bob Hope, dressed as a used-camel salesman boasts: "Now that the Arabs own Beverly Hills there'll be caravans down Rodeo Drive."

Hail to the Chief features Libyan terrorists that hold Bob Hope's

USO tour hostage. "Give me a unit of Green Berets and I'll level *falafel* land in half an hour," shouts the U.S. general. *Chief* flashes anti-Arab barbs nearly every week.

In *Dynasty,* Ahmad, the Arab, proves no TV Arab can be trusted. Rather than keep his promise to John Forsythe, he eagerly beds Joan Collins. Naturally, he wears a *kaffiya* with his silk suit, but not, surprisingly, when he is in the nude.

Popular music videos, *Rock the Casbah* (The Clash) and *California Girls* (David Lee Roth) feature Arabs flaunting oil riches and ogling blonds.

Lace I and *Lace II* focus on a desert kingdom, complete with veiled, cackling women, clad in black.

Not Necessarily the News and *Saturday Night Live* show stock footage of death and destruction in Beirut. Interspersed with these scenes are shots from a video game, "Druze Invaders." A narrator caustically invites viewers to visit Lebanon.

Key to Rebecca focuses on Sonia, an Egyptian belly dancer with kinky sexual habits, who hates the British. Joining Sonia are hordes of Nazi-loving Egyptians, including the villain who is half-German.

In the TV movie, *Seduced,* a street vendor reveals that the Palestine Liberation Organization killed a man because he "was a terrific supporter of Israel."

A Miss Marple TV movie begins with Marple happily arriving in London. On entering her hotel, however, she is stunned by an Arab giant (6½ feet tall) and his three dwarf-like wives.

In *Highway to Heaven,* a man dresses as an Arab to enhance the value of some homes. Such a ploy ensures "a fair shake."

In *Cover-Up,* Arabs are drug merchants with "bad breath" who kidnap American women. White slavery is the theme, and the destination is Tunisia—"the marketplace of the world."

The mini-series *Evergreen* shows Syrians killing Jews, including the grandson of the series star, Lesley Ann Warren (Anna Friedman).

In *Matt Houston,* Matt matches wits with "a terrorist trained inside Lybia—where they teach you to know more about the target than the target knows about himself."

In *Knight Rider,* several Americans steal a horse. Do they try to sell the horse to one of the thousands of horse trainers in the U.S.? No. Enters an Arab: "You bring horse tomorrow," he says, "I bring money."

Often what we do not see is just as important as what we do see. The 1984–85 season also featured "invisible Arabs"—no Arab families

and no Arab heroes. How long has it been since TV offered viewers a contemporary Arab artist, doctor, sculptor, or philosopher? Common sense says that we should have balanced portrayals of Arabs and other ethnic groups and minorities. Hopefully, common sense will affect TV professionals.

Tom Kersey, ABC's vice president of broadcast standards, states: "We spend most of our time rejecting (demeaning) Arab stereotypes, but rather than changing the character to positive representations, the producers and writers simply drop the character and Arabs per se disappear from the television screen. There have been exceptions, of course, but very few."[32]

Conclusion

To date we have not seen an Arab with wit and intelligence sharing laughs with Bill Cosby on *The Cosby Show*. Nor has an Arab physician performed on *Trapper John, M.D.* or *St. Elsewhere*. *Hill Street Blues* and *T. J. Hooker* could benefit by featuring an American cop with Arab roots. Or consider the effect of seeing Blake Carrington of *Dynasty* in love with an attractive Arab. And couldn't Webster, the adorable boy who stars in a show of the same name, share roots with a friend from the Middle East?

Television has chosen to ignore the Arab stereotype. The following is an all-too-familiar treatise.

A *TV Guide* commentary contends that a "long line of minority groups . . . claim that TV has done them wrong. . . . Indeed, it's hard to find a minority these days that hasn't been maligned on television."[33]

A *Donahue* program featured Bill Cosby and his story consultant, Dr. Alvin Poussaint, a Harvard psychiatrist. Their witty and informative discussion focused on the need to eliminate stereotypical images of blacks on TV. They also made a plea for fair TV portrayals of other groups.

An *Entertainment Tonight* five-part series took an in-depth look at media stereotypes.

A Roper study surveyed public perceptions of the treatment of various groups on television entertainment shows. A list of groups was presented, and participants were asked whether they thought each group was portrayed on most television entertainment shows fairly, too favorably or unfavorably. Minorities responded to the study by stating that

television gives unfavorable portrayals of the elderly, homemakers, Hispanics, and blacks.[34]

Interestingly, Arabs are not included in the Roper study, nor are they included in any of the preceding studies or the 1985 television programs—either as observers or participants.

Television multiplies the impact of images. It is powerful—more powerful than any other medium that shapes the images which are attached to people. Isn't it time to debunk Arab myths and misperceptions?

Washington Post columnist Philip Geyelin notes: "There is a nasty impulse" to resort to "indiscriminate slur[s] of Arabs, to think and speak of them collectively, to judge the many by the egregious excesses of the few." As to why the slurs exist, Geyelin explains that, "It is not so much a matter of a flaw in our national character. It comes down to a matter of familiarity, of understanding, of stereotypes in cartoons [and] on television and motion-picture screens." He adds, "Scholars write of Arab 'tribalism' and unsettled 'nomadic' instincts. The suggestion is that 'Arabs' are somehow incapable of statecraft or stable nationhood. They dress funny, carry guns." Concludes Geyelin, "Arabs as well as Jews are 'Semites' by ethnic origin and by definition. It is enough to note that for bigotry applied to Arabs there is no comparable rebuke."[35]

Stereotyping is not a modern phenomenon, existing only in a modern mass medium, such as television. In the Bible, for example, we find the parable of the good Samaritan, whose people in biblical days were stereotyped as villains. The parable forever eliminated that stereotype.

The idea that a *good* Samaritan exists was a revolutionary thought at that time and place. The connotation of the word *Samaritan* was completely reversed. Today, *Samaritan* is synonymous with goodness and compassion.

As of this writing the future of the TV Arab is unclear. The stereotype persists in new programs and reruns. To correct the problem, television professionals need to become aware of the demeaning images and to subsequently eliminate them.

Producers and writers should stress the importance of dignity for every human being. When any ethnic or minority is degraded, for whatever reason, we suffer. When balanced portrayals appear, we benefit. Writers and producers, in cooperation with network officials, could convey a realistic image when they begin to *see* Arabs—indeed all people—as the multifaceted beings they are.

Notes

1. Walter Lippmann, *Public Opinion* (New York: Macmillan, 1922), 59–70.

2. Joseph Boskin, "Denials: The Media View of Dark Skins and the City," in *Small Voices and Great Trumpets,* ed. Bernard Rubin (New York: Praeger, 1980), 141.

3. Laurence Pope, "Flickers of Our Anti-Islam Bigotry," *Los Angeles Times,* 1 March 1985.

4. The Japanese internment is discussed in Jacobus ten Broek and Edward N. Barnhart, *Prejudice, War, and the Constitution* (Berkeley: University of California Press, 1954).

5. See Erik Barnouw's *The Sponsor* (New York: Oxford Univ. Press, 1978), 101, 102. See also Barnouw's article, "Documentary as a Subversive Activity," in *TV Quarterly* (Spring 1983), 25–28.

6. Archibald MacLeish in *Broadcasting* (28 Sept. 1959), 90.

7. For more information concerning Dr. George Gerbner's views on stereotyping, see *Media Portrayals of the Elderly: Hearings Before the Select Committee on Aging, House of Representatives,* Los Angeles, California, 26 March 1980. Comm. Pub. No. 96–231 (Washington: U.S. Govt. Printing Office, 1980).

8. For more information on the number of households in the U.S. with TV sets see Len Riley, "All White or All-American? in *Emmy* magazine (Spring 1980), 30–36.

9. Portions of this essay are from the author's book, *The TV Arab.*

10. "Today's Children Listen More to TV than Teacher," *Christian Science Monitor,* 17 Oct. 1983.

11. Carlos Cortes, "The Societal Curriculum and the School Curriculum: Allies or Antagonists?" *Journal of Educational Leadership* (April 1979).

12. David Lamb, "A Bad Rap for the Arabs," *Courier-Journal* (Louisville, Ky.), 31 March 1985.

13. According to a 1981 World Bank Development Report, except for Saudi Arabia, Qatar, Kuwait, and the United Arab Emirates, the per capita income is less than $850 per year.

14. Lamb, "A Bad Rap for the Arabs."

15. This information is based on my experiences in the Middle East as a Fulbright scholar. I taught mass communications at the American Univervity of Beirut in 1974 and 1975 and at the University of Jordan in 1981 and 1982. Also, under the auspices of the United States Information Service, I traveled extensively throughout the region.

16. Lamb, "Bad Rap for the Arabs."

17. Ibid.

18. William K. Chung and Gregory G. Fouch, *Survey of Current Business* (Aug. 1983), 31–41.

19. Lamb, "Bad Rap for the Arabs."

20. John R. Hayes, "American Attitudes toward Arabs—Perceptions and Misperceptions" (Paper delivered at the conference "U.S.-Arab Relations: The Current Political and Economic Commitment," Salt Lake City, 27–29 March 1985, p. 12.

21. Smith Hempstone, "If OPEC Falls Apart at Geneva . . . ," *Washington Times,* 21 July 1985.

22. These syndicated cartoons were seen periodically over a ten-year period on numerous TV stations throughout the U.S. All the cartoons are still being telecast.

23. Interview with Harve Bennett, Los Angeles, 7 July 1980.

24. *St. Louis Post-Dispatch,* 19 April 1985.

25. Walter M. Brasch, "Ethnics and Wasps in American Animated Cartoons" (Paper delivered at the annual meeting of the Popular Culture Association, Toronto, Ontario, 29 March–1 April 1985), p. 1.

26. Interview with Tom Kersey, Los Angeles, 29 July 1980.

27. Interview with Cy Chermack, Los Angeles, 10 July 1980.

28. See James R. Baerg, "Television Programming Practice," in *The American Media and the Arabs,* edited by Hudson and Wolfe (Center for Contemporary Arab Studies at Georgetown University: Washington, D.C., 1980), 45–48.

29. Interview with Virginia Carter, Los Angeles, 15 July 1980.

30. Interview with Alan Rafkin, Los Angeles, 2 July 1980.

31. Interview with Bob Carroll, Jr., and Madelyn Davis, Los Angeles, 22 July 1980.

32. Kersey interview, 29 July 1980.

33. "Commentary," *TV Guide,* 13 June 1981.

34. "Public Attitudes Toward Television and Other Media in a Time of Change," *The Fourteenth Report in a Series by the Roper Organization Inc.* (1982), p. 15.

35. Philip Geyelin, ". . . and Arabs," *Washington Post,* 28 July 1985.

11

Hollywood Markets the Amish

JOHN A. HOSTETLER AND
DONALD B. KRAYBILL

On March 3, 1984, the *Wall Street Journal* carried an article entitled "Hollywood Today Is All Over the Place As States Lure Films."[1] The author remarked, "States are winning movie business because they offer fresh and authentic things to film as well as lower costs, far less red tape, cooperative communities and a great deal of help in finding suitable locations."

The cooperation between the states and Hollywood is illustrated clearly in the making of the film *Witness* in the Amish country in Lancaster County, Pennsylvania. Early in 1984 the "Today Show" announced that Paramount Pictures was making a major feature movie in Amish country. No one in Lancaster County, however—neither the Tourist Bureau nor the Amish—knew anything about the proposed movie. It came as a complete surprise, and met with two very different reactions: excitement among movie fans and merchants, and dismay among the Amish who were to be the subject of the film.

Paramount decided to make the film after a great deal of solicitation by the state's Bureau of Motion Pictures. The first person to take credit for the decision was James Pickard, Pennsylvania's Secretary of Commerce. He said, "A major influence in bringing the production crew here for the shooting of the movie . . . has been the State Bureau of Motion Pictures . . . the Bureau is responsible for getting film companies to shoot productions in Pennsylvania, providing them with any requested assistance. . . ."[2] Pickard said his staff worked day and night with the production company to bring this film to Pennsylvania. Paramount wanted to know whether fifty Amish buggies could be made available for shooting the film, and whether enough Amish clothing

could be secured for the actors. Scores of farm sites in every part of the county were evaluated for their suitability.

In the story, an Amish boy named Samuel Lapp is traveling with his widowed mother, Rebecca (Kelly McGillis), to visit a relative, when he sees a murder committed in the men's room of a Philadelphia train station. The Philadelphia detective (Harrison Ford) investigating the case detains them; later, when he finds his own life in danger, he follows them back to their farm. In that pastoral hideout he develops a romance with the Amish widow. The movie ends with a shoot-out on the Amish farm.

Paramount sought a farm site where the major filming could be done. Finding that the Amish were unwilling to collaborate in a movie, the studio selected a non-Amish farm. Shooting was to be done in May and June. R. C. Staab of the Pennsylvania Bureau of Motion Pictures assured residents that "the Paramount people have shown sensitivity for local concerns and the way of life of residents."[3] Director Peter Weir announced that he would not use Amish persons in the cast and would discourage his crew from taking personal photographs of the Amish. Even so, the illusion of non-interference could not be maintained.

The Ethics of Access

Paramount's vans moved into the community on a Sunday and were parked along the country roads. The vans were large enough to transport hundreds of hogs to market, and the Amish naturally wondered why all these trucks were needed. For weeks the local newspapers carried stories about this or that movie star, and furnished a steady stream of detail about the making of the movie. Amish farmers reported that they had been offered large sums of money if they would lease their farm for six weeks as a site for the movie. A crew of carpenters which included Amish persons was hired to alter the buildings on the farm site where shooting was to take place. (When it was discovered that the carpenters were not union members, Paramount was forced to discharge the crew and hire unionized labor.) An Amish mother said that her son was offered $35,000 if he would work with the film crew. Another woman said that her son, who was no longer Amish, was hired by Paramount but complained because he was paid only fifty dollars a day.

The Amish bishops warned their members not to work for Para-

mount, not to loan or sell any equipment or clothing to aid production of the movie. Asked by a reporter about this restriction, an Amish person said, "We knew by our upbringing that the movie was too commercial. We didn't have to ask the bishops."[4] Another said, "We can't stop them, but we don't have to help them. We don't want it. It doesn't belong here. It really makes hard feelings."[5]

Then the unexpected happened. According to Producer Feldman, Kelly McGillis who was to play the role of an Amish widow, was "placed" in an Amish home to learn Amish customs. When her photograph appeared in the local paper, identifying her as an actress, the Amish family asked her not to return. When asked about this event, producer Feldman told a reporter, "They [the Amish] were very polite about it. They just didn't want to be connected in any way with the picture. And the minute they found out [McGillis] was an actress in it, they weren't interested in having her there any longer." He added, "There have been worse deceptions."[6]

"Now that was an intrusion," commented an Amish mother. "These movie actors wearing our clothes, and coming to our private homes and getting a widow to help them out on the sly. We wouldn't do that to them. They would hike us out the door faster than we ever came in."

In a later interview with the *New York Times*,[7] McGillis denied that she had not identified herself as an actress. She said she had helped on the farm (for three days) and attended religious services.[8] Unable to find tape recordings of the language, she "wandered about the community on market days, wearing a Walkman recorder." "Totally illegal," she said, "I'd pretend I was listening to music and instead I'd tape people's conversations."[9] McGillis apparently did not know or was not informed that Pennsylvania German grammars and dictionaries are available, that the dialect has been taped, and that it has been taught for decades in several Pennsylvania colleges.

Shooting was not restricted to a single farm site. The film crew moved to the front of Zimmerman's store in the small village of Intercourse, where most Amish in the area do their shopping. The area roads were barricaded by the police, which prevented the Amish from using the hitching posts for their horses. The store was surrounded by trailer trucks, tons of equipment, staged Amish carriages, and several hundred onlookers.

The Amish took offense at the store owners for allowing Paramount to use their space. One Amish preacher delivered a letter in person to Mr. Zimmerman, the store's manager, saying that the Amish were "victims of a mass deception for the love of money, fame, and worldly at-

tention. A business our plain people helped to build up is now being turned into apostasy."[10] The letter asked for a public apology.

Zimmerman said that the incident was a nightmare for him. "I went to see a couple of bishops. I lost a couple of nights' sleep." Later he published an apology in the Amish newspaper.[11]

After the major shooting was completed, the Amish people reported an incident they considered a grand deception. A businessman from the city of Lancaster approached an Amish farmer, asking if he could use his open field to fly a large balloon. The Amishman asked if the event was connected in any way with the movie. The merchant explained that it was and the Amish farmer did not consent. The merchant then approached another Amish farmer in the neighborhood, who did not think to ask about a possible connection with Paramount. That farmer gave his approval. On the day the balloon was to be flown, many Amish children and adults came to watch the spectacular scene. When a large crowd had gathered, a "passenger" train suddenly appeared on the adjoining railroad tracks and stopped long enough for Paramount's cameras to photograph the scene from its open windows.

The Amish perceived this intrusion into the community as an imbalance in human reciprocity. As one spokesman put it, "We have done nothing against those people (Paramount). How would they like for us to come and invade their privacy and expose their way of living to the whole world? We don't like to have our things broadcast and our religion marketed. If they had any Christianity at all they would leave us alone."

The logic is pertinent, for the municipality of Hollywood has banned passenger tourist buses from its streets at the request of movie stars, who object to the invasion of their privacy. A Canadian journalist has suggested facetiously that a movie be made of "fifty Amish farmers who arrive in Hollywood with a tank and drive up to Peter Weir's mansion and start digging up the lawn with horses and plows and teach him how to grow turnips and cabbages and learn how to make sauerkraut. I assure you that Weir would protest all the way back to Australia if this ever happened to him."[12]

Fearing that one movie made in Amish country would lead to more such movies, a delegation of Amish bishops asked for an interview with the state's governor. In a meeting with Lt. Governor William Scranton III, they expressed their displeasure. "We don't like to be exposed, especially in movies. This makes us feel like moving elsewhere."[13] They said they were being "misrepresented and mocked," and they feared that the movie would bring in more tourists and more peo-

ple of an "undesirable kind." The Amish delegation asked the governor's help in preventing future use of the Amish in making movies.

The Amish had some grounds for their fears, for Secretary Pickard indicated in a press release that the Bureau of Motion Pictures worked "with the thought in mind that maybe the production company will come back later." The state, he said, is "geared to making production companies feel welcome and appreciated in Pennsylvania."[14] In a telegram to the premiere opening in Lancaster, Harrison Ford said he hoped to return to Lancaster County to make another movie.[15]

In response to the delegation, Mr. Pickard sent a letter of agreement to the Amish. The letter stated that the Bureau would not promote the Amish as subjects for feature films, would discourage filmmakers from taking photographs of the Amish, and would refuse to deal with film companies that attempted to film the Amish without their consent.[16] In an interview with the press, however, Mr. Pickard said that the state could not prevent film-makers from making a movie about the Amish if they insisted.

The premier opening of *Witness* in Lancaster was attended by a thousand people, who purchased $60 and $100 tickets. Governor Dick Thronburgh and his wife attended the event with stars from the movie, and proclaimed it "marvelous."[17] His wife called it "absolutely superb." When civic and local dignitaries were interviewed after the showing, reporter Ernest Schreiber noted that "none objected to the occasionally vulgar language, two episodes of violence, or one brief moment of semi-nudity."[18] An Amish bishop who read the script of *Witness*, however, was shaken by the numerous indecent words. He asked, "If our government approves of such lies and foul language what will happen to our country?"

The full impact of the movie on the Amish themselves may not be known for some time. A few disturbing events have been reported. An Amish boy resembling that of Lucas Haas in *Witness*, narrowly escaped kidnapping in a village shopping center.

An Amish woman who saw a newspaper clipping of the passionate embrace between the Amish-clad Kelly McGillis and Harrison Ford, said: "How do we know what will happen? Some of those movie-goers may say 'let's get us an Amish girl' and they may just grab one. The police in town warned our bishops not to let our young people walk alone, or to go to the store or doctor by themselves. I was thoroughly frightened when I heard about it."

From the beginning of production the most important considera-

tions have been financial; an annual $300-million tourist industry is based on curiosity about the Amish. Because of the movie, said County Commissioner Robert Boyer, the flow of tourists could increase from four to ten million per year.[19]

The Ethical Dimensions

What are the ethical dimensions of the making of *Witness,* both for the film-maker and the anthropologist? In the Introduction to this volume the editors suggest three separate but related moral issues faced by film-makers: (1) the image maker's contract with himself to produce an image which is somehow a true reflection of the producer's intention—to be true to oneself; (2) the producer's moral obligation to his or her subject; and (3) the producer's moral obligation to his or her audience.

Peter Weir, the producer of *Witness,* may have satisfied his commitment to produce a document that met his intention, but whether he met his moral obligations to his subjects and his audience is debatable. The Amish were displeased at having their space invaded, being publicized in the entertainment industry, having their sacred images rendered in what to them is a profane medium, and having these images broadcast to millions around the world. The production of the movie would have been less disruptive to the community had the movie been produced elsewhere.

The anthropologist is frequently forced into the role of informant, broker, or spokesman. Peter Weir had a copy of my book,[20] *Amish Society,* and had seen the documentary *The Amish: A People of Preservation,* for which I had served as co-producer and consultant. When Paramount invited me to serve as an adviser for the production of *Witness,* I asked whether the movie was based on a historical incident or whether it was fiction. My contact, R. C. Staab, informed me that it was fiction, and asked if I wished to speak with the director.

My choice was either to take a position as a member of a Hollywood team and hope to have a positive influence over the outcome, or to remain independent of the movie production and attempt to interpret the Amish position to the wider American society. Knowing the Amish value system and Hollywood's reputation for producing erotically charged films, the latter was the only appropriate course I could take.

My decision was based on my knowledge of the Amish taboo against pecuniary-laden entertainment based on romance and violent images and the strength of that taboo, as distinguished from their attitude toward other kinds of representations. The Amish have deeply rooted religious reasons for regarding Hollywood movies as an affront to their community life. Modern theatergoers scarcely understand the intensity of the Amish teaching against the taking of human life. The Amish are even more deeply repelled by the voluntary act of seeing an artificially produced murder, and by the spending of money for the experience of seeing a killing on the screen.

Meanwhile a group of Lancaster County Amish persons, all respected by their community for their wisdom, shared with me their concerns about the forthcoming movie. Knowing their apprehension, I wrote an article for the press expressing their concerns.[21] Had anyone made an impact study of the film? I asked, if a movie attracted revenue into the state, what else would it attract into the community? Was it not ironic that the "Quaker State" itself, a model of integrity in dealing with minorities, was now instrumental in violating the sensitivities of longstanding religious communities? Didn't the citizens of Pennsylvania know that the Amish considered a Hollywood movie "extremely obnoxious," as one Amish person wrote in their newspaper? Didn't the county government know that the flow of tourists would increase greatly? Was the county prepared for the increase?

The Amish feared that the merchants' voluntary restraints of blatant exploitation would come to an end, and they feared the proliferation of images of indecency and violence. The trusting relationships between the Amish and strangers, they said, would erode as more leisure seekers and film-makers overran the landscape. Surreptitious entrance into their homes, religious services, schools, and gatherings, they said, would increase with the increase in the number of visitors and tourists.

I asked, "Are these erosions worth three million dollars to the Commonwealth, which the Secretary of Commerce said would be gained in revenue?" At issue, I pointed out, was a practice much broader than inconvenience to the Amish. If a state government follows a policy of stimulating the economy without regard for the religious life of its citizens and the welfare of its communities, then other groups, too, might suffer the loss of privacy and common courtesy in one way or another. Supreme Court Justice Louis Brandeis called the right to be left alone "the most comprehensive of rights and the right most valued by civilized men."[22] The Amish people, I suggested in the article, deserve the right to be left alone by those who would mer-

chandise their "redemptive community" for entertainment and pecuniary gain.

The local Paramount office in Lancaster told the public that I had refused to advise the movie because I was not offered enough money. (At no time had a fee been discussed.) A former Amish person who asked to see the script was refused permission. I watched the shooting in front of the village store, and observed the faces of both tourists and Amish. Later, in a published interview, I said that Paramount might be within the law, but that the film crew was breaking the hearts of the Amish people and grossly violating human sensibilities.

In an interview with a reporter, the Amish bishops affirmed my statements. "We are really opposed to it. That's all that need be said," stated one bishop. Another said, "We feel bad about it because everything is make-believe. They dress up like Amish and go through their play. But they are just using the Amish."[23]

Peter Weir defended the movie as "a sensitive and accurate portrayal of the Amish." In a published reply, Weir accused me of "seeking publicity," setting myself us as "a self-styled spokesman," and perpetrating "a tissue of lies and deception." The movie, he said, "will come and go like a summer breeze," and "Hostetler will be proved wrong when the film, in its finished form, is finally released early next year."[24]

Authenticity

How authentic is *Witness?* The answer, of course, depends upon the viewer's social context. The most favorable reviews describe the movie as "sensitive," "artistic," "stunning," "erotic in the purest sense," and "enormously powerful." Less than favorable are these comments: "A conventional doomed romance stapled onto an even more conventional cop thriller, *Witness* never hangs together" (*Washington Post*); "For a film that means to admire the Amish ways . . . *Witness* contains a lot of aggressive violence" (*New York Times*); "To what degree can we tolerate 'artistic lies,' especially those dealing with the previous religious values of vulnerable minority sects?" (*Commonweal*).

From the viewpoint of the Amish, the film is anything but authentic. All the leading characters would be spotted as phony in any Amish group. Although the mood is usually "right," the details in virtually every scene are wrong. McGillis's grooming and hair styles, for example, do not conform to the dress of an Amish widow, nor does she wear

the head covering at the right time; what passes in the film for Amish dialect is an awkward imitation of high German; a new groom would not show a full beard; the Amish do not kiss in public when boarding a train; in loading a wagon with hay, an Amish farmer begins from the rear, not from the front; the Amish do not make overtures of courtship and never tell off-color jokes at a funeral; nor do they sing at a barn raising.

Highly offensive to the Amish is Harrison Ford, who, dressed as an Amish man, threatens to strangle a female tourist with her brassiere, and descends from a carriage to fist-fight with visitor-tourists on the sidewalk. Not only are the Amish portrayed as violent but the Amish symbols are desecrated. A major problem with the production is that in the more accurately depicted scenes the viewer sees what the Amish do, but does not discover why. Harrison Ford is confronted with Amish customs, but learns nothing about the Amish; nor do they learn or change because of him. One reviewer observed that Ford might just as well have fallen into a cave and discovered the lost civilization of peaceful busy dwarfs. There is little reason for *Witness* to include Amish at all. Although the film toys with the notion of nonviolence, it is overwhelmingly preoccupied with violence as entertainment. If the movie contains a message of nonviolence, it is that Ford killed two cops rather than three.

Witness is not an authentic source of information on Amish culture. Many details are un-Amish and give a false message. The director interpreted selected Amish traits effectively, but he was bound by his profession to include elements foreign to Amish life.

Like contemporary film images of Third World cultures, *Witness* is important not for what it communicates about a "foreign" culture but for what it says about American-Hollywood ideology. Claudia Springer has observed that "one of the recurrent themes in American films about Third World encounters is that of the noble savage."[25] The myth of the noble savage, she says, is a means by which Americans and Europeans use indigenous people to play out their fantasy of a simple life unencumbered by the stresses of modern society. Noble savages are typically seen as innocent and unself-conscious. Noble savages usually represent something intangible which the film-makers perceive as missing from their own culture; the latter are concerned less with social change than with fulfilling a desire for escape. Once the Amish are perceived as noble savages they can be treated in movies, with popular culture paying its last respects before the tourists render them extinct.

The Amish Perspective[26]

Two fundamentally different world views lie beneath the varied re-sponses to *Witness*. On the surface these different perspectives might be characterized as "modern" vs. "traditional." The modern world view as exposed in typical movie reviews understands a film like *Witness* as a work of art—a statement that touches, expresses, and articulates key motifs of the human condition. The modern mind evaluates a film by asking whether it captures in a sensitive way the ethos and spirit of its subject. The Amish, who embody a traditional world view, appraise a motion picture from a radically different perspective. For them, *Witness* clashes not with a single isolated precept but with a whole way of living. The values which shape the Amish objections to a major motion picture like *Witness* are discussed below. While baffling to the modern mind, these objections are internally consistent within the Amish frame of reference.

Integrity. The Amish reason that a movie, like a staged performance, is an artificial creation, considered inauthentic and artificial because it is an excursion into the world of make-believe. An actor is seen as a phony, playing the part of someone else. In the Amish mind, playing the role of a character in a drama is the equivalent of a lie because the actor puts on a mask and deceives the audience by pretending that he's someone that he's really not. As fabrications and symbolic representa-tions of reality, film and drama make an audience vulnerable to manipulation by the writer or director.

The Amish will contend that things should always be what they appear to be. Appearance and reality should coincide perfectly. The "yes" should always mean "yes" and a person should be only his or her "true" self in every situation. Consequently, the historic concern of the Amish and Mennonites for genuineness and integrity in all of life has resulted in taboos against theatre and motion picture films. By the same token, the historic Amish and Mennonite restrictions against makeup, jewelry, cosmetics, and faddish costume were established be-cause these enhancements were seen likewise as creating or "making up" a false person and projecting a fraudulent self-image.

This concern for integrity is related to the Amish refusal to swear an oath out of literal obedience to the words of Jesus: "Let your yes be "yes" and your no, "no." " The early Anabaptists argued that their

"yes should be yes" in every situation; to swear in a courtroom that they are telling the truth is hypocritical because it suggests that they don't always tell the truth. The notion of integrity also implies honesty, truthfulness, and a high degree of correspondence between words and action. In short, as the Amish would say, let your life demonstrate your beliefs, or "practice what you preach." The Amish people use metaphors and stories didactically to support their religious values, but they reject those forms of communication (motion pictures and projected images) which they perceive as a threat to their community.

Oral Tradition. The theater encourages critical analysis and self-reflection, but in a culture like the Amish, where the overwhelming concern is preservation of the social bond, abstract thinking and individual self-analysis are not ends in themselves. The Amish value obedience to their community more highly than critical thinking and acknowledge this commitment by terminating formal education with the elementary grades. They teach practical and utilitarian skills, which do not encourage introspection. The Amish emphasize visceral training for life participation; like their founding fathers, they warn their people against the danger of "pagan" thinking, which they associate with self-exaltation, pride of position, enjoyment of power, and the arts of war and violence.

A movie like *Witness* encourages the viewers to reflect about themselves by snatching a fragment of life and projecting it on the screen. Dramatization forces audiences to look at life—often an episode from their own lives—from a detached perspective, which raises questions and provokes conscious reflection about the meaning of living. This process is attractive to the modern mind, but threatening to the Amish because it erodes the authority of wisdom-tradition. The Amish know from experience what social scientists have concluded from their scientific studies: that objectification of one's culture leads to alienation. They want no part of it. In *Witness,* "fake" Amish-like images are now being "studied" by millions of moviegoers all over the world.

Humility. The Amish will not knowingly pose for picture-taking. This prohibition is based on the Second Commandment: "You shall not make for yourself a graven image, or any likeness . . ." (Exodus 20:4). Throughout their history the Amish have interpreted this passage to mean that statutes of the human figure and photographs must be avoided. Thus the taboo is not a personal dislike of pictures, but a rule affirmed and agreed to by every faithful church member. Amish

families do not allow commercially made dolls in their homes, for example, because dolls have faces and moving eyes, and are embellished with all the likenesses of the human figure. The major transitions in life, such as birth, baptism, and marriage, are not photographic events.

This restriction emphasizes the importance of the community over the individual. Picture-taking is self-exalting; thus it is carnal, a manifestation of pride, and man-pleasing. Individuation would weaken the cohesion of the corporate community. (Uniformity of dress and grooming is another way in which the community minimizes the influence of individualism.) Although *Witness* does not photograph Amish people directly, it attempts to capture their images and portray them to the public in a medium which the Amish ardently despise.

Separation. The Amish faith requires stringent separation from the values and lifestyles of the larger society, or "the world." The worldly, carnal, unbelieving system is powerful and ambitious, but degenerate and bent on self-destruction. From the Amish viewpoint, the Hollywood movie industry is the epitome of the worldly system.

From the Amish perspective, the biblical teaching of "separation from the world" is violated in a movie that artificially juxtaposes contradictory and incongruent elements: peaceful Amish with violence. What the film director regards as an achievement of distinction, the Amish see as "a cultural insult of the highest order." The violent killings in the Philadelphia depot and on the Amish farm, although mild by the standards of contemporary film, are a mockery to the Amish people, who have for so long exemplified the values of non-violence and sexual purity. When a Hollywood producer serves as a self-appointed interpreter and purveyor of the Amish way of life, they consider it a slap in the face.

The modern moviegoer will argue with the Amish at this point: even though *Witness* portrays violence, does it not also portray the quiet non-violence of the Amish? A little violence, it can be argued, is necessary as a contrast with the peaceful ways of the Amish. The Amish disagree: violence is always wrong, even if contrived and shown on the screen for a noble purpose. Their concern for integrity leaves no room for ambiguity. No expression of violence can have redeeming value, regardless of the virtue of the ultimate outcomes.

Modesty. The Amish object to appearances of success, and the cultivation of modesty is a landmark value in their Amish ethos. They are

suspicious of pride and fame, believing that it will ultimately lead to "a fall." The Amish have no yearning for worldly acclaim, and quote the scriptural verse, "Beware when all men speak well of you. . . ." Growing public admiration is a sure sign of coming doom. To receive "good press" and to have "positive images" of their culture projected on screens around the world, the dream of every public relations firm, is a travesty to the Amish, who desire to remain modest, unassertive, and inconspicuous.

Privacy. Although separate from the world in many ways, the Amish know that a major film company will reap substantial profits. In the first five weeks after its release, *Witness* grossed $31.6 million at the box office and was earning about $5 million per weekend, making it one of the most popular movies of the year. Not only do the Amish realize that enormous profits are being made at their expense, they also know that such publicity will attract more and more tourists to see them in real life, although few tourists can ever invade the backstage of the local tourist industry and actually speak with real Amish. The handsome payoff for the tourist industry—for Lancaster County in particular and for the state in general—is undoubtedly the reason why municipal agencies and chambers of commerce, from the governor's office down, were ready accomplices to the making of *Witness*. The Pennsylvania Dutch Visitors Bureau invites out-of-state visitors to come to Lancaster to "Visit another country . . . Pennsylvania Dutch Country, as seen in the movie *Witness*." Tourists will come in increasing numbers to stare at the "backward" Amish, a persistent intrusion and nuisance in their otherwise serene life. To be sure, the Amish also reap some benefits from the tourist trade in food and craft sales, as well as in service jobs. Yet above all, they yearn to be left alone, to have the freedom to live their lives quietly according to their convictions, and most of all to be away from the glare of public scrutiny—a dream which *Witness* erodes.

Finally, there is an implicit message in the Amish view that goes beyond the objections arising out of their "traditional" mind set. While the world at large is moving from a word-centered to an image-culture, the Amish fear that this transformation signals a supreme danger. By insisting on maintaining a community based on the spoken word and refusing access in their homes to the vendors of the electronic age, they have screened out of their lives the worldly metaphors of "bigger and better," "convenience," and "time-saving." By refusing to plug into the images of opulence and success touted on the screens of theatre and

television they have held at bay many destructive impulses of modern life that lead to aimlessness, alienation, violence, waste, and the disintegration of community life.[27] And while the logic of their opposition to a movie like *Witness* is foreign to the modern mind, the integrity, durability, and character of their corporate life is an implicit message in itself that speaks in a compelling way to the image makers of the modern world.

The Amish insist that the form and not simply the content of communication is necessary for maintaining the boundaries of their community and sustaining their religion. They have discovered in their collective wisdom that face to face communication of the spoken word is essential in achieving a viable community. They believe that communication based on electronic images, especially inappropriate ones, can destroy human communities. And they may be right, for "the Indian who learns television is an Indian no longer."[28]

The Israelites were forbidden from making concrete images of anything (Deut. 20:4). Why do the Amish persist in this line of thinking? Why would Jehovah give instructions on how his people were to symbolize, or not to symbolize their experience?[29] Unless there is an assumed connection between the forms of communication and the quality of life, the injunction scarcely makes any sense. Jehovah was to exist in the Word and through the Word—a rather high order of abstraction. Iconography was blasphemy, for through it new loyalties and gods could enter and take command of the community.

So, as the Amish would say, if anyone is truly enamored with our way of life, let them not applaud it in theatres, but rather let them cast off their fabrications and come join our community as a living witness.

Discussion and Summary

In the production of a cross-cultural feature movie such as *Witness,* the image maker is confronted with a variety of structures in opposition. Some of these conflicts are ethical, and the ethical systems themselves are in conflict. The entertainment industry is attracted to the Amish, but the Amish are repelled by the industry. The Amish seek the right of privacy, while Hollywood seeks the right of access. The Amish are powerless and will not use lawyers or police, while Hollywood has the full sanction of law and the resources of state agencies. The Amish maintain that fiction movies are contrived, while Hollywood maintains that their messages are truthful. The Amish seek separation from the world, while Hollywood wishes to include them in the public pool of image

resources. The Amish maintain sacred boundaries, while Hollywood recognizes only legal and profane boundaries. Images of violence are as important to Hollywood as tranquillity is to the Amish. In *Witness,* fiction is made into reality, but to the Amish, reality is made into fiction.

An ethnographic description of a culture is one thing, but to dramatize that culture is another. Neither process is free from appropriate ethical considerations and human sensitivities. In the production of *Witness* we have described specific ethical situations scarcely anticipated by the producers, including the role of governmental agencies that promote entertainment movies implicating historic groups who have religious objections to iconography. The anthropologist who knows the intimacies of a human community and who becomes an informal spokesman for its concerns may be forced to choose between loyalties—to the community or to the entertainment industry. Although the producer asserted a policy of not photographing the Amish people, making the movie in the environs of the Amish community was disruptive in the Amish view and betrayed their trust in state government and local entrepreneurs. Had the movie been made outside the Amish community, many intrusive elements would have been avoided.

Notes

1. March 6, 1984.
2. *Lancaster Intelligencer,* March 4, 1984; April 7, 1984.
3. Ibid.
4. *Lancaster Sunday News,* May 6, 1984.
5. Ibid.
6. *Lancaster Intelligencer,* April 27, 1984.
7. *New York Times,* Jan. 3, 1985.
8. *Newsweek,* March 11, 1985.
9. *New York Times,* Jan. 3, 1985.
10. Letter dated June 30, 1984. The writer wishes to remain anonymous.
11. *The Budget,* July 1984.
12. John Schmidt, personal correspondence.
13. Minutes of July 3, 1984.
14. *Lancaster Intelligencer,* April 7, 1984.
15. Ibid., Feb. 8, 1985.
16. James Pickard letter to Andrew Kinsinger, Sept. 11, 1984.
17. *Lancaster Intelligencer,* Feb. 8, 1985.

18. *Lancaster New Era,* Feb. 8, 1985.

19. *Lancaster Intelligencer,* Feb. 8, 1985.

20. Johns Hopkins University Press, 1980. Use of the first person in this chapter refers to Hostetler.

21. *Gospel Herald* (Scottdale, Pa.), June 26, 1984; *Lancaster New Era,* May 8, 1984; *Lancaster Intelligencer,* June 29, 1984.

22. *Olmstead v. United States,* 277 U.S. 438, 478 (1928).

23. *Lancaster New Era,* June 30, 1984.

24. *Lancaster Intelligencer,* June 29, 1984.

25. Claudia Springer, "Viewing the Other: Representations of the Third World Noble Savage in Contemporary American Cinema." Manuscript. International Conference on Visual Communication, University of Pennsylvania, Annenberg School of Communications. May 30–June 1, 1985.

26. Parts of this chapter are excerpted and adapted from Donald B. Kraybill, *"Witness:* Interpreting the Amish View." *Elizabethtown College Bulletin* (July 1985). Used by permission.

27. Readers who feel that TV is "neutral" might read: "The Inherent Biases of Television," chapter 4 in Jerry Mander, *Four Arguments for the Elimination of Television* (New York: Morrow, 1987), 261–98.

28. Ibid., 354.

29. For this association the authors are indebted to Neil Postman, *Amusing Ourselves to Death: Public Discourse in the Age of Show Business* (New York: Viking, 1986), 9.

12

Out of South Africa:
THE GODS MUST BE CRAZY

TOBY ALICE VOLKMAN

In 1981 an obscure South African film opened in movie theatres in half a dozen U.S. cities and closed soon afterward without a ripple. In Europe, Japan, and South America, however, *The Gods Must Be Crazy* created major waves. Perhaps inspired by its international success, 20th Century–Fox acquired the film and opened it in New York in the spring of 1984. Since then, *Gods* has become a raging success in North America. In less than one year it grossed $1 million at New York's 68th Street Playhouse, with minimal advertising. Nor is it just a New York phenomenon: it has played continuously in cities throughout the country, and remains, according to 20th Century–Fox, "hard as nails." Internationally, it has earned more than $90 million since 1981, including $40 million in Japan alone. The film has inspired rave reviews, picket lines, and a protest resolution at the 1984 meetings of the American Anthropological Association.

What is the extraordinary appeal of *The Gods Must Be Crazy?* Are its critics humorless activists and stuffy scholars who fail to appreciate the delights of harmless fiction?

The Plot

In the wilds of the parched Kalahari Desert a group of cheerful Bushman leads simple lives, foraging and drinking the morning dew. In their isolation and their ignorance of property, proclaims a narrator, they are "the most contented people on earth." Alas, paradise is quickly

lost, harmony disrupted: a thoughtless (civilized) pilot tosses an empty Coke bottle to the ground below. The resourceful Bushmen put the novel object to good use (roots are pounded, music made), but it soon stirs unfamiliar emotions. Jealousies erupt, people even hit each other over the head. A Bushman named Xi resolves to return the evil object to the gods' abode, from whence it must have come.

Xi journeys to the edge of the world, bottle in hand. In the course of his trek he encounters: a fair-haired white journalist who has abandoned her bourgeois career and her integrated [!] Johannesburg office in order to teach school in the hinterland of Botswana; a bumbling white biologist studying elephant dung and competing for the heroine's attentions with a white macho safari guide; and an unruly contingent of card-playing black guerrillas attempting to overthrow an unspecified and utterly incompetent black government. Also embroiled in the story are the biologist's sidekick, an ingenious colored mechanic named Mputi; a chorus of radiant Tswana villagers; and a school full of beguiling black children, shiny as buttons, who are taken hostage by the nasty guerrillas.

If the Coke bottle marks the end of innocence, Xi's journey progressively introduces him to the weirdness and constraints of civilization. He observes with silent or softly clicking wonder. One day he shoots a goat with his bow and arrow, is arrested and jailed. Mputi, the marginal multicultural mechanic who spent three years in the bush and speaks Xi's language (and English with Yiddish syntax), understands that Xi will die in prison: "he doesn't know from walls." With Mputi's help, Xi is freed from jail by the biologist who takes him on as a kind of sweet pet and ecological consultant. Here the plot gets particularly interesting: the terms of Xi's release are that the biologist must pay him wages and must not let him go. Always lovable and accepting, Xi assumes his wage-laborer role with grace and makes himself an asset through his native tracking skills.

Meanwhile, another subplot thickens. The guerrillas have bungled their attempted coup and are fleeing maniacally across the border. On the way they kidnap the black schoolkids and march them, along with their white teacher, through the countryside. Sharp-eyed Xi spies them from a distance (the high-tech scientist lacks Xi's natural gifts and must use a cumbersome long lens). The biologist master-minds a solution: he provides Xi with an immobilizing drug, a miniature bow and arrow, and instructions. Xi infiltrates the enemy lines disguised as a black girl (he is after all a pint-sized Bushman); he shoots his tiny but well-aimed arrow at the guerrillas.

Xi, having heroically carried out the wishes of the white man, saved the children, and defeated the enemy, fulfills his mission: he flings the bottle far off into the clouds at the edge of the world. Happy and empty-handed, he returns to Bushman paradise.

This in a nutshell is the plot of what one reviewer called "the year's wackiest movie." And funny it is, joining old-fashioned slapstick prat-falls with satiric digs at the urbanities and inanities of modern life (traffic circles, alarm clocks, boring office jobs). Captivated by its quirky comedy, reviewers described *Gods* as "inspired looniness" (Newhouse Newspapers), "downright hilarious . . . riotously funny" (Gannet Newspapers) "perfectly delightful" (WABC Radio), "even funnier than it is eccentric" (*New York Times*). A *Boston Globe* writer notes that the audience she saw the film with was rolling in the aisles with laughter and applause. But, she adds (Shute, 1984), "as an exiled South African, I cringed all the way through. . . ."

What is the problem with *The Gods Must Be Crazy?* It purports to be an innocent joke: "an epic comedy of absurd proportions," the advertising campaign proclaims. Jamie Uys, the film's South African director, takes this position. "It's just a slapstick comedy, with no message," he told a *New York Times* (1985:15) reporter. "I've been making comedies most of my life, and I never put a message in—it's bad for business."

Black Humor

There are, of course, many messages in *Gods:* about power; about whites, blacks, and Bushmen; about nature, technology, culture. Let us look first at the portrayal of blacks.

Gods has been protested and picketed by groups who argue we must not support South African cultural productions in any form. Other critics counter that analyses of works such as this are a necessary part of the anti-apartheid struggle. Beneath the simple surface of the film, writes Peter Davis (1985:3), "lies a psychogenic parable about white South Africa, an exploitation of its myths, and an attempt to exorcise the Black Devil of those myths by means of laughter."

The blacks portrayed in *Gods* are both the powerless and those struggling to obtain or maintain power. The former include children who are not only harmless but adorable, obedient to their white teacher, and kidnapable by black guerrillas; and a village full of farmers who sing a smiling hymn of welcome to the white teacher. The reality of

the depiction of either group leaves something to be desired. Jennifer Shute (1984) writes in the *Boston Globe:* "When the new schoolmarm earnestly sets about teaching her little charges the four food groups, nothing in Uys's narrative acknowledges that many of these children would consider themselves lucky to see any food at all, whatever its group . . . and a 50-percent infant mortality rate could be on another planet, rather than just offscreen."

And, of the radiant villagers, Shute comments: "In one of the film's most touching moments, the entire Tswana village turns out, brightly garbed and beaming, to sing its welcome song to the new arrival; the scene is so charming that one forgets to wonder at all these smiling black faces welcoming their white savior from the south."

More prominent than either kidnapable kids or earthy farmers are the blacks on both sides of the power struggle—the struggle, that is, with each other, since a struggle between whites and blacks would be far too stiff a dose of reality for Uys's comedy. These include an absurdly buffoonish group of guerrillas trying to overthrow an absurdly incompetent black government of an unidentified state. "Here," notes Shute, "all subtlety departs. . . . Idi Amin has always been an indispensable figure in white South African mythology, trotted out to 'prove' that blacks are incapable of governing themselves. . . . [T]his is the gang that can't shoot straight—a comforting fantasy for white South Africans, as the regional struggle intensifies."

Another reading of the plot is offered by Davis, who argues that in the film blacks are like children, easily led astray by outside agitators. (The leader of the guerrillas is vaguely Cuban in appearance with a strange accent). When this happens, suggests Davis (1985:8), "the threat is not only to blacks but to the white race personified in the heroine. To save black and white alike, white organizational skills must mobilize all indigenous peoples and even African nature itself [a reference to a poisonous bush that is used to fell some of the black guerillas]. Andrew Steyn, the pacific, unworldly scientist—the personification of a technologically advanced but non-aggressive South Africa—beats all the odds." Needless to say, South Africa, unlike biologist Andrew Steyn, is neither non-aggressive nor armed only with science, technology, and handy Bushman helpers. But Uys's film projects this fantasy so smoothly that the viewer scarcely notices it; after all, this is message-free comedy, pure entertainment.

The Charm of the Other

What sets *Gods* apart from a mere parable about white and black in South Africa is the presence of Xi the Bushman. It is Xi who charms the reviewers and the viewers; it is Xi who is the centerpiece of both plot and subtler fantasies. Xi and his fellow Bushmen are at first introduced through the distancing omniscient narrator's voice; but thanks to the intervention of the Coke bottle, we begin to have something in common. We begin to like Xi, to realize that he is a person, that his clicking speech is also language (although as if to reassure us of difference Uys overlaid extra clicks). We begin to see some of the stranger aspects of our world through his eyes, as we follow him in his progression from innocence and wandering freedom through his encounter with property, law, imprisonment, money, wage labor, the machine, the safari, the revolution, and finally, as if there were a choice, his return to hunter-gatherer paradise of the Kalahari. This on the surface is the story of Xi: endearing and curious, different and desirable, and ultimately free. How could we fail to be charmed? I overheard a young woman ask her friend after the movie: "Where do you think they found those Africans? Do you think they are real?"

Indeed, reading the press, from Jamie Uys's own comments to cinema publicity, realities begin to blur. Uys, who certainly must know better, told the *New York Times* (1985) "the tiny Bushman [N!Xau] had only seen one other white man, a missionary" before Uys discovered and hired him. The *Times* article elaborates: " 'The Bushman agreed,' Mr. Uys said, 'because they are such nice guys that when you ask them for something, they say O.K.' N!Xau handed his bow and arrow to his son, climbed into the plane, and flew with Mr. Uys to Windhoek." Uys also told the reporter that paying wages was a mistake, because N!Xau had no use for money. " 'I found out later that the money had blown away,' Mr. Uys said."

Like the film itself, Uys's statements consistently reflect a wished-for Bushman world that bears little resemblance to reality. Let us look simply at the comments quoted above. N!Xau had in fact seen quite a few white men before he was rescued from naiveté by the great white director; white administrators had been in the Kalahari for decades, as had white schoolteachers, anthropologists, writers, film-makers, and, since 1978, the white South African Defense Force. John Marshall, who has worked in the Kalahari since the 1950s, reports that N!Xau grew up as a herdboy—not a hunter—on a Herero farm in Botswana,

and moved in 1976 to Bushmanland (Namibia) to take a job as a cook in the local school. It is highly unlikely that this school cook would have had a bow and arrow to hand to anyone. More importantly, N!Xau certainly knew about earning and spending money (and there was plenty to buy on Bushmanland when Uys appeared in 1978).

Director Uys has a strong investment in portraying, even perceiving, a particular version of Bushman 'reality.' Hence the need to un-clothe the Bushmen of their Western rags, to build a perfect if over-sized grass hut instead of shooting the squalid shanties in which they live, to substitute noble hunting gear for ration tags; to add extra clicks for a convincingly exotic soundtrack (meaning is submerged by the sound of authentic otherness). In relation to the 'reality' he would create on film, Uys appears to see himself as a great discoverer/bene-factor/adventurer. He told one *New York Times* reporter, for example, that "when he wants to see N!Xau he flies 1,400 miles and then circles over the approximate area, until N!Xau makes a fire to signal his whereabouts."

N!Xau, in the real world, is easy to find. He, along with 1,000 other Bushman (or Ju/wasi, !Kung, or San), lives at Tshumkwi in the northeastern corner of Namibia. Tshumkwi is the major settlement on the homeland known as Bushmanland, administered by South Africa since 1970. No smoke signals are necessary to locate Tshumkwi.

How Tshumkwi came to be is a long story (Volkman, 1982). One could begin over 300 years ago, with the arrival of Dutch settlers in southern Africa. For two centuries, the Europeans waged a grim and successful war of extermination against the original inhabitants, the San, whom they called "Bushmen," in the south (the present Republic of South Africa). To the north, the San of the Kalahari Desert escaped the fate of their southern cousins, probably because of the inaccessi-bility and relative uselessness of their dry land to European settlers. Today, about 40,000 Bushmen remain, living primarily in Bostwana, Namibia, and to a lesser extent in Angola, Zambia, and Zimbabwe. Of these, the northern San number 15,000 and speak a language known as !Kung. Some 6,000 !Kung in Namibia and Botswana call themselves Ju/wasi, "the true people." N!Xau, the other Bushmen in *Gods,* and the other inhabitants of Tshumkwi are Ju/wasi.

Before 1950, the Ju/wasi of the Kalahari had little sustained con-tact with Europeans, although they had traded and sometimes fought with Bantu peoples in the area, particularly with Herero pastoralists. In 1951 the first Marshall family expedition visited the area: retired Cambridge, Massachusetts, businessman Laurence Marshall, his wife

Lorna, and their children Elizabeth and John. The Marshalls found the Ju/wasi living much as their ancestors had, hunting antelope and other game, gathering wild plant foods, and moving with the seasons from camp to camp. The intent of the expedition, sponsored by the Peabody Museum of Harvard University and the Smithsonian Institution, was to find and study one of the last remaining groups of hunting and gathering peoples in the world. Like Jamie Uys, the Marshall expedition had its visions and its limits; as John Marshall now recalls, their quest for a 'pure' hunter/gatherer society led them to ignore the evidence that many !Kung were already practicing a mixed economy. "Bitter Melons," a song sung by an old man which became the theme and title of a poignant film about survival in this harsh land, is about not wild but garden melons. Marshall recalls that he did not want to film agriculture, "but we *had* to record that song; it was too beautiful." Still, most of the film that Marshall shot and edited from the 1950s was about 'traditional life'—quintessential images of man the hunter.

In 1959 the first white Bushman Affairs Commissioner, Claude McIntyre, arrived in Ju/wasi territory, and settled at the site of a waterhole named Tshumkwi, where a Ju/wasi band was living. McIntyre began to visit groups in the area to encourage people to join him at Tshumkwi, where he hoped to help them begin a new life of pastoralism and gardening. He told them of goats and a "mealie land," a large garden on which the corn known as "mealie" could be raised. He promised help against the encroachments of Herero pastoralists who had in the past attempted to settle with their cattle on Ju/wasi lands. Some bands responded positively, following the path of other San whose lives were already closely entwined with the Bantu or white economy, with cattle-raising or farming. Throughout the 1960s, Tshumkwi grew, and by 1970 it had gardens, goats, and about 700 Ju/wasi inhabitants.

In 1970 South Africa drew borders around "Bushmanland" as an official homeland, accomplishing the formal inclusion of the !Kung within the apartheid system and simultaneously eliminating two important foraging areas. Restricted in their movements and deprived of ancestral subsistence territories, the Ju/wasi moved in greater numbers into Tshumkwi, which began to resemble an overpopulated, impoverished slum in the middle of the desert, complete with Dutch Reformed Church, clinic (for the many tubercular Ju/wasi), administrative center (where rations were dispensed), school (with white teachers), and store (where one could buy sugar and canned chicken as well as tea sets and, since 1981, hard liquor).

By 1978, when by a curious coincidence both John Marshall and Jamie Uys happened to film in Tshumkwi, virtually none of the nearly 1,000 Ju/was living there continued to hunt and gather full-time in the bush. In spite of immigration and shorter birth intervals, the population had scarcely grown. The causes for a high death rate included tuberculosis, poor sanitation (exacerbated by the sedentary situation), dietary changes, and the enormous tensions that life at Tshumkwi created: depression, lack of anything to do, lack of the mobility which in the past had served to defuse stress, and the availability of large quantities of unequally distributed goods. In the past, a foraging !Kung family could carry less than sixty pounds of possessions, and goods such as ostrich eggshell beads were continually exchanged. Meat and plants foods were shared, formally and informally, among the group. The growth of a cash economy stimulated inequalities that revealed a darker side of sharing. Money, unlike fresh meat, need not be divided; neither perishable nor visible, it is easily hidden and hoarded. And unlike roots and tubers, money does not grow abundantly in the bush, accessible to all. Arguments at Tshumkwi were rife and painful. In John Marshall's film *N!ai, the Story of a !Kung Woman,* N!ai sings bitterly to those who accuse her of hoarding: "Don't come to me now. Don't look at my face. Death is dancing with me now."

In 1978, another element complicated the scene at Tshumkwi, as South Africa escalated its campaign against SWAPO, the South West African Peoples Organization. Founded by black Namibians in 1960 as an anticolonial movement, SWAPO was recognized in the early 1970s by the United Nations General Assembly as the "sole legitimate representative" of the Namibian people. As SWAPO increased the level of armed struggle in the 1970s, South Africa moved 50,000 troops into northern Namibia and built a massive base and airfield at Grootfontein, 145 miles west of Tshumkwi. In 1975 a secret army base was established in the western Caprivi strip, offering food and shelter to San refugees from the Angolan war across the border to the north. Many of these refugees had fought with the Portuguese against the Anglan insurgents and were forced to flee following Angola's independence. The practice of recruiting San continued, and in 1978 a base was set up 30 miles west of Tshumkwi. This became the center for a new battalion of Namibian !Kung. By September 1981, 140 men from Tshumkwi, or nearly 50 percent of the men between ages 15 and 45, had joined the army. The men brought their families to the camps. Elsewhere several hundred San were stationed at seven major bases in Bushmanland.

According to the army's own figures, one out of every four !Kung San in Namibia is now linked to the army, either directly or as a dependent. Richard Lee has noted: "In relative terms, this is the highest rate of military service of any ethnic group in the world, much higher, for example, than that of the Gurkhas of Nepal or the Montagnards of Vietnam" (1982:7). Marshall estimates that nearly 40 percent of Bushmanland's population is supported at army camps, while indirect support in the form of food, clothing, and money is spread throughout the whole of Bushmanland and several communities in Botswana.

From the army's perspective, !Kung are good trackers, valued for their skill in the field and their extraordinary endurance. And there is the added pleasure of bringing civilization to savages, as this passage from the *Windhoek Advertiser* suggests:

"Deep in the dense Caprivi bush a colony of Bushmen are being taught a new culture and a new way of life by the white man. More than a thousand Bushmen have already discarded the bow and arrow for the R1 rifle and their wives are making clothes of cotton instead of skin. Gone are their days of hunting aimals for food and living off the yield. They now have 'braaveis' [*sic*, barbecue] and salads with salt and pepper while the men wear boots and their ladies dress in the latest fashions. Their children go to schools and sing in choirs. . . . The men are being trained as soldiers while their womenfolk learn how to knit, sew, and cook. . . . It is an open camp and the people may come and go as they please, but most of them prefer to stay" (quoted in Lee, 1980:1–2).

From the !Kung perspective, one does not have to look far to discover the attractions of the army. In 1982 a soldier's average pay was Rand 500/month; a lucky employee at Tshumkwi's administrative center could earn at best R200. When rations were stopped for old and tubercular people at Tshumkwi, people simply moved to the army camp, where they could live with relatives and enjoy a share of the military's material bounty. The small wages of a native film star are nothing in comparison with this.

Myths and Metaphors

We have come full circle back to *The Gods Must Be Crazy*. In 1978 Jamie Uys walked right into Tshumkwi: into its squalor, its jealous quarrels, its hunger and disease and apathy. He hired N!ai to play "the

wife in the hut," the same N!ai who told John Marshall that she was tormented by her friends and family and that death was dancing her ragged. He hired N!Xau the school cook to play the pristine hunter-hero. He hired extras to greet the brave hunter returning from his mission. He constructed a clean grass hut and told his actors to dress like natives; his crew washed the children's faces so the audience would like to look at them. Perhaps Uys was simply following Robert Flaherty's maxim, said of the over-sized igloo built for *Nanook,* that "one often has to distort a thing in order to catch its true spirit" (quoted in Rotha, 1980:50). But what is the spirit captured here? And unlike Flaherty, Uys couples his distortions with denial, as his press interviews reveal. Rather than seek either truth or distortion, we may see *Gods* as a portrayal of a metaphorical reality, far more timely than its director's explicit statements about smoke signals and Bushman bliss.

Some of the metaphors are clear and simple. The guerrillas are SWAPO, the Southwest African Peoples Organization, led by a wild-haired, light-skinned (Cuban?) agitator. Xi represents the Bushmen who are now being recruited by the South African Defense Force—"agile little brown men with razor-sharp senses and a killer instinct" as that state's press describes them—to counter the Namibian independence movement. The episode replicates in perfect miniature the political reality, adding a wished-for outcome: the white/brown (scientist/agile marksman) victory over the band of black (inept) guerrillas. What is insidious is that this makes us laugh.

The !Kung Bushmen among whom this was filmed, as we have seen, no longer hunt or gather; they drink home brew or Johnnie Walker, not morning dew. Anyone who has seen *N!ai, the Story of a !Kung Woman,* is wrenchingly aware of the contemporary situation: a thousand former hunter/gatherers crowd into a slum on Bushmanland, living on government handouts of mealie meal and sugar, fighting with each other ("the harmless people"?), joining the South African army not for fear of SWAPO but for incredibly high wages and lack of anything else to do. In 1978, as Marshall was still filming on Bushmanland, two groups of whites arrived: army recruiters, and the South African crew shooting *The Gods Must Be Crazy.* Viewers of *N!ai* will recall a short sequence in which the shabby misery of Tshumkwi temporarily disappears, and the !Kung perform before Uys's camera shorn of their Western clothes. The scene-in-progress is the conclusion of *Gods:* Xi, having successfully traveled to a breathtaking precipice and thrown the Coke bottle over the edge, now returns where he belongs, to the Edenic bush.

Like other ethno-fiction films, the apparently harmless humor of *Gods* conceals disturbing real-world implications. Apartheid finds legitimation in an excruciatingly nasty, condescending view of blacks, whether those in power (the ludicrous black government) or out (the equally absurd guerrillas). The only inoffensive black people are the truly powerless: kidnaped children and singing villagers, wrapped in gorgeous colors, earthy, and minding their own business down on the farm.

Of the !Kung, *The Gods Must Be Crazy* is dehumanizing and de-historicizing in its reverence. Usy told the *New York Times* he "fell in love with" the Bushmen, and some theater publicity writers seem to have fallen in love with their own bizarre fantasies. Read, for example, these lines from a Philadelphia cinema blurb: "[M]ost Bushmen live their lives believing they are the only creatures of their type in the world. . . . As the lushness of the Kalahari shrank, so did the Bushman. Today the tallest Bushman grows no taller than four feet. Their small bodies are perfectly proportioned, with delicate wrists and ankles and nimble fingers." The text then comments on their lack of sense of ownership, which extends to wives, children, and all other useful articles; and on their inability to speak a common language: each family unit "develops their own vocabulary, making the prospects of a cohesive unifying language an impossibility."

The Gods Must Be Crazy perpetuates the myth that Bushmen are blissfully simple creatures, while its popularity persuades South Africa that the world wants to continue to see them that way. It is no surprise then that the film's immense international success is being used in Namibia to promote a plan to convert Eastern Bushmanland into a nature reserve where white tourists could admire wildlife, including bow-hunting Bushmen. This latest scheme may be even more devastating than alcoholism, tuberculosis, or militarization. Aside from museumizing and commoditizing the !Kung, it would bring an end to cattle raising, the one subsistence alternative on Bushmanland through which some !Kung have begun to reclaim a measure of economic independence and dignity (Marshall and Ritchie, 1984).

Writing in the *New York Post*, Rex Reed said that "the most delightful thing about 'The Gods Must Be Crazy' is the way it intercuts the goofy people it invents with the real animals, natives and nature." Xi is such an endearing character that the categorical distinction between "people" (goofy) and "natives" (real? like animals and nature?) is as buried in the film as it apparently is in the reviewer's consciousness. It is, nonetheless, critical. It is this distinction that enables Jamie

Uys to construct a protagonist of exquisite innocence and purity, who "doesn't know from" walls or weeks or wages. We watch Xi's gentle twinkling eyes and listen to his clicking speech (who knows what he is really saying?) and are convinced we know and love him. Unlike E.T. or the brother from another planet, however, Xi and his fellow San are very much of this planet and this moment. The denial of this reality allows South Africa to continue to dispossess them of their autonomy, their history, and their land.

References

Davis, Peter. 1985. "The Missionary Position" (unpublished manuscript).

Lee, Richard. 1982. "SWAPO: Best Hope of the San," ARC Newsletter 6:1 (Boston: Anthropology Resource Center).

———. 1980. "The Kalahari San: Montagnards of South Africa?" TCLSAC Reports (Toronto: Toronto Committee for the Liberation of Southern Africa).

Marshall, John, and Claire Ritchie. 1984. Where are the Ju/Wasi of Nyae Nyae? (Capetown: Center for African Studies).

The New York Times. 1985. " 'The Gods Must Be Crazy'—A Truly International Hit" (April 28).

Rotha, Paul, with Basil Wright. 1980. "Nanook and the North," *Studies in Visual Communication,* 6:2.

Shute, Jennifer P. 1984. " 'The Gods Must Be Crazy' Is Unrealistic and Offensive," *Boston Sunday Globe* (November 18).

Volkman, Toby Alice. 1982. *The San in Transition: A Guide to N!ai, the Story of a !Kung Woman.* Occasional Paper 9 (Cambridge and Watertown, MA: Cultural Survival and Documentary Educational Resources).

13

Lesbian and Gay Documentary: Minority Self-Imaging, Oppositional Film Practice, and the Question of Image Ethics

THOMAS WAUGH

Ever since Stonewall, the Greenwich Village uprising of street gay people against the police that symbolically inaugurated the era of gay liberation, documentary film has been a primary means by which lesbians and gay men have carried out their liberation struggle. Most of the Western industrial democracies have seen a lively proliferation of documentaries by lesbians and gay men, gaining momentum in particular in the late seventies. This proliferation has occurred both within the mainstream media and within the alternative circuits and has aimed at both general and specialized audiences, gay and non-gay.

Lesbian and gay documentaries have addressed both general issues—identity and consciousness, civil rights and political transformation—and the stakes of specific and/or localized struggles—for example, child custody, or local mobilizations in Toronto or Sydney. Coming from different cultural, political, and personal backgrounds, the films, as might be expected, range across a broad spectrum of ideological, technical, and aesthetic choices. At the same time, seen together as a single corpus, they reflect the shared evolution of the international lesbian/gay movements over the years, their shift of focus from pride to power, from crisis reaction to strategy building and community consolidation. This paper addresses ethical issues that arise from these endeavors by lesbians and gay men to use documentary film to represent themselves,

to mobilize their communities, and to achieve goals of social and political change.

To date, most discussion has centered on mainstream media and state legal apparatus. Even lesbian and gay critics raising questions of image ethics tend to do so in terms of how we are represented by straight image-makers, that is, their ethical accountability to us, rather than in terms of the ethics of our own self-representation (cf. Gross in this volume). Such criticism seldom achieves concrete results; the dominant media, on those rare occasions when they in fact do listen to us, invoke a code of ethical principles and procedures which from our point of view is nothing more than rationalization for silencing, scapegoating, trivialization, tokenism, contempt, sensationalism, and ridicule. How many times, for example, has the media blackout been lifted briefly only to have us debate our right to live and love with, at best, apologists for discrimination, and, at worst, proponents of concentration camps and even capital punishment?[1] It's called the ethics of balance. Lesbians and gays have this in common with other disenfranchised groups, that media access is systematically blocked, not *despite* codes of journalistic ethics but *because* of them. For lesbians and gays, this impasse is especially frustrating because of our status as a largely invisible minority for whom the already complex issues of representation are compounded by our straddling of boundaries of race, gender, class, and culture.

Rather than playing by the rules of the dominant media, lesbian and gay documentarists must develop an independent set of ethical principles suitable to an oppositional or radical film practice. Such principles apply regardless of whether the documentaries aim simply at filling the representation vacuum left by the dominant media, whether they aim at political reform or integration, or whether they aim at fundamental societal transformation. In fact, such a code has already evolved in practice for lesbian and gay documentarists, just as similar codes have evolved in parallel areas of cultural practice committed to social change and/or minority empowerment (though these oppositional and minority ethical codes have seldom been formulated in systematic ethical terms).

What are the ethical principles that we have developed in this work of counter-information, community mobilization, and the undermining of the system? And which of these principles are specific to us, which do we share with other minority cultural workers, and which are common to all cultural workers committed to change? How are these principles derived from our experience as oppressed sexual minorities living

under patriarchal capitalism? If, as recently argued, the three funda-
mental ethical principles of the gay movement may be summarized as
a basic truthfulness engendered by respect for the self, the freedom of
individual (sexual) choice, and—believe it or not—love, how are these
translated into the nuts and bolts of documentary film technique?[2]

This essay attempts to locate a number of areas within which the
ethical principles of lesbian/gay self-representation may be hammered
out. But since an ethics of minority culture is surely a code of moral
and political relativity, I do not offer a list of prescriptions—at least I
will try to avoid this—but a series of foci around which lesbian and
gay documentary film-makers must make—and have been making—
informed and relative ethical choices. My emphasis on oppositional
self-representation is not meant to denigrate the work of those trying to
assert our right to control our images in Hollywood or CBS or the pub-
lishing industry or wherever. Rather it is intended to underline our cru-
cial stake in radical cultural practice in a conjuncture which, for the
foreseeable future, will continue to impede the aspirations of lesbians
and gays, of women, of the working class, and of all disenfranchised
people.

I am basing these reflections on twenty-four lesbian and/or gay
documentaries for which I provide the credits and a brief summary of
content and method in the following list. The works originate in the
U.S., Canada, Australia, England, West Germany, and France, and
within the national groupings reflect many more different political, eco-
nomic, and cultural contexts. They are arranged chronologically within
the national groups. Although my primary focus is film, I include two
of the more prominent videotapes to have emerged recently: as the cur-
rent funding crisis deepens, more and more work by lesbian and gay
documentarists will be appearing in this medium.

U.S.A.

In the Best Interests of the Children. Frances Reid & Elizabeth Stevens (Iris
Films), independent, 1977; portraits of eight lesbian mothers and their children,
based principally on first-person participant testimony.

Word Is Out. Mariposa Film Group, independent, 1977, 135 min.; subtitled
"Stories of Some of Our Lives," portraits/first-person case histories of twenty-six
men and women.

Double Strength. Barbara Hammer, independent, 1978, 16 min.; wry autobio-
graphical/diaristic reflection on artist's past relationship with a trapezist—infatua-
tion and rupture.

Loads. Curt McDowell, independent, 1980, 20 min.; diaristic, participatory account of author's casual sexual encounters with straight men, erotic and ironic.

Greetings from Washington. Lucy Winer, independent, 1981, 30 min.; vérité images of the 1979 March on Washington by 125,000 American lesbians and gays.

We All Have Our Reasons. Frances Reid & Elizabeth Stevens (Iris Films), independent, 1981; study of alcoholism as a women's issue via a portrait of a Los Angeles center for lesbian alcoholics.

Pink Triangles. Cambridge Documentary Films, independent, 1982, 35 min.; essay on homophobia, historical and contemporary, including some archival material on Nazi gay holocaust, establishing analogies with current New Rights.

Choosing Children. Debra Chasnoff & Kim Klausner, independent, 1984, 45 min.; essay on lesbians having and rearing children via portraits of five different representative "families."

Silent Pioneers. Lucy Winer, independent, 1984, 45 min.; portraits of gay/lesbian senior citizens based primarily on interviews.

The Times of Harvey Milk. Robert Epstein & Richard Schmiechen, independent, 1984, 87 min.; narrative of career of gay politician and its context, ending in his assassination and its aftermath, constructed from TV archives and first-person participant interviews.

Before Stonewall. Greta Schiller, independent, 1984, 87 min.; archival complication of U.S. gay/lesbian history, supplemented by interview and vérité reminiscences of first-person participants.

CANADA

Some American Feminists. Nicole Brossard, Margaret Westcott, & Luce Guilbeault (National Film Board of Canada), 1977, 55 min.; interviews with 6 U.S. feminist leaders and theoreticians, including lesbians Rita Mae Brown, Kate Millett, and "political lesbian" Ti-Grace Atkinson; concluding account of Susan Saxe case.

Michael, A Gay Son. Bruce Glawson, independent with NFB distribution, 1980, 27 min.; a young man comes out—discussion with a peer support group followed by role-playing of family confrontation improvised also by peers.

Track Two. Harry Sutherland, Gordon Keith, & Jack Lemmon, independent, 1982, 90 min.; study of community resistance to police oppression, focused on 1981 bathhouse raids and unsuccessful municipal electoral campaign; many interviews plus vérité coverage of rallies and demonstrations.

Heroes. Sara Halprin (formerly Barbara Martineau), independent, 1983, 23 min.; collaborative auto-portraits of an elderly handicapped woman, an elderly immigrant black woman, and a middle-aged lesbian carpenter, developing the concept of everyday heroism.

Orientations. Richard Fung, independent, 1985, video, 56 min.; first-person discussions by a dozen lesbians and gays of different Asian backgrounds looking at interface of gay and lesbian identity with their cultural heritage.

AUSTRALIA

Witches and Faggots—Dykes and Poofters. One in Seven Collective, independent, 1979, 45 min.; Sydney gay/lesbian resistance to police oppression in 1978–79, first-person participant testimony with vérité coverage of police attacks, counter-demonstrations, and political meetings; archival prologue.

WEST GERMANY

It Is Not the Homosexual Who Is Perverse, But the Situation in Which He Lives. Rosa von Praunheim & Martin Dannecker, state TV, 1971, feature; self-oppression in gay culture conveyed through fictional didactic sketches and analysis of the sketches.

Army of Lovers (Revolt of the Perverts). Rosa von Praunheim, state TV, 1978, 93 min.; journalistic survey of American gay community, including recent history, based on participant interviews and some sketch material.

*Taxi Zum Klo.** Frank Ripploh, independent, 1981, 93 min.; autobiographical episodic narrative of personal and professional adventures of Berlin gay schoolteacher against backdrop of sexually active ghetto: humor, eroticism, domestic melodrama, some media collage.

FRANCE

Un Siècle d'Images d'Homosexualité (The Homosexual Century). Lionel Soukaz & Guy Hocquenghem, independent, 1979, 105 min.; four "moments" from 20th-century gay history conveyed through some archival material but primarily through interpretative sketch reconstructions: von Gloeden, turn-of-century photographer of male nudes; Hirschfeld, scientist victim of Nazi terror; late sixties sexual revolution; late seventies stock-taking in Paris ghetto.

L'Aspect rose de la chose. Chi Yan Wong, independent with some public funding, 1980, 74 min.; current lesbian/gay problematic explored through eleven collaborators' statements on various subjects, plus vérité group discussion—Brechtian in tone.

ENGLAND

Framed Youth. Lesbian and Gay Youth Project, independent, London, 1983, 45 min., video; the problematic of lesbian/gay youth through participant interviews, vérité group discussions, media collage.

Breaking the Silence. Melanie Chait, Channel 4 TV, 1984, 60 min.; lesbian mothers and their struggle to retain custody under patriarchal law, explored through group discussions and individual statements.

* (Although strictly speaking, the semi-fictional *Taxi Zum Klo* does not really belong in this survey of documentary films, I include it because of its autobiographical nature and documentary influences, and in response to the suggestion of participants in the Image Ethics Conference of January 1984 where a preliminary version of this paper was presented. The suggestion was that the inclusion of a film as popular as *Taxi* would clarify many of the issues I raise for readers who are not familiar with current tendencies of independent documentary in the United States or elsewhere.

Our Constituency and Ourselves

These twenty-four documentaries crystallize ethical discussions that are all relative to their specific conjunctures but all revolve around a notion of accountability. Conventional assumptions about a documentary film-maker's ethical accountability point to the subject (the subject must consent to the use of his/her image, must not be exploited, etc.), and secondarily to the audience (the audience must not be misled, etc.). This paper maintains of course these two ethical foci, but adds two others, that of the constituency and that of the self. Gay and lesbian cultural workers share their accountability to their constituency with all minority and oppositional activists. In fact, mainstream media workers and journalists are also accountable to a constituency—white middle-class heterosexual men—though of course this accountability is unacknowledged and masked by the media's claims to be speaking for society as a whole. My notion of accountability to the self is more distinctive, in fact unique to lesbians' and gays' identity as an invisible sexual minority.

In the scheme of things that I propose, accountability to the constituency and to the self cannot be secondary to either the subject or the audience, and in some cases may even have priority over these two traditional ethical foci. With regard to the subject, for example, I could not easily refute a justification of the easy superficial caricatures of homophobic subjects in *Pink Triangles* (an ex-Marine, a Catholic housewife) established through person-on-the-street interviews (a device that is ethically delicate in any circumstance, though the authors of *Framed Youth* and *Silent Pioneers* include similar material with seemingly much less of the caricatural bent). My reasoning is that the film-makers' decision to dramatize the universality of homophobic discourse threatening their constituency takes precedence over the film-makers' responsibility to homophobes (whose views are fully represented in the media anyway). Or, to take a more distant example, would anyone argue with the well-known use of false credentials by progressive Chilean and East German film crews in Chile in 1973 to gain access to reactionary interview subjects?

As far as lesbian/gay film-makers' audience goes, this is not always identical to their constituency, that is, the lesbian/gay community, or its parts. The films under review have a wide variety of audience goals, from the broad general public broadcasting audience (*Word Is Out, Before Stonewall, Breaking the Silence*) to the alternative lesbian femi-

nist network (*Heroes, Double Strength*) to the specialized public of professional decision-makers in child custody litigations (*In the Best Interests of the Children*). It is therefore not difficult to conceive of many other instances where a film-maker's accountability to his/her constituency might be seen as having priority over a broad general audience. Certainly the several film-makers represented here who have suppressed easily misinterpreted and controversial aspects of gay lifestyles, say promiscuity, have weighted their responsibility not to disseminate harmful stereotypes or AIDS panic or whatever over the general public's "right to know."

As for accountability to the self, I cannot conceive of any circumstances in any of the six countries in question, where a film-maker's masking of his/her sexual orientation, and the toll of self-oppression this entails, would be warranted by accountability to subjects or audience. Admittedly some situations are ambiguous: for example, I could not easily criticize a lesbian film-maker of my acquaintance who stayed in the closet during the shooting of a film about strikers' wives so as to not alienate her sexually conservative working-class subjects. Yet for any project related to sexuality or to sexual politics, a film-maker's choice of the closet, either on the set or in the text, seems categorically unacceptable. The closet is an institution to which I will return.

One final corollary to the foregoing discussion of accountability is that gay or lesbian film-makers' accountability to the mainstream media and other institutions of heterosexist patriarchal capitalism (such as the law) is negligible. Beyond their responsibility to stay solvent and out of jail wherever possible, they must as a general principle avoid all collaboration with the dominant media (except where concrete short-term goals are clearly achievable) and above all with the police (except, for example, to help in the apprehension of queerbashers, etc.).

Moreover, lesbian and gay media activists must not hesitate to engage in extra-legal activity wherever this is in the interest of lesbian/gay self-representation, resistance, and liberation. By this I mean civil disobedience, ranging from smuggling and copyright commandeering to the reappropriation of equipment and resources and to the active sabotage of homophobic image makers and censors inciting violence against us. Cultural work is not all arts and leisure.

Censorship and Self-Censorship

To what degree and under what circumstances can an ethically account-able documentarist representing an oppositional minority be justified in telling less than the full truth? Self-censorship is perhaps the thorniest ethical issue raised by the twenty-four films under review. However, it must first be recognized that self-censorship is often if not always mo-tivated by the realistic apprehension of potential external censorship. Many of the film-makers under consideration here have faced and ex-perienced that danger, whether it took the form of bureaucratic obsta-cles to broadcast access (*It Is Not the Homosexual . . .*), police ha-rassment and threatened confiscation (*Track Two*), actual confiscation by official censors (*Loads, Framed Youth*), threatened funding cutoff (*L'Aspect rose de la chose*), mutilation by official censors (*Race d'ep*), etc. The ensuing discussion must be balanced by an awareness of this harsh reality. Each decision about "controversial" content must reflect a careful weighing of the ethical and political risks of each individual context. A reckless taunting of the censor, invited suppression and ven-geance upon the constituency at large, is as ethically problematical on the part of the film-maker as an unjustified withholding of the full truth of a situation. At the same time, a minority's self-appointed image rep-resentatives have the ethical duty to run reasonable risks and most of those discussed here have by and large fulfilled this duty courageously.

Very few minority or other political documentarists accountable to a specific constituency manage to avoid being taxed with sins of omis-sion. Gay/lesbian documentarists in particular continually face criti-cism for leaving out this or soft-pedalling that. This is not only because of the context of media inaccessibility, causing even single-issue films to assume the encyclopedic mission of documenting the entire condition of homosexuality. It stems also from our long collective and individual histories of invisibility and silence in the closet, of the hiding and self-censorship necessary to avoid daily violence and rejection. The reflex of self-censorship still comes automatically, every day, to all of us, and so innocent omissions take on the character of self-censorship no matter how well motivated. *Word Is Out,* for example, is charged by Ray Olson with having suppressed, despite its 135-minute length, the follow-ing list of subjects: work, politics, systematic oppression, legal persecu-tion, street violence against gays, the lack of gay access to public me-dia, benighted attitudes of church and psychiatric institutions, and most important, the gay liberation movement.[3] While we may wonder whether

some of these might not be legitimate omissions in a film showing twenty-six individuals' personal evolutions, the final item—the omission of the mention of the gay liberation movement—seemed a valid complaint when it was revealed that at least nine of the twenty-six subjects are political activists in that movement and that this aspect of their personal evolution had been downplayed by the editors. This ellipsis was apparently not motivated by any expectation of censorship (though it is obviously no accident that the film that systematically understates collective activism achieved the broadest distribution of all of the films under consideration, whereas *Track Two*, unforgettable for its strong images of angry unified crowds in Toronto's wintry streets, has run into obstacles at every turn).

The same issue is raised by the debate around the "positive image" question, and by the confusion of audience goals that frequently permeates this debate. Reacting to generations of mainstream images depicting our loneliness and depravity, lesbian and gay documentaries quite naturally seek to provide self-valorizing yet self-critical, exemplary yet realistic models to their lesbian/gay audiences, and anti-stereotype positive images to the general public. These two options seldom coincide and attempts to combine them sometimes result in films that are stilted, schizophrenic, or bizarrely discontinuous. This double bind, I think, is behind the distinctly rosy tint of *Michael, a Gay Son, Greetings from Washington,* and the two Iris Films productions, *In the Best Interests of the Children* and *We All Have Our Reasons,* to mention only four (though none of these is any less cathartic for lesbian/gay audiences for all their glow). However valid and real the injunction against washing dirty linen in public may be, we have much to gain by washing it in private. Now, in what might be called a third generation of lesbian/gay documentary, past the stages of self-recognition and of self-valorization (of which *Word Is Out* marked perhaps the end), we are now engaged in a stage of gay power and politics and of collective memory; an essential component of that stage, in fact an ethical imperative, is the kind of self-analysis, self-criticism, self-evaluation necessary to any healthy community. Confusion over audience goals on the part of film-makers, or the appeal to multiple or overlapping audiences, has tended to remove the element of self-criticism from our films.

Track Two is symptomatic of this problem. Originally intended for general, theatrical audiences (unrealistically, it may be argued), designed to build alliances with the straight liberal public and only secondarily aimed at gay spectators, the film glows with self-righteous sanctity: no acknowledgment of "street people" despite the title's reference

to the police habit of grouping gays with prostitutes; no trace of "effeminacy" in its roster of witnesses, in contrast to very useful appearances by "queens" and "butch" lesbians in *Word Is Out, L'Aspect rose de la chose, Before Stonewall,* and *Taxi Zum Klo;* no analysis of the pedophile issue despite its prominence in Toronto's local hate literature and New Right mobilization, and the police exploitation of it as a pretext for their first attack; no analysis of the institution of the commercial ghetto, which was after all the target of the police raids that set off the chronology of the film, and which is perhaps a key to an historical understanding of the gay male movement (as Rosa von Praunheim hints suggestively in his two films without further development of the idea). In short, a conceptual and strategic miscalculation snowballed into an ethical and political blunder when the film reached its real (gay) public, primarily on the alternative circuit.

Ray Olson complains of the tendency towards sexual self-censorship in a group of similar films he labels as "accommodationist":

> . . . their collective motto might be "We are normal and we want our piece of the action." This is disingenuous. Gays are not "normal." They are homosexual, something these films are very chary of acknowledging, betraying deep-rooted insecurity vis-à-vis the straight norms. . . . To avoid even frank discussion, let alone full and frank information, on homosexuality as much as these films do, is to risk being crucially beside the point . . .
>
> . . . the only way to address the homophobe and homophobic society in a liberatory gay film is to unflinchingly present the reality and pervasive presence of homosexuality in our society. There must be frank and totally unapologetic discussion and illustration of how homosexuals make love and how they respond sexually to their environments. And this explicitly homosexual contact must be personally presented . . .[4]

Along these lines, one may wonder the rationale for apparent gaps in the sexual thematics of the two most recent U.S. features: the ellipsis from *The Times of Harvey Milk* of the hero's personal sexual identity and relationships with lovers; the omission from *Before Stonewall* of the most plentiful cinematic documentation of the gay male past, namely erotic materials?

In contrast, mainstream depictions of homosexuality seldom flinch from dealing with sexuality, but reflect a sensationalist, voyeuristic, heterosexist point of view. In fact, Canadian Broadcasting Corporation cameras had followed a documentary character down the same sauna

corridors as in *Track Two,* tailing him even into a cubicle for a sexual encounter, taking exactly the same route as the police would take a few weeks later with their clubs.[5] We do not need to worry about providing our enemies with evidence and negative stereotypes when they so easily manufacture their own. I would even argue that no independent lesbian/ gay documentary in the present context will reach a broad or a susceptible enough audience in the alternative circuits to do any serious social damage no matter how frank and self-critical the film is, and this includes films frankly depicting sexuality. We do ourselves a grave disservice in suppressing our sexuality, that factor of our identity that distinguishes us as a group. We will never win over straight liberals and civil libertarians by masking the issue of our sexual rights by a respectable discourse of civil rights. And in speaking of our sexuality, we must be sure to search for alternative formats to both the heterosexist sensationalism of the mainstream media and the macho fantasies of current commercial gay male pornography.

Oppositional documentary is clearly an ideal medium for this search. Of the twenty-four films under review, five films deal explicitly with sexuality: *Double Strength, Loads, Army of Lovers, Taxi Zum Klo,* and *Race d'ep.* Interestingly, these are the films that have the least connection with the lesbian or gay movements, and they all overlap more or less with the experimental/art cinema constituency. *Double Strength* is at the same time a joyous, athletic celebration of sexuality which manages to completely shun *Penthouse* pseudo-lesbian clichés, and a semi-narrative analysis of the evolution of the author's relationship with another woman, including vividly symbolic reflections on romance, passion, and separation that never lose the grain and wrinkle of documentary despite the abstract and stylized "artistic" vocabulary.[6] Of the male films, *Loads* and *Taxi,* like *Double Strength,* are personal, confessional, and autobiographical; for that reason, they are vastly superior as sexual discourse to the sensationalistic *Army* or the voyeuristic *Race.* Irony, humor, collage, sound-image opposition, and collaborative performance (to which I will return) are some of McDowell's techniques that may be useful models for our future documentary explorations of sexuality, and to this Ripploh adds the intimacy and lyricism of improvised re-enactment and the bite of archival compilation. Whether or not *Loads* and *Taxi* are, as has been argued, compromised, like *Army* and *Race,* by their ethical and ideological complicity in the masculinist imaging of sexuality, both are at least partially successful in representing and discussing male sexual behavior—the authors' own and that of

their partners—in a manner that raises critical questions about gay sexuality, and in fact about all male sexuality.

In conclusion, the representation and discussion of sexuality are ethical tactical minefields, but gay and lesbian documentarists must not claim audience considerations as a pretext for avoiding them any longer.

From Consent to Collaboration

Traditional consent contracts signed by documentary subjects during filming have usually formalized more than consent. In fact they formalize the subjects' surrender of their images, the agreement that film-makers may impose their own voices over the images of their subjects. In the lesbian and gay movements, the ethical lessons we have learned about individual freedom, the respect we have developed for the variety of human sexual and cultural expression, have encouraged our film-makers, perhaps more than those of any other constituency, to seek alternatives to the traditional consent ripoff. As we continue to emerge from our invisibility and silence, lesbian and gay film-makers are often reluctant to re-impose that invisibility and silence on their subjects, and seek means by which they may let their subjects speak rather than speak for them, let their subjects control their images rather than control them for them.

The present twenty-four films show many different techniques and procedures whereby the traditional consent/surrender of the subject is replaced by strategies that heighten collaboration between film-maker and subject, that maximize the subject's control over his/her image. Needless to say, this is often in direct contradiction of the spirit of orthodox American vérité à la Wiseman, in which observational, noninterventionist discourse imprisons the individual subject's soul in the black box. Significantly, not a single one of the twenty-four films relies to any major extent on observational vérité: whether or not budgetary factors are the determining factor here, our souls have been imprisoned too often for us to be easily led to oppress each other in the same way.

To begin with, lesbian/gay documentary is most often collective film-making. Of the twenty-four titles, only four can be considered products of individual authorship—*Loads, Taxi Zum Klo, Double Strength,* and *Army of Lovers*—and all four of these films employ important collaborative techniques. It is by no means a coincidence that

all four of these film-makers come from an "art film" milieu, a constituency whose mystique of individual creativity has gained very few footholds in lesbian/gay documentary. Other individually signed films are based on such close collaboration with producers (*Harvey Milk, Silent Pioneers*) or subjects (*Orientations, Michael, a Gay Son*), that they are to all intents and purposes joint films, films of shared creative responsibility rather than of personal expression. Rob Epstein, a member of the Mariposa Film Group, author of *Word Is Out*, describes how that film's collective authorship ensured the film's political and ethical accountability to its constituency:

> . . . Individually we saw different needs for the expanded film (as did the audiences). It became evident that a group, working as a unit with several different points of view, would be more likely to produce a "broader look at gay life" than several people working together under a more hierarchical setup functioning to bring the director's "singular vision" to life. And the thrust, so necessary in forming such an alliance, was forming as a result of our work . . .[7]

Of the many collectively authored films in this survey, a further important distinction may be noticed in passing. At least nine are joint lesbian-gay projects. This proportion may seem remarkable in view of the autonomous and relatively separate constituencies represented by the two gender groups, each one with its own press and cultural institutions and only partly overlapping political agendas. This encouraging pattern obviously indicates a crucial need for resource-sharing and coalition in the present political conjuncture.

Beyond the fundamental character of collective authorship, the films under review show many techniques facilitating collaboration between author(s) and subject, of which the most important is more than familiar: the interview. The interview has long been shunned by the purist inheritors of the non-interventionist American School of vérité, macho fetishists of untampered visual surfaces; it has been denounced by critics muttering about "talking heads" as if they had never seen *The Sorrow and the Pity* or *Portrait of Jason*. The interview, however, has been re-invented by lesbian/gay film-makers. Or rather, re-invented by the "consciousness-raising" feminist films of the early seventies, it has been refined and shaped in new directions by the present film-makers. A flexible and sensitive format for subject-artist interaction, the interview is at the most basic level a more faithful reflection of the actual circumstances of film-making than the pretense of pure observation affected by the Wiseman school. The variety of approaches to the inter-

view visible in almost all of these films, each variation with aesthetic and ethical overtones of its own, suggests that the film-makers are aware of the special ethical traps inherent in the interview technique: after all, the networks rely on the interview as a basic means of manipulation and distortion, primarily through careful selection of the subjects, through selective editing of the responses by means of abridgment and contextualization, and if necessary through aggressive interrogation.

By conventional standards, all of the present films tend to be too long (though lesbian and gay audiences I've been part of have never been bored) because subjects are usually heard out. The interviewer encourages them to develop arguments, explain in personal terms, even to prepare statements (as we shall see). As for the editing, as often as not it endeavors to preserve the full scope and rhythm of the interview. The editor in fact becomes a key to the film-maker's ethical accountability to subject, constituency, and audience: the longer the take, the more control the subject tends to have over his/her speech. One extension of this principle is the reluctance to edit out the role of the interviewer, a rejection of the ethically dubious tactic of stringing together a series of answers as a continuous spontaneous statement. In these films, the presence of the interviewer varies from a sporadic acknowledged visibility in much of *Word Is Out* and *Heroes,* to a much greater presence in parts of *Some American Feminists* (equal visual weight for speaker and questioner/listener at several points). Of course the strategy of keeping the interviewer in the frame, a refusal to hide the subjective presence that has catalyzed the subject's contribution, requires at the same time a refusal to grandstand, a personal humility. Interestingly enough, both Hammer and McDowell, whose avant-garde formation perhaps discouraged them from the shared control of the interview format, have experimented with interviewing in their more recent films, *Audience* and *Taboo* respectively.

Another format, one step beyond the interview proper, present most notably in *Heroes* and *L'Aspect rose,* can allow even more input from the subject: the "statement." Here the subject prepares and delivers his/her own intervention in an on-camera direct-address statement to the camera. The director of the latter film, Chi Yan Wong, describes how this strategy was effected, replying to the question of how he worked with "actors":

> I would say "interveners" rather than actors. Their commitment goes beyond the notion of a role, they do not play a fictive part. Their participation goes further: they assert themselves [*s'assumer,* also

sometimes used in French for "come out"—TW] in front of the
camera, both body and words. The members of the G.L.H. (the
Groupe de libération homosexuelle, of which the sponsoring "cell" is
a part), at least those who agreed with the principle of the film, were
enthusiastic. I had explained to them the different parts of the film
as well as my aesthetic choices. A series of determined themes
(ghettoes, "queen-dom", pedophilia, sisterhood, activism, aging, etc.)
had been divided up according to each person's desire to work on
some aspect of our experience. Each one wrote a text, worked on it
at great length, sometimes individually, sometimes collectively. I gave
them some guidelines such as "I want a text that is analytic but also
sufficiently personal, with anecdotes, a text that could not be said by
anyone but its author." Then each person chose their set, their place
where they felt comfortable, their clothes, in order to be filmed.
Everyone rehearsed. We lived together during four months before
the shoot. This tenderness that exists among us is visible on the
screen and that's good.[8]

This is the film that the apostles of vérité must really hate, all of their
bugbears together at one: "talking heads" compounded by staging, re-
hearsing, and scripting. The effect is refreshing, fascinating, and in my
opinion an ethical as well as an aesthetic breakthrough. Halprin uses a
similar technique in *Heroes:* the three subjects prepared in advance
their answers to three questions about their lives and then their formal
direct-address statements were included in the film without editing. One
final variation of the "statement" is of course the nonverbal statement,
or direct-address "performance." In *Silent Pioneers* and *Before Stone-
wall,* it is a question of musical performances by subjects. *Loads* makes
use of erotic performances. Here, the sexual interaction between cam-
era operator and subject is foregrounded, the subject looking into the
lens with honesty, vulnerability, submission . . . pride? In short, *Loads*
is one of the most startling and probing films on male sexuality I have
seen, though it might have gone even further if McDowell had added to
the non-verbal performances the verbal dimension of conventional in-
terview or monologue techniques.

Other techniques go beyond the two-way structure of the above
films to show multiple interactions and collaborations. In several films,
a group discussion is set up with the same interventionist pre-meditation
as the interview, and then catalyzes within this artificial framework a
spontaneous collective reflection on a given issue. This is the format
that reflects most the genius of consciousness-raising as a format of po-
liticization. The film-maker may or may not be present: she is present

in memorable scenes from *In the Best Interests* where Liz Stevens talks with a group of lesbians' children, and from *Word Is Out,* where the women collective members chat around a table with elderly poet Elsa Gidlow, facilitating a stirring exchange of points of view among different generations of lesbians. In *Pink Triangles, Framed Youth, Before Stonewall,* and *We All Have Our Reasons,* several group discussions among subjects, both expert and lay, succeed admirably in getting intellectual and emotional juices flowing, with only a rare overtone of dogmatism.

Still another variation is closer to traditional vérité and may be called "collaborative vérité." A semi-controlled event, usually within a defined space, one which might have taken place without the film-makers' intervention, proceeds with all participants aware of and consenting to the camera's presence and with an unspoken but visible collaboration shaping the event. In *Before Stonewall,* for example, the film-makers arranged a reunion of former habitués of a historic San Francisco bar, and in *Breaking the Silence,* lesbian mothers assemble within the ominous architecture of the courthouse that symbolically menaces their families. Here, as in others of the present films, both group interactions and individual self-perceptions remain lively and things actually get said; this mise-en-présence occasioned by the camera provides just enough artifice to break up the naturalistic surface of the event and reveal its true political insight. This artifice, like Brechtian stylization in fiction falsifies neither the event nor the subjects, but heightens the film-maker's accountability to them.

Thus far in discussing collaborative techniques, I have emphasized the stage of cinematography, but collaboration is a feature of lesbian/ gay film-makers' methods at other stages as well. The Mariposa Film Collective's extensive consultation with national lesbian and gay communities over a period of years prior to the final shooting of *Word Is Out* is a well-known model for politically/ethically accountable procedures during the pre-production stage. Rob Epstein provides a glimpse of how mid-shooting consultation shaped the direction the film was taking:

> . . . Peter cut a three-hour assembly which he screened to predominantly gay audiences for feedback and financing, not necessarily in that order. We realized then that people were somehow seeing the film as a definitive statement on gay life, so we felt it needed to be broadened beyond the scope of the eight people we had already filmed.[9]

Epstein's candid reference to the role of fund-raising in this process is not irrelevant. For his most recent film, *The Times of Harvey Milk,* the financing was based on the same consultative process around a 16-minute sampler reel that made the rounds for years. Of course, the danger exists in such a process that film-makers' accountability will be directed towards investors rather than towards their constituency, but this is a danger that grass-roots financing tends to minimize. It is no accident that the two films for which the financing seems to have been least difficult, the West German television films, *It Is Not the Homosexual . . .* and *Army of Lovers,* would seem to be those which, in view of their sometimes eccentric subjectivism, might have profited most from prior consultation with their constituency.

Another cautionary note in regard to community consultation has been sounded by the dispute that arose between the *Before Stonewall* authors and gay/lesbian historians whose research preceded and inspired the production of the film. Collaboration, consultation, and resource-sharing by media workers must be extended throughout the still fragile cultural networks of gay and lesbian constituencies, and must be based on the utmost consideration of those individual and collective moral and political rights not enshrined in the legal apparatus invoked and enjoyed by mainstream media.[10]

Post-shooting consultation is another matter. Ever since Flaherty's legendary screening for *Nanook,* this process has been a common ideal and a less common practice of documentarists. The normal procedure of testing a rough cut on a fresh mind has often been expanded in the films under review to incorporate a larger dynamic of community accountability. By this means, subjects and constituencies may heighten their control over their image, not only over the way it is photographed, but also the way it is contextualized. Community dialogue during or after the shoot is now less the exception than the rule in lesbian/gay documentary in the U.S.

The final stage of exhibition also becomes for most of the film-makers under discussion a context for consultation. Post-screening discussion is a regular feature of exhibition for most of the film-makers in this sample, an interest they have inherited from other alternative and especially feminist film-makers, even where, as with Sara Halprin, this means a deliberate abandonment of the ideal of a large audience.[11] Von Praunheim is another interesting case in point, despite his roots in an art-cinema background where community consultation is virtually unknown: the American version of *It Is Not the Homosexual . . .* incorporated footage of angry American gay audiences reacting to the

film. Whether or not this kind of post-screening consultation which in fact becomes part of the text is as useful and accountable as ongoing consultation before and during the creative process is another question.

Coming Out

The single ethical problematic that is most characteristic of and is in fact unique to the lesbian and gay movements and our cultural work is summed up in the two words that are both our collective battle-cry and the key challenge of our individual lives, "Come Out!" Our variation of the "The Personal Is Political," the concept of "coming out" connotes not only a personal self-affirmation—to self, family friends, co-workers, media—but also an affirmation of collective political empowerment.

The earliest gay documentaries often achieved their most striking impact by simply concentrating on one or more subjects "coming out" to the camera. *Word Is Out* was a kind of milestone in that respect, a "talking heads" epic of twenty-six individual comings-out that still had devastating impact even ten years after Stonewall, but that symbolized in a way the end of that period of gay pride. All the same, this basic political ritual continues today as a basic aesthetic device and ethical problem of our culture. The consent to declare oneself before the camera still has for every potential subject of a lesbian/gay documentary all of the dimensions of an irreversible life-changing political commitment, whatever may be the other normal implications of the decision. It is for this reason that the autobiographical subgenre well represented in my selection has such a centrality in our culture, far beyond the boundaries of the cinema.

Michael, a Gay Son is not an autobiographical work but presents at very close range an exemplary case study of one individual's realization of the act of coming out. It is an act so fraught with psychological, social, and ethical delicacy as well as technical problems and excruciating dramatic tension that the film-makers render it only at a distant remove, through the mechanism of improvisational semi-fictional role-playing by members of Michael's support community. This mechanism nonetheless does not fail to document in very authentic terms the place of coming out in our collective and individual aspirations—a very real Michael interacts through the mediation of a very real social worker with his fictive family. More recent works have sustained and enriched the iconic power of the coming out ritual within our culture by dealing with coming out in ways that challenge the media's 1970 gay-lib stereo-

type of the rootless young white middle-class male, for example, coming out within non-white cultures in *Orientations, Framed Youth,* and *Pink Triangles,* or coming out as middle-aged lesbian mothers in *Heroes, Breaking the Silence, Choosing Children,* and *Best Interests.*

A whole set of consent procedures has evolved for ensuring that each individual has the right to come out on his or her own terms, at the chosen moment, to the chosen degree. The authors of *Track Two,* for example, decided not to film some indoor political rallies that were part of the mobilization campaign covered by the film, at the request of the organizers, in deference to the rights of participants not ready to come out in the media. Our film-makers can never forget that the single act of filming a gay person can expose them to eviction, firing, family rejection, violence, loss of child custody, and even criminal charges. The authors of *Pink Triangles* allude to the delicacy of this matter in their credits acknowledgment of "the many people we cannot name publicly because of family pressure, child custody battles, immigration laws and job discrimination." In *We All Have Our Reasons,* interviews with "drinkers" in a lesbian bar setting are re-enacted rather than caught in vérité spontaneity for at least partly the same reason; one wonders whether the frequent recourse to dramatized formats by European documentarists in this sampling has something of the same rationale.

A scene from *Before Stonewall* capsulizes the entire problematic of coming out. To film a subject remembering her victimization by Mc-Carthy-era armed forces purges, the film-makers agreed to preserve her anonymity by use of a silhouette setup. Unprecedented in gay/lesbian liberation cinema, the silhouette device originated generations ago in mainstream depictions of homosexuals—it evokes all of the shame and fear that society has wanted us to feel, and which we have had to struggle against. One hopes that there were good reasons for seemingly thoughtless repudiation of every principle of our movement. Surely if an anonymous witness was indispensable, this exigency could have been foregrounded in such a way as to contribute to the political discourse of the film rather than undermining it: *Breaking Our Silence* includes the audio-only voice of one participant, protecting her identity for fear of custody battles, but presenting the anonymity in a way that somehow breaks through the closet rather than shores it up.

As for lesbian/gay documentarists themselves, in the face of society's heterosexist assumptions about everyone being "straight" (especially people strong enough to hold a camera), the ethical obligation to come out is clear. The self-declaration of the film-maker not only has a

crucial pragmatic relation to the lesbian/gay spectator's extension of trust and belief, but also to the film's political and ethical integrity. Film-makers who are unwilling to "make an issue of it," who "don't believe in labels," cannot be delegated the responsibility of representing us, of making our self-images. This is particularly important in the light of the oppressive and fraudulent representations handed down to us by Hollywood and the networks by straight and some gay liberals who solicit our identification only to pull the rug out from under us. Non-gays usually understand this principle instinctively in reverse, witness the never-fail formula of actors/directors who, being interviewed about their gay or lesbian roles or films, trot out their heterosexual spouses, children, and grandchildren in response to every question, and claim the film is about universal human relations. The authors of *Pink Triangles* make it very clear in their promotional material that they are a "group of nine women and men, both gay and straight."

The declaration of an even greater personal stake is evident in *Heroes,* where it is revealed in a pleasurably incidental manner that the lesbian character is the film-maker's lover. The effect in this modest film about a range of feminist issues beyond sexual orientation in itself is significant. It is essential for our political empowerment that lesbians and gays establish our right to speak out on all issues, e.g. *We All Have Our Reasons,* which speaks out with great clarity on alcoholism as a general women's issue, but from a lesbian viewpoint. *Some American Feminists,* although lesbian-authored in part, unfortunately doesn't go that far: though there is perhaps an implicit lesbian point of view in the film's central focus on lesbianism within a survey of American feminism, the ultimate avoidance of the explicit lesbian voice is an unfortunate reminder of the need for discretion within a homophobic state apparatus like the National Film Board of Canada.

Feminist umbrella films, lesbian-authored or not, have a crucial responsibility to contradict the invisibility of lesbians within the women's community. This is especially true in an atmosphere where right-wing pressure groups are co-opting feminist mobilization around such issues as pornography, "family rights," and abortion: a documentary about such an issue that does not at the same time make explicit connections to less co-optable issues such as lesbian rights or sex education is a backward step, a serious political and ethical compromise as well as a tactical error. (By the same token, at a time when the dominant order survives by dividing oppositional constituencies, a lesbian or gay "single-issue" film that does not include coalitionist discourse, that does not link sexual orientation to other issues of race, class, and gender in-

equity is no less retrograde. *Track Two, Framed Youth, Orientations,* and *Harvey Milk* are all exemplary in this regard in their linking of discourses on labor unions and racial minorities to the gay/lesbian struggle.)

The ethical imperative of coming out on the part of the film-maker, or more generally, the film-maker's revelation of his/her interest in the film, may be extended further to include the revelation of sexual and financial interest. This takes the rather particular form of a confessional self-critical gloss with three of the male film-makers in this survey who deal most directly with sexuality itself: McDowell, Ripploh, and von Praunheim (*Army of Lovers*). For one thing, all take the act of coming out to an ultimate degree, all engaging in on-camera sexual acts: Not only am I gay, but here I am sucking cock (with McDowell and von Praunheim both incidentally incriminating themselves in relation to American state sodomy statutes). While courageously offering images of personal performance as a challenge to patriarchal notions of privatized, reproductive sexuality, all three directors also acknowledge and analyze in a very revealing way their complicity in self-oppressive and oppressive behaviors and attitudes.

As for financial and other equally figurative levels of coming out, a full financial accounting and declaration of political affiliation, etc., is in my opinion a bottom-line requirement of all political film-makers, not only of lesbians and gays. One of the most endearing aspects of *Greetings from Washington* is that the credits with its list of contributors, participants, and institutional sponsors is almost longer than the film itself! It is to be hoped, for example, that the new cycle of gay health films already undertaken in response to the current AIDS crisis will be as frank in their disclosure of pharmaceutical company investments, for example.

I recognize that the ethical dimensions of the issue of coming out are not always clear cut because of certain strategic options around a given film. The authors of *In the Best Interests*, for example, obviously sensed that a too fervent declaration of interest on the part of the three lesbian film-makers would compromise their effectiveness with their primary audience, mostly straight social workers and legal officials who make the life-affecting decisions in child custody cases. For the secondary lesbian/gay audience, however (numerically the larger audience as it turns out—the film went on to become the most respected and popular lesbian documentary in the U.S.), the price must be paid. Though the stake of the film-makers could never be doubted by an

alert lesbian/gay audience thanks to a nebulous but unerring sixth sense, few spectators would not notice at the same time that the issue is carefully avoided.

A related problem is familiar in most political documentaries, but it is feminists who have focused on it most sharply: the invocation of expert authorities as witnesses to pronounce upon the subject at hand. Whereas the appearance of an openly gay or lesbian expert can have a refreshing anti-stereotype effect, as in *Pink Triangles* or *Silent Pioneers,* the effect is as often a mystification of science and professional knowledge, the dismissal of ordinary people's knowledge of or their right to control their own lives. With films about lesbians and gays, the expert witness usually belongs to the professional institutions that have had the most direct hand in our oppression: medicine, psychiatry, law, academia, legal enforcement, the social sciences, the church.[12]

Track Two reveals its own unique entanglement with this problem. The film-makers present ten or so straight expert witnesses, all community or political leaders or media stars (like author Margaret Atwood, or ex-mayor John Sewell, who incredibly gets the last word in the film), who are clearly intended to be seen as vital allies of the gay struggle against the police (as indeed they were, bringing a huge morale boost to the beleaguered lesbian/gay communities and adding to their credibility in the public eye). All the same, there is an uncertain boundary between the invocation of alliances and coalitions, and the deference to heterosexual authority to legitimize our struggle. *Track Two* hovers dangerously close. Somehow, the heterosexual witnesses (one in fact is a famous closeted journalist whose presence in the film is ethically scandalous and intolerable: the ethical imperative of coming out becomes proportionally clearer as one ascends the hierarchy of power, wealth, security, and celebrity) are coded both within the pro-filmic event (speaking at a rally on a platform with a microphone, gratefully applauded by the gay masses down below) and in the editing, so as to appear to justify our struggle by their support rather than to consolidate it.

One final qualification of the foregoing discussion of coming out is that this personal and political ritual has admittedly a slightly different significance for lesbians than for gay men (just as it is different for me, as associate professor with tenure in a liberal faculty of fine arts, than it is for friends who are unemployed, underemployed, or insecurely employed). It also arouses different questions for lesbian film-makers who want to stress the importance of the lesbian perspective

within a spectrum of feminist causes. All the same, closet lesbians and gays must confront this question with full realism and ethical accountability in this era of rising threats and heterosexual backlash.

Conclusion

A number of tentative conclusions may be drawn from this discussion of four basic ethical foci for lesbian/gay documentarists. Two fundamental overlapping axioms of image ethics, demonstrated I hope by my references to these twenty-four sample documentaries, are that, while there are inherent connections between specific aesthetic/technical forms and specific ethical liabilities, the ultimate determination of these connections is relative to the individual historical conjuncture of each film. Lesbian/gay film-makers must continue to pursue a double tack. They must continue their exploration of alternatives to forms that have evolved within heterosexist (patriarchal capitalist) culture—a random listing of such forms would include those that mystify "expert" knowledge or the authorial voice, that use lives and bodies as intellectual abstractions or sexual objects, that foster a cult of "personal expression," that profess such ideals as "objectivity" and "balance" and effect such results as disenfranchisement, sensationalism, and voyeurism. At the same time they must base these explorations on close analysis of the global and historical context of their work, weighing in each circumstance their ethical accountability to subject and audience together with their accountability to constituency and self.

The concept of a collective ethical accountability implied by the notion of constituency provides no easy challenge to our documentary film-makers. Many different notions of what our constituency is or should be are of course in constant collision within our communities; gay chambers of commerce could naturally never agree with gay radical organizations as to what that constituency is, and lesbian separatists and artists working within traditional frameworks would likely provide two more completely opposing conceptions. Gay/lesbian documentarists must reflect and be accountable to this pluralism, even when they ally themselves with a single one of the tendencies or factions within our communities.

The problematic of the collective and the constituency contradicts, as I stated at the outset, the traditional individual focus of (image) ethics. This is why the term ethics in this essay has frequently tended to

overlap with, or to be interchangeable with, the term politics. This overlapping is intentional. The twenty-four documentaries discussed in this chapter demonstrate, as do the issues they raise, that there is no ethics for lesbian/gay cultural activism, of our oppositional self-representation, separate from its politics. For us, as for all oppositional cultural workers, the ethical, like the personal, is ultimately the political.

Notes

1. On a recent issue of the Canadian Broadcasting Corporation's *The Journal*, Troy Perry, head of the Metropolitan Community Church, was invited to debate AIDS with Jerry Falwell. *Pink Triangles* includes a television clip of a California Moral Majority leader advocating capital punishment for gays.

2. Peter Millard, "In Search of Our Own Morality," *The Body Politic* (Toronto), No. 97 (October 1983), 32–33.

3. Ray Olson, "Gay Film Work: Affecting, But Too Evasive," *Jump Cut,* No. 20 (May 1979), 9–12.

4. Ibid.

5. For a gay/lesbian perspective of John and Rose Kastner's CBC documentary *Sharing the Secret,* see Thomas Waugh and Joyce Rock, "Gays Set the Record Straight," *Cinema Canada,* No. 73 (April 1981), 32–33.

6. An excellent discussion of Hammer's work is Jacquelyn Zita, "Films of Barbara Hammer: Counter-Currencies of a Lesbian Iconography," *Jump Cut,* No. 24/25 (March 1981), 26–30, and Andrea Weiss, *"Women I Love* and *Double Strength:* Lesbian Cinema and Romantic Love," *Jump Cut,* No. 24/25, p. 30. The same special section on lesbians and films also includes a discussion of the autobiographical work of another well-known lesbian film-maker, Jan Oxenberg.

7. Rob Epstein, *"Word Is Out: Stories of Working Together," Jump Cut,* No. 24/25 (March 1981), 9–10.

8. Chi Yan Wong, *"L'Aspect Rose de la chose* (Interview)," *Cinemaction* (Paris), No. 15 ("Cinémas homosexuels," Summer 1981), 97–98. Translation by the author.

9. Epstein, *"Word Is Out."*

10. Edward Jackson provides an account of the dispute in his discussion of *Before Stonewall, The Body Politic* (Toronto), no. 108.

11. Until a few years ago, Barbara Hammer restricted her films to women's audiences; lifting that restriction has greatly extended dialogue between the lesbian constituency and other oppositional groups. Other lesbian

cultural workers, including a well-known Montreal video collective, continue this restrictive practice. Sara Halprin (Barbara Martineau) discusses her exhibition experiences in "Talking About Our Lives and Experiences: Some Thoughts about Feminism, Documentary, and 'Talking Heads'," in *Show Us Life: Towards a History and Aesthetics of the Committed Documentary,* Thomas Waugh, ed. (Metuchen, N.J.: Scarecrow Press, 1984).

12. Halprin discusses the problem of expert testimony in ibid.

A Selected Annotated Bibliography on Image Ethics

LISA HENDERSON

This bibliography organizes current material that addresses ethical issues raised by the production and use of people's images in journalism, art, entertainment, and scientific research. In sections organized by medium and source, I have included discussions by theorists and practitioners of the ownership of images; balancing the personal right to privacy with the public right to know; the photojournalistic treatment of sensitive issues such as violence and suffering; sexual imagery; the responsibilities of image makers to their subjects; informed consent to the production and distribution of personal images; censorship and prior restraint; images of women and minorities; cameras in the courtroom; and the use of photographic evidence in jurisprudence and social scientific research. In most cases authors are directly concerned with subjects' and image makers' rights, though I have included other titles for their analyses of a variety of intersections between types of images and forms of power.

Principal sources for the bibliography include the *Current Law Index*, the *Index to Legal Periodicals, Sociological Abstracts, Psychological Abstracts, Index to Film Literature, International Index to Film Periodicals*, and the *Reader's Guide to Periodical Literature*. For the most part, these sources were surveyed from 1970 to 1986 (or from their first issue to 1986, where publication began after 1970) though earlier landmark discussions are also included.

Along with periodical publications, I have annotated book-length analyses, anthologies, and reports from the daily press. As well, most sections include relevant case studies that evoke new ethical questions and raise familiar ones in specific contexts. In several instances, the

cases cited continue to be debated, some among media professionals, their subjects, and their critics; others in court.

Since research for this bibliography began, certain areas of theory and practice have generated considerable discussion and bibliographies of their own. This is especially true of pornography and the political and legal questions it engenders. I have included several titles on sexual imagery and censorship (in both the Film/Television/Videotape and Legal sections), though refer readers to the following authors for a more comprehensive introduction to pornography and sexual politics: Varda Burstyn (ed.), *Women Against Censorship* (Vancouver: Douglas McIntyre, 1985), Andrea Dworkin, *Men Possessing Women* (New York: Perigree, 1981), Thomas Emerson, "Pornography and the First Amendment: A Reply to Professor MacKinnon," in *Yale Law and Policy Review* (3[1] 1984 130–43), Catherine MacKinnon, "Not a Moral Issue," in *Yale Law and Policy Review* (2[2] 1984 321–45), Ann Snitow et al. (eds.), *Powers of Desire: The Politics of Sexuality* (New York: Monthly Review Press, 1983), Carole Vance (ed.), *Pleasure and Danger: Exploring Female Sexuality* (London: Routledge & Kegan Paul, 1984).

Entries are listed within sections and subsections alphabetically by author. Where an author's name does not appear, selections are entered by title. To avoid the duplication of cross-referencing, I have added "see also" notes at the beginning of relevant sections. I have also avoided duplicating references and bibliographies from papers in this volume. Finally, where possible, I have quoted from authors' abstracts in annotating their work.

Generally, the bibliography reflects a diversity of interpretation about what aspects of image creation and use deserve or require ethical consideration. It is intended as a resource not only for readers concerned with what ethical standards should be, but also as primary material for those interested in the social processes through which formal ethical codes are constructed, and informal choices negotiated, by different groups of people involved in the creation and distribution of images for a variety of purposes.

Table of Contents

FILM, TELEVISION, AND VIDEOTAPE

Altman, Lawrence K.
1974　"A Fatally Ill Doctor's Reactions to Dying," *New York Times,*
July 22, pp. 1, 26.
An account of the death due to cancer of a 39-year-old cancer research physician. A large part of the account comes from tapes of interviews with Dr. Gary Leinbach and his colleagues, made during the last six weeks of his life. The situation is both ironic and a rare example of sensitivity to the experience of death (and its taping), given Dr. Leinbach's own background in using videotape to teach doctors-in-training how to cope with and care for dying patients.

Barrett-Page, Sally
1978　"Making Ain't Nobody's Business But My Own," *Filmmaker's Newsletter,* March, pp. 22–24.
A short description of the recruiting efforts of Sally Barrett-Page for subjects for her documentary on female prostitution, called "Ain't Nobody's Business." The article describes both the relationship Barrett-Page developed with the women who agreed to participate in filming at the First World Meeting of Prostitutes in Washington, D.C., and Barrett-Page's independent distribution efforts and successes. The author does not mention any difficulties with the identification of or consent from people filmed.

Bedell, Sally
 1983 "Movie About Terrorist's Use of News," *New York Times,*
 Jan. 29, pp. 15, 48.
 About a television movie that presents a fictitious hostage
 situation as seen by television news watchers. Analogous to
 Orson Welles' "War of the Worlds," "Special Bulletin" fea-
 tures an anti-nuclear group demanding the release of 960
 nuclear warheads for disarmament at the threat of detonat-
 ing one of their own. The issue raised is whether the pro-
 gram exploits the very TV news conventions it purports to
 critique, despite a frequently-telecast disclaimer that identi-
 fies the program as fictional.

Blumenberg, Richard M.
 1977 "Documentary Films and the Problems of Truth," *Journal of
 the University Film Association,* 29(1), Fall, pp. 19–22.
 A tentative discussion of documentary film ethics that
 substitutes "authenticity" for "objectivity," which the author
 feels is a false issue in non-fiction film. Authenticity is
 achieved by the two qualities of legitimacy (which, by means
 of cinematography, shows the events or actions actually hap-
 pened) and significance (which renders events important by
 virtue of their being photographed and projected). The au-
 thor poses five critical questions for judging the ethical values
 of a documentary film: (1) Is there justification in the ex-
 perience for the subject? (2) Does the subject warrant the
 significance given to it by filming? (3) Is the film's structure
 coherent, and aesthetically, conceptually and psychologically
 satisfying to the subject? (4) Do we recognize something
 authentic (a "truth") about the human condition as a part
 of the visual and audio data given to us in the film? and (5)
 Does the film play to a group or to a group idea, or is it free
 to explore the group in which the subject rests?

Coetzee, J. M.
 1987 "Out of Africa!" *American Film,* 12(5), March, pp. 19–23.
 A review essay on "The Africans," a television series by
 Kenyan political scientist Ali Mazrui. The series was pro-
 duced for Western audiences and sponsored in part by the
 National Endowment for the Humanities, which ultimately
 withdrew its name from the credits in the midst of political
 discomfort engendered by the program's confrontation of fa-
 miliar Western images of Africa. Coetzee, a white South Af-
 rican novelist and literature professor, compares Western

views of Africa as a distant, spectacular but troubled continent to be studied though not learned from, with Mazrui's analysis of the consequences of colonialism and the complexity of African societies. He also describes Mazrui's depiction of Islam in Africa and his appeal for the future to the "essence" of Africa, based on the integration of gods, ancestors, living creatures and Earth itself, and on the family as the foundation of African social structure. In conclusion Coetzee despairs of the absence of any sense of personal identity in the series, though predicts it will become the standard audiovisual introduction to the continent in colleges and universities. Relevant especially to local versus external depictions of cultures and societies.

Collinge, Jo-anne
1985 "Under Fire," *American Film*, 11(2), November, pp. 30–38.
A comprehensive review by a senior writer from the Johannesburg *Star* on oppositional film-making in South Africa. Considers the strategies independent film-makers have used to fund fictional and documentary anti-apartheid films, and the political and financial consequences most have suffered. Describes many films in detail though concentrates on conditions of production and distribution, including police intervention during filming, sanctions imposed by government censors and funding sources, and the limited interest expressed by many U.S. distributors. Includes information on how to obtain rental prints or videotapes of some of the films described.

Columbia Broadcasting System
1976 *CBS Television News Standards.*
In-house publication concerning production and personnel standards, including a separate section on outside requests for as-broadcast or outtake material. In particular, see sections on editing (pp. 9–10), electronic eavesdropping (hidden cameras, pp. 12–15), Free Press-Fair Trial (pp. 18–20) and releases from participants in broadcast programs (p. 36).

"Counterattack: Crime in America"
1982 *Variety*, May, p. 124.
A negative review of "Counterattack," a television series of reenactments of crimes that solicits the viewers' co-opera-

tion, through a California organization known as "We Tip," by requesting them to call in anonymously with any information they may have about any crime. The article is concerned with the way the program raises volatile issues and then smothers them in "gimmicky television drama style," and the "We Tip" hotline's potential for abuse by people eager to inform and be informed about others whom they think might be guilty of a crime.

Cultural Survival Quarterly
1983 "The Electronic Era," 7(2), Summer.

An issue of *Cultural Survival* devoted to the impact of new media technologies in the Third World, focussing the image ethics discussion on autonomy, censorship, ideology, and acculturation in developing countries. (Articles are brief and several refer to communication technologies that do not make use of images, for example radio.) For discussions particularly relevant to this bibliography, see the Introduction, p. 4; "Media Autonomy in the Third World—No Win" by John Lent; "The Texture of Change: Yoruba Cultural Responses to New Media" by Marilyn Houlberg; "Video and Cultural Awareness: An Egyptian Experience" by Elizabeth Combier; "Film and the Third World" by Dominique Callimanopulos; "Herzog's 'Fitzcarraldo' "; and "Censorship in the Middle East."

DeVore, Irven
1977 "DeVore Explains Sociobiology Film Interviews," *American Anthropology Association Newsletter,* 18(8).

Harvard sociobiologist Irven DeVore defends himself and two colleagues against the illegitimate use of interview footage that appeared in a sensational film called "Sociobiology: Doing What Comes Naturally." According to the article, the footage was used without the knowledge or consent of DeVore, who felt that the film blatantly misrepresented him and his work.

Egan, John
1982 "Film-makers Are Not Nice Guys: In Defense of Unpopular Films," *Sightlines,* Summer, pp. 8–12.

On balancing exploitation and empathy in the production of non-fiction cinema. The author uses examples such as David Parry's "Premature," Mitch Block's "No Lies" and

the work of Frederick Wiseman in a discussion of documentary film's need for conflict in order to achieve its "social purpose." In particular, Egan considers the ethical issues that such a thematic and structural conflict may provoke in the context of "family films," where the film-maker is a close kin relation to his or her subjects, some feature of their relationship often being the film's central focus (e.g. "Premature"). He concludes, in part, that the film-maker's necessary suspension of sympathy (i.e. his objectivity) is what distinguishes him from his subjects and from the audience, and that for this reason we can never call the film-maker a "nice guy" (p. 12).

Erens, Patricia
 1974 "Images of Minority and Foreign Groups in American Films: 1958–73," *Jump Cut*, 8, Nov./Dec., pp. 21–23.
 An annotated bibliography of film titles.

Feldman, Seth
 1977 "Viewer, Viewing, Viewed: A Critique of Subject-Generated Documentary," *Journal of the University Film Association*, 29(1), Fall, pp. 23–36.
 A historical analysis of the participatory ideal in documentary film and film-making that takes the East African Bantu Kinema Educational Experiment of 1975 as its illustrative case and small-group dynamics as its theoretical starting point. Feldman argues that film-making creates roles which in turn require decisions about the "powers and freedoms of the individuals concerned." He concludes that these decisions have always been made and always will be, and that their acknowledgement, rather than denial, is the most productive route for filmmakers to follow, one that may inspire them to self-consciously play with such decision-making for an audience aware of what's being done.

Funt, Allen
 1952 *Eavesdropper at Large*. New York: Vanguard Press.
 Narrative accounts by the founder of "Candid Mike" (radio) and "Candid Camera" (television) of particularly memorable sequences from both programs, including com-

ments on their conception and preparation and on the "creative use of hidden cameras and microphones." Illustrated with a group of candid portraits. See pp. 178–84 on the "moral aspects of eavesdropping." According to Funt, his pursual of candid events and his retreat from secret ones upheld his moral responsibility in both programs.

Goldberg, David A.
1983 "Resistance to the Use of Video in Individual Psychotherapy Training," *American Journal of Psychiatry*, 140(9), September, pp. 1172–76.
A brief discussion of the sources of resistance, including the student therapist's fear of exposure and criticism in a training process whose methods are often only vaguely described, and threats to the privacy of patient-therapist relationships. Goldberg concedes these worries but advocates informed guidance rather than abandoning video altogether in psychotherapy training. In his experience, "intrusion is greatest initially and diminishes markedly over time, patients are far more open to its use than anticipated, therapists are much more anxious than patients but adjust rapidly when given proper guidance and support, the impact of video can be explored with the patient in therapy, therapy usually progresses meaningfully and profitably, and experienced therapists do not feel that the presence of video substantially alters their style" (p. 1174).

Goldman, Debra
1985 "When the Stations Tremble," *The Independent*, 8(10), December, pp. 5–6.
A brief but useful account of network equivocation around the PBS broadcast of "When the Mountains Tremble," a feature documentary on Guatemala by Peter Kinoy, Pam Yates and Tom Sigel. Illustrates organizational tensions among network executives, affiliate programmers and independent film-makers in the production and distribution of controversial material. Describes the means proposed by the network to soften the film's liberal slant (including a "wraparound" commentary) and the last-minute postponements that delayed the broadcast some two months.

"Indians Watch Television Tapes to Learn About Legends"
1982 *The* (Toronto) *Globe and Mail,* Oct. 13, p. 16.
A brief account of the use of television in recollecting and presenting traditional legends and historical events by tribal elders to Native Canadian children in Alberta. Initially apprehensive, the elders co-operated when they learned the tapes would be used only in schools and not for profit.

Kaufman, Michael T.
1983 "A TV Leak Snarls Canadian Budget," *New York Times,* April 20.
Reports on a federal budget news leak, where the printed though unpublished document was videotaped and broadcast by a Hamilton television station prior to the official budget presentation in Parliament. Members of the Conservative opposition subsequently called for the resignation of Canadian Minister of Finance Marc Lalonde for what they termed his gross irresponsibility in failing to protect the document. Following the incident, then-Prime Minister Pierre Trudeau refused to consider Lalonde's resignation, accusing the opposition of exaggerating the gravity of the so-called "leak" and deflecting questions about its possible effect on the international value of the Canadian dollar.

King, Noel
1981 "Recent 'Political' Documentary: Notes on 'Union Maids' and 'Harlan County U.S.A.'," *Screen,* 22(2), pp. 7–18.
A detailed, comparative analysis and critique of the two films, drawing from Marxist cultural theory. The author joins other reviewers in questioning the value of traditional textual analyses of films that "successfully alert people to contexts of struggle."

Koper, Peter
1982 "Can Movies Kill?" *American Film,* July/Aug., pp. 46–51.
Twenty-eight people died from playing Russian roulette, apparently after watching "The Deer Hunter." To what extent can the film be held responsible? Koper concludes that "the responsibility of the storyteller is to tell the story, and the responsibility for behavior lies with the individual. . . . Despite the escalation of violence in recent American movies,

it seems foolish, shortsighted and unconstitutional to hold the people who make these films responsible for what people do after seeing them."

Kuhn, Annette
1985 "A Moral Subject: The VD Propaganda Feature," *The Power of the Image: Essays on Representation and Sexuality.* London: Routledge & Kegan Paul, pp. 96–132.
A case study of the role of visual representations in the evolution of moral and ideological discourses on sexuality. Kuhn considers a subset of British "social problem" features from Britain in the late 1910s, and explores the relationship between filmic text and context in particular historical and institutional circumstances.

Leo, John
1982 "As Time Goes Bye-Bye," *Time,* July 19, p. 46.
On electronic time-compression in radio and television programming to allow for more material in slightly reduced time periods (e.g. drama *and* commercials in 60 minutes) with no noticeable change in sound or image. Considers the consequences of altering the speech style of politicians and other public figures.

Levin, G. Roy
1971 *Documentary Explorations.* New York: Doubleday and Company, Inc.
Fifteen interviews with documentary film-makers. See Willard Van Dyke (pp. 175–94) on what the subject matter of documentary film is, Richard Leacock on observational cinema (pp. 203–18) and exploitation in "Happy Mother's Day" (p. 204), and Don Alan Pennebaker on his contempt for a woman who appeared in "One PM" and who demanded post-production cuts from the film (pp. 247–48).

Linton, James M.
1976 "The Moral Dimension in Documentary," *Journal of the University Film Association,* 28(2), Spring, pp. 17–22.
On the following ethical issues in documentary film-making: (1) Responsibility to self versus responsibility to community; (2) Objectivity, subjectivity and 'taking a stand';

(3) Presenting a point of view vs. allowing one's subjects to speak for themselves and one's audience to come to its own conclusion; (4) A film-maker's respect for her subjects; (5) Collaboration between film-maker and subject; (6) The subject's control in production and distribution.

Lyon, Danny
1983 "Digging into the Soul," *Southwest Media Review,* 2, Spring, pp. 24–35.

A lengthy conversation between photographer/film-maker Danny Lyon, film-makers James Blue and David McDougall, and several students at the Rice Media Center, recorded in 1974. The focus is Lyon's film "Los Ninos Abandonados" ("The Abandoned Children"), filmed in Colombia that year. Details production circumstances and explores the responsibilities of the artist and the relationship between "film and life."

Mamber, Stephen
1973 "Cinéma Vérité and Social Concerns," *Film Comment,* 9(6), Nov./Dec., pp. 9–15.

The author argues that cinéma vérité is not always suited to investigations of social concerns and that its use ought to be directed from the specific to the general. "A film-maker cannot start from a broad problem and then seek to shoot a cinéma vérité film about it. Instead, it is out of interest in and knowledge of individual conditions, certain special events, or particular people that the best cinéma vérité films have been made" (p. 15). In this light, Mamber considers Arthur Barron's "Factory," Fred Wiseman's "Basic Training," and the Maysles' "Gimme Shelter."

Mehta, Ved
1980 *The Photographs of Chachaji: The Making of a Documentary Film.* New York: Oxford Univ. Press.

On making a documentary film in India about the author's aging uncle. Mehta acts as writer (without a screenplay), Indian liaison, and creative and cultural consultant to director Bill Cran, who manages to move through New Delhi and Calcutta thinking primarily about getting film in the can, and considering particular personal and cultural features only insofar as they can be made into television. The situation is balanced by an Indian eagerness to co-operate and his own

ability to act as a trustworthy and culturally sympathetic go-between.

Nichols, Bill
1983 "The Voice of Documentary," *Film Quarterly* 36(3), Spring, pp. 17–30.
 A discussion of four major styles of exposition and authority in the history of documentary film, including the direct address of the Griersonian tradition; the "transparency" of cinéma vérité; the interview-oriented political film; and the self-reflexive documentaries that combine several techniques and that present themselves as constructed depictions rather than neutral reports.

O'Connor, John
1982 "An Exhibitionism Epidemic," *New York Times,* June 20, p. 31.
 A negative review of "real life trauma" television series, focussed on a program called "Couples" in which married and unmarried couples discuss problems in their relationships with a host psychiatrist in front of a television camera. In one case, O'Connor questions the ethics of a counsellor who sends a couple home to "give it another shot," and then turns to the tv audience in the couple's absence and declares the marriage a dismally incompatible failure. He also criticizes TV for "once again tapping the extraordinary willingness of ordinary people to reveal in public the most intimate details of their private lives." As well, O'Connor provides useful descriptions of the verbal and gestural manners the TV psychiatrist has developed to accompany the discussion of different types of problems and different degrees of severity.

Porter, Vincent
1979 "Copyright and Edelman's Theory of Law," *Screen,* 20(3–4), Winter.
 For a description of Edelman's theory, see Edelman, Bernard, in Photography section of this bibliography.

Pryluck, Calvin
1976 "Ultimately We Are All Outsiders: The Ethics of Documentary Filmmaking," *Journal of the University Film Association,* 28(1), Winter, pp. 21–29.

The first JUFA discussion of documentary film-making ethics. Deals with the difficulty of truly informed consent, the subject's right to privacy, and his or her participation in post-production.

Rosenthal, Alan
 1980 *The Documentary Conscience*. Los Angeles: Univ. of California Press.
 An anthology of interviews with film- and video-makers, usually about particular projects. Most of the interviews reflect the author's interest in the ethics of documentary filmmaking. In his introduction (pp. 1–35), Rosenthal describes ethical questions as "unfashionable," but states that a discussion of the extent to which a producer can exploit a subject "in the name of general truth," along with the subsequent questions of consent and control, are among the organizing principles of the book. In particular, see interviews with "World at War" researcher Sue McConachy; film-maker George Stoney; Roger Graef (on knowledgeable consent and exploitation, pp. 175, 179–81); Doug Leiterman on the outsider's view (p. 187) and on the distinction between documentary drama and documentary journalism (p. 191); Emile de Antonio on FBI subpoenas of Weatherman footage; and Ellen Hovde, editor, in defense of "Grey Gardens." Generally, the book is very useful for its descriptions of ethical decisions made in relation to specific cases.

Sobchack, Vivian C.
 1977 " 'No Lies'. Direct Cinema as Rape," *Journal of the University Film Association*, 29(1), Fall, pp. 13–18.
 A very detailed analysis of Mitchell Block's scripted "documentary" film of a rape victim's unanticipated account of her rape. Sobchack's point is that through a union of form and content that makes the categories impossible to separate (indeed, form becomes content as Block demonstrates the scriptability of direct cinema conventions), "No Lies" undermines the typical passivity and voyeurism of documentary film viewing.

Springer, Claudia
 1984 " 'Vietnam: A Television History' and the Equivocal Nature of Objectivity," *Wide Angle*, 7(4), pp. 53–60.

A critique of the 13-part PBS television series based on an analysis of its narrational strategies which, Springer argues, favor equal time over substantive debate and testimony over argument in the construction of objectivity, and which dichotomize sentiment about the war into hawk/dove, pro/con instead of using the footage and airtime to delve more deeply into political and economic explanation.

Stein, Elliot
 1979 "In Dubious Battle," *Film Comment,* 15(3), May/June, pp. 31–32.
 On whether or not the violence and death in Walter Hill's film "The Warriors" can be held responsible for three murders associated with it (two committed in California theatres where the film was shown). With contempt for the campaigners against the film, Stein concludes that the excitement and tension aroused by their reactions and "irresponsible publicity" has added fuel to what otherwise might have remained a "little fire."

Task Force on Editorial Responsibility
 1980 *Independent Documentarians and Public Television.* New York: National News Council.
 Report to the National News Council concluding that (1) the dialogue between independents and stations should continue and (2) PBS and its member stations have an obligation to take the public into their confidence on the programming of independent documentaries, by filming and broadcasting discussions of a station's program choices, including the public's participation.

Vogel, Amos
 1979 "Independents," *Film Comment,* 15(2), March/April, pp. 75, 77.
 Review of George Stoney's "How the Myth Was Made" (a return to the Aran Islands some 40 years after Flaherty's "Man of Aran" was filmed) and a discussion of the fiction/fact controversy raised by Flaherty's film.

Wilson, David, and Jerome Kuehl
 1974 "The Truth of Film History," *Sight and Sound,* Autumn, pp. 240–42.

Two writers argue for and against the method used by Robert Vas in his film on the British general strike, "Nine Days in '26." Whereas Kuehl finds Vas's use of fiction film footage (from stories that took the strike as their theme) misleading and irresponsible, Wilson defends Vas, claiming that "Nine Days" doesn't claim to be documentary reportage.

Winston, Brian

1985 "A Whole Technology of Dyeing: A Note on the Ideology and the Apparatus of the Chromatic Moving Image," *Daedalus,* 114(4), Fall, pp. 105–23.

A case study in the bias of visual technologies. Winston details the history of motion picture film stocks and their representation of color, particularly their sensitivity to and variable reproductions of black versus Caucasian skin tones. In this account, he takes on the ideological appeals to scientific precision and impartiality expressed, e.g., by officials of the Eastman-Kodak company, and demonstrates the cultural specificity and determinism of technological development.

1983 "Hell of a Good Sail . . . Sorry, No Whales," *Sight and Sound,* 52(4), Autumn.

Detailed analyses of several episodes from two televised film series, Peter Davis' "Middletown" and Roger Graef's "Police." Subtitled "Direct Cinema: The Third Decade" and reflective of the Griersonian tradition in documentary film theory, Winston's article compares the two series in making the point that in the least successful cases of contemporary direct cinema, social analysis has been displaced by dramatic "personality exposés" that are usually unrepresentative of the people or communities they allege to represent. Here all episodes of "Middletown," save DeMott and Kreine's "Seventeen," (which never made it to air), are implicated by their unfulfilled claim to analytic legitimacy which, says Winston, was accomplished in large part through a superficial association with Robert and Helen Lynd's classic sociological study of the same title and locale. Absent from the films however is any consideration of significant social forces and activities (race, class and work among them). Some of the episodes also suffer from a pretense to what Winston describes as a lamentable, uncritical and misguided fly-on-

the-wall notion of objectivity. By contrast, Graef's series makes a more modest attempt than to characterize the community that supposedly characterizes us all, focussing on specific activities among a particular (and powerful) group of people, the details of his presentation ultimately forming a far more coherent social picture than the dramatic "mishmash" of the "Middletown" series. Throughout Winston's article, and featured in its conclusion, is a discussion of the rights of documentary film subjects, considered in terms of social change, of what viewers may or may not know about the social context of depicted events and activities and how this might be accounted for in documentary film theory and practice, and also considered in light of a more skeptical treatment of cinematic objectivity.

Young, Colin
 1974 "The Family," *Sight and Sound,* 43(4), Autumn, pp. 206–11.

 On the pre-production, shooting and broadcast of (and reaction to) the BBC's series "The Family." The program has often been compared to PBS's "An American Family" given the similarities in concept and production, but Young points out a crucial difference between the two in how each was scheduled. Unlike "An American Family," broadcast only after all shooting and editing was over, "The Family" maintained a schedule of broadcasts that started, and continued, while the second half of the series was still being shot. This allowed the Wilkins family (English counterpart to the Louds) to not only see the program in time to make adjustments for subsequent shooting, but as well to hear the reactions of viewers and critics before production ended. Young deals with audience complaints of voyeurism, cruelty to the family and disgust with the family itself, and levies his own criticisms, primarily against some aspects of the editing structure used in the series. In addition, he considers the difficulties involved in the positions of family, film-maker and audience, including the double bind film-makers often find themselves in when trying to be fair to their subjects and to please a commercially cultivated television audience.

FILM—Censorship and Sexual Imagery
(See also: FILM: Images of Women and Minorities)

Baer, Randy C., and Christopher Baffer
1974 "TV Censorship and the Movies," *Take One*, 4(10), March/
April, pp. 16–19.
On editing feature films for television. Discusses cutting
to time, removing "pornographic" or otherwise "inappro-
priate" scenes, and the placement of commercial advertise-
ments.

Cohen, Gayle
1982 "Porno: Eight Women Speak Out," *Cinema Canada*, July,
pp. 18–21.
A group interview with eight Canadian women on sex-
uality, pornography, censorship and the media.

"Dialogue"
1973 *Action*, 9(2), pp. 23–25.
Conversation between film directors Robert Aldrich and
Bernardo Bertolucci on film censorship. (Both directors
have been the subjects of obscenity charges or rating prob-
lems, Aldrich for "The Killing of Sister George" and Berto-
lucci for "Last Tango in Paris.")

Fisher, Robert
1975 "Film Censorship and Progressive Reform: The National
Board of Censorship of Motion Pictures, 1909–22," *Journal
of Popular Film*, 4(2), pp. 143–56.
A descriptive history of the first national, private film
censorship board in the U.S.

Hunnings, Neville
1975 "Censorship in France," *Sight and Sound*, 44(3), Summer,
p. 158.
Brief discussion of former French president Giscard
d'Estaing's "liberalisation" of film censorship in France in
the mid-70s, and concomitant economic restrictions in the
form of increased control over publicity.

Jarvie, Ian C.
1985 "Suppressing Controversial Films: From 'Objective Burma'
to 'Monty Python's Life of Brian'," in Bruce A. Austin

(ed.), *Current Research in Film: Audiences, Economics, and Law* (Volume 1). Norwood, N.J.: Ablex.

Distinguishes between public and private forms of censorship and recounts the resistance met by each film, in the case of "Objective Burma" (1945) from the British press (which led to Warner Brothers' suppression of the film's general release until 1952) and in the case of "Life of Brian" from a variety of organized religious groups in the U.S. (with little consequence for the film's distribution or content). Jarvie draws from current theories of the audience's role in shaping the public meaning of a film, and concludes that despite the diminished significance of films as a mass medium since the '60s, it remains a target for declining or threatened groups who may attempt to defend or enhance their status by taking on a popular film's representation of them.

Jump Cut
1985 "Sexual Representation," 30, March.

A collection of articles on often-overlooked areas of pornography and sexual imagery, particularly gay porn, and their consequence for sexual analysis. See articles by Richard Dyer on the romantic structure of gay male features, Tom Waugh on a comparison of commercial gay and straight porn films, and John Greyson on gay personal video. Lisa DiCaprio writes about "Not a Love Story," produced by Bonnie Sherr Klein at the National Film Board of Canada and often regarded as the touchstone film in the feminist pornography debate. DiCaprio has also interviewed Klein for this issue. The forum is introduced by Chuck Kleinhans, who joins co-editor Julia Lesage in an article on the politics of sexual representation. Note that the forum is continued in *Jump Cut* No. 32, April 1986, with articles on "Pornography and the Doubleness of Sex for Women" by Joanna Russ; an interview with six women porn stars by Annette Fuentes and Margaret Schrage; "Bright Victory," a photoroman by Ann Pearson and Yvonne Klein; and three reviews of pornographic/erotic films, one by Gina Marchetti of "Firecracker" (1981), a second by Jake Jakaitis of "Giving Way" (1979), and a third by Patricia Erens of "The Seduction" (1981).

MacDonald, Scott
1983 "Confessions of a Feminist Porn Watcher," *Film Quarterly*, 36(3), Spring, pp. 10–17.

A very frank account of the author's use of pornography, framed self-consciously and critically in terms of the "educational" function of pornography and its value as psychic release. The article is presented in part as a response to B. Ruby Rich's call (in the *Village Voice*) for "some concrete analysis, from both men and women, of how screen pornography and erotica actually operate." After describing some of his experiences with pornographic films in arcades and theatres, and after considering the predominant themes and images of the films and their relation to cultural taboos, MacDonald concludes that "in our culture men and women frequently feel alienated from their own bodies and from each other. Pornography is a function of this alienation, and I can't imagine it disappearing until we have come to see ourselves and each other differently."

Meredith, Raina
1982 "The Amateur Shtup Tapes," *Village Voice*, Nov. 23.

A report on Susan's, a national amateur porn video club in which members trade, rent and buy tapes of each others' sexual performances. "It's more *real*," says one member, "it depicts *real* people in *real* houses, showing *real* lust." In addition to the tapes submitted by Susan's members, the club serves as a forum for customized tape requests and provides some technical guidelines to new members planning on making their own tapes. The author interviews the club's proprietors and a couple of members, and consults a Berkeley sex therapist on the possible "function" of home (vs. commercial) pornography.

Moss, Robert
1974 "The Supreme Court, Artistic Freedom and the Movies: No Dear Critic, Sex is Not the Answer," *Film Heritage*, 10(1), Fall, pp. 37–44.

A discussion of the generally mediocre and irrelevant use of sex in many popular American films, and the "irony" of the critical defense on its behalf against the U.S. Supreme Courts's 1973 obscenity rulings (though the author concedes "the necessity of this defense").

Nobile, Philip
 1986 *United States of America v. Sex; How the Meese Commis-
 sion Lied About Pornography.* New York: Penthouse Press.
 A severe critique of both the methods and conclusions
 of the U.S. Attorney General's Report on Pornography
 (1986); (see below).

Phelps, Guy
 1973 "Censorship and the Press," *Sight and Sound,* 42(3), Sum-
 mer, pp. 138–40.
 About the effect of pre-release coverage of official cen-
 sorship decisions in England.

"Porn Symposium"
 1973 *Take One,* 4(5), May/June, pp. 28–30.
 A collection of brief articles by several authors on many
 aspects of film pornography, including censorship, exploita-
 tion and gay porn films.

Slade, Joseph W.
 1984 "Violence in the Hard-Core Pornographic Film: A Historical
 Survey," *Journal of Communication,* 34(3), Summer, pp.
 148–63.
 Slade argues that by a variety of definitions violence and
 brutality occur infrequently in pornographic films from the
 early 20th century forward. The most prevalent theme is
 female sexual insatiability, a theme difficult to reconcile with
 brutality as distinct from sexual activity. He agrees that while
 the representation of physical brutality may be infrequent
 in porn, that doesn't make it trivial or any less offensive
 when it does occur. But the more general issue is the differ-
 ence in male and female sexual sensibilities and the persistent
 subordination of female desire to the presumed preferences
 of male audiences. Even as violence begins to occur more
 often in pornography since the '70s, aggression rates remain
 relatively low and violent depictions are not characteristic
 of "mainstream" porn films (versus those identified by pro-
 ducers, distributors, exhibitors and consumers as "fetishis-
 tic").

Trauth, Denise M., and John L. Huffman
 1985 "Public Nuisance Laws: A New Mechanism for Film Censor-
 ship," in Bruce A. Austin (ed.), *Current Research in Film*
 (Volume 1). Norwood, N.J.: Ablex.

On public nuisance laws as a local (versus federal) means of prior restraint. The authors provide a brief review of the history of film censorship and of different types of cen-·sorship that are currently engaged. However they concentrate on North Carolina's public nuisance statutes as a potential means of prior restraint against "pictorial obscenity," especially since those statutes were ruled constitutional by the U.S. Court of Appeals for the Fourth Circuit in April 1982.

United States Commission on Obscenity and Pornography
1971 *Technical Report.*
A nine-volume report, each volume containing separately authored articles on: Preliminary Sociological Studies (V.1); Legal Analyses (V.2); The Pornography Industry (V.3); Empirical Studies of the Pornography Marketplace (V.4); Societal Control Mechanisms (V.5); National Surveys of Attitudes Toward and Experience with Erotic Materials (V.6); Erotica and Antisocial Behavior (V.7); Erotica and Social Behavior (V.8); The Consumer and the Community (V.9). See also the consolidated Report published September, 1970, including an overview of the findings, recommendations of the Commission, reports of the panel, and statements by the Commission members. (For sale through the Superintendent of Documents, U.S. Government Printing Office, Washington, D.C., 20402).

United States Department of Justice
1986 *Attorney General's Commission on Pornography: Final Report.* Washington, D.C.
Popularly known as the "Meese Commission" report (after Attorney General Edwin Meese), including sections on the history of pornography, First Amendment constraints, the pornography market and industry, the question of harm, current laws controlling distribution, child pornography, private control, content of pornographic materials, statements by lay and expert witnesses testifying before the commission, recommendations for restricted distribution of pornographic materials. (For a critique of the Meese Report, see Nobile [1986], above.)

"Viewpoints"
1973 *Action,* 9(2), pp. 7–10.
 A series of statements by eleven film-makers on official film censorship.

Wise, Robert
1973 "Special Report," *Action,* 9(2), pp. 15–17.
 Comments from Robert Wise, former president of the Directors Guild of America, on the Guild's reaction to the 1973 Supreme Court ruling on obscenity.

Williams, Bernard (ed.)
1981 *Obscenity and Film Censorship.* London: Cambridge University Press.
 An abridgement of the Williams Report by the (British) Committee on Obscenity and Film Censorship. Includes background sections on current law and film censorship, an analysis of freedom of expression, harm, offensiveness and pornography, and art, and proposals for the controlled distribution of graphic publications, live entertainment and films.

FILM—Docudrama
(See also LEGAL: Libel; Privacy/Publicity)

Davidson, Bill
1979 "TV's Historical Dramas: Fact or Fiction?" in Lewis Jacobs (ed.), *The Documentary Tradition* (2nd Edition).
 Uses several recent examples of television docudrama, many of them controversial and some of them in court, to discuss the following questions: (1) Is docudrama generally more dramatization than documentary? (2) Are facts sometimes distorted or omitted to make a better story? (3) Is the American public deliberately being misled by representations that suggest these films are true stories? Much of Davidson's discussion comes from interviews with producers, writers and other participants in the production of television docudrama.

Hoffer, Tom W., and Richard Alan Nelson
1978 "Docudrama on American Television," *Journal of the University Film Association,* 30(2), Spring, pp. 21–27.
 Traces the historical antecedents of television docudrama to British and American public TV, particularly in its use of

trial records for dramatic recreation. In a section titled "Problems and Controversies" (pp. 26–27), the authors discuss the potential for abuse "when the needs of drama may tend to take priority over journalistic standards."

Lewin, Tamar
 1983 "Whose Life Is It Anyway? Legally, It's Hard to Tell," *New York Times,* November 21, Arts and Leisure, pp. 1, 26.
 On how the television docudrama may pose threats to the personal privacy of the people it fictionalizes, focussing in particular on Elizabeth Taylor's attempted prior restraint against ABC's proposed docudrama of her life and career. Once again, the First Amendment is offered as the network's principle defense. The author also discusses the descendability of the right to privacy and the right to publicity in New York Civil Rights Law, and how it may figure in judicial interpretations with respect to TV docudrama. Several illustrative cases are cited.

Schwartz, Tony
 1980 "Some Public TV Stations Cancel Film on Saudi Princess," *New York Times*, May 3.
 The program was cancelled to "protect the national interest against any reactions from Saudi Arabia to a program that might be offensive to them." The article lists the various Saudi national groups (in Saudi Arabia and in the U.S.) who responded to the program and who joined in a campaign to either stop the broadcast or be granted equal time for an explanation of the depicted activities.

FILM—Ethnographic Film

Baldwin, Lori A.
 1979 "Producing Ethnographic Films: An Interview with Filmmaker Gei Zantzinger," *Perspectives on Film,* 2, pp. 10–15.
 Comments on the subjects' influence on film content and their feedback during editing.

Heider, Karl
 1976 *Ethnographic Film.* Austin: University of Texas Press.
 In a brief section "The Ethics of Ethnographic Filmmaking" (pp. 118–21), Heider quotes at length the "Princi-

ples of Professional Anthropology" adopted by the Council of the American Anthropology Association in 1971, though ultimately concedes they are not very helpful in the complex issues related to film. He also discusses the "myth" of informed consent in ethnographic and documentary film, so described given the impossibility of predicting in advance what the image of a participant will be in the final film or how viewers will react to it. This problem is especially relevant, and difficult, where ethnographic films are used in the community in which they were made and are not reserved for projection to unrelated audiences. In conclusion, Heider urges that although ethnographic film studies may rarely please everyone involved, they should "at least not be vulnerable to charges of falsification of a situation" (p. 121).

1979　" 'Truth' in Film and Ethnography," *Perspectives on Film,* 2, pp. 16–18.

A brief article differentiating between written and filmic ethnographies which concludes that because film is more subject to distortion and misinterpretation, ethnographic filmmakers must be especially "uncompromising" about scientific methodology. Heider suggests guidelines for the evaluation of ethnographic film and advocates ethics over aesthetics in ethnographic film production.

Hockings, Paul (ed.)
1975　*Principles of Visual Anthropology.* The Hague: Mouton Publishers.

An anthology of essays. Ethical issues dealt with include making observational films about people you dislike (see Young, pp. 65–79 and response by Temaner, p. 80); the discrepancy between what little the observational film-maker is required to explain about her work and the openness she asks of her subjects (Marshall, p. 118); privacy, consent, and confidentiality of data in videotape observation (Schaeffer, pp. 254–55); privacy in relation to access to and use of visual records (Sorenson, pp. 474–75). More generally, the articles by Young and MacDougall embody a concern for a treatment of film subjects that allows the information and mandate for what to shoot to come from the subjects themselves (i.e. 'showing' versus 'telling').

Jarvie, Ian C.

1983 "The Problem of the Ethnographic Real," *Current Anthropology,* 24(3), June, pp. 313–25.

On "naive inductivism" in anthropology and film-making. Jarvie claims that the mandates and strengths of social science (to advance the disciplinary problems posed by one's subject matter) and film-making (to express creatively one's vision) are incompatible, and that film, being limited to appearances, is unable to yield much insight on the social and institutional relationships that inform those appearances. Ultimately, the use of film in anthropology may be merely illustrative rather than evidentiary. Jarvie's article is followed by a series of comments from scholars and ethnographic film-makers, who often agree with his critique of inductivism but who question the premises that (a) film ought to do what written ethnography does and (b) film's strengths (precisely in revealing appearances) are of any less value to anthropology than the more traditional discursive modes of data collection (field notes) and presentation (verbal monographs). Jarvie responds to his commentators on p. 323. See also the later discussion by Olivier de Sardan (*Current Anthropology,* 24[4], Aug.–Oct. 1983, p. 533).

MacBean, James Roy

1983 "Two Laws from Australia, One White, One Black," *Film Quarterly,* 36(3), Spring, pp. 30–43.

MacBean focuses on the heated debates at the 1978 International Ethnographic Film Conference in Canberra, Australia, on the films of Judith and David MacDougall, and finally on Cavadini and Strachan's "Two Laws," in a discussion of power and practice in ethnographic films and film-making. MacBean upholds both the MacDougalls and Cavadini and Strachan as practitioners who take seriously the active participation of their subjects in the filmic expression of local culture and the material production of the films.

Nacify, Hamid

1979 "Jean Rouch: A Personal Perspective," *Quarterly Review of Film Studies,* Summer, pp. 339–62.

An interview with Jean Rouch including comments upon subjects' reactions to films (p. 343), on what and what not to shoot (p. 346), subjects' participation in film production,

keeping secrets (p. 351), effect of the camera's presence on subjects (p. 357), and voyeurism and the use of hidden cameras (p. 359).

Staal, Frits
1979 "Comment: Altar of Fire," *American Anthropologist,* 81, pp. 346–47.

A defense by one of the makers of the ethnographic film "Altar of Fire" against allegations from a reviewer who stated that Staal and co-producer Robert Gardner staged the ritual event depicted in the film.

FILM—Images of Women and Minorities
(See also: FILM: Censorship and Sexual Imagery)

Citron, Michelle, John Hess, Chuck Kleinhaus, and Helene Langer
n.d. "The Audience Strikes Back," *Jump Cut,* 22, p. 38.

A report on several citizens' movements protesting the representation of women and minority groups in some U.S.-released fiction films, including "Dona Flor and Her Two Husbands," "Boulevard Nights," "Windows," and "Cruising."

Cripps, Thomas
1975 "The Movie Jew as an Image of Assimilationism, 1903–1927," *Journal of Popular Film,* 4(3), pp. 190–207.

The author separates American popular film from other popular arts in the early 20th century as uniquely non-Anti-Semitic. This he attributes to two factors: (1) The movie industry's dependence upon ethnically diverse urban audiences (trained in the ethnic tradition of vaudeville, with its own checks on pejorative stereotypes); and (2) the control of the medium in Hollywood by a segment of the immigrant population. Together, the author claims these forces produced "a sentimental stereotype of an American immigrant who symbolized the assimilationist experience of the Jewish studio bosses" (p. 191).

Dyer, Richard
1984 *Gays and Film* (2nd Edition, revised). New York: New York Zoetrope.

A collection of four essays by gay and lesbian scholars, and a comprehensive, international filmography of titles

featuring gay and lesbian characters and themes. Both Dyer's own article, "Stereotyping," and Caroline Sheldon's "Lesbians and Film: Some Thoughts" consider different forms of streotyping and the possibility of using gay types for positive representational ends. Their analyses refer extensively to both popular and less familiar films and characters (e.g. "The Killing of Sister George," "The Boys in the Band," "Madchen in Uniform"). Jack Babuscio's article "Camp and the Gay Sensibility" explores camp as a strategic response to heterosexual oppression and considers how four features of camp—irony, aestheticism, theatricality, humor—are constructed and reflected in a variety of films. Finally, Andy Medhurst contributes "Notes on Recent Gay Film Criticism," a brief review of Vito Russo's *The Celluloid Closet* (see below), of debates and responses to "Cruising" and "Making Love" in the gay press, and of lesbian film criticism as a distinct discourse within feminist analysis. Importantly, all authors write as members of the communities and audiences whose responses and practices they describe. In addition to the filmography, see Dyer's selected bibliography of books and articles on gays and film.

1983 "Seen To Be Believed: Some Problems in the Representation of Gay People as Typical," *Studies in Visual Communication,* 9(2), pp. 2–19.

An exploration of gay types in the visual media (though primarily in film) that starts with a discussion of the "near necessity" of a repertoire of visual and gestural signs to render visible an otherwise invisible status. Dyer considers the social, political, practical, and textual bases of homosexual and lesbian typifications and identifies four primary types that illustrate "the importance of gender and of biology/nature in gay representation, as well as the pressure from both dominant and subcultural forces to produce gay types." They are (1) In-betweenism, the queens and dykes who are neither "real men" nor "real women"; (2) Macho, characterized by an exaggerated, self-conscious deployment of the signs of masculinity; (3) The sad young man; and (4) Lesbianfeminism, in which a lesbian cultural tendency toward "naturalness" contrasts the gay male cultural tendency to-

ward artifice. (Note: This issue of *Studies* features five articles on issues in the representation of gays. See JEB (under Photography, below) for an article on lesbian photography. Also included, though not annotated here, are "Iconography of a Scandal: Political Cartoons and the Eulenberg Affair," by James D. Steakley; a review essay of Vito Russo's *The Celluloid Closet: Homosexuality in the Movies,* by Richard Dyer; and "Wilhelm Von Pluschow and Wilhelm Von Gloeden: Two Photo Essays," by Bruce Russell.)

Friedman, Lester D.
1982 *Hollywood's Image of the Jew.* New York: Frederick Ungar Publishing Co.

Among the few book-length accounts of Jews in cinema that place Hollywood's characterizations in cultural and historical context from the silent era through the early eighties. Friedman also relates Jewish images to Jewish operation and control of the studios, and provides an extensive filmography and 16mm rental information.

LaValley, Al
1982 "Out of the Closet and Onto the Screen," *American Film,* 7(10), September, pp. 57–64, 81.

A summary of telephone interviews with nine film critics and scholars on the recent appearance of four major Hollywood films with gay themes and gay characters—"Making Love," "Victor/Victoria," "Personal Best," and "Partners." Responses to questions on why these films are appearing now, on the comic use of gay characters, on the depiction of lesbian versus gay relationships in fiction film, on the difference between mainstream Hollywood features about gays and the independently produced "Taxi Zum Klo," on reversing the stereotypes by casting gay actors, and finally, on the future direction gay films might take toward independent or mainstream cinema.

Lear, David J.
1975 "A Pale Black Imitation: All-Colored Films: 1930–60," *Journal of Popular Film,* 4(1), pp. 57–76.

A brief and disparaging history of ghetto-oriented "Jim Crow" films, made within the staple Hollywood feature genres of musical, western, and gangster.

Miller, Randall M. (ed.)
 1978 *Ethnic Images in American Film and Television.* Philadel-
 phia: The Balch Institute.
 Published proceedings of ongoing symposia among schol-
 ars, media producers, and representatives of community eth-
 nic organizations on ethnic representation. In his introduction,
 Miller poses assimilationism against multi-culturalism and
 describes television and film as proponents of the former
 which may threaten the cultural and social integrity of ethnic
 minorities in the U.S. The collection includes papers on the
 representation of blacks, Jews, Germans, Irish, Italians, Poles,
 Puerto Ricans, and Asians, and is particularly useful for its
 responses from ethnic community authors writing both as ac-
 tivists and audience members.

Richards, Mary
 1982 "The Gay Deception," *Film Comment,* 18(3), May/June,
 pp. 15–18.
 On the image of gays in fiction film, with reviews of
 "Making Love" and "Personal Best."

Roffman, Peter, and Bev Simpson
 1984 "Black Images on White Screens," *Cineaste,* 13(3), pp.
 14–21.
 Traces a shift from racist and stereotypical images of
 blacks in U.S. films from the early 20th century, through
 '50s integrationism, again through a combination of "blax-
 ploitation" films and quality performances in the early '70s,
 and finally through the return to a limited portrayal of blacks
 in the early '80s. Focuses on particular actors (Sydney Poitier,
 Richard Pryor, Cicely Tyson, Eddie Murphy, Howard Rol-
 lins) and on the contours of their careers as exemplars of
 these periods in black images and roles and the professional
 treatment of black actors. Also discusses Hollywood's exploi-
 tation and abandonment of the black audience since the box
 office successes of the early '70s, and the historical signifi-
 cance of Melvin Van Peebles' *Sweet Sweetback Badass Song,*
 an unapologetic story of a black character's revolt against
 the white establishment.

Russo, Vito
 1987 *The Celluloid Closet: Homosexuality in the Movies* (2nd
 Edition). New York: Harper and Row.

A critical, political survey of gay representation in films that attempts to trace the historical development of gay images in relation to social changes in both homosexuality and cinema. (See also Richard Dyer's review essay in *Studies in Visual Communication*, 9(2), Spring, 1983, pp. 52–56.)

Trevino, Jesus Salvador
 1985 "Latino Portrayals in Film and Television," *Jump Cut*, 30, pp. 14–16.
 A brief analysis of several Latino images in popular movies and commercial advertising, including the early stereotypes of the greasy bandit, the Latin lover, the dumb peon, and the (female) spitfire, and later reprises featuring Mexicans as comical, lazy, and thieving. Trevino is critical of the very poor representation of Latins in media professions (especially in Los Angeles where they make up 20 percent of the city's population), to which he attributes the lethargy of dispelling popular stereotypes, though is hopeful that the market potential of the Latin audience will move advertisers to revamp their characterizations (which, he says, some have already done).

Woll, Allen L.
 1974 "Hollywood's Good Neighbor Policy: The Latin Image in American Film, 1939–46," *Journal of Popular Film*, 3(4), Fall, pp. 278–93.
 Argues that a change in the image of Latin Americans in U.S. films (from greaser to talented performer and romancer) occurred in 1939 following Roosevelt's establishment of his "good neighbor" foreign policy with Latin America.

Yacowar, Maurice
 1974 "Aspects of the Familiar: A Defense of Minority Group Stereotyping in the Popular Film," *Film Literature Quarterly*, 2(2), Spring, pp. 129–39.
 Yacowar's model separates history and poetry so that the latter needn't be accountable in terms of the former. In this sense, film characters are to be understood as types, not people. They are the "poet keeping his peripheral characterizations all compact" (p. 136).

FILM, TELEVISION, VIDEOTAPE—Cases

"AN AMERICAN FAMILY":

Gilbert, Craig
 1982 "Reflection on 'An American Family'," *Studies in Visual Communication,* 8(1), Winter, pp. 24–54.
 A lengthy diary by the originator and producer of "An American Family," including reflections on the idea for the program, the search for a family and the recruitment of the Louds, on shooting, editing, and the several crises that occurred during both these stages of production, on the broadcast, and an extensive account of audience and participant reactions.

Kreuger, Eric
 1973 "An American Film—An American Family," *Film Comment,* 9(6), November, pp. 16–19.
 On the film, its publicity, and why the Loud family agreed to be its subjects; about the effect of a camera and sound crew on the Louds' behavior; and on the film's point of view as judge or witness. In writing about these issues, the author uses comment from Pat Loud (published elsewhere), and is critical of most of the published responses to the series.

Loud, Pat (with Nora Johnson)
 1974 *Pat Loud: A Woman's Story.* New York: Coward, McCann and Geoghegan.
 An autobiographical account of her life before, during and after the filming of "An American Family." Describes living with a camera crew (and "doing scenes" rather than just being followed around), her own reactions to critical and popular responses to "An American Family" (including many excerpts from press reviews), a degree of contempt for Craig Gilbert (the series producer), and reflections upon what Loud thought her life should have been, what it became, and the influence of "An American Family" on the latter.

Raymond, Alan, and Susan Raymond
 1973 "Filming 'An American Family'," *Filmmakers Newsletter,* 6(5), March, pp. 19–21.
 Miscellaneous remarks on technical and interactional aspects of the project.

Ward, Melinda

1973 "The Making of 'An American Family'," *Film Comment,* 9(6), Nov./Dec., pp. 24–31.

What to film and what not to film and the film-makers' decisions on how to interact with the Louds. Includes "week-in-the-life-with-the-Louds" descriptions.

1973 "Pat Loud, an Interview," *Film Comment,* 9(6), Nov./Dec., pp. 20–23.

A general interview with Pat Loud about her participation in "An American Family." Gets at what she would like to have seen included in the series that was in fact shot but left out; what her behavior might have been in certain situations had the crew not been there; and the instructions the family received during filming.

ARTHUR BARRON:

Levin, G. Roy (ed.)

1971 "Arthur Barron," in *Documentary Explorations,* New York: Doubleday, pp. 295–312.

An interview with Arthur Barron on recruiting subjects for his film "Birth and Death"; getting "honesty" from subjects on camera; subject community reactions to Barron's films; getting releases and showing rushes to subjects; television network censorship; the effect of participation in a network documentary film on the subjects' lives after the film is televised; and on objectivity and subjectivity in documentary film.

Rosenthal, Alan

1971 " 'Sixteen in Webster Groves' and 'The Berkeley Rebels': Arthur Barron," in *The New Documentary in Action,* Berkeley: The University of California Press.

An interview with Arthur Barron about his films "Sixteen in Webster Groves" and "The Berkeley Rebels." Comments on getting permission to work with a large group of sixteen-year-olds (by only partly honest means); directing a documentary film toward a very specific, preconceived message; cinéma vérité (in contrast to the former approach); "Webster Groves" as a carefully constructed indictment of the American dream; using survey data to determine the "spirit"

of a situation to be depicted in a documentary film, in this case "Webster Groves"; network censorship; being sent back to Webster Groves following the broadcast of the film to make a second documentary on the community's reactions to the first (whose outrage threatened the operation of the local CBS affiliate); "The Berkeley Rebels" and CBS censorship; and finally, the use of narration to "tone a picture down."

"BEST BOY":

Insdorf, Annette
 1980 "The Compassionate Man Behind Best Boy," *New York Times,* March 16, Section 2, p. D19.
 A lengthy, descriptive review of the film "Best Boy" and interview with its director Ira Wohl, on his own career, on the making of the film, and on his relationship with its central character, Philly.

Robinson, David
 1980 "Philly's Family," *Sight and Sound,* 49(4), August, p. 268.
 A very favorable review of "Best Boy" that sees the film as the locus of a relationship between Wohl, Philly, and Philly's parents, rather than a show that succumbs to voyeurism in the treatment of personal misfortunes and handicaps.

"CALIFORNIA REICH":

Allen, Tom
 1978 "Deutschland über Fresco," *Village Voice,* Oct. 23.
 Favorable review of "California Reich" (see Schwarz, below) that describes the film as isolating a "pathetic group of disaffected losers that at the same time shares their humanity, in a limited sense, with the viewers."

Schwartz, Jerry
 1978 "Ten Vandals Stop Film on Nazism," *Philadelphia Inquirer,* Oct. 30.
 Press report on the destruction of a movie projector and stage sets in a New York theatre showing "California Reich," a documentary that some say favorably portrays Nazi followers in California. Responsibility for the vandalism was

claimed by the Revolutionary Socialist League and Committee Against Racism.

"CRUISING":

Guthman, Edward
 1980 "The *Cruising* Controversy: William Friedkin vs. the Gay Community," *Cineaste,* 10(3), Summer.
 Discusses the First Amendment implications of the Spring 1979 protests to prevent the production of William Friedkin's film "Cruising."

"FITZCARRALDO":

CIPA "The Aguaruna and Werner Herzog"
 1982 *Cultural Survival.*
 A very critical article on the conduct of Werner Herzog and his film crew in Peru and their "mistreatment" of Peruvian Indians in the interest of producing "Fitzcarraldo." According to the article, the production was supported by Peruvian government officials, who threatened and bullied Indians into co-operating despite their collective decision to forbid the crew to work on their territory or employ their people. (The conclusions reached in this article are somewhat in contrast to those appearing elsewhere. See Goodwin, below.)

Goodwin, Michael
 1982 "Herzog: The God of Wrath," *American Film,* 7(8), June, pp. 36–51, 72–73.
 A fairly detailed description of the production conditions in the Peruvian Amazon jungle for Herzog's "Fitzcarraldo." Of interest to this bibliography both for Goodwin's account of the unreasonable demands made by Herzog on his crew and cast, and for the somewhat contrasting report of Herzog's treatment of Peruvian Indians (see CIPA, above).

"GREY GARDENS":

Davidson, David
 1981 "Direct Cinema and Modernism: The Long Journey to 'Grey Gardens'," *Journal of the University Film Association,* 33(1), Winter, pp. 3–13.

A comprehensive formal and political analysis of "Grey Gardens" that considers the film alongside published remarks from Albert and David Maysles about "Grey Gardens" and their earlier work.

Klemesrud, Judy
1978 "From Grey Gardens to Reno Sweeney," *New York Times,* January 10, p. 38.
Interview with Edith Bouvier Beale (Jr.), (who, with her mother, was a central figure in Albert and David Maysles' film "Grey Gardens"), just prior to the opening of her first New York singing engagement at the Reno Sweeney night-club. (Ms. Beale did not feel she was being exploited by the club as the subject of "Grey Gardens.")

Pryluck, Calvin
1976 "Seeking to Take the Longest Journey: A Conversation with Albert Maysles," *Journal of the University Film Association,* 28(2), Spring, pp. 9–16.
Maysles addresses some of the ethical criticisms provoked by "Grey Gardens" and comments upon Pryluck's article "Ultimately We Are All Outsiders" (see above). As well he discusses film reviewer Pauline Kael's accusations of staging in "Salesman!" and "Gimme Shelter."

Rosenthal, Alan
1980 "Grey Gardens: Ellen Hovde," *The Documentary Conscience.* Los Angeles: Univ. of California Press.
An interview with the editor of "Grey Gardens" that deals directly with the ethical issues and attacks provoked by the film.

Sargent, David
1975 "When Does Invasion of Privacy Become Art?" *Village Voice,* Oct. 13, p. 134.
A sympathetic review of the Maysles' "Grey Gardens" following its premiere at the New York Film Festival in 1975. The review describes some of the debate which attended the screening and though he does not underplay questions of privacy invasion and exploitation, the author con-

cludes that the film "exalts" the Beales and their nonconformist humanity.

Saxon, Wolfgang
1977 "Edith Bouvier Beale, Recluse, Dead at 81," *New York Times,* February 7.
 Obituary of Edith Bouvier Beale, Sr., that briefly describes her family history, the police raid on her East Hampton, Long Island, home and her participation in "Grey Gardens."

"HIROSHIMA-NAGASAKI":

Barnouw, Erik
1982 "The Case of the A-Bomb Footage," *Studies in Visual Communication,* 8(1), pp. 7–14.
 A case study of the production of "Hiroshima-Nagasaki" which used footage shot by a Japanese film unit named Nippon Eiga Sha, commissioned by the Japanese government following the A-bomb detonations. The article recounts the collaboration between Barnouw and his Japanese co-producer Akira Iwasaki, who headed the Nippon unit when the original footage was shot. In addition to details of the production, the article describes the "secret" military classification that prevented circulation of the footage in the U.S. for some 25 years after shooting, and the reactions of an international audience following the film's release in 1970.

TEHERAN HOSTAGE COVERAGE:

Carmody, Dierdre
1980 "Hostages' Families Discuss News Media," *New York Times,* Nov. 9, Section 1, pp. 19, 25.
 An account of the various measures taken by the families of American hostages in Teheran to protect themselves against invasion by news media. In some cases, media personnel spent days on end with several families, who report their co-operation and respect for household privacy. In others, families were forced to unlist their telephone numbers due to media harassment, at the risk of missing calls from the family member held hostage.

"MIDDLETOWN":

Rodman, Howard
 1982 "Muncie's Blackboard Jungle," *American Film,* 7(8), June,
 pp. 10–14.
 On the withdrawal of "Seventeen" from the PBS "Mid-
 dletown" series. The hour-long documentary by film-makers
 Joel DeMott and Jeff Kreines angered citizens of Muncie,
 Indiana, with its portrayal of "youth culture" as a cycle of
 sex, drug abuse, alcoholism, and high-school dropping out.
 Issues raised by the article are misrepresentation and fail-
 ure to acquire subjects' consent. Interestingly, DeMott and
 Kreines invoke their proximity to their subjects at all times
 during the shooting as consent. Their critics claim that this
 overlooks the teenagers' intoxication and consequent inabil-
 ity to consent responsibly. (See also Brian Winston's article
 titled "Hell of a Good Sail" in Film/Television/Videotape,
 above.)

"ONE WOMAN'S STORY":

McMillan, Nancy Pomerene
 1980 "The Film Diary of a Terminal Cancer Patient," *New York
 Times,* January 20.
 On the making of "One Woman's Story," a film about
 the last 22 months in the life of cancer patient Joan Robin-
 son. The article raises several ethical issues, among them
 whether the filming was an affirmation that Mrs. Robinson
 would die (particularly in terms of applications for founda-
 tion funding—would the film ever be finished?), and the dis-
 ruption created by filming in a hospital ward.

"THE UNCOUNTED ENEMY: A VIETNAM DECEPTION":

Bernstein, Richard
 1983 "CBS Releases Its Study of Vietnam Documentary," *New
 York Times,* April 27.
 On the Benjamin Report, a CBS in-house investigation
 of the production of "The Uncounted Enemy." A Federal
 District Court judge in Manhattan ordered that the report be
 turned over to General William Westmoreland, who sued the
 network for libel immediately following the program's broad-

cast. The premise of the documentary was that General Westmoreland had "intentionally manipulated information about the strength of enemy troops during the Vietnam war," in order to present an image of his imminent military success to President Lyndon Johnson. Although the report conceded many accusations of press irresponsibility listed in a *TV Guide* article in May, 1982 (see Kowet, below), it upheld an earlier statement that CBS would stand by the documentary.

Friendly, Jonathan
 1983 "Decision in CBS Case Raises New Press Concerns," *New York Times,* April 30, Section 1, p. 48.
 On the possible "chilling" effect of the Manhattan Federal District Court ruling that CBS's Benjamin Report on the preparation of "The Uncounted Enemy" be turned over to General Westmoreland. Judge Pierre Leval agreed that CBS had "no right to keep the report confidential since it had cited its conclusions publicly" at an earlier date. Because Leval did not specifically rule on "whether there was a constitutional privilege for internal investigations," and because CBS did not appeal the ruling, the legal issue remained in limbo.

 1983 "CBS Is Told to Give Westmoreland Internal Study on Vietnam Report," *New York Times,* April 22, pp. 1, A1.
 A brief summary of events leading up to the court order.

Kowet, Don, and Sally Bedell
 1982 "Anatomy of a Smear: How CBS Broke the Rules and 'Got' General Westmoreland," *TV Guide,* May 29, pp. 3–15.
 A detailed investigation of the production of "The Uncounted Enemy" that alleges (a) producer George Crile's preconception of a conspiracy to prevent vital military information from reaching President Johnson just prior to the Vietnam Tet offensive in 1968; (b) the uncritical "irresponsible" use of former CIA analyst Sam Adams as consultant and primary witness, despite Adams' "known" obsession with the Vietnam conspiracy theory; (c) CBS's violation of its own official guidelines in the rehearsal of its paid consultant prior to his interview; (d) the recruitment and soft treatment of other witnesses sympathetic to the conspiracy allega-

tion; (e) the program's misrepresentation of accounts by unsympathetic witnesses; and (f) the out-of-context use of quotes to make implications that were not intended.

Larsen, Jonathan
1983 "The Battle of Black Rock: General Westmoreland's Guerilla War with CBS," *New York Magazine,* Oct. 24, pp. 40–53.

A chronology and analysis of Westmoreland's libel suit against CBS-TV.

Schwartz, Tony
1982 "Who Really Reports News on Television," *New York Times,* June 23.

A brief critical analysis of the TV news correspondent's role in the production of public affairs items. Along with some of the network personnel he interviews, Schwartz suggests that the on-camera reporter's presentation is misleading about who is actually responsible for investigation and production. Mike Wallace's participation in "The Uncounted Enemy" is the high-profile example.

1982 "Documentary by CBS on Vietnam Questioned," *New York Times,* May 27.

An introductory article, citing the *TV Guide* report, on the questionable practices of CBS in the investigation and production of "The Uncounted Enemy." In particular the article mentions what General Westmoreland felt to be a violation of his agreement with Mike Wallace, to include the assertion that he had *over*estimated the number of enemy troops in the Tet offensive (no such comment was broadcast). The article also discusses Sam Adams' preparation before being interviewed by Wallace, in direct contravention of CBS News policy, and the elimination of all interview footage with Walt Rostow in the program's final cut.

FREDERICK WISEMAN:

Anderson, Carolyn
1981 "The Conundrum of Competing Rights in 'Titicut Follies'," *Journal of the University Film Association,* 33(1), Winter, pp. 15–22.

A detailed discussion and chronology of the legal deci-
sions and controversies surrounding Frederick Wiseman's film
"Titicut Follies," particularly the conflict between the First
and Fourth Amendments raised by the court-ordered restric-
tions on public screenings of the film in the state of Massa-
chusetts.

Halberstadt, Ira
1974 "An Interview with Fred Wiseman," *Filmmakers Newsletter,*
7(4), February, pp. 19–25.
About production techniques and the social interactions
and negotiations that occur between Wiseman and his sub-
jects (including consent and intervention). Various technical
and ethical dimensions of research, production, and distribu-
tion are covered.

Nicholson, Philip, and Elizabeth Nicholson
1975 "Meet Lawyer-Filmmaker Frederick Wiseman," *American
Bar Association Journal,* 61, pp. 328–32.
Interview with Wiseman on choosing subjects, balancing
conflicting interests (between fairness and drama), the al-
leged ambiguity of Wiseman's films, and the possible uses of
his films for lawyers.

Slifkin, Irv
1980 "Controversial Film About Northeast High Finally Screened,"
The Jewish Times of the Greater Northeast (Philadelphia),
March 20.
A report on the first screening of Wiseman's "High
School" (at Temple University's Conference on Visual An-
thropology, 1980) and the debate that followed.

Westin, Alan
1974 " 'You Start Off with a Bromide': Conversation with Film-
maker Frederick Wiseman," *American Civil Liberties Re-
view,* Winter/Spring, pp. 52–67.
Interview about the relation between Wiseman's work
and the "problems of personal liberty in urban life." Com-
ments on filming private life, able consent, the public's right
to know (and Wiseman's right to film) versus the subject's
right to privacy, and on the controversy following the release

of "Titicut Follies," filmed at the Massachusetts Institute of Correction, Bridgewater.

Wiseman, Frederick
1973 "Wiseman on Juvenile Court," *Journal of the University Film Association,* 25(3), 1973, pp. 48–49, 58.
 Interview with Wiseman about some of the production techniques and social negotiations involved in the making of his film "Juvenile Court."

LEGAL

Barnes v. Ingalls (SupCtAL)
1863 Alabama Reports, 39, pp. 193–202.
 Court report of action on promissory note and various common counts. An interesting historical example where expert testimony is invoked to judge the merits of a photograph as technically well-executed and competent, while a non-expert witness is called upon to judge the photograph's success as a likeness (to support the defendant's claim to have fulfilled his contract with the plaintiff as a photographer-painter).

Carmody, Dierdre
1977 "Court Extends Rights of the Press to Film," *New York Times,* Oct. 2.
 Federal Panel rules documentary maker is entitled to protect unidentified sources under the Constitution.

Cavallo, Robert M., and Stuart Kahan
1979 *Photography: What's the Law?* (Second Edition). New York: Crown Publishers.
 Comprehensive treatment on many aspects of law relevant to amateur and professional photographers. Includes comments on what can and cannot be photographed, who owns the picture, how photographs may be used (especially regarding press privilege and the publicity/celebrity area), release forms, copyright, obscenity, publishing, misrepresentation, and liability for truth in advertising (etc.). Citing a variety of cases, the authors concentrate primarily on New York as the precedent-setting state. Remarks are intended as

basic legal information for practitioners; there is little ethical discussion or explanation of the development of laws related to photography. Cavallo is a New York lawyer specializing in photography, and general counsel to the American Society of Magazine Photographers. At the time of the book's publication, Kahan was ASMP Executive Director. (For a brief summary of photography and the law, see Cavallo "Photography: Law in Focus," *Trial,* 14(5), May, 1978, pp. 23–25.)

Colker, Ruth
1986 "Published Consentless Sexual Portrayals: A Proposed Framework for Analysis," *Buffalo Law Review,* 35(1), Winter, pp. 39–84.

Colker identifies five groups of people who have typically brought actions against the nonconsensual publication of sexual portrayals, including (1) well-known nonpolitical individuals, often models or actresses, (2) private individuals whose sexual behavior or victimization is published as news, (3) public or private persons whose sexual conduct is fictionally portrayed, (4) those about to enter the political arena who face sexual invectives about their gender, and (5) private individuals who appear in sexually suggestive advertisements. Typically, says Colker, only the fifth group has been protected in cases of explicitly commercial exploitation. She argues to extend protection to the other four groups. Detailed case references and bibliography (particularly of feminist and anti-pornography debates and civil ordinances proposed to allow plaintiffs to sue distributors of consentless portrayals).

Franklin, Marc A.
1977 *Cases and Materials on Mass Media Law.* Mineola, N.Y.: The Foundation Press.

Major aspects of media law (First Amendment and subsequent interpretations of freedom of expression, business aspects, constraints of information gathering from public and private sources, regulation of media content, broadcasting and broadcast licensing) and a description and analysis (with case illustrations) of "the tensions between the First Amendment and legal regulations." In particular, see pp. 749–74

on the Fairness Doctrine. (Includes material on some cases involving privacy and photography, e.g. *Gallela v. Onassis.*)

Merryman, John Henry, and Albert E. Elsen
1987 *Law, Ethics, and the Visual Arts* (Second Edition, Vols. 1 and 2). Philadelphia: University of Pennsylvania Press.
On a wide range of intersections among law, ethics and the elite visual arts (painting, sculpture, and architecture, modern and ancient). Writing as attorneys, legal scholars, and arts activists, Merryman and Elsen include chapters on plunder, destruction, and reparations; ownership and the illicit international art trade; artists' rights in works of art; artistic freedom; the institutional operation of art worlds and the daily practice of artists; collectors; and museums. The two volumes are made up of extended excerpts from historical and sociological accounts, philosophical treatises, statutes, legal case reports and judicial opinions, connected by Merryman and Elsen's analyses and commentary. In particular, see Ch. 4, "Artistic Freedom and Its Limitation," which draws from historical examples (among them Nazi art, art in the Soviet Union, American art in the McCarthy era) and considers artistic speech and the First Amendment, controversial public art, and government patronage and the limits of artistic freedom in public art. Detailed bibliography, table of cases and index.

Pear, Robert
1980 "ABC News to Give Up Some Tape," *New York Times,* March 5, Section A, p. 18.
Press report on White House Chief of Staff Hamilton Jordan's alleged use of cocaine. The tapes of a discothèque cocaine sale were subpoenaed as evidence of the credibility of three witnesses for the plaintiff, not as evidence of the crime (which violated the Ethics in Government Act of 1978). Raises the issue of whether or not news agencies should be protected by First Amendment from having to release videotape under subpoena. (In this case, all three people who appeared in the tapes with Jordan and who were to appear as witnesses waived confidentiality rights, leaving ABC little support for its First Amendment claims.)

LEGAL—Biomedical Research

Morse, Howard Newcomb
1966 "Legal Implications of Photographing Surgical Operations,"
 Journal of the American Medical Association, 198(13), pp.
 221–22.
 A brief article citing cases involving filming and pho-
 tography for medical purposes and the privacy infringements
 committed by medical professionals who fail to obtain writ-
 ten releases from the patients photographed or filmed. Dis-
 tinguishes between medical photography for educational or
 informative purposes and for trade purposes (such as before-
 and-after surgery shots). Concludes with a mention that even
 the consensual use of film and photography must not identify
 the patient. The article is dated in its account of the status
 of privacy law in the U.S., but the issues raised concerning
 medical photography remain relevant.

Office of the General Counsel, American Medical Association
1976 *Medicolegal Forms with Legal Analysis.* Chicago: American
 Medical Association.
 A booklet of medicolegal forms for use by doctors, hos-
 pitals, and their attorneys. See particularly section 5 on the
 patient's right to privacy, which includes release forms for
 medical photography, and for filming and televising surgical
 operations.

Stevens, George E.
1978 "Medical Photography, the Right to Privacy and Privilege,"
 Medical Trial and Techniques Quarterly, 24, pp. 456–64.
 Discusses patient's privacy rights in terms of consent,
 conduct and publication. (Conduct and publication are sep-
 arated because the protested or nonconsensual photograph-
 ing of a patient is actionable, in some cases, even if the pho-
 tographs are never printed or published.) Considers medical
 photography and right of publicity (i.e. regarding the com-
 mercial use of medical photographs) and notes that publica-
 tion may be technically "commercial" even where the con-
 text is not (e.g. medical journals). Concludes with the need
 for the patient's consent while noting that not all forms of
 consent remain valid through time. Useful case references.

LEGAL—Cameras in the Courtroom

Carter, Charlotte A.
 1981 *Media in the Courts*. Washington: National Center for State Courts.

 An overview of the camera in the courtroom controversy, including summaries of state guidelines allowing media coverage on a permanent and experimental basis. Includes sections on the adoption of Canon 35 (prohibiting photographic courtroom coverage), early camera coverage, prejudicial publicity, arguments for and against courtroom photography and the right to a public trial.

Kielbowicz, Richard B.
 1979 "The Story Behind the Adoption of the Ban on Courtroom Cameras," *Judicature,* 63(1), June/July, pp. 14–23.

 A description of the Bruno Hauptmann kidnapping and murder trial (the "Lindbergh baby" trial, September 1934) in which Judge Thomas Trenchard restricted the use of still and motion picture cameras in the courtroom. The rules were obeyed, except for one major transgression by a newsreel crew who soundproofed a camera and filmed in the courtroom during the delivery of the verdict. When the footage was released Judge Trenchard ended all photographic courtroom coverage, and shortly thereafter the American Bar Association adopted Canon 35, recommending a ban on courtroom photography. Canon 35 was ultimately adopted by all but three states, and remained intact in its original form through the establishment of the new ABA code of Judicial Ethics (1972), Section 3A(7). The author's contention is that in fact Canon 35 was an exaggerated response to an exceptional situation, and reflected the activities of photographers outside—not inside—the Hauptmann trial.

Marcus, Paul
 1982 "The Media in the Courtroom: Attending, Reporting, Televising Criminal Cases," *Indiana Law Journal,* 57, pp. 235–87.

 Thorough treatment of the conflict between the First Amendment and the right to a fair trial by due process with respect to media attending, reporting, and televising criminal cases.

Margolick, David
 1982 "Bar Association Still Struggling Over Policy Banning Cameras in the Courtroom," *New York Times,* Jan. 27.
 Legislation on cameras in the courtroom continues to take its cue from the American Bar Association, which feels photography is incompatible with fair trial in part because of its effect on the courtroom behavior of trial participants.

Power, Richard W.
 1982 "Television in the Courtroom: Von Bulow and the Jazz Singer," *Saint Louis University Law Journal,* 25, pp. 813–20.
 A general discussion of arguments against and in favor of television cameras in the courtroom, using the televised murder trial of Claus Von Bulow as a high-profile example. Power argues for a sustained ban on television in the courtroom, not as an infringement of the right to fair trial, but as a matter of judicial accuracy, the preservation of courtroom decorum, and the moral and dignified treatment of trial participants.

LEGAL—Censorship

Copp, David, and Susan Wendell
 1983 *Pornography and Censorship.* Buffalo, N.Y.: Prometheus Books.
 A useful collection of essays on the philosophy of pornography and censorship and on social scientific research on pornography's effects. Includes selected case studies from the U.S. and Canada and a selected bibliography of social scientific essays and legal analysis.

de Grazia, Edward
 1969 *Censorship Landmarks.* New York: R. R. Bowker.
 A comprehensive collection of landmark decisions ruled in censorship/obscenity cases (involving many media) from 1600 to 1968, in England and the U.S. Full text of judgment provided in each case (with a few earlier ones in Latin, untranslated). Cases are tabled chronologically and alphabetically. Includes a brief legal, philosophical, and historical discussion of American media censorship in the author's introduction. (De Grazia is a lawyer who has defended many publications and films against obscenity charges in the U.S.)

Hunnings, Neville March

1967 *Film Censors and the Law*. London: George Allen and Unwin.

A comparative study of the practice and history of censorship law in several countries (selected to illustrate variations in legal treatments of freedom of expression and censorship). Includes sections on England, the U.S., Canada, India, Australia, Denmark, France, Soviet Russia, and a separate section on the nature of film censorship (pp. 383–96). (Some of the material is dated though the work remains valuable for its historical perspective.)

1985 "Video Censorship," *Public Law*, pp. 214–22.

A severely critical analysis of the British Video Recordings Act of 1984 which compares its authors' ostensible mandate—protecting children from the unrestricted distribution of sado-masochistic videotapes—with the Act itself, a general prior censorship measure.

LEGAL—Copyright

Bender, Ivan R.

n.d. "The Legal Copy," *TLC Guide*, 3(3), pp. 5, 8. (Television Licensing Centre of Films Incorporated)

A brief summary of the suit against the Board of Cooperative Educational Services (BOCES), by Encyclopaedia Britannica Educational Corporation, The Learning Corporation of America, and Time-Life Films Incorporated for copyright infringement in the unlicensed, off-air taping and presentation of films produced by the plaintiff organizations. The principle defense of fair use was rejected by the U.S. District Court for the Western District of New York in June 1982.

Faaland, Susan Linehand

1981 "Parody and Fair Use: The Critical Question," *Washington Law Review*, 57, pp. 163–92.

Argues that the value of parody lies in its critical effect, which qualifies it for fair use. The parodist may borrow from the work parodied to the extent necessary to achieve that critical effect and such borrowing should be considered fair use under copyright law. As well, the author proposes a "test of critical affect" for protecting "valid parody." Rele-

vant to visual, verbal, and musical parody. Includes useful case references and descriptions of copyright law and fair-use doctrine.

Forkosch, Morris D.
1974 "Obscenity, Copyright and the Arts," *New England Law Review*, 10(1), Fall, pp. 1–24.
 Proposes that visual and other art copyright is seriously threatened by Chief Justice Burger's guidelines for obscenity and pornography, which may prohibit the copyright of works which "as a whole appeal to the prurient interest when contemporary community standards are applied; and that depict or describe, in a patently offensive way, sexual conduct which the law specifically defines and condemns; and, taken as a whole, that lack serious literary, artistic, political or scientific value."

Kunzle, David
1980 "Hogarth Piracies and the Origin of Visual Copyright," in John Lawrence and Bernard Timberg (eds.), *Fair Use and Free Inquiry*. Norwood, N.J.: Ablex Publishing Corporation, pp. 19–28.
 On the Engraver's Act of 1735, which was based on a petition submitted to the English Parliamentary House by the engraver Hogarth to protect his engravings and his income against piracy. The author describes this period as the first phase of the concept of art objects as publicly purchasable commodities and of the artistic ideal as legal property.

Ladd, David
1982 "Home Recording and Reproduction of Protected Works— Copyright Policy and Home Taping: The Issues Before Court and Congress," *American Bar Association Journal*, 68, January, pp. 42–45.
 Discussed in terms of the need for commercial copyright law to continue to adapt to technological innovation.

Lawrence, John Shelton, and Bernard Timberg
1980 *Fair Use and Free Inquiry: Copyright Law and the New Media*. Norwood, N.J.: Ablex Publishing Corporation.
 An anthology of legal/historical essays on fair use in "new" media (film, TV, radio, comics, recorded music) in

teaching and academic publishing. Comprehensive treatment of the impact of copyright law on scholars, publishers, creators, producers and educational institutions. Includes section on international copyright law/fair-use policy and an interesting historical essay on the 18th-century origins of visual copyright (see Kunzle, above). Also includes fair-use bibliography and a selected list of fair-use cases.

Mayer, Michael F.
 1980 *Selected Issues in Media Law: An Approach to Copyright, Option Agreements and Distribution Contracts for Independent Producers.* New York: Young Filmmakers Video Arts.
 Brief and casual question/answer format: Section on copyright most useful to this bibliography. (Cursory treatment of copyright, registration of works, infringement, fair use, libel, privacy, defamation.)

LEGAL—Copyright—Cases

UNIVERSAL CITY STUDIOS *v.* SONY CORP.

Barkan, Judith
 n.d. *"Universal v. Sony:* Is Home Use in Fact Fair Use?" *Comm/ Ent (Communications Entertainment) Law Journal,* 3(1), pp. 53–81.
 Comment on the Betamax case including overview of rights granted by law to copyright owners, exemptions to copyright monopoly created by doctrine of fair use, description of the infringement implications of the *Universal v. Sony* case. Points out the need to amend the copyright act in light of *Universal v. Sony.* (Article written prior to the case's appeal and reversal.)

Universal City Studios v. Sony (CA 9) (659 F.2d 963)
 1981 *Media Law Reporter,* 7, pp. 2065–76.
 Full text of U.S. Court of Appeals 9th Circuit opinion that reversed the original fair-use decision. (Note: in 1984 the Federal Supreme Court overturned this reversal, judging home recording to be fair use.)

Universal City Studios v. Sony Corp. (DC CCal 480 F.Supp. 429)
 1979 *Media Law Reporter,* 5, pp. 1737–68.
 Full text of 1979 opinion in *Universal v. Sony* respon-

sible for landmark decision that private, noncommercial home recording of copyrighted TV programs constituted "fair use." Discusses parties, products, advertising, evidence of home use copying, recording by retail defendants, harm to plaintiff, ratings, liability of corporate defendants, and injunctive relief. (Argued in U.S. District Court, Central District of California and reversed by the U.S. Court of Appeals, 9th Circuit.)

LEGAL—Filmed and Videotaped Testimony

Begam, Robert G., and Richard J. Begam
1978 "A Day in the Life of a Quadriplegic," *Trial,* 4(5), pp. 25–27.

An outline for the production of filmed damage suit testimonies for quadriplegic plaintiffs. Includes suggestions for structuring films visually, for content (e.g. waking up, eating, transportation, physio- and occupational therapy etc.). In their description of the relation between structure and content, the writers (one a lawyer and the other a video producer) stress "communication in a form the jury will readily understand from their years of television-watching and movie-going."

Clark-Weintraub, Deborah
1985 "The Use of Videotaped Testimony of Victims Involving Child Sexual Abuse: A Constitutional Dilemma," *Hofstra University Law Review,* 14, Fall, pp. 261–96.

Reviews state statutes allowing videotaped testimony from child sexual abuse victims, intended to protect children from the potential psychological harm of testifying in open court. Analyzes tension between such videotaped testimony as an exception to the hearsay rule, and the confrontation clause of the Sixth Amendment (which allows a defendant to confront his accusor in person). Throughout the article, Clark-Weintraub makes procedural recommendations in light of her analysis.

"First Taped Trial Set in Slaying Case"
1982 *New York Times,* March 22, Section A, p. 11.

Ohio court allows videotaped testimony in murder case, with objections, arguments about evidence and conferences

at judge's bench edited out. It is felt that taped testimony in civil cases will expedite such cases to and in court.

Goldstin, Elliott
1985 "Using Videotape to Present Evidence in Criminal Proceedings," *The Criminal Law Quarterly*, June, pp. 369–84.

An overview of videotape as demonstrative and testimonial evidence in Canada and the U.S. Includes bibliography.

Hobbs, James R.
1981 "Plaintiff's Use of 'Day in the Life' Films: A New Look at the Celluloid Witness," *University of Missouri Kansas City Law Review*, 49(2), pp. 179–90.

A discussion of the inadmissibility of day-in-the-life films as testimony in Missouri courts. Though the debate specifically concerns Missouri, some of the objections to the use of these films are generally relevant (particularly the claim that because movies are not subject to cross examination, they are self-serving). The author concludes that if a foundation for the use of day-in-the-life films (or tapes) is established (e.g. the cross examination of an independent witness such as the photographer) they are effective illustrations "of a particular plaintiff's injuries and associated rehabilitations" (p. 189) and should be admissible in court.

Kaminsky, Edmund P., and Gerald R. Miller
1984 "How Jurors Respond to Videotaped Witnesses," *Journal of Communication*, 34(1), Winter, pp. 88–102.

Reports on an experimental study of the effects of shot composition (long shot, medium shot, close-up) and witness's presentational style on jurors' perceptions of the witness's composure, credibility, authoritativeness, and character; on jurors' retention of trial-related information; and on jurors' interest in trial proceedings. Few significant differences could be attributed to shot composition, though a slight difference occurred in the interaction between composition and witness's presentational style (coded "strong" or "weak"). Discusses the practical advantages of taped witnesses and the concerns judges and lawyers have expressed about their admissibility. Reviews earlier research on production techniques and jurors' responses.

Merritt, James A., Jr.
 1982 "Day in the Life Films: The Celluloid Witness Comes to the Aid of the Plaintiff," *South Carolina Law Review*, 33, pp. 577–92.

 An examination of admissibility requirements, objections to admissibility, and procedural implications of day-in-the-life films as testimony for severely injured plaintiffs. Recommends these films be shown at the end of plaintiff's case, when the film's content will linger in the minds of jurors and undercut the defense's evidence. Also recommends the films be shown only once.

Misko, Fred Jr.
 1985 "Videotape for Litigation," *South Texas Law Review*, Fall, 485–512.

 On videotaped depositions, among other uses. Includes appendices of forms and instructions to attorneys for preparing videotape "brochures" on behalf of plaintiffs in litigation. Such brochures are "packaged evidence," in the author's words "mini trials . . . that provide insurance carriers with concrete and vivid means of evaluating the probable character and quality of the evidence the plaintiff will be able to produce at trial if the case is not settled" (p. 503).

"Practical Trial Suggestions: Moving Pictures—A Symposium,"
 1958 *Defense Law Journal*, 4, pp. 131–56.

 Concerning the use of films by defense counsel to reveal the physical ability of malingering personal injury plaintiffs. On preparing a jury for filmed evidence, on using film only when the claim is grossly exaggerated, on having films made by expert photographers and preferably away from the plaintiff's home (to avoid privacy invasion accusations), on not portraying the subject in intimate or compromising relationships, on using accomplices to entrap the plaintiff demonstrating physical ability, on ensuring that films clearly identify subjects, and on presentation in court. Describes examples of successful cases using filmed defense witnesses.

Videotape Evidence Sub-Committee—American Bar Association of Litigation Trial Evidence Committee (Gregory P. Joseph, Chair)
 1985 "Videotaped Evidence in the Courts," *South Texas Law Review*, 26 (Fall), pp. 453–83.

A comprehensive case survey and analysis of the eviden-
tiary uses of videotape and the legal issues they engender.
Sections on the use of videotape as demonstrative evidence
in civil action cases, including recreating physical circum-
stances, demonstration and instruction (e.g. in the use of
a machine), tests and experiments that illustrate testimony,
accident reconstruction or re-creation, day-in-the-life presen-
tations, deposition testimony, surveillance. Also on criminal
action uses, including confessions, surveillance, re-enactments
and views of a crime, and evidence of intoxication in drunk
driving allegations. Finally, on depositions. The authors gen-
erally favor videotape in court, though describe and caution
against prejudicial uses.

Weiss, Michael
 1982 "Trial by Tape," *American Film,* 7(8), June, pp. 61–64.
 On the use of taped testimony in the courtroom, including
 the conventions and style of testimony tape, legal video-
 making companies, the novelty of courtroom video, advan-
 tages of taping whole trials. From the judge's point of view
 taped testimony "takes less time, makes trials less confusing
 by editing out the diversionary objections and frees the courts
 since there's no waiting to gather every witness into a court-
 house at once."

LEGAL—Libel
(See also: FILM, TELEVISION, VIDEOTAPE—Docudrama)

Anderson, David A.
 1978 "Libel Law Today," *Trial,* 14(5), May, pp. 19–21.
 A brief treatment of libel law since *New York Times v.
 Sullivan* (see Brosnahan, below under Libel—Cases: *Gertz
 v. Welch*) particularly in relation to the shift from the War-
 ren Court to the Burger Court (which ceased to shield pub-
 lishers from libel attack), to the public figure doctrine, and
 to conspiracy of silence (where journalists refuse to testify
 against other journalists or publishers).

Carmody, Dierdre
 1977 "Libel Questions Against CBS Raise Questions About the
 Release of Data," *New York Times,* Nov. 15.

First Amendment protects editorial decisions as well as outside sources. Some description of historical precedents for this decision (made in the U.S. Court of Appeals for the 2nd Circuit).

Pilpel, Harriet F., and Jerry Simon Chasen
1980 "The Trouble with Faction," *Publisher's Weekly*, July 18, pp. 20–21.

Two specialty lawyers look at the legal problems involved in the blending of fact and fiction (including libel and privacy invasion). The four most frequent libel categories are (1) the commission of a crime, (2) having a "loathsome" disease, (3) in the case of a woman, that she is unchaste and, most importantly, (4) that a person is incompetent in his or her trade or profession. As the authors describe, privacy claims are more difficult to define, with the possible exception of right of publicity, in which a plaintiff feels he or she has been financially deprived through the nonconsensual use of his or her name, image, personality, or life story.

LEGAL—Libel—Cases

BODDIE *v.* ABC (CA 6, 1984) (731 F.2d 333)

"Jury Finds in Favor of ABC in Suit Over '20–20' Program"
1982 *New York Times,* May 11.

Press report on *Boddie v. ABC,* in which Sandra Boddie claimed deception and privacy invasion by an ABC crew using a hidden camera to interview her concerning her "illicit" sexual relations with a judge. Her claims of libel and slander were based upon ABC's portrayal of her as a prostitute.

"Jury Receives Libel Suit Against TV Network"
1982 *New York Times,* May 9, Section 1, p. 21.
Brief report on *Boddie v. ABC.*

1984 *Media Law Reporter,* 10, pp. 1923–28.
Full text of opinion.

GERTZ *v.* WELCH (USSupCt 418 U.S. 323)

Brosnahan, James J.
 1975 "From *Times v. Sullivan* to *Gertz v. Welsh:* Ten Years of
 Balancing Libel Law and the First Amendment," *The Has-
 tings Law Journal,* 26, January, pp. 777–96.
 In *Times v. Sullivan* (1964) the U.S. Supreme Court
 upheld the *New York Times*'s right to publish against claims
 of defamation by L. B. Sullivan, the elected Commissioner
 of Public Affairs of Montgomery, Alabama. Though it was
 conceded that reports of alleged police activities against black
 demonstrators in Montgomery may have been libelous toward
 Sullivan (responsible for supervising the police department),
 the U.S. Supreme Court reversed the decision made in Sulli-
 van's favor by the Alabama Appeals Court and affirmed by
 the state Supreme Court. The reversal was made on the basis
 of absence of malice: the plaintiff, a public official, had to
 establish that the defamatory statement had been made with
 "knowledge of its falsity or reckless disregard of the truth."
 If malice could not be established, the *Times* was protected
 under the First Amendment. Ten years later, in *Gertz v.
 Welsh,* a libel judgment was awarded to the plaintiff on the
 basis that he was not a public figure or official. The defendant
 publisher was not protected by absence of malice under the
 First Amendment. The article describes three major develop-
 ments in Gertz that represent substantial departures from
 the *New York Times:* "(1) Adoption of a constitutional bal-
 ancing test which weighs the First Amendment interest in
 the institutional autonomy of the media against the state's
 interest in compensating an individual for wrongful injury
 to his reputation, (2) reformulation of the "public figure"
 concept, and (3) significant alteration of the common-law
 rules governing damage in libel actions" (p. 778). Though
 neither of the cases dealt with concerned visual images, the
 article is included in this bibliography for its lucid discussion
 of two landmark decisions in U.S. libel law, particularly with
 respect to the treatment of public versus private figures, that
 would be brought to bear in rulings involving defamatory or
 libelous images.

 1974 *Media Law Reporter,* 1, pp. 1633–65.
 Full text of opinion.

Naughton, James P.
 1980 "Gertz and the Public Figure Doctrine Revisited," *Tulane Law Review,* 54, pp. 1053–93.
 An examination of *Gertz v. Welsh,* the public figure doctrine and criticisms levied against the latter (including its vagueness, its attempt to induce media self-censorship and its basis in "questionable assumptions about the public figure's access to the media and waiver of privacy rights" [p. 1075]).

"MISSING":

"Diplomat, Aides Sue Makers of 'Missing' "
 1983 *Toronto Star,* January 12, Section E, p. 6.
 Former Ambassador to Chile Nathaniel Davis, former military attaché Ray Davis, and consul Fredrick Purdy filed a $150 million libel suit against the producer of the film "Missing," about an American journalist's disappearance and death in the Chilean coup of 1973, which allegedly occurred with the co-operation of U.S. government representatives. The plaintiffs have also sued the publisher of the book upon which the film was based.

PRING *v.* PENTHOUSE (DCWyo), (CA 10)

Blair, William E.
 1982 *"Penthouse* Ruling Lauded by Lawyer," *New York Times,* November 7.
 Report on an Appeals Court ruling in defendant's favor in *Pring v. Penthouse.* Kim Pring, Miss Wyoming, sued *Penthouse* for an allegedly libelous satiric piece that featured the sexual exploits of an unidentified Miss Wyoming pageant contestant. The ruling overturned a $12.5 million award to the plaintiff by a Cheyenne Federal Court jury. First Amendment lawyer for the defendant, Dan Paul of Miami, lauded the ruling, adding that "if this case had stood, the impact on parody and satire would have been devastating."

Hentoff, Nat
 1981 "Miss Wyoming Miraculously Defamed and Other Grief," *Village Voice,* May 20–26, p. 8.
 Very critical article on libel and defamation suits by a First Amendment absolutist.

1982 *Media Law Reporter*, 8, pp. 2409–14.
 Full text of opinion from Court of Appeals for the 10th
 Circuit of California.

1982 *Media Law Reporter*, 7, pp. 1101–4.
 Full text of opinion from the District Court of Wyoming.

SILBERMAN *v*. GEORGES (NYSupCtAppDiv 456 NYS2d 395)

Glueck, Grace
 1980 "When Art Imitates Life Controversy Arises in Art and Le-
 gal Circles," *New York Times*, Dec. 23, p. C5.
 Press report on *Silberman v. Georges* (see below). While
 most libel cases involve verbal rather than visual portrayals,
 Glueck points out that the central issues, such as intent,
 damage to plaintiff's reputation or privacy, and artistic li-
 cense remain the same.

 1982 *Media Law Reporter*, 8, pp. 2647–48.
 Full text of Appellate Court opinion reversing earlier
 decision that granted awards to the plaintiff. Silberman, a
 painter, sued Georges, also a painter, for his alleged depic-
 tion of Silberman in his painting "The Mugging of the Muse,"
 suggesting an attack on art which Silberman claimed was
 libelous. Appellate Court dismissed Silberman's action. (This
 is the only case located where a libel action has been based
 on visual representation. For an analysis of the case, see
 Merryman and Elsen (1987), above.)

STREET *v*. NBC (*The Scottsboro Boys*) 645 F.2d 1227 (6th C), cert.
dismissed, 102 S.Ct. 667 (1981)

Ester, Elizabeth K.
 1982 "*Street v. NBC:* Libel and Invasion of Privacy," *Northwestern
 University Law Review*, 77, pp. 84–111.
 Following its broadcast of a docudrama on the Scotts-
 boro Trials, NBC was sued by Victoria Price Street for libel
 and invasion of privacy in its presentation of her as a "per-
 jurer and a whore." Street had been the main witness and
 prosecutrix in the Scottsboro Trials of the mid-30s, after
 which she "retreated into obscurity" for 40 years until the
 broadcast of the NBC show. The article discusses what its
 author considers the misapplication of the public figure doc-

trine (see Brosnahan, in *Gertz v. Welch,* above) that decided the case in NBC's favor. (Note: Street and NBC settled out-of-court after the Supreme Court granted certiorari in 1981.)

LEGAL—Prior Restraint

Friendly, Jonathan
 1983 "Free Press, Fair Trial Balancing Act," *New York Times,* January 17.

 A discussion of a Federal judge's "failure" to block a national television broadcast about an upcoming trial in Dallas of a murder case initiated in New Orleans. The primary issue raised is the conflict between freedom of journalistic expression versus the defendant's right to a fair trial "unaffected by prejudicial news coverage." The article notes that no appellate court has upheld a prior restraint order since the Supreme Court overturned a Nebraska State ruling that attempted to block the publication of pretrial material in 1976. Consistent with that observation, the Appeals Court decision in this case in fact reversed a restraining order from the Federal District Court in New Orleans. Though the case did not break any new legal ground, it raised the question of whether or not the restraining order, and the network's appeal, generated more pretrial publicity than might have occurred if the segment had been initially broadcast.

Margolick, David
 1983 "CBS Appeals Order Blocking a Segment for '60 Minutes'," *New York Times,* Jan. 16, Section 1, p. 18.

 A report on the initial New Orleans Federal District Court prior restraint order to block the broadcast of a '60 Minutes' segment on a New Orleans murder case. (The ruling was subsequently overturned in Appeals Court.)

"Judge Curbing Television in Court Drawings"
 1982 *New York Times,* December 24.

 Report on an Arizona judge's order requiring judicial clearance of jury sketches by television artists prior to showing them on television. The order, upheld on appeal, was intended to protect jury members who feared for their safety given their involvement in an alleged gangland murder. In a six-page opinion, the Appeals Court judge stated that the or-

der in no way interfered with the reporting of facts on the public record and therefore was not an infringement of the journalists' First Amendment rights.

LEGAL—Privacy/Publicity

Bala, Ganesh
 1981 "The Right of Publicity vs. The First Amendment: Reconciling the Conflict Between a Proprietary Interest of the Plaintiff and the Constitutional Guarantee of Free Speech," *Villanova Law Review,* 27, pp. 1205–43.

 A review of the history of the right of publicity including its roots in privacy law and its initial state and Federal Supreme Court recognition. The review is followed by a discussion of the First Amendment as a defense in right of publicity cases with respect to news, entertainment, and commercial sale. Finally, a case-by-case analysis is proposed for deciding right of publicity actions, taking into account the "degree of similarity between the defendant's representation and the plaintiff's right of publicity, the primary purpose behind the representation, and the nature and extent of harm done to the plaintiff's interest" (p. 1243).

Ben, Lawrence S.
 1978 "Constitutional Law—Newsgathering: Reporters Have No Right to Use Hidden Recording Devices," *University of Florida Law Review,* 30, pp. 652–68.

 Re Florida statutes, with reference to photography on p. 660.

Berkman, Howard I.
 1976 "The Right of Publicity—Protection for Public Figures and Celebrities," *Brooklyn Law Review,* 42, pp. 527–57.

 A discussion of the right to publicity (the right to exclusive profit from one's name or likeness) and the constitutional limitations upon it. The author concludes that publicity should be viewed as a common law property right, protecting a pecuniary interest rather than a personal one.

Bloustein, Edward J.
 1964 "Privacy as an Aspect of Human Dignity. An Answer to Dean Prosser," *New York University Law Review,* 39, December, pp. 962–1007.

A reintegration of Prosser's four privacy torts (see below) under the single social value of human dignity. According to Bloustein, such an integration would substitute an entirely different set of values (similar to those involved in battery, assault and false imprisonment cases, rather than in mental distress and misappropriation cases) for Prosser's emotional tranquility, reputation, or the monetary value of a name or likeness (p. 1005).

1974 "The First Amendment and Privacy: The Supreme Court Justice and the Philosopher," *Rutgers Law Review,* 28, 41–95.

Distinguishes between the public's governing interest, the public's curiosity, and the publisher's private right in addressing the issues and cases that involve the First Amendment versus the right to privacy. Given this distinction, the question becomes "what constitutional interest is served by the actual identification of name or likeness in a particular instance of its mass publication?" (p. 95).

Boone, Keith C.
1983 "Privacy and Community," *Social Theory and Practice,* 9(1), Spring, pp. 1–30.

An article on the tension between privacy and community that considers legal, social, and cultural theoretical approaches to the study of privacy, which attempts to overcome the prevailing conceptual opposition of privacy and community, and which situates 20th-century American culture's "loss of community" not in the emergence of a "protected private sphere" but rather in industrial, urban, and institutional development. (For two earlier comprehensive articles on the concept of privacy in the social sciences see Barry Schwartz (1968) "The Social Psychology of Privacy" (*American Journal of Sociology,* 73(6), 741–752) and Arnold Simmel (1968) "Privacy" (*International Encyclopedia of the Social Sciences,* David Sills (ed.), V.12, 48–87). Simmel includes an extensive bibliography.)

"Britain Is Shaken by TV Film of Woman Urging Suicide on Her Mother"
1977 *New York Times,* Aug. 27.

Videotapes of affair taken in nursing home bedroom with

a hidden camera were used in court as evidence and were subsequently broadcast. Ethical issues raised include whether Mrs. McShane, the defendant, was in effect tried twice for the same crime, once in court and once on TV.

"Civil Rights Law—Invasion of Privacy—Use of Photograph"
1971	*Albany Law Review,* 35, pp. 790–98.
	A discussion of *Murray v. New York Magazine Co.,* a case in which the defendant published a photograph of the plaintiff (taken by a third party freelance photographer not named in the action) without his consent. The photograph depicted a parade participant dressed in traditional Irish garb and was used to illustrate an article on "The Last of the Irish Immigrants." The case is included here because of its remarkable similarity to *Arrington v. New York Times et al.* (see below under "Cases"), with the important distinction that in that suit action was brought against the freelance photographer as well as the publisher. Like the New York Times in *Arrington,* New York Magazine Company was protected under the First Amendment by the "newsworthiness" of the photograph and the establishment of non-commercial motives for its publication. *Arrington* (1982) came close to setting a precedent where the photographer, whose involvement with the picture is for purposes of trade (i.e. sale to the publisher) is liable under Sections 50 and 51 of New York Civil Rights law (rights of privacy and publicity).

Clemons, S. L.
1930	"The Right to Privacy in Relation to the Publication of Photographs," *Marquette Law Review,* 14(4), June, pp. 193–98.
	An early review of American court cases in which the right to privacy was invoked against the nonconsensual commercial publication of photographs.

"Constitutional Law: Right of Privacy in Photographs and Fingerprints," *New York Law Forum,* 17, pp. 1126–32.
1972	
	A comment on *Eddy v. Moore,* where the petitioner demanded the return of her fingerprints and photographs, taken in relation to a charge that had since been dismissed. (Decision not based upon common law right to privacy, in fact, but upon a Fourteenth Amendment violation.)

Emerson, Thomas
 1979 "The Right of Privacy and Freedom of the Press," *Harvard Civil Rights—Civil Liberties Law Review,* 14(2), pp. 329–60.

 The right to privacy and freedom of the press are generally not in conflict, except in the two major areas of the right to publish and the privacy tort (or the protection of privacy through civil suit for damages), and the privacy exception to the right to know (or to obtain personal information). Emerson dismisses the so-called "conflict" in these two areas given the disparity between the well-established freedom of the press and the less developed, less stable right to privacy. He proposes that progress toward balancing privacy and press freedom will best be achieved through a concentration on the privacy side of the equation in both areas. Though the article does not deal specifically with images, cases involving the publication of photographs are cited in the section on freedom of the press and the privacy tort (see p. 346). Generally, the issues are relevant to press images as well as prose. Includes case references and historical and theoretical overview of privacy.

Felcher, D. L., and E. L. Rubin
 1979 "Privacy, Publicity and the Portrayal of Real People by the Media," *Yale Law Journal,* 88(8), pp. 1577–1622.

 Proposes that "libel," "privacy," and "publicity" be replaced by principles of "media purpose" and "identifiable harm," for clearer, more predictable law directly incorporating the First Amendment and with a link to libel. In the development of their argument, the authors cite many contrasting privacy decisions made since 1890, providing a useful bibliography of cases.

 1980 "The Descendibility of the Right of Publicity: Is There Commercial Life After Death?" *Yale Law Journal,* 89, pp. 1125–32.

 On a descendant's right to profit from an individual's name or likeness. The topic stems in part from recent rulings concerning the estate of Elvis Presley, in which it was judged that although publicity was generally uninheritable, "the exclusive right to exploit the Presley name and likeness, because exercized during Presley's life, survives his death"

(p. 1126). In arguments by analogy, publicity is related to privacy, which is a personal freedom and therefore not inheritable. The same conclusion is reached in analogy to defamation, also a personal invasion. In an analogy to property, however, publicity is held to be inheritable because property is divisible. The authors conclude that the right of publicity essentially serves a social role recognized by copyright law, and therefore will deserve recognition when it can be brought into a form consistent with the First Amendment. (See also Viera, this volume).

Gerety, Tom
1977　"Redefining Privacy," *American Civil Rights—Civil Liberties Law Review*, 12(2), Spring, pp. 233–96.

Defines privacy as "autonomy or control over the intimacies of personal identity" based upon two premises: (1) we have some common commitment to the value of what is private in our lives; and (2) we have some common conception of what in our lives in fact is private.

Gurney, D. Scott
1986　"Celebrities and the First Amendment: Broader Protection Against the Unauthorized Publication of Photographs," *Indiana Law Journal*, 61, Fall, pp. 697–719.

Proposes extending protection without compromising constitutional rights, in light of two familiar interpretations of First Amendment theory. Includes a brief history of the rights of privacy and publicity.

Hyde, H. Montgomery (ed.)
1947　*Privacy and the Press: The* Daily Mirror *Press Photographer Libel Action*. London: Butterworth and Company (Publishers).

An account of an English libel case in 1946 where a press photographer had his camera smashed and was himself assaulted by a young police officer who resented having his picture taken without consent or invitation at his private wedding reception. Following the incident, comment upon the event was published in the *Justice of the Peace and Local Government Review*. The comment was sympathetic to the officer and described the photographer (whose damages were

awarded to him) as "cowardly," "ungentlemanly," and "vulgar" and his practices an "unmixed evil." The photographer subsequently sued the *Justice* for libel. The book provides a verbatim report of the trial along with an account of the incident at the wedding and the subsequent damages trial against the assaulting officer. Though the lengthier transcript reports the libel suit (in response to a verbal "slur"), the author (a lawyer) considers "the extent to which press representatives are justified in intruding themselves into the private lives and personal affairs of their fellow citizens."

Kulzick, Kenneth E., and Amy D. Hogue
1980 "Chilled Bird: Freedom of Expression in the Eighties," *Loyola of Los Angeles Law Review,* 14, pp. 57–58.
An analysis of the threats to freedom of expression in films, publishing, and broadcasting posed by publicity, privacy, defamation, and copyright law. These threats take both direct and indirect forms; they "impose liability on expression which should be protected and they raise the cost of defending meritless claims" (p. 78).

Lamoreux, Stephen
1961 *The Right of Privacy: A Bibliography: 71 Years: 1890–1961.* (Bound mimeo available through interlibrary loan from the Biddle Law Library, University of Pennsylvania.)
An annotated bibliography of legal and popular material whose primary sources are the *Index to Legal Periodicals* and the *Reader's Guide to Periodical Literature.* Following a general introduction, privacy literature is divided into sections on constitutional law, history, newspapers, television, movies, photographs, publishing, business invasion, celebrities, police records, personal letters, and wiretapping, among others. Very useful references for earlier writing on privacy. (In particular, see sections on movies, television, and photographs.)

Louch, A. R.
1982 "Is Privacy Immoral?" *Human Rights,* 10(7), pp. 22–25, 52–54.
On why the individual right to be let alone is under attack.

Lundsgaarde, Henry P.
 1971 "Privacy: An Anthropological Perspective on the Right to
 Be Let Alone," *Houston Law Review*, 8, 858–75.
 Discusses the tensions between law and social scientific
 research on the privacy question, specifically: (1) Social
 science emphasizes those aspects of human behavior that are
 general; law stresses those that are unique. (2) Explanation
 in social science is implicitly probabilistic, legal thinking
 tends to be dichotomous and normative. (3) Social science
 is concerned with the description and analysis of observable
 social facts and the prediction of change processes; law,
 especially in its capacity as a regulatory social institution,
 mostly reaches to the past for solutions and immediate prob-
 lems (pp. 865–67). Also provides a useful overview of the
 development and form of Alan Westin's theory of privacy
 and freedom. (See Westin, below.)

Markle, Jane E.
 1982 "Privacy Tort Law in New York: Some Existing Routes to
 Recovery," *Buffalo Law Review*, 31, pp. 255–71.
 Argues that the application of sections 50 and 51 of New
 York Civil Rights Law is neither as inconsistent nor as un-
 stable as critics suggest, and outlines routes to recovery for
 plaintiffs in New York privacy actions via penal statutes and
 the emotional distress doctrine.

Mayer, Michael F.
 1972 *Rights of Privacy*. New York: Law-Arts Publishers.
 A broad (if dated) treatment of privacy in relation to
 information gathering, abortion, the commercial exploita-
 tion of personality, pornography, and debt collection. Of
 particular interest is a section on captioned photographs,
 and defamatory picture/text combinations (pp. 120–25).

New York State Civil Rights law
 n.d. Article 5, Sections 50 and 51 (right of privacy, right of
 publicity).

Prosser, William L.
 1960 "Privacy," *California Law Review*, 48(3), August, pp. 383–
 423.
 One of four or five landmark essays in the development
 and discussion of American privacy law (see also Warren

and Brandeis, Bloustein (1964), Gerety (1977), Westin (1967)). Prosser formulated the four torts of privacy law: (1) Intrusion upon the plaintiff's seclusion or solitude, or into his private affairs; (2) Public disclosure of embarrassing private facts about the plaintiff; (3) Publicity which places the plaintiff in false light in the public eye; and (4) Appropriation, for the defendant's advantages, of the plaintiff's name or likeness. The article considers each tort in detail.

Reporters Committee for Freedom of the Press
1986 "Photographer's Guide to Privacy," *The News Media and the Law*, 10(2), Summer (supplement).

A concise reference guide for photographers, with examples (many illustrated) from photojournalism. Introduced with accounts of litigated photographs and a discussion of the right of privacy versus freedom of expression under the First Amendment. Describes each of the four torts of privacy law and their relevance to photographers, and discusses defenses against alleged privacy invasion. Also recommends how to avoid privacy suits and provides a state-by-state list of the applicability of each tort.

"Right to Privacy in 19th Century America"
1981 *Harvard Law Review*, 94, pp. 1892–1910.

Questions whether American law afforded privacy protection before Warren and Brandeis (1890—see below under "Privacy/Publicity—Warren and Brandeis"). Concludes that in the areas of private property, confidential communication and personal information, it most certainly did and that the Warren and Brandeis article and contribution must be reevaluated against the 19th-century background of common law, constitutional, and statutory protection.

Ruebhausen, Oscar M., and Orville G. Brim, Jr.
1965 "Privacy and Behavioral Research," *Columbia Law Review*, 65, pp. 1184–1211.

An early essay on balancing the right to privacy with the right to know in a scientific rather than journalistic context. Does not deal explicitly with images, though includes direct observation, self-description and description by informant, all methods used in ethnographic film, for example,

in its broad categories of behavioral research. Develops the concept of consent and confidentiality in an attempt to balance privacy and research. Proposes general guidelines for the formulation of professional codes of ethics, which the authors feel are supported by several legal dimensions, including the extension of privileged status to behavioral scientists regarding confidential communication, the provision of civil and criminal remedies for breaches of privacy, the assessment of breaches vs. benefits in research, the preclusion of public officials or employees from disclosing confidential information acquired during employment, disciplinary proceedings enforcing the claim to privacy against public officials, and, finally, a possible supportive legal measure requiring the registration of all privacy-invading devices (here the authors specifically mention tape recorders, dictaphones, and wiretappers).

Simon, Todd F.
 1985 "The Right of Publicity Reified: Fame as a Business Asset," *New York Law School Law Review,* 30, Winter, pp. 699–755.

 Distinguishes between the right of publicity as a personal versus business plea and recommends a business analysis. Summarizes analogies, in recent publicity opinions, to the law of trade name, unfair competition, common law servicemark infringement, misappropriation, and moral rights. Notes, moreover, the "rejection of privacy law extensions by opinions adopting property definitions of publicity infringement." Simon recommends still greater separation of privacy and publicity, which, he feels, has more in common with the law of trade regulation and intellectual property.

Treece, James M.
 1973 "Commercial Exploitation of Names, Likenesses and Personal Histories," *Texas Law Review,* 51(4), April, pp. 637–72.

 See pp. 652–54 for a summary of the right to control names or likenesses; pp. 660–64 for descriptions and analysis of cases where the newsworthiness of a photograph protected a defendant, notwithstanding his commercial motive; and pp. 668–71 for a treatment of issues at odds in advertising and the First Amendment.

Westin, Alan F.
 1967 *Privacy and Freedom.* New York: Atheneum.
 On the origins of privacy (invoking Edward T. Hall and
 theories of territoriality), the social functions of privacy and
 surveillance, the tools of privacy invasion, controlling inva-
 sion, and privacy policy decisions. Concentrates primarily on
 the privacy implications of military, police, and government
 surveillance rather than commercial invasions, though does
 include comment upon privacy and observation in behavioral
 research. Material is somewhat dated in terms of the author's
 specific predictions about technological advance and privacy
 protection. For sections on photography and privacy, see:
 pp. 86–87 on observation and photography of physical acts,
 pp. 344–47 for common law attempts to limit physical sur-
 veillance by photographic means, and 130–32 on govern-
 ment uses of photography.

LEGAL—Privacy/Publicity—Cases

ARRINGTON V. NEW YORK TIMES ET AL. (NY SUP CT APP DIV).
(SEE COCKBURN, BELOW, FOR CASE DESCRIPTION.)

 1980 *Media Law Reporter,* 5, pp. 2581–84.
 Full text of New York Supreme Court opinion that
 granted defendant's motion to dismiss but gave plaintiff leave
 to serve an amended complaint.

 1980 *Media Law Reporter,* 6, pp. 2354–55.
 Full text of Appellate Division (N.Y. Supreme Court)
 opinion following plaintiff's amended complaint (decided in
 favor of defendant).

 1982 *Media Law Reporter,* 8, pp. 1351–55.
 Full text of New York Court of Appeals opinion fol-
 lowing plaintiff's appeal of Appellate Division's dismissal of
 his amended complaint. This decision ruled that defendant
 New York Times was not liable but that defendants Contact
 Press Images et al. (named in the amended complaint) were
 liable.

Cockburn, Alexander

 1982 "The Fatal Photo," *Village Voice,* June 1, p. 8.

Re *Arrington v. New York Times et al.* Clarence Arrington's photograph appeared without his consent on the cover of the *New York Times Sunday Magazine* to illustrate an article "Making It in the Black Middle Class." His suit for invasion of constitutional and common law right to privacy was dismissed, but his complaint based on the sale of the photograph (by Contact Press Images to the *New York Times*) was upheld in the New York Court of Appeals. Under this decision, Arrington could claim against CPI (whose dealings with the picture were explicitly and exclusively commercial), but not the *New York Times,* which was protected by the photo's "newsworthiness" under the First Amendment. Cockburn's contention is that this ruling would restrict the entire operation of freelance photography and of publications that rely heavily on freelance work. He argues that the use of Arrington's picture was "ethically" dubious but suggests that the legal decision amounted to an arbitrary division of defendants that will help no one trying to balance the First Amendment with the right to privacy in photojournalism. (Note that the case was ultimately settled out of court.)

Malyon, Tim
1982 "The Fateful Photograph," *Camera Art,* October, pp. 26–27, 87–88, 90–92.

The most detailed account of *Arrington v. New York Times et al.,* from which Alexander Cockburn's *Village Voice* piece (above) was taken. Includes a very useful chronology of the major legal turns in the case's history, up to the denial of the defendants' Motion for Reargument and the court's refusal to read *amici curiae* briefs submitted on behalf of several photographic and publishing interests.

Richards, Laura M. Murray
1983 *"Arrington v. New York Times Company:* A Missed Opportunity to Recognize a Constitutional Right to Privacy of Personality," *Howard Law Journal,* 26, pp. 1579–1611.

Argues the validity of Arrington's constitutional claim, against a historical background of the source and elements of a constitutional right to privacy.

GALLELA V. ONASSIS: (487 F.2d 986; US DIST CT S.D.N.Y.).

1973 *Media Law Reporter* 1, pp. 2425–33.
Full text of opinion that resulted in a court order (entered Jan. 8, 1975) prohibiting paparazzo photographer Ronald Gallela from approaching within 25 feet of Onassis or her children when photographing them.

1982 *Media Law Reporter* 8, pp. 1321–25.
Full text of U.S. District Court opinion holding Ronald Gallela in contempt of court following his transgression of the above order.

"Photographer's Pledge"
1982 *New York Times,* March 25.
Brief press report on Ronald Gallela's agreement to cease photographing Jackie Onassis and her family, on pain of a possible six-year prison term and a $120,000 fine for violating an earlier injunction that required him to stay at least 25 feet from Onassis.

ONASSIS V. CHRISTIAN DIOR LTD. (122 MISC.2D 604, 604, 472NYS 2ND 254, 257) and ALLEN V. NATIONAL VIDEO, INC. (610 F. SUPP, 612, 618 (SDNY, 1985).

Lee, Elizabeth C.
1985 "Celebrity Look-Alikes: Rethinking the Right to Privacy and the Right of Publicity," *Entertainment and Sports Law,* Fall, pp. 193–217.
An analysis of *Onassis v. Christian Dior* and *Allen v. National Video, Inc.,* both recent cases in the "look-alike controversy," both ruled in favor of the plaintiff. In the first, the court granted injunctive relief to Mrs. Onassis for invasion of privacy and ordered that the Dior model who appeared in an advertising photograph stop working as an Onassis look-alike. In the second, Woody Allen was granted relief from a videotape rental company for their use of an Allen look-alike in print advertisements. Lee asks whether privacy rights outweigh a look-alike's property rights in employment and whether an advertising agency "should be able to do indirectly (through the use of a look-alike) what it cannot do directly" (p. 195).

Shenon, Philip
 1984 "Mrs. Onassis Wins Injunction on Ads," *New York Times,*
 January 13.
 Report on *Onassis v. Christian Dior.*

TAGGART V. WADLEIGH-MAURICE AND WARNER BROS., INC.: U.S.
COURT OF APPEALS, 3RD CIRCUIT, NO. 72–1531 (489 F.2D 434–
441).

 Full text of Appeals Court opinion. Taggart sued Wad-
leigh-Maurice and Warner Bros. for mental anguish, em-
barrassment, public ridicule, and privacy invasion following
the inclusion of a two-minute clip of him performing his
duties as a latrine maintenance man in the Warner Bros.
film "Woodstock." The court ruled in Taggart's favor, dis-
tinguishing between simple participation in a newsworthy
event, and being drawn into participation by the film-makers
for their own purposes. In addition to awarding Taggart
monetary damages, the court ordered the deletion of the
offending clip from all prints of "Woodstock," including
those already in circulation.

LEGAL—Privacy/Publicity—International

Levitsky, Serge L.
 1979 *Copyright, Defamation, and Privacy in Soviet Civil Law.*
 Germantown, Maryland: Sijthoff and Noordhoff.
 Includes a general introduction and presentations of the
right to one's own image, the creation and publication of
works of pictorial film art, the meaning of "consent," excep-
tions to protection, and copyright. The author considers per-
sonal versus state rights in each of these issues, though par-
ticularly with respect to copyright.

"Protection of Privacy (A Symposium)"
 1972 *International Social Science Journal,* 24(3), pp. 417–602.
 General definitions and specific provisions of privacy law
in ten countries are surveyed, including Mexico, Venezuela,
Argentina, Brazil, Federal Republic of Germany, Sweden,
France, Switzerland, U.S.A., United Kingdom. Discusses
particular intrusions, including the appropriation of one's
name or likeness, and unauthorized photographs, films, and

"peeping." Slightly dated (at least with respect to the U.S.) but nonetheless useful for a brief introduction to international privacy legislation.

Wagner, W. J.
 1980 "Photography and the Right to Privacy: The French and American Approaches," *Catholic Lawyer,* Summer, pp. 195–227.

A description of American and French privacy law, particularly in the contexts of medical cases, judicial proceedings, and amateur and professional street photography. (The section on medical cases considers those incidents where photographs have been made (by press photographers and doctors, among others, for commercial publication and private circulation) of ill or deformed people without their consent.) The author concludes that the real issue in the right to privacy "is the mental tranquility . . . and human dignity . . . of the people rather than their property or financial interests" (p. 225), though he acknowledges the development, in some jurisdictions, of a "right to publicity" that can be computed in monetary terms. Useful historical comment on photographs and privacy in French law. For two related articles see: Wagner (1970), "The Right to One's Own Likeness in French Law," *Indiana Law Journal,* 46(1), pp. 1–36, which describes mid-19th-century legal decisions that laid the foundation for French privacy law; and Wagner (1971), "The Development of the Theory of the Right to Privacy in France," *Washington University Law Quarterly,* 45, pp. 45–69, a further discussion of the right to one's own likeness emphasized in French law.

LEGAL—Privacy/Publicity—Warren and Brandeis

Barron, James H.
 1979 "Warren and Brandeis: The Right to Privacy, 4 Harvard Law Review 193 (1890): Demystifying a Landmark Citation," *Suffolk University Law Review,* 13(4), pp. 875–922.

A comprehensive, critical analysis of the original right to privacy article that suggests its theoretical limitations and its basis upon an elite reaction to Boston press gossip are in part responsible for the "stunted growth" of modern privacy law today.

Gordon, Harold R.
 1960 "Right of Property in Name, Likeness, Personality and His-
 · tory," *Northwestern University Law Review,* 55, pp. 553–90.
 Discusses the narrowness characterizing modern judicial
 interpretations of Warren and Brandeis's privacy tort. Sug-
 gests this narrowness is in part a consequence of confusion
 about how the tort should be applied in cases involving
 television, radio, and motion picture exploitation, technical
 developments the tort's authors couldn't have anticipated.
 Through a detailed analysis of cases, Gordon concludes that
 insufficient awards are made to litigants partly because plain-
 tiffs invoke the right to privacy (based on injury to feelings),
 rather than the commercial exploitation of name, likeness,
 etc., in cases where the injury to feelings has only secondary
 application.

Warren, Samuel D., and Louis Brandeis
 1890 "The Right to Privacy," *Harvard Law Review,* 4(5), Decem-
 ber, pp. 193–220.
 The first argument set forth for the court's recognition of
 a "right to be let alone" under common law in the United
 States, free from unwanted and undeserved publicity. Al-
 though there is persuasive evidence on record of earlier
 formulations of this personal right and of attacks on press
 irresponsibility, Warren and Brandeis were the first scholars
 to "synthesize a specific legal right and propose a tort remedy
 for its invasion" (Barron, above).

Zimmerman, Diane
 1983 "Requiem for a Heavyweight: A Farewell to Warren and
 Brandeis's Privacy Tort," *Cornell Law Review,* 68, pp. 291–
 350.
 Traces the "failure" of the privacy tort and suggests
 eliminating it, as in England.

LEGAL—Surveillance

Castillo, Angel
 1980 "Police Use of Video Surveillance Faces Major Challenge in
 Courts," *New York Times,* Sept. 28.
 On the legal and ethical implications of police surveil-
 lance tape in criminal investigation. Cites case of Dr. Marvin

Teicher, dentist, who was convicted in 1978 for sexually abusing a female patient. The evidence used to convict him included undercover police videotapes.

Columbia Human Rights Law Review
1972 *Surveillance, Dataveillance and Personal Freedom: Use and Abuse of Information Technology* (A Symposium). Fairlawn, N.J.: Burdick, Inc., Publishers.

A collection of papers on the constitutional threats posed by military, police and criminal justice surveillance through computer and other technologies. Of particular interest is a paper on "Police Use of Remote Camera Systems for Surveillance of Public Streets," an overview of the nature and extent of such surveillance and an analysis of its constitutional implications with respect to the First and Fourth Amendments.

Eastman Kodak Company
1972 *Photographic Surveillance Techniques for Law Enforcement Agencies.* Rochester, N.Y.: Eastman Kodak Company.
An industry manual.

Hentoff, Nat
1980 "ABSCAM'S Master Criminal Was Behind the Camera," *Village Voice,* Nov. 5–11, p. 8.

A critique of the production and broadcasting of the ABSCAM tapes asking what the cameras were doing there in the first place. What are the Fourth Amendment implications of government "stings," where traps are set up for people on the basis of their "predisposition," without prior evidence of their having committed a crime?

Marks, Lawrence Kaiser
1982 "Telescopes, Binoculars and the Fourth Amendment," *Cornell Law Review,* 67, pp. 379–95.

A brief discussion of the history of the Reasonable Expectation of Privacy Standard under the Fourth Amendment, and a review of its application to evidence obtained through telescope and binocular surveillance. The author concludes that the use of these instruments for law enforcement without police warrant violates an individual's expectation of privacy. It argues that "the limited impairment to law enforcement of a requirement that police first obtain warrants

before using telescopes and binoculars to view private activity unobservable by the naked eye is a small price to pay for the significant privacy interests that such a requirement would promote" (p. 395).

MEDIA ETHICS

Cullen, Maurice R.
 1981 *Mass Media and the First Amendment: An Introduction to the Issues, Problems and Practices.* Dubuque, Iowa: William C. Brown.
 A comprehensive introduction including chapters on: (1) The historical background of the First Amendment; (2) mass media responsibility; (3) news reporting; (4) mass media audiences (including, for example, the stereotypical portrayal of minorities); (5) mass media and the Executive Branch of Government; (6) mass media and the Legislative Branch of Government; (7) mass media and the Judicial Branch of Government; (8) sex and the mass media; (9) libel and privacy; (10) other controls; (11) mass media ethics; (12) the business side of mass media; (13) new technologies and the First Amendment.

First Amendment and the News Media
 1973 *Final Report of the Annual Chief Justice Earl Warren Conference on Advocacy in the United States.* Cambridge, Mass.: The Roscoe Pound American Trial Lawyers Foundation.
 See chapter on the First Amendment and broadcast journalism by Sig Michelson (first president of CBS News). Deals primarily with television, the First Amendment and the Fairness Clause (Communication Act, 1959, section 315).

Jones, J. C.
 1980 "Mass Media Codes of Ethics and Councils: A Comparative International Study on Professional Standards," *Reports and Papers on Mass Communication,* Special Issue. Paris: UNESCO.
 International survey of media codes of ethics in fifty countries in Europe, North and South America, Africa, and Asia. Special section devoted to media councils in Third World countries, and a historical overview of international mass me-

dia ethics activities. Summarizes significant trends culled from the survey and presents a set of guidelines for the assistance of countries attempting to establish communications codes of ethics.

McIntyre, J. S.
1979 "The Hutchins Commission's Search for a Moral Framework," *Journalism History,* 6(2), pp. 54–57.

A brief, retrospective study of the Hutchins Commission on Freedom of the Press (1940s) and its attempt to translate moral questions into a practical framework for journalists. The central debate was between voluntary regulation and government intervention. The commission concluded by advocating against regulation but proposing the formation of a citizen's agency to act both as a research body and as "an agency of persuasion which would function as an interpreter between the press and the public" (p. 256). Generally, the commission's recommendations were not favorably received by the professional press.

McKerns, Joseph M.
1978 "Media Ethics: A Bibliographical Essay," *Journalism History,* 5(2), Summer, pp. 50–53, 68.

A historical survey of work on media ethics including a list of earlier bibliographies and indices useful to media ethics research. The titles collected by McKerns include those on general ethical theory, early 20th-century pleas for ethical codes in journalism, freedom of the press, the media as social institutions, media performance, news room policies and practice, the New Journalism, and ethical problems in broadcast journalism.

Rivers, William L., Wilbur Schramm, and Clifford G. Christians
1980 *Responsibility in Mass Communication* (3rd edition). New York: Harper and Row.

A discussion of responsibility in the contexts of authoritarianism, liberalism, and social responsibility theory, and of freedom in relation to government and business. Presents a case study of minorities and the news (from the perspectives of minority hiring, of stereotypical news portrayals of minorities, and "full-context" reporting); discusses responsibility in relation to media concepts of popular art; discusses media

censorship, ethical codes, and assumptions made by the media about their audiences; truth and fairness in broadcasting (including a section on "Visual Accuracy"—in news photography, tape, and film, pp. 155–60). Includes valuable codes in appendices (radio code, television code, movie rating system [1978], among others).

Rubin, Bernard (ed.)
 1978 *Questioning Media Ethics.* New York: Praeger.
 Anthology produced by the Institute for Democratic Communication at Boston University. The editor's introduction discusses ethics in a variety of media, though primarily print journalism and television. Describes several incidents on the premise that media ethics emerge as decisions are made from case to case. Of particular interest is the brief description (pp. 26–27) of the (British) YTV telecast of police surveillance tapes of Mrs. Yolanda McShane trying to induce her aging mother to commit suicide. The primary ethical issue raised was whether the broadcast of the film should be added as "undue punishment" to the 2-year sentence Mrs. McShane received. Other discussions in the anthology include representations of blacks, women, and the Third World by the mass media, the legal-ethical relation in print reporting, the Fairness Doctrine, advertising to children, and popular film portrayals of the press and of broadcasters.

Sigma Delta Chi
 1926 "The Code of Ethics of the Society of Professional Journalists" (revised 1973).
 Categories include responsibility, freedom of the press, accuracy and objectivity, ethics, and fair play.

Thayer, Lee (ed.)
 1980 *Ethics, Morality and the Media: Reflections on American Culture.* New York: Hastings House.
 Essays on ethics and responsibilities in print and broadcast journalism, public relations, advertising, and public opinion polling, along with interviews with media figures from film critics to ad agency executives. Miscellaneous references to film and tape throughout the book, though no specific piece on images. In a somewhat related vein, film critic Judith Crist discusses the ethical implications of film criticism (pp. 245–

55) and its influence on the film medium. Thayer's introductory article, "Ethics, Morality and the Media: Notes on American Culture," addresses media ethics with reference to culture and language.

PHOTOGRAPHY

Angeli, Daniel, Jean-Paul Dousset, and Anthony Burgess
 1980 *Private Pictures.* New York: Viking Press.
 Black and white photographs of "stars" caught off-guard, in some cases unbeknownst to them.

Beloff, Halla
 1983 "Social Interaction in Photographing," *Leonardo,* 16(3), Summer, pp. 165–71.
 An argument for the systematic study of photographing people as a form of complex social interaction. Considers a psychoanalytic interpretation in which photographing people is a form of voyeurism. Also considers the nature of the interaction given power relations between photographers and their subjects, using the work of several well-known "street" photographers as examples.

Edelman, Bernard
 1979 *Ownership of the Image: Elements for a Marxist Theory of Law.* (Elizabeth Kingdom, trans.). London: Routledge and Kegan Paul.
 A development of a Marxist theory of law (with its origins in Kant, Hegel, and Althusser) that uses the "paradox" of photography, the "ambiguous nature" of property and ownership in relation to photographs, as a microcosm of defining the juridical "real" in law. See especially chapter "The Juridical Production of the Real," which deals explicitly with photography and film in relation to copyright, privacy and the artist's moral rights. Based primarily on French law. (See also Gever, and Hirst and Kingdom, below.)

Freund, Gisele
 1974 *Photography and Society.* Paris: Editions du Seuil (English translation 1980, Boston: David R. Godine).
 One of the first introductory works on photography in social context. In particular, see "Photography as a Political

Tool," (pp. 161–74), "Photography and the Law," (pp. 175–80), and "The Scandal Mongering Press," (pp. 181–92). On interpretation, captioning and the calculated juxtaposition of photographs; on false light representation of public figures; self-censorship among photojournalists; ownership of the image; and the birth and development of *Playboy* magazine. Each of these issues is discussed generally, often accompanied by illustrative anecdotes.

Friendly, Jonathan
 1981 "Drawing a Privacy Line: Inside Publicity's Glare," *New York Times,* December 27, p. 30.
 On balancing the public figure's right to privacy and the photo- and broadcast-journalist's right to gather news and information. The article is sympathetic to privacy rights in the face of journalistic abuses and quotes interviews with press professionals who fear that invasions may undercut public support of the press.

Gillespie-Woltemade, Nellice
 1984 "Power, Politics, and Photography," *Humanity and Society,* 8(3), August, pp. 385–92.
 On teaching visual sociology. Gillespie-Woltemade examines seven areas in the photographic process which contribute to the ideological nature of photographs and which students can learn to analyze. They include the photographer's consciousness, affinities between types of equipment and types of pictures, darkroom procedures, editorial processes, the juxtaposition of photographs and text, and the context and form in which photographs are presented. Brief list of introductory references on visual sociology.

Gever, Martha
 1981 "Photographs as Private Property: A Marxist Analysis," *Afterimage,* 8(6), pp. 8–9.
 A summary and review of Edelman's *Ownership of the Image* (see above), with particular discussion of those sections that directly concern photography and copyright, the right to privacy and the artist's moral rights.

Gold, Peter
 1983 "Returning Photographs to the Indians," *Studies in Visual Communication,* 9(3), Summer, pp. 2–14.

A photoessay on Hopi Indians, with photographs by Joseph Dixon (c. 1913) and descriptive comment on each image collected and edited by Peter Gold. Gold's introductory essay describes his successful attempt to use the photographs as informal elicitation devices in conversations with Hopi tribal elders, who were able to identify and give some insight into the people, settings, and activities the photographs depicted. Gold also hoped "that the person responding would be moved to speak of his or her inner thoughts and values as the photograph stimulated a wealth of memories and associations." As well, the photographs were returned to the Hopi as a gesture motivated by the author's conviction that the Indians are owed a "long-overdue repayment for their collaboration in making [them] possible." The author considers a photographer/researcher's responsibility to a host population, particularly one so culturally different and to whom the act of taking a photograph means something quite removed from familiar Western conceptions.

Goldman, Judith
 1976 "The Camera Confronts Death," *Village Voice,* June 28, p. 120.

 A review of an exhibition of photographs (by Nina Alexander and Herta Hilscher Wittgenstein) of a breast cancer patient during the last two months of her life. Discusses death as a photographic subject, including a brief historical account. Mentions Mark and Dan Jury's book *Gramp* (see Cases, below) and suggests that its subject, Frank Tugend, did not consent to the making of the photographic record of his death (unlike Toni, the woman described above).

Heyman, Ken
 1965 "On Being a Photographer of People," *Popular Photography,* 56(2), pp. 52–53, 55, 96–97.

 On how to photograph people up close without having them affected by your presence in the final picture (e.g. being confident without being self-conscious, acting unconcerned, watching people peripherally without looking at them, staying prepared to shoot, tricking subjects out of posing).

Hirst, Paul, and Elizabeth Kingdom
 1979 "On Edelman's *Ownership of the Image,*" *Screen,* 20(3–4), pp. 135–40.

A summary of Edelman's book by its translator and the author of its introduction (respectively).

Jay, Bill
 1984 "Photographer as Aggressor," in David Featherstone (ed.), *Observations: Essays on Documentary Photography*. Carmel, CA: Friends Photography.

Traces contemporary sentiment about photographers as aggressors through late 19th- and early 20th-century editorials on the etiquette of snapshooting and published reactions to photographers' frequent privacy violations by surreptitious means. Also considers the image of the photographer as aggressor in 20th-century fictional portrayals, including such novels as *The Photographer, The Parallax View, Game Bet,* and *Blind Date.*

JEB (Joan E. Biren)
 1981 "Lesbian Photography—Seeing Through Our Own Eyes," *Studies in Visual Communication,* 9(2), Spring, pp. 81–96.

A discussion of lesbian images by lesbian and non-lesbian photographers. Biren is concerned with three relationships, between photographer and viewer, between photographer and "muse" (a term she prefers over "subject") and between viewer and muse. She advocates against lesbian images designed to "pass," which deliberately give no visual sign of lesbians being different from the dominant culture. She also proposes a collaborative relationship between photographer and muse that will not objectify wimmin (*sic*) and that will allow a womon (*sic*) being photographed to choose how she will present herself, "based, in part, upon who the photographer is and how well the muse and photographer know and understand one another." Biren makes recommendations for protecting the muse against the possible consequences of publication, and includes a sample release form that incorporates clauses concerning the identification of the womon (muse) as a lesbian.

Joint Ethics Committee of the Graphic Communication Industry
 1978 "Code of Fair Practice for the Graphic Communication Industry," New York.

A code formulated in 1948 and revised in 1978, sponsored by the Society of Illustrators, the Art Directors Club,

the American Society of Magazine Photographers, Society of Photographer and Artist Representatives, and the Graphic Artists Guild. Outlines functions of the JEC in mediation between members and employers, and states articles which deal entirely with the relations between artist and buyer (re copyright, commissions and property rights).

Kahan, Stuard (ed.)
1982 *Professional Business Practices in Photography.* New York: American Society of Magazine Photographers.
 A compilation of descriptions, rate recommendations, legal protection, accounting practices, etc., for assignment photography and stock pictures. Examples of form agreements. Recommendations on the photographer/agent relationship, copyright, insurance, book publishing, disputes and trade definitions. In particular, see pp. 87–93 (settling disputes), 66–72 (copyright protection), 44–46 (on model releases).

Lifson, Ben
1979 "That's Entertainment," *Village Voice,* Sept. 10, p. 67.
 Review of photographer Larry Fink's Museum of Modern Art exhibit. (On his "cynicism," "glibness," "bravery," "art.") (See also Thornton, below.)

"Photos of Tribal Ritual Prompt Suit"
1984 *New York Times,* March 13, A17–18.
 Report of a $3.65 million lawsuit brought by the Santo Domingo pueblo in New Mexico against a local newspaper for publishing photographs (taken from a low-flying airplane) of sacred tribal dances. The pueblo community charged the paper with trespassing, violation of tribal law, and invasion of privacy.

Rosenblum, Barbara
1978 *Photographers at Work: A Sociology of Photographic Style.* New York: Holmes and Meier.
 No direct discussion of ethics and photography but for those interested in the institutional contexts of photographic practice, particularly in newspaper photography, a useful description of professional training and day-to-day work. See, for example, section on the "choreography of the unobtrusive" among photojournalists (pp. 22–25).

Sekula, Allan
 1979 "Dismantling Modernism, Reinventing Documentary," *Photography/Politics,* 1(1), pp. 171–85.
 "Notes on the politics of representation," calling for "an art that documents monopoly capitalism's inability to deliver the conditions of a fully human life" (p. 185). Considers several groups of images by photographers concerned with content rather than with the formal criteria of photography as a high art. In Sekula's judgment, these photographers have created images (often juxtaposed with text) that are at once socially critical as well as metacritical of documentary photography as a form. They have not fallen prey to the notion that a successful photograph transcends verbal comment, delivering its message (including all necessary information about its context) through its visual arrangements alone, a notion often allied with a naive conception of the privileged subjectivity of the artist, on the one hand, and the fundamental objectivity of photographic realism, on the other (p. 185). It is Sekula's contention, indeed his political call to arms, that these conceptions can only be overcome "in a recognition of cultural work as praxis . . . A didactic and critical representation is a necessary but insufficient condition for the transformation of society. A larger, encompassing praxis is necessary."

Thornton, Gene
 1979 "When the Camera Produces Fiction," *New York Times,* Sept. 2, Section 2, p.D17.
 On the photographs of Larry Fink. "Freaky decadence" is not in the subjects of Fink's photography, but in his way of looking at them. The article briefly describes the tension between a photograph's connection to and distortion of the subject. (See also Lifson, above.)

Webster, Frank
 1980 *The New Photography: Responsibility in Visual Communication.* London: John Calder.
 A treatment of photography as communication in social, cultural, and political context. Includes an analysis of how photographs communicate, using examples from images of sex roles, race, law and order; a brief section on the political uses of photographs; the paradoxical nature of the pho-

tographic sign (as both existential and symbolic); a diversion into semiological principles and practices; and finally, a treatment of the relationship between language codes and visual codes illustrated by a study of two newspapers. Also discusses photojournalism and the role of photographs in transmitting a biased view of social reality, and the professional news values and cultural assumptions of the photojournalist. "Responsibility" is in recognizing photography as a culturally and socially determined way of seeing, and being aware of ethnocentric impositions upon photographic subjects. But this ethnocentrism is structural; it is not in the individual photographer or photojournalist.

PHOTOGRAPHY—Cases

"GRAMP":

Broyard, Anatole
1976 "Documenting Death," *New York Times,* March 5.
A description and review of Mark and Dan Jury's "Gramp."

Callahan, Sean
1976 "What Kind of Art Is Dying?" *Village Voice,* March 1, pp. 99–100, 103.
A review of Mark and Dan Jury's "Gramp" (see below) that asks if the book is photojournalism. Callahan concludes that despite the difficulty of defining the genre, "Gramp" qualifies.

Jury, Mark, and Dan Jury
1976 *Gramp.* New York: Penguin Books.
A photo/text essay by his grandsons on the last three years in the life of Frank Tugend, who died of arteriosclerosis (or "senility"). The publication, with its verbal and visual descriptions of Mr. Tugend being fed, bathed, and "toileted" (among others), has been the source of several essays in the popular press on aging, death, and personal dignity, and on photography and privacy.

PHOTOGRAPHY—Amateur

Barnard, Charles N.
1978 "The Thoughtful Photographer," *Travel and Leisure,* December, pp. 111–12.

On being considerate when photographing people in foreign places. Advises against "candid" photographs (or trying to be sneaky), suggests that subjects should be approached tactfully, that there's nothing wrong with paying for a pose, that pictures themselves make good gifts, and that a photographer should "know when to say goodbye." When possible, says the author, it's good to take a local person with you, for translation and introduction.

"The Casuistry of Photographic Ethics"
 1899 *The American Journal of Photography,* 19, pp. 81–83.
 A brief treatise on the "indecency" of snapshooters who invade the privacy of others in public. Recollects an incident in which the author purposefully ruined an exposed negative plate belonging to a snapshooter who had illicitly photographed a young couple in a park.

Chalfen, Richard
 1980 "Tourist Photography," *Afterimage,* Summer, pp. 26–29.
 After outlining three types of tourist photography (pictures for, about, and by tourists), Chalfen concentrates on the third category, photograhs by tourists of host populations and settings. His discussion is based on a conception of both photography and tourism as social interaction, characterized by culturally defined norms and sanctions. He examines categories of tourists from an anthropological perspective, and considers how types of photography may be variably related to types of tourists and touristic experience. He also considers such issues as the tourist photographer's "freedom to shoot" in unfamiliar surroundings, illustrated with a variety of cultural taboos and legal prohibitions met by international travelers, and the degree and type of accommodations different countries will make for the tourist photographer. He proposes that the use of cameras must be considered as a contributing agent (rather than a primary one) in an accelerated process of culture modification (p. 29). The trend, he notes, seems to be in the direction of locals taking greater control over what and how visitors photograph; photographers are free to shoot but only on native terms, which may include the creation of specialized spaces designed to accommodate tourist photographers. Finally, Chal-

fen concludes that "just as some art historians have studied the deliberate transformations of indigenous art into hybrid forms that satisfy the values, motives, perceptions and aesthetics of Western art markets, we may now be seeing manipulation and re-creation of native life for the sake of tourists' photographic recreation" (p. 29).

Editors of Time-Life
1972 "Rules and Regulations in Foreign Lands," in *Travel Photography*. New York: Time-Life Books, pp. 84–87.
Includes brief comment on officially restricted subject matter for photographing outside the U.S., along with information on customs office limitations and technical resources in several American, European, Asian, and African countries.

Farber, Jules
1966 "No Snap for Photographers," *New York Times,* April 24, Section 20, p. 33.
An account of photographing people in Staphorst, the Netherlands, where photography is strictly prohibited both by cultural taboo and legal sanction. The article is accompanied by four "contraband" photographs, taken with a pre-set and prefocused camera hung from the photographer's neck and exposed by means of a cable release hidden in his pocket.

Gersten, Leon
1977 "Use with Discretion," *New York Times,* June 26 (Arts and Leisure).
On the one hand, several accounts of mishaps provoked by the "inconsiderate" use of a camera in foreign cultures, and, on the other, recollections of situations in which its "respectful" use opened the door to a broad range of cross-cultural experiences for the author.

Herda, D. J.
1979 "A Portrait Is Often Where You Find It," *Washington Post,* January 12, p. 20.
Instructional article for amateur photographers interested in candid street photography. The basic tenet is "grab it," short of creating a dangerous situation for yourself or subject.

Holland, Robin
 1978 "Street Photography: Possibilities Unlimited," *New York Times,* January 15, p. 33.
 Recommendations for amateur street photography including the assertion that no one on the street has an unchallengeable right to privacy that supersedes the photographer's right to work and that most people actually like to be photographed and are happy to see pictures of themselves.

Linn, Alan
 1971 "Taking This Photograph Got Me Locked Up," *New York Times,* August 21, Travel Section, p. 1.
 A photographer's account of being arrested without explanation after photographing a group of Gypsies in Yugoslavia. Though several hypotheses were offered by knowledgeable travelers and consulate representatives, Linn was never able to find out precisely what regulation or taboo he had transgressed. He concludes with a quote from a professional travel photographer, who advises always asking permission to photograph in foreign countries, adding that "although you'll miss a lot of great pictures, it's the only way to stay out of trouble."

Neubart, Jack
 1982 "Some Rules to Follow in Candid Photography," *New York Times,* May 16, pp. 44–45.
 Suggestions to amateurs for candid street photography. Insists that photographers consider privacy invasion, even if a person is photographed in public. Recommends various ways of negotiating with potential subjects and photographing inconspicuously when negotiation is "undesirable." Extensive comment on using model releases whenever possible, especially if there is any chance of publishing a photograph.

Rokeach, Allen, and Ann Millman
 1980 "On Photographing People in Foreign Countries," *New York Times,* May 18, pp. 48, 50.
 Some technical suggestions for photographing people with dark skin and some recommendations for flattering potential subjects into co-operating.

Suplee, Henry Harrison
 1890 "The Ethics of Hand Cameras," *The American Annual of*

Photography and Photographic Almanac. New York: Scoville Company, Publishers.

Advocates "gentlemanly discretion," and resistance to the nuisance of uninvited public snapshooting.

Trackman, Helen
n.d. "Taking Travel Portraits," *Photo-Travel Division Guidelines* (#3). Philadelphia: Photographic Society of America.

Recommendations to amateur photographers on lenses, film stocks, lighting, flashes, etc. to use when making travel portraits. Also includes sections on "self-justification," (re intrusion into other people's lives), techniques for catching candid photographs, spoken and unspoken contracts, and miscellaneous suggestions for making oneself and one's subject more comfortable and one's photographs more "successful." Concludes that the essential ingredients for good travel portraits are sensitivity and empathy between photographer and subject.

PHOTOGRAPHY—Photojournalism

Carmody, Dierdre
1978 "Pulitzer Photos from Rhodesia Are Now Subject of Controversy," *New York Times,* April 22.

Pulitzer jury questions the means through which prize-winning photographs of Rhodesian war atrocities were obtained. (In one instance, for example, the photographer reports to have been forced to participate in Rhodesian army activities, to which he pretended to be sympathetic for the purpose of photographing.)

Chapnick, Howard
1983 "Getting the Pictures Is Only the First Worry of Photojournalists; How It Affects Subjects Is Another," *Popular Photography,* 90(8), August, pp. 40, 93.

A photojournalist's discussion of ethics, responsibility, and credibility in a professional world "falling prey to superficiality and fashion in the journalistic coverage of events."

Columbia Journalism Review
1965 "The Cruel Camera," Spring, pp. 5–10.

Asks "what standards can be applied to the journalistic depiction of the violence and grief of mankind?" Six repre-

sentatives from three branches of photojournalism, among them photographers, photoeditors, and television news producers, respond to ten photographs, debating whether or not they are publishable and the criteria brought to bear in each case.

Ephron, Nora
 1975 "The Boston Photographs," *Scribble Scribble,* New York: Knopf.

 On photographs of death in several contexts, but particularly about three fire-rescue photographs in which two victims (a woman and her small child), seemingly safe in the first picture, are seen falling in mid-air in the last. "The caption accompanying the pictures internationally states that the woman was killed and the child, though badly injured, lived." Discusses readers' overwhelmingly critical reactions and some of the editorial concerns of running such newsphotos.

Geiselman, Arthur W.
 1959 "Take Pictures of Tragic Scene or Flee from Irate Onlookers?" *Editor and Publisher,* August 15, p. 13.

 A photojournalist's account of photographing at the site of a child's drowning. The photographer-author concludes that he might have worked unimpeded if he'd used 35 mm equipment rather than a 4x5 view camera which, he felt, was too obtrusive and too reminiscent of the more sensational newspapers "of the past."

Gordon, Jim
 1979 "Questions of Credibility," *News Photographer,* October, pp. 20–23.

 On credibility and misrepresentation in news in light of increasing sophistication among readers and viewers about the potential of photojournalistic fakery. The article considers Martha Cooper's photograph of a mother with her child in arms following the Three Mile Island nuclear power plant accident, and John Filo's Kent State picture, both subjects of various staging accusations since their publication.

 1980 "Judgment Days for Words and Pictures," *News Photographer,* July, pp. 25–29.

A report on editorial decisions surrounding the controversial publication of several news photographs in 1980.

1981 "Foot Artwork Ends Career," *News Photographer*, November, pp. 32–36.
On set-ups in photojournalism. Gordon considers a benign incident that cost Norman Zeisloft, a photographer with the *St. Petersburg* (Florida) *Times*, his job. Zeisloft was fired after a photograph of him setting up a fan at a college baseball tournament was published by a competing newspaper.

Mallette, Malcolm F.
1976 "Should These Pictures Have Been Printed?" *Popular Photography*, March, pp. 73–75, 118–20.
A description of the editorial dynamics and difficulties of publishing certain kinds of newsphotos (particularly those involving violence, suffering, and sex) in family newspapers. In 1976, the author was the director of the American Press Institute.

Mundt, Whitney R., and E. Joseph Bronssard
1979 "The Prying Eye: Ethics of Photojournalism," paper presented to the Photojournalism Division, Association for Education in Journalism Convention, Houston, Texas, August 5–9.
On photojournalistic invasion of privacy. The authors solicited the reactions of professional photojournalists to eight hypothetical scenarios that represented the four torts of privacy law (as formulated by Prosser, see Legal—Privacy/Publicity, above). Responses to the situations were gathered by questionnaires distributed to a national random sample of 700 photojournalists. Descriptions of each scenario, along with the tabulated findings, are presented and summarized, leading the authors to conclude that professional photojournalists are uncertain as to exactly what constitutes unethical journalistic conduct.

National Press Photographers Association
1975 *Rochester Photo Conference Digest*. Rochester, N.Y.: NPPA and International Museum of Photography, George Eastman House.

A collection of papers by speakers at the 1975 Conference, among them picture editors, photojournalists, and consultants. In particular see "Ethics in News Pictures" by Malcolm F. Mallette (a version of the paper annotated above), pp. 6–10; "Responsibilities in Magazine Publishing" by Bob Guccione (editor and founder of *Penthouse* magazine), pp. 11–14; "Reader and Audience Reaction to Photos" by Robert Gilka, Director of Photography, *National Geographic,* pp. 40–47.

News Photographer
1980 "Why Do They React?" March, pp. 20–23.
Report on the newspaper publication of two photos deemed in poor taste by the publications' readers. Claims that editors are acting irresponsibly if they do not take the risks involved in publishing such photos.

Nottingham, Emily
1978 "Photojournalist-Subject Interaction in Street Encounters," *Report #4,* Bloomington: Center for New Communications, Indiana University.
Reports tersely on a study of videotaped interactions in one setting, taking into account such features of a photojournalist's "interactive style" as: average time spent with each subject (in seconds); whether or not permission is requested (prior to or following photographic exposure); percentage of total time spent talking; percentage of total time spent with camera in action; and "selectivity," or the number of pedestrians each photographer let pass before selecting a potential subject. Following the administration of an additional survey questionnaire to subjects photographed, Nottingham concludes that journalists should be aware of the public's attitude toward photographers, and of the nature of photographer-subject interaction. As well, she suggests that although "feature" street photography still has the general goodwill of the public, the photographer needs to go out of his way to encourage goodwill and to calm unease, toward both an improved image of the newspaper as an institution and better pictures from public encounters. (See also the condensed report in *News Photographer,* Dec., 1978, pp. 24–25.)

Pierce, Bill
 1983 "Photographing Violence," *Popular Photography,* 90(11), November.
 Subtitled "some personal opinions on the role of being a photojournalist under fire," this brief article attempts in part to overcome the hero-amidst-flying-bullets image of the photographer in combat zones, and to point out how photographers balance risks in violent situations and as well how they can protect themselves—from wearing flak jackets and traveling in pairs to speaking the local language.

Schiller, Dan
 1981 *Objectivity and the News.* Philadelphia: University of Pennsylvania Press.
 An explanation of the origins of objectivity in American journalism, which Schiller locates in a movement to serve the public good that had its root in positivism and a belief in an objective world "out there." In line with this analysis, Schiller relates objectivity to the development of photographic realism. The book includes a study of the sources of the American penny press in relation to its business acumen and alliance with the artisan ideals it claimed to represent, and a careful analysis on the *National Police Gazette* during the period from 1845 to 1850, a publication representative in its pursuit and definition of the conventions of journalistic objectivity. For an earlier article that deals explicitly (and briefly) with the connection between objectivity and photography, see Schiller's article "Realism, Photography and Journalistic Objectivity in 19th Century America" (*Studies in the Anthropology of Visual Communication,* 1977, 4(2), pp. 86–98).

Squiers, Carol
 1982 "The Picture Perfect War," *Village Voice,* August 3, pp. 76–77.
 A detailed form and content analysis of the *New York Times'* photographic coverage of the Israeli invasion of Lebanon, summer 1982. Overall, Squiers interprets the images as the *Times'* presentation of an editorial range on the event from an insensitive, cool detachment to a decided bias in favor of the Israelis.

PHOTOGRAPHY—Photojournalism—Cases

ROBERT CAPA'S "DEATH IN ACTION" (aka "Moment of Death"):

Cockburn, Alexander
1975 "Picture Stories: The Row About Capa," *Village Voice,*
June 16, pp. 20-21.
A defense of the authenticity of Robert Capa's Spanish
Civil War photograph "Death in Action" against British
author Philip Knightley's claims to the contrary in *The First
Casualty* (see below). Includes interview with Capa's brother,
Cornell Capa.

Friedman, Stanley P.
1975 "A Question of Capa and Captions," *Village Voice,* Aug.
18, p. 83.
A defense of Robert Capa's "Death in Action" against
Knightley's conclusion that "a picture that depends on a
caption isn't so great to begin with." In his brief argument,
Friedman discusses the relation between photographs and
captions and upholds the necessity of captioning newsphotos.

Goldsmith, Arthur
1981 "Moment of Truth," *Camera Arts,* March/April, pp. 111–14.
Another defense of the authenticity of Robert Capa's
Spanish Civil War photograph. Discusses the authenticity
debate at length and concludes that the photograph "remains
an archetypal image of war, one of the most powerful ever
made."

Knightley, Phillip
1975 *The First Casualty: From the Crimea to Vietnam, the War
Correspondent as Hero, Propagandist and Myth Maker.* New
York: Harcourt Brace Jovanovich.
See chapter "Commitment in Spain," particularly pp.
209–12 on Robert Capa's famed photograph "Moment of
Death" (*sic*), which depicts a Republican militiaman falling
to the ground after being shot in the Spanish Civil War. Ac-
cording to Knightley, the photograph "doesn't tell us any-
thing as a picture." As first published in *Life* magazine, its
meaning comes largely from its caption, which read "Robert
Capa's camera catches a Spanish soldier the instant he is
dropped by a bullet through the head in front of Cordoba."

What would have become of the picture, asks Knightley, if the caption had read "soldier slips and falls during training"? Knightley sees the problem as accepting as important an image dependent on a caption for its authentication.

LET US NOW PRAISE FAMOUS MEN:

Raines, Howell
1980 "Let Us Now Revisit Famous Folk," *New York Times Sunday Magazine,* May 25, pp. 31–41, 46.
Interviews with and photographs of the relatives of those Alabama sharecroppers featured in Walker Evans and James Agee's *Let Us Now Praise Famous Men.* The message is that many of the people described in the original book still resent its portrayal of them as dirty, poor, undignified tenant farmers. What is not clear, however, is whether or not the people interviewed in this article are in fact those pictured some forty years ago. In many cases they were the children of Evans's and Agee's adult subjects. The article raised controversy among Agee's bibliographers and among historians and researchers of the period who felt it treated Agee and Evans unfairly.

ARTHUR ROTHSTEIN'S FSA "SKULL" PHOTOGRAPH:

Rothstein, Arthur
1961 "The Picture That Became a Campaign Issue," *Popular Photography,* Sept., pp. 42–43, 79.
On Rothstein's "Skull" picture and ensuing controversy. After the photograph had been published by the Resettlement Administration as a symbol of the dust bowl drought of 1936, the *Fargo* (North Dakota) *Forum* accused Rothstein of fakery when it was discovered that he had not found the skull in the location where he photographed it. This issue was subsequently treated by many national newspapers as a microcosm of larger-scale "fakery" in Roosevelt's New Deal campaign of 1936.

1978 "Setting the Record Straight," *Camera,* 35, April, pp. 50–51.
Brief explanation by the photographer of the origin of two "photo-fakery" controversies concerning FSA photographs (Rothstein's "Dust Storm" and "Skull," both 1936). Rothstein concludes that photographers must be concerned

about the captions and text accompanying their photographs in print, even where they cannot control them.

SOCIAL SCIENCE RESEARCH

(Note: Includes titles both in the general area of research ethics and in the use of visual media as tools in social research. See also Film, Television, Videotape—Ethnographic Film.)

Albrecht, Gary L.
 1985 "Videotape Safaris: Entering the Field with a Camera," *Qualitative Sociology,* 8(4), Winter, pp. 325–44.
 From the author's abstract: "[E]xamines how video methods are used to record what people do as a basis for generating ideas, constructing data, testing hypotheses, and developing grounded theory. Fieldwork with a camera captures emergent social structure and processes that arise from human interaction." In a section titled "The law and ethics of video methods: discovering secrets," Albrecht raises ethical questions about inadvertently disclosed information. He also interprets two principles relevant to video methods from the American Psychological Association's Ad Hoc Committee on Ethical Standards in Psychological Research and later concludes that researchers can use videotape records of behavior in public places if they "follow the ethical guidelines of their profession, the norms of the community, and the law."

American Anthropological Association
 1976 "Professional Ethics: Statements and Procedures of the AAA" (Rev'd). Washington, D.C.: AAA.
 Sections on informed consent and privacy are relevant.

American Sociological Association
 1984 *Code of Ethics*
 See section on "Respect for the Rights of Research Populations" (p. 3).

Appell, G. N.
 1978 *Ethical Dilemmas in Anthropological Inquiry: A Case Book.* Waltham, Mass.: Crossroads Press.

Reports on 91 cases (some briefly described) in areas such as relations and responsibilities to the host community, to respondents and informants, and to the host government; relations with outside agencies in regard to host community and with other social scientists; dilemmas in the use of social scientific data; problems in publication and teaching; and responsibilities to funding agencies. One of the book's themes is the tension between ethically responsible research and growing competition for profit and power in American anthropology. All sections are generally relevant to social research involving visual media, though none deal with the specific problems they raise.

Asch, Timothy
 1979 "Making a Film Record of the Yanomamo Indians of Southern Venezuela," *Perspectives on Film*, 2, pp. 4–9, 44–49.
 A diary of one field trip (primarily recounting exhaustion and pitfalls) that illustrates the need for anthropological awareness and language ability in cross-cultural film-making (an awareness and ability Asch felt he did not have).

Barnes, J. A.
 1977 *Ethics of Inquiry in Social Science.* New Delhi: Oxford University Press.
 Three lectures on the ethical implications of research sponsorship, differing cultural notions of privacy, covert inquiry, the limits of participatory research, knowledge as power and property, and the social sciences as an integral part of the culture of industrialized and non-industrialized nations. Refers to cases, including Witchita Jury case (concealed recording of jury proceedings), the Glacier Project, Project Camelot, and others, though does not refer directly to cases involving image production or use.

Becker, Howard
 1978 "Do Photographs Tell the Truth?" *Afterimage*, February, pp. 9–13.
 Becker rephrases the question to ask "what is this picture telling us the truth about?" Suggests the kinds of questions that can be asked of photographs, even if they do not seem to relate to a photographer's intention with respect to a particular image. Threats to the validity of photographic asser-

tions are discussed prefaced by the following cautions: (1) photographs do not tell the whole truth, and unless contradictory, multiple assertions do not necessarily undermine each other; (2) the "truth" will ordinarily not be verified by a single photograph, but instead will require many pictures, among other forms of evidence; (3) the validity of what a photograph asserts may shift as new evidence is found; and (4) "no single standard of proof is acceptable for all social groups and purposes." Threats to validity include suspected fakery, photographers' attempts to create artistic renderings at the expense of crucial detail, inadequate sampling and problems of access to subjects and settings, and the consequences of personal and institutional censorship.

1974 "Photography and Sociology," *Studies in the Anthropology of Visual Communication*, 1(1), pp. 3–26.
 Considers some shared features of the historical development of photography and sociology as areas of theory and practice motivated by "social exploration." Introduces the literature of photography, its topics, and its modes of presentation, and discusses photography's relevance to sociological theory. Becker concludes with a fairly lengthy section on sampling, reactivity, access to subjects, the relation between ideas and images (or "concepts and indicators"), limitations of photography in social research, and the problems of personal expression and style. On ethics, see "Getting Access," pp. 19–21.

Bower, Robert T.
1978 "Informed Consent," in *Ethics in Social Research; Protecting the Interests of Human Subjects.* New York: Praeger.
 A discussion of content, extent and procedure when using informed consent in social science studies, with emphasis on: (1) whether the subject's initial participation is voluntary, unrequired, and granted with impunity or not; and (2) whether her participation may be withdrawn at any juncture, freely, completely, and without embarrassing consequences (p. 43). Also deals with the issue of signatures on consent contracts that might identify subjects unnecessarily (alluding to problems of identification with film, photography, or videotape).

Cassell, Joan
 1980 "Ethical Principles of Conducting Fieldwork," *American Anthropologist*, 82, pp. 28–41.
 Argues that unlike biomedical research, which often serves as the model for federal regulations protecting human subjects, fieldwork endows the investigator with comparatively little power in and control of the setting and context of research, and embodies fairly low calculable risks and benefits. A biomedically based code of ethics may therefore be inappropriate for field research.

Cassell, Joan, and Murray L. Ward (eds.)
 1980 *Social Problems*, 27(3), February.
 A full issue of *Social Problems* devoted to ethical questions in fieldwork. Includes sections (each comprised of 2–3 articles) on (1) Paradoxes and Problems of Informed Consent; (2) Fieldwork and Social Change; (3) The Fieldworker and Regulatory Agencies; and (4) Ethical Discourse, Theory and Practice.

Chilungu, Simeon W.
 1976 "Issues in the Ethics of Research Method: An Interpretation of the Anglo-American Perspective," *Current Anthropology*, 17(3), pp. 457–81.
 On "Anglo-American thinking in the selection of anthropology as a profession, in the selection of non-Western cultures as target cultures, in the terms used in recording, describing, and classifying phenomena related to these cultures, and in the methods used in research among them" (p. 458). Though the author does not address images directly, his discussion of Anglo-American ethnocentrism in non-Western cultural research raises issues relevant to visual anthropology. As well, Chilungu's consideration of the images and descriptions of "primitive," "non-literate," and "uncivilized" people, often characterizing written ethnographies of non-Western cultures, may apply to visual representations. The article is followed by critical comments from several anthropologists, both Western and non-Western, and with the author's reply.

Collier, John Jr.
 1967 *Visual Anthropology: Photography as a Research Method.* New York: Holt, Rinehart and Winston.

Discusses ethical aspects in relation to using photography as a "can-opener" (as an introductory device that may help initially in relating to one's subjects). Also includes remarks about "risks to rapport in photographic probing" (including the confidential treatment of photographs and "errors in taste" in terms of which photographs may be shown to whom). In both cases, remarks are directed toward the protection of the anthropologist and his or her research, rather than the subject.

Collier, John, and Malcolm Collier
1986 *Visual Anthropology: Photography as a Research Method* (Revised and Expanded Edition). Albuquerque: University of New Mexico Press.

A comprehensive description of still and motion picture photography in social and cultural research. See Ch. 3, "Orientation and Rapport" on overcoming ambivalence about using cameras in cross-cultural research. Cites ethnographic examples from the literature and from the authors' experience.

Diener, Edward, and Rick Crandall
1978 *Ethics in Social and Behavioral Research*. Chicago: University of Chicago Press.

A review of social science research ethics and the role of personal values in research, including guidelines for ensuring the welfare of individuals and groups studied. Includes sections on consent, privacy, deception, cross-cultural research, disguised participant observation (these latter two categories from a psychological rather than anthropological perspective), honesty and accuracy in publishing, and the role of values in social scientific work. Also includes professional codes of ethics for the American Anthropological Association, American Sociological Association, and American Psychological Association (though they are somewhat dated), and an extensive bibliography in social scientific research ethics (none of the titles listed indicates a particular concern with the creation or use of images).

de Sola Pool, Ithiel
1979 "Prior Restraint," *New York Times,* Dec. 16.

Pool's reaction to and campaign against the Department of Health, Education and Welfare's 1977 regulations on re-

search with human subjects is based upon what he considers its unconstitutionality. He uses a journalistic analogy, suggesting that much of the survey and interview research conducted by social scientists that would require prior review by an institutional board would be protected by the First Amendment were it to occur in a journalistic context. (See also Reinhold, below.)

Feld, Steven, and Carroll Williams
1975 "Toward a Researchable Film Language," *Studies in the Anthropology of Visual Communication*, 2(1), Spring, pp. 25–32.

A comparison of three paradigms for filming behavior in social scientific research: the "locked-off camera" (LOC), where the camera, usually hidden, is placed in a single position on an immobile tripod for the duration of the filming period (which may be intermittent and controlled electronically by programmed starts and stops); "conventional film language" (CFL), the "theatrical mode of filmic translation" in which "events, or messages about events, are temporally and spatially condensed and ordered in a way that will be easily comprehended by an audience"; and "researchable film observation" (RFO), which denotes not so much a specific technique as a "way of thinking about the variables to be dealt with in order to do research with film." RFO demands skill in filming *and* training in the specific area of research for which filmed records are being made. In RFO, film is recognized as a translation process rather than treated as a neutral device whose use is epistemologically unrelated to the phenomena under study. The authors describe the assumptions and operations of each paradigm in detail, and argue the heuristic and ethical preferability of RFO, ethical because it requires a researcher to deal with the problematic relationship between filmer and filmed, a relationship the "hidden camera" approach evades.

Fetterman, David M.
1983 "Guilty Knowledge, Dirty Hands, and Other Ethical Dilemmas: The Hazards of Contract Research," *Human Organization*, 42(3), pp. 214–24.

From the author's abstract: "Field workers encounter numerous personal and professional hazards in contract re-

search. A few potentially hazardous situations include entrance into the field, role conflicts, fieldwork in the inner city, ethnographic reports, and dissemination of findings. Job stress and burnout pose an additional problem. Urban fieldwork in particular forces an ethnographer to confront the realities of guilty knowledge—confidential knowledge of illegal activities—and dirty hands—a situation from which one cannot emerge innocent of wrongdoing. Developing moral decision-making guidelines is imperative if one is to deal effectively with these problems. A risk-benefit approach, the respect-for-persons ethic, and basic pragmatism must all be used as guidelines." The article does not address the use of visual media in research though it is clearly relevant to sponsored film-making or to films/videotapes about cultural sub-groups whose members routinely engage in illegal activities (e.g. drug users).

Geertz, Clifford
 1968 "Thinking as a Moral Act: Ethical Dimensions of Anthropological Fieldwork," *Antioch Review,* Summer, pp. 139–58.

Following John Dewey, "thought is conduct and the results of thought must reflect the quality of the human situation in which they were obtained." In this context, Geertz discusses ethical dimensions of his own fieldwork in the "new states" (particularly in Indonesia and Morocco), where thought as conduct has the power to expose a situation rather than to solve the problems it may embody. Agrarian reform is a case in point. Questions discussed include what right an anthropologist has to expect his respondents or informants to accept him and co-operate with him, and the nature of "scientific detachment," or the relationship between subjects and scientist.

Georges, Robert A., and Michael O. Jones
 1980 *People Studying People: The Human Element in Fieldwork.* Los Angeles: Univ. of California Press.

A discussion of the human relationship between fieldworkers and fieldwork subjects. Deals with issues involved in explaining one's presence as a fieldworker, gaining the acceptance, confidence, and co-operation of one's subjects, and maintaining mutually acceptable relationships throughout the fieldwork period. Chapters on dilemmas, alternative

means of fieldwork, confrontation, clarification, and compromise, reflection/introspection, and results. Throughout the book, issues relating to the use of film and still cameras and other recording devices are considered. In particular, see pp. 91–97 for a description of a film project among Albertan Hutterites (despite the group's taboos on photography of any kind). (The section is offered as an illustration of the unsettling consequences of compromise in a field population.) See also pp. 143–47 for a discussion of particular fieldwork results that may arise when recording devices are used.

Grimshaw, Allen D.
1982 "Whose Privacy? What Harm?" *Sociological Methods and Research,* 11(2), November, pp. 233–47.

One of very few articles to deal directly and at some length with issues of privacy, risk, benefit, harm, and consent in the production and use of sound-image recordings (SIR) for social research. Grimshaw considers privacy and research historically, connecting (though noting important differences between) concerns raised by biomedical and social study. He illustrates his arguments with well-known cases of published images (for example, *An American Family*) that are ethically problematic because of the constantly shifting sets of social and organizational considerations and constraints that render definitions of privacy and its invasion elusive. In this respect, Grimshaw argues that issues of privacy raised by SIR are phenomenally similar to those faced in all interaction, but are magnified by both the permanence of the record and the possible publication of analyses and the visual data from which they are drawn. Grimshaw concludes by noting that although the dangers of SIR in social research cannot be eliminated, they can be reduced by "prior ethnography, by full explanation of research purposes, modes of analysis, likely format of final reports and possibly distressing findings," and by avoiding altogether the surreptitious recording of sound-images (for which, he says, there is rarely a defensible need).

Hass, Hans
1970 *The Human Animal: The Mystery of Man's Behavior.* New York: G. P. Putnam and Sons.

An ethnological approach to the study of human behavior. The author uses the film camera to study people "with the same objectivity usually reserved for the study of marine life." Hass does not discuss the ethical implications of using film as a research tool, but throughout the book describes circumstances in which candid films were made (that is, unbeknownst to the subjects), the premise upon which the camera, as a tool of objectivity, was used in the first place (p. 11) and the use of film that has been speeded up and slowed down for the analysis of movement (pp. 80–86). As an introduction to the group of plates accompanying the text, Hass shows how he and co-researcher Eibl Eibesfeldt used cameras equipped with concealed prisms that allowed them to face away from their subjects while filming. He notes that though the photograph (in the book) that shows him shooting with this method depicts "rickshaw coolies in Hong Kong, hardly anyone spotted the trick, even in Europe" (facing p. 97, see also p. 80).

Health, Education and Welfare, U.S. Department of
1971 "The Institutional Guide to DHEW Policy on the Protection of Human Subjects," Washington, D.C.: DHEW.

1974 "Protection of Human Subjects," *Federal Register*, 39(105), pp. 18914–20.

1975 "Protection of Human Subjects," *Federal Register*, 40(50), pp. 11851–58.

1978 "Protection of Human Subjects," *Federal Register*, 43(141), pp. 31786–94.

Health and Human Services, U.S. Department of (formerly DHEW)
1983 "Additional Protections for Children Involved as Subjects in Research," *Federal Register*, 48(46), pp. 9814–20.

Honigman, John J.
1976 "The Personal Approach in Cultural Anthropological Research," *Current Anthropology*, 17(2), pp. 243–61.

Describes the personal (vs. objective) approach in cultural anthropology, placing values in the combination of "interests, personal values, theoretical orientation, imagination, sensitivity and other idiosyncratic qualities embodied

in a particular competent investigator or team of investigators" (p. 250). Acknowledges the difficulty of testing the approach for credibility in terms of standards applied to "objective" research and concludes that credibility in fact depends on the cogency, consistency, logic, and persuasiveness with which arguments are presented. The author considers the approach most appropriate for research whose goal is "historical narration, depicting a way of life, the interpretation of meaning, or tracing relationships between cultural patterns." Comments by anthropologists and author's reply follow the article. Not specifically about images, but about a research approach that may include visual media.

Horowitz, Irving Louis
1983 "Struggling for the Soul of Social Science," *Transaction/ Society,* 20(5), July/August, pp. 4–15.

On the Stephen Mosher dismissal from the doctoral program in anthropology at Stanford University and its ethical implications for social science. Mosher was charged by Chinese authorities with several breaches of "scholarly misconduct" during fieldwork in mainland China, among them the publication of photographs in a local Chinese newspaper of expectant mothers about to undergo abortions in their eighth month of pregnancy, as required by the Chinese birth control program. Horowitz discusses the various difficulties in assessing the allegations against Mosher, concludes in part that the punishment does not fit the "presumed crime," and considers the possible effects of Mosher's dismissal (and its consequences for his career) on academic freedom.

Pandey, Triloki Nath
1972 "Anthropologists at Zuñi," *Proceedings of the American Philosophical Society,* 116(4).

Pp. 331–32 include an account of camera-smashing at Zuñi, involving a film project under the direction of anthropologist F. W. Hodge in 1923. Though several somewhat discrepant accounts of the incident have been reported (p. 332), the issues seem to relate to Protestant-Catholic factionalization in the pueblo, and who among the faction leaders was authorized to permit the filming and who was required to comply. Ultimately, the incident led to Hodge's expulsion from the pueblo.

Reinhold, Robert
 1980 "Guidelines on Studies of Humans Stir Protest," *New York Times,* April 22, pp. C1, C6.

An overview of negative reaction to Health, Education and Welfare (now Health and Human Services) guidelines and prior review procedures for research with human subjects. Academic opposition was directed primarily at the inclusion of social scientific research under the same ethical and policy restrictions as biomedical and behavioral research. Several examples of the consequences of a literal interpretation of the guidelines are provided. While supporters and authors of the then-new guidelines praised the protection they offered human subjects, they too called for a less ambiguous reformulation.

Rynkiewich, Michael A., and James P. Spradley
 1976 *Ethics and Anthropology: Dilemmas in Fieldwork.* New York: John Wiley and Sons.

A casebook of ethical dilemmas. Includes treatment by twelve writers of the following issues: (1) the anthropologist's provision of medical treatment; (2) pursuing secondary research topics (revealed after work on primary research has begun); (3) secret government contract research (especially in cases where the contract initially allows the researcher to share all information with informants); (4) the anthropologist's involvement in political discussion in a community; (5) people's needs vs. anthropological research interests (asking the question "what good will it do us?"); (6) permission to observe in a public setting (in this case, an urban bar); (7) studying elites and ending relationships with groups that have accepted you as a member; (8) when informants reveal extremely personal information; (9) dual responsibilities to subjects and to research when studying secret groups as both anthropologist and member; (10) taking sides during research in a revolutionary setting; and (11) why anthropologists choose to study what they study.

Sandall, Roger
 1976 "A Curious Case of Censorship," *Encounter,* July.

On banning films and in some cases books that depict sacred Australian aboriginal rituals (discussed briefly in the more general context of Revivalism in anthropology).

Stasz, Clarice
 1979 "The Early History of Visual Sociology," in Jon Wagner (ed.), *Images of Information.* Beverly Hills: Sage, pp. 119–36.
 A useful background on the early collaboration of photography and sociology (from about the turn of the century through the early '50s), including an account of why photography fell out of favor as a tool of sociology some 15 years afer its introduction.

Walbott, Harold G.
 1982 "Audiovisual Recording: Procedures, Equipment and Troubleshooting," in Klaus K. Scherer and Paul Ekman (eds.), *Handbook of Methods in Nonverbal Behavior Research.* Cambridge: Cambridge University Press.
 See section on ethical concerns in audio and visual recording for behavioral research, including problems of subject consent and making records accessible to the public (pp. 573–77).

Contributors

Robert Aibel is assistant professor, Department of Humanities and Communications, Drexel University, and senior lecturer, Annenberg School of Communications, University of Pennsylvania.

Carolyn Anderson is assistant professor of Communication Studies at the University of Massachusetts at Amherst.

Tom Beauchamp is a professor in the Department of Philosophy and the Kennedy Institute for Ethics, Georgetown University, Washington, D.C.

Howard S. Becker is MacArthur Professor of Arts and Sciences in the Department of Sociology at Northwestern University.

Thomas Benson is a professor of Speech Communication at Pennsylvania State University.

Larry Gross is a professor of Communications at the Annenberg School of the University of Pennsylvania.

Lisa Henderson is assistant professor of Communications at Pennsylvania State University.

John Hostetler is professor emeritus of Sociology at Temple University and scholar in residence at Elizabethtown College, Pennsylvania.

John Stuart Katz is a screen writer, author, and professor of Film at York University, Toronto.

Judith Katz is a clinical psychologist and professor at York University, Toronto.

Stephen Klaidman is a former reporter with the *New York Times, Washington Post,* and *International Herald Tribune* and is currently senior research fellow at the Kennedy Institute of Ethics, Georgetown University, Washington, D.C.

Donald Kraybill is professor of Sociology at Elizabethtown College, Elizabethtown, Pennsylvania.

Jay Ruby is associate professor of Anthropology at Temple University.

Jack Shaheen is professor of Mass Communications at Southern Illinois University in Edwardsville, Illinois.

David Viera is professor of Radio-Television-Film at California State University–Long Beach, California.

Toby Alice Volkman is a cultural anthropologist and staff associate at the Social Science Research Council in New York City.

Thomas Waugh is associate professor of film at Concordia University in Montreal.

Brian Winston is dean of the School of Communication at Pennsylvania State University.